Fascist Visions

Art and Ideology in France and Italy

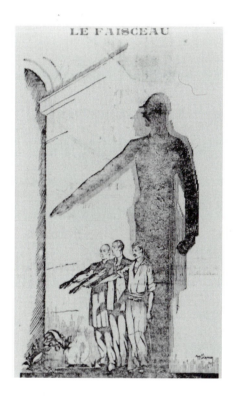

Edited by Matthew Affron and Mark Antliff

Princeton University Press
Princeton, New Jersey

Copyright © 1997 by Princeton University Press

Published by Princeton University Press,
41 William Street, Princeton, New Jersey 08540

In the United Kingdom: Princeton University Press, Chichester, West Sussex

Library of Congress Cataloging-in-Publication Data

Fascist visions: art and ideology in France and Italy / edited by Matthew Affron
 and Mark Antliff.
 p. cm.
 Includes bibliographical references and index.
 ISBN 0-691-02738-2 (alk. paper)—ISBN 0-691-02737-4 (pbk.: alk. paper)
 1. Fascism and art—France. 2. Art and state—France. 3. Fascism and art—
Italy. 4. Art and state—Italy. I. Affron, Matthew. II. Antliff, Mark.
N8846.F8F3 1997
709'.44—dc21 97-8461

This book has been composed in Fairfield Medium and Futura

Princeton University Press books are printed on acid-free paper and meet the
guidelines for permanence and durability of the Committee on Production
Guidelines for Book Longevity of the Council on Library Resources

Printed in the United States of America

10 9 8 7 6 5 4 3 2 1

10 9 8 7 6 5 4 3 2 1 (pbk.)

Designed by Bessas & Ackerman

Frontispiece: Miramey, *Le Faisceau*, reproduced in *Nouveau siècle*
(12 November 1925).

Fascist Visions

Contents

List of Illustrations

Acknowledgments

A number of individuals and institutions played important roles in seeing this volume to completion, and we would like to thank the following for their support. For their help in the editorial process, we are indebted to Patricia Fidler, Elizabeth Johnson, Elizabeth Powers, and Timothy Wardell of Princeton University Press. We would also like to thank the reviewers for their astute recommendations, all of which proved helpful in shaping the final manuscript. The volume could not have been completed without the generous material assistance of Grinnell College, The Johns Hopkins University, and Queen's University. For their friendship, moral support, and intellectual encouragement at various stages during the development of the project, we gratefully thank Robert L. Herbert, Patricia Leighten, Sophie Rosenfeld, and Daniel Weiss. Finally, we warmly thank our coauthors for their hard work and their collaboration in all stages of work on this collection.

Fascist Visions

Art and Fascist Ideology in France and Italy:
An Introduction

Matthew Affron and Mark Antliff

Fascist Visions: Art and Ideology in France and Italy examines the engagement of artists, decorative artists, art critics, and political theorists with protofascism and fascism in France and Italy from the last quarter of the nineteenth century through the Second World War.[1] In contrast to recent anthologies that take a broad approach to the subject—incorporating essays on fascism and culture throughout Europe and in a variety of media[2]—we have chosen to to focus on developments in two countries where modern aesthetics and fascist politics were often closely aligned. Indeed recent comparative studies have demonstrated that the Franco-Italian case presents distinctive and significant problems within the broader field of the study of fascism.[3] The common premises of fascist thought in France and Italy led to the development of shared ideological and cultural precepts; and these principles were often expressed and promoted by figures who maintained links with both countries. The introduction to this volume will assume two related tasks. First, it will briefly outline the evolving historical debate over the roots, course, and nature of fascism in France and Italy. Second, it will introduce the theoretical and historical issues that are central to the study of fascist culture and modern art in France and Italy, and thereby set the stage for the eight essays that follow.

A major difficulty facing any treatment of fascism's relation to culture is that of defining fascism itself, a problem compounded by the widespread acknowledgment that there are many varieties of fascism.[4] Our own choice in limiting this anthology to protofascism and fascism in France and Italy is in part a response to that issue, for scholars concur that proponents of fascism in these two countries derived their ideology from a shared body of philosophical positions. Eugen Weber, in essays and books published over the last thirty years, and Zeev Sternhell, beginning with his book on Maurice Barrès in

1972, have provided the terms for the study of fascism as an ideology. Weber was among the first to examine the history of national socialist discourse in France. In a 1962 essay titled "Nationalism, Socialism, and National Socialism in France" he set out to analyze the "inherent contradictions" of that political tradition, and then proceeded to chart the "ideological alliance" between nationalism and socialism in France from the 1880s to the 1940s.[5] Weber followed his early essay with a series of studies focusing primarily on the Action Française and other groups that he identified with the antiparliamentary right.[6] Sternhell subsequently studied their counterparts on the French and Italian left, paying special attention to the impact of national socialism's French progenitors on the Italian national syndicalists and nationalists who would eventually join forces under the auspices of the *Fasci di combattimento*, the nationalist movement that Mussolini founded in 1919. Sternhell then followed Weber in studying the left-wing syndicalist and nationalist authors who defined the national socialist agenda in the 1890s—Maurice Barrès, Fernand Pelloutier, Charles Maurras—and in emphasizing the importance of Georges Sorel's anarcho-syndicalist theories to the subsequent development of fascism in France and Italy.[7]

Weber concluded that the overarching ideological theme shared by national socialists was an "interest above all in national unity" that caused them to "reject class war in favour of class integration, without, however, approving a capitalist and bourgeois order they despise."[8] Thus the national socialist followers of Sorel who formed the Cercle Proudhon (1912–14) (most notably royalists Georges Valois and Henri Lagrange and syndicalist Edouard Berth) labeled democratic institutions and ideals a reflection of capitalism which served to undermine French "culture and productivity."[9] By pointing to the link posited by national socialists between economics and culture, Weber anticipated a key aspect of subsequent analyses of fascist ideology, namely, that theories of productivity were integral to Sorelian anticapitalism and to fascist theories of moral and cultural regeneration. Sternhell then demonstrated how, reproving the speculative and materialist capitalism of the international financier, but also rejecting the mechanistic foundations of Marxism, the national socialists instituted a new anti-materialist and neo-idealist political doctrine.[10]

In contrast to Weber, who attempted to differentiate pre-1914 national socialists from post-1918 fascists, Sternhell analyzed the ide-

ological factors that led Sorelian national socialists like Georges Valois to become full-fledged fascists after the First World War. Crucial among these was a belief in violence as an ethical and regenerative force in itself and as the key to national renewal and unity. For Stern-hell, prewar Sorelians and Sorel's postwar followers shared a desire for "regeneration" that was "simultaneously spiritual and physical, moral, social and political," and a totalizing "revolt against deca-dence."[11] Thus, when Valois founded the first fascist movement in France in 1925, the Faisceau, he hoped to unite a regenerated prole-tariat and bourgeoisie in an alliance premised, in part, on the "spirit of victory" created by the war effort. As Sternhell and Emilio Gentile have pointed out,[12] violence was not only a means to a particular political end; it was a moral value crucial to the perpetuation of the fascist state even after the fascists were firmly in control of the state apparatus. Furthermore, violence was not only the vehicle of social revolt and regeneration; it was the authentic source of creative energy in a fascist order, with the ability to transform the individual. Thus, far from being an art-for-art's-sake attitude that excluded all other val-ues from the political agenda,[13] the fascist aestheticization of violence had a moral import that was crucial to the fascist project. To be truly beautiful, Sorelian violence had to express the creative and moral transformation of each individual; otherwise it would resemble the brutal, immoral violence of the tyrant. As Roger Griffin points out in his exemplary study of generic fascism, "palingenetic"—or regenera-tive—myths of renewal and rebirth are central to fascist ideology, so that fascists "believe the destruction unleashed by their movement to be the essential precondition to reconstruction" that gives rise to a "creative nihilism."[14]

 In support of his argument that antimaterialist revolt was a defin-ing trait of fascist ideology, Sternhell demonstrated how the Sorelian doctrine of national socialism, once established in France, also flour-ished in Italy before 1914.[15] This ideology had its origins in the post-1909 alliance of integral nationalists associated with Charles Maurras's royalist Action Française and revolutionary syndicalists formally affili-ated with the syndicalist journal *Mouvement socialiste* (1905–14). Sorel himself signaled his shifting allegiances by replacing his earlier anarcho-syndicalist myth of the general strike with the myth of an inte-gral nation-state as the ideological motor of social regeneration. Sorel's national socialist allies in the royalist and syndicalist camps con-

demned democracy as a doctrine of ultra-individualism, one that served both to atomize society and to replace those ethical values that gave individuals a sense of community with a capitalist materialism wholly concerned with self-interest. Thus the pride of syndicated workers in their particular métier, or the religious values that united French Catholics in a spirit of community, were undermined when the "integral," antimaterialist values of the syndicalist or Catholic were replaced by the materialist ones of the reigning "plutocracy." In addition, democratic materialism was associated with a political tradition grounded in Enlightenment rationalism; the national socialists therefore turned to the antirationalism of figures such as the sociologist Gustave Le Bon and the philosophers Henri Bergson and Friedrich Nietzsche, to justify their theories of spiritual transformation. Concurrently, Sorel critiqued the economic materialism and historical determinism of Marx on the basis of Bergsonian anti-intellectualism, and defined a revolutionary role for mythic structures as the "intuitive" motivators best able to provoke a revolutionary situation. Sorelian national socialists, to quote Reed Dasenbrook, thus "seemed to give mythmakers, hence artists, an important role in social life," which accounts in part for fascism's appeal in artistic circles.[16]

This "national socialist" synthesis had its Italian counterpart in the collaboration between revolutionary syndicalists like Arturo Labriola and Roberto Michels, and the ultranationalist Enrico Corradini, who founded the *Associazione Nazionalista Italiana* in December 1910 to propagate his Sorelian conception of Italy as a "proletarian nation" that should pursue a colonial and imperialist course in conflict with "plutocratic nations." That same year Corradini joined forces with the Sorelian syndicalists Paolo Orano and Labriola in founding the Florentine journal *La Lupa*. Like their French counterparts within the Action Française and the Cercle Proudhon, Corradini and Orano regarded war waged in the name of antimaterialist, antiplutocratic values to be of positive import; appropriately they exalted Italy's 1911 military intervention in Libya as evidence of the decay of democratic values and their replacement by Sorelian virtues that could potentially overcome the democratic system. As Sternhell demonstrates, Mussolini himself came to embrace that same ideology. With the founding of *Il Popolo d'Italia* in 1914 and the *Fasci di combattimento*, Mussolini joined Corradini and Orano in advocating war between nations as a route to antiparliamentary revolution at home. In this regard Sternhell

followed the lead of A. J. Gregor who also argued that Mussolini had developed a coherent ideological system during the war years.[17]

Although Sternhell's model has been undeniably influential, his interpretation of fascist ideology has met with important criticism from historians of fascism. Some perceive a failure to relate theory to praxis; others ask Sternhell to account for the transformation of fascism's ideological underpinnings once fascists gained power in Italy and, with Valois's Faisceau, became a fully developed movement in France.[18] Sternhell's critics argue that while his model of fascism can be legitimately applied to the study of idealists associated with fascism's origins, it does not provide a method for understanding the large-scale movement that brokered power with Italy's conservative elite in 1922. Thus historians such as Jacques Juillard claim that Sternhell's "history of ideas" is divorced from any history of fascism based on historical events, with the result that Sternhell has "artificially separated fascist ideology from fascism itself."[19] In a related argument, historian Robert Soucy goes even further by claiming that Sternhell takes "too much of fascism's rhetoric about national 'socialism' at face value, thereby ignoring many of the rationalizations and mystifications perpetrated by such propaganda."[20] Citing the example of Faisceau, Soucy argues that the monetary support Valois received from industrialists like Eugène Mathon and François Coty, combined with the lower-middle-class makeup of the fascist rank and file, meant that the ideology of national socialism mapped out by Sternhell was so much window dressing for a fundamentally conservative movement whose members were threatened by the rise of communism and socialism within France.[21] "What separated French fascists from French parliamentary conservatives," Soucy claims, "was primarily issues of tactics and style: fascists were more eager to abandon political democracy and resort to paramilitary force than conservatives, and their style was more military than bourgeois in tone."[22] Arguing that the supporters of fascism came primarily from the right, Soucy joins a number of scholars who would question Sternhell's thesis that French fascism's adherents were dissident leftists advocating a doctrine of Marxist revisionism.[23]

By claiming that the "leftist" pretensions of fascist "theory" were divorced from the "economics" of fascist praxis, Soucy not only reiterated the familiar Marxist correlation of fascism with the politics of the *petite bourgeoisie*, he denied that the doctrine of "national socialism" outlined by Sternhell had any impact on historical developments. How-

ever, in not taking theories of national socialism at "face value" Soucy goes to the extreme of not granting that discourse any value at all, even when it affected the historical evolution of a given movement. For instance, if one studies the rise and fall of Valois's Faisceau it is clear that the ideology of the movement undermined its economic viability, for Valois's attacks on the Action Française and his repeated attempts to win over syndicalists as well as industrialists in the name of Sorelian national socialism eventually alienated financial backers such as the royalist sympathizers Coty and Mathon.[24] These industrialists, like Soucy, may have initially thought Valois's Sorelianism mere "rhetoric"; historical events, however, were to prove otherwise, and Valois's leftism eventually led him to abandon fascism altogether in favor of Sorelian syndicalism rather than Sorelian national socialism.[25] Thus to claim that Sternhell's "history of ideas" is divorced from historical events by labeling such ideas mere "rhetoric" is to underestimate the role ideology plays in historical developments and, in Soucy's case, to give too much weight to an analysis of base structure economics.

Historians who agree with Sternhell's affiliation of fascism with left-wing politics nevertheless follow Soucy in faulting him for over-valuing the ideological dimension of fascism. As Robert Paxton has recently noted, Sternhell's model "puts more weight upon origins than upon later developments, and it rates the thinkers as more authenti-cally fascist than the doers." By emphasizing theory over praxis, other historical factors that may have contributed to the rise of fascism appeared to be excluded: thus, since fascist ideology, in Sternhell's account, was fully developed before 1914, the historical circumstance of World War I provided its practitioners "only with auspicious circum-stances and new recruits."[26] To account for the evolution of fascism from its protofascist beginnings as a doctrine of antimaterialism advo-cated by small dissident groups to a totalitarian state in Italy, historians such as Pierre Milza have spoken of a "first" (idealist) and "second" (pragmatic) fascism.[27] In this reading the antimaterialist ideals that animated Italian fascists during fascism's first phase were reduced after 1922 to rhetorical slogans that served to hide a fundamentally conser-vative agenda. Antimaterialism now served to justify a corporatism that undermined socialist labor unions, and heroic violence was put to use in attacks on the pacifist Socialist Party and its affiliated unions. Unlike Soucy, Milza argues that we should take seriously the leftist aspirations of fascist ideology, but only during the period before the fascist push to

gain power in Italy. As for France, it has been argued that "first fascism" survived simply because fascism itself was a marginal element on the French political landscape. "Wherever fascism remained pure," states Robert Paxton, "it remained limited to cafés, struggling newspapers, and the occasional street demonstration."[28]

We believe, however, that in marginal and, eventually, in state-sponsored cultural production we find both the expression of fascist ideology and projects and practices that were integral to the totalitarian consolidation of power. Culture can be conceived as a dynamic in modern political systems, and in the case of fascism this relation is magnified. As Walter Benjamin argues in his seminal essay "The Work of Art in the Age of Mechanical Reproduction" (1936), fascism can be seen as a form of aestheticized politics in which aesthetic issues permeated all aspects of society; and the political, economic, and cultural realms should not be considered separately when discussing fascism.[29] Rather than dismissing fascist ideology as a form of "false consciousness," as Soucy does, one should recognize the very real role of cultural production in the formation of groups and constituencies favorable to fascism. Indeed, recent scholarship in the domain of literary criticism has demonstrated the fruitfulness of approaching fascism from this perspective. In her influential book, *Reproductions of Banality: Fascism, Literature, and French Intellectual Life* (1986), Alice Kaplan fully reflects the impact of such thinking in that volume's successful fusion of Sternhell's work with a theoretical approach indebted to Althusserian Marxism, feminism, and psychoanalysis. In Kaplan's words, "Althusser's notion of ideological interpellation in language has made a bridge between linguistics and politics, between politics and psychoanalysis." This conception informs Kaplan's study of fascism's "pre-Oedipal relationships to language" and that doctrine's exploitation of "mother- and father-bound desires." Rather than employing an economic model to study fascism, Kaplan would have us consider "other kinds of production" in order to understand the function of fascist ideology "as a reproduction of desires and discourse, that is, in terms of the persuasive language used by fascists."[30] In Kaplan's reading, the media through which fascist propaganda is conveyed are very much part of the ideological message. Her example is the radio: in their attempt to transform social subjects, French fascists seized on radio as the means of imbuing language with a sense of immediacy, fabricated through the rhythmic cadence of speech, the Derridean

"false origin of writing." To operate successfully, fascist speech exploited pre-Oedipal desires to overcome subject-object boundaries through the psychic merger of individuals into the "maternal" crowd, a boundary-less sensation akin to religious experience.

While Kaplan notes that the maternal rhetoric of boundary-less unity began to dissipate once the fascists gained political hegemony in Italy, she argues that the maternal and paternal aspects of fascism coexisted throughout the movement's historical evolution: fascism's maternal language was always spoken by a male orator, and the bound-ary-less crowd was animated by the soldier's virile *esprit de corps*. Kaplan elucidates fascism's totalitarian aspirations by analyzing its abil-ity to "appeal at different emotional registers at different moments," a coexistence "that reminds us that fascism works by binding doubles." Kaplan points to Sternhell's analyses of fascism's claim to be neither left nor right as an example of its bipolar structure: in its antimaterial-ist critique of rationalism, fascism aims to transcend both Marxism and democracy by condemning both for their materialist approach to social relations.[31] Over the course of its development from theory to praxis, from "first fascism" to "second fascism," the polar emphasis may have shifted, but the fundamental duality remained intact, and ideology had a formative role to play within the state apparatus.

Kaplan's model accords with Roger Griffin's "palingenetic" con-ception of fascism, for the fascist "thrust towards a *new* type of society means that it builds rhetorically on the cultural achievements attrib-uted to former, more 'glorious' or healthy eras in national history only to invoke the regenerative ethos which is the prerequisite for national rebirth, and not to suggest socio-political models to be duplicated in a literal minded restoration of the past."[32] Emilio Gentile reached similar conclusions in his claim that the "cult of Romanness" in Italian fas-cist discourse "was reconciled, without notable contradiction, with other elements of fascism that were more strictly futurist, such as its activism, its cult of youth and sport, the heroic ideal of adventure, and above all the will to experience the new continuity in action projected toward the future, without reactionary nostalgia for an ideal of past perfection to be restored."[33] Thus fascism's palingenetic, totalitarian aspirations allowed it to incorporate past cultural traditions into a pro-gram for a "new civilization" that combined the constructive and destructive, the revolutionary and conservative. Fascism's "polarity machine" allowed this ideology to address both the past and the future

by proclaiming the present to be decadent, and thus in need of regenerative cultural renewal.

The concept of ideological polarities, furthermore, is particularly germane to the study of fascist aesthetics, and this is especially evident in critical reassessments of Walter Benjamin's evaluation of the relation of Italian futurism to fascism, as developed in "The Work of Art in the Age of Mechanical Reproduction" (1936).[34] In this text Benjamin highlights the fascist championing of the retrograde aesthetics of art for art's sake, and contrasts that aesthetic model to the emancipatory role signaled by new aesthetic forms such as cinema and photomontage. In Benjamin's theory the latter aesthetic forms alone were adapted to the collective consciousness of the emerging proletariat; as a result, both were divorced from the auratic properties of older art forms, whose organic completeness, Benjamin argued, was designed for the passive contemplation of single individuals. By cloaking politics in auratic rituals and aestheticized rhetoric, fascism sought to impose passivity on the working class and simultaneously uphold the bourgeois order that was threatened by the class-based politics of this newly created urban proletariat. As Russell Berman has noted, Benjamin argues that "the emancipatory potential of social modernization" is blocked by fascism, which "mobilises aesthetic categories in order to impede the dissolution of the traditional social order."[35] Aesthetic notions of an unchanging, organic unity, whose self-referential value transcends the historical circumstances from which it emerged, were transferred to the political realm to justify fascism. Thus, in Benjamin's view, fascism seeks to overcome the sociopolitical dissension caused by capitalism by imposing an aestheticized ideology on the fragmented and pluralistic flux of contemporary society. Part and parcel of this transferral is a denial of historical change, and the replacement of the ever-changing, dynamic condition of human history with a closed, unified, and static model of organic completion, wherein existing socioeconomic hierarchies would become ossified and forever fixed. To quote Berman, Benjamin regards "the closed order of the organic work of art," as "a deception that imposes an enervated passivity on the bourgeois recipient;" in contrast, Benjamin valorizes "fragmentary, open genres: the German Trauerspiel of the baroque as well as the avant-gardist valorisation of montage," whose negation of aesthetic closure precludes any passive response on the part of what is invariably a collective audience.[36] "In place of the auratic art work,

with its isolated and pacified recipient lost in contemplation," asserts Berman, "Benjamin proposes a postauratic model that would convene a collective recipient (the 'masses') endowed with an active and critical character."[37] As the carrier of new cultural forms and new modes of aesthetic reception, the proletariat is the class best adapted to the new collectivist economy; the bourgeoisie and their fascist apologists on the other hand marshal the auratic aesthetic of an earlier era to defend the outmoded politics of private ownership. To Benjamin's mind, this model is confirmed by Italian fascism's relation to futurism: having quoted extensively from a futurist text extolling the beauty of the war in Ethopia, Benjamin correlates the aestheticism of art for art's sake with Marinetti's futurist defence of fascist violence:

Fiat ars—pereat mundis, says Fascism, and as Marinetti admits, expects war to supply the artistic gratification of a sense perception that has been changed by technology. This is evidently the consummation of "l'art pour l'art." Mankind, which in Homer's time was an object of contemplation for the gods, now is one for itself. Its self-alienation has reached such a degree that it can experience its own destruction as an aesthetic pleasure of the first order. This is the situation of politics which fascism is rendering aesthetic. Communism responds by politicizing art.[38]

The battle between fascism and communism has an aesthetic correlate in the closed order of organic form and the fragmentary dynamism of collage, and only the latter is attuned to the socioeconomics of the twentieth century. Thus Benjamin valorizes those art movements—dada and surrealism—which consciously attack bourgeois notions of artistic autonomy, while aligning futurism to the aestheticized discourse of the latter.

Benjamin's analysis has inspired contemporary scholars not only to explore the implications of his model for an analysis of literary texts written by fascism's apologists,[39] but also to counter that the aestheticization of politics can serve a variety of political positions,[40] and to question Benjamin's restriction of fascist aestheticization to nostalgic models of organic unity and completion. In this regard fascism's relation to futurism has undergone revision, for a number of historians have argued that futurist aesthetics embraced the very fragmentary, dynamic, and collage-based aesthetic that Benjamin would associate with antifascism and proletarian emancipation.[41] Thus in a recent book, literary historian Andrew Hewitt claims that Benjamin's relation of fascism's politics to "falsified principles of harmony, organic total-

ity, and unity," serving to mask a society typified by class conflict and social fragmentation, cannot explain the fascist embrace of futurism, because that movement trumpeted the very conflict fascism supposedly sought to cover up.[42] Turning Benjamin's construct on its head, Hewitt argues that futurist proponents of fascism thought contemporary society to be in a condition of ossification, organic closure, and stasis, and thus in need of rejuvenation through violence. By calling for "the ontologization of struggle as both an aesthetic and a political principle,"[43] the futurists wished to reinvigorate a culture subsumed in the very organicist metaphors Benjamin would identify with the fascist project. "Whereas a more traditional analysis might stress the occultation and aesthetic resolution of class struggle under fascism," states Hewitt, "it might be more valuable to speak instead of the generation of depotentialized areas of struggle within the aesthetic," that is, the transference of the dynamism of class conflict to a realm of avant-gardism.[44]

Hewitt's critique of more "traditional" analyses, which, like Benjamin's, would relate futurism to "the classical aesthetic of harmonization" and "the false reconciliation of social conflict,"[45] finds an echo in George Mosse's recent essay on "The Political Culture of Futurism."[46] Here Mosse analyzes two forms of nationalism, one that "apparently slowed down change and restrained the onslaught of modernity" by "condemning all that was rootless and that refused to pay respect to ancient and medieval traditions" and "another kind of nationalism exemplified by the futurists in their acceptance of modernity."[47] Paradoxically, "while most twentieth-century nationalism retained its role as an immutable and unchanging force, the repository of eternal and unchanging truth," futurism exemplified a "different nationalism" that exalted violence, condemned the past, and declared modern technology to be "a vital symbol" of renewed national energies. The human correlate to this cult of violence and technological dynamism was the "so-called new man—symbolic both of modernity and the power of the nation."[48] Thus, for Mosse, fascism in Italy embraced two aesthetics, one dynamic and fully accepting of technology, the other more traditional in its desire to anchor nationalism in the organicist and auratic aestheticism outlined by Benjamin.

Here Mosse raises a key issue, that is, whether fascism, though resolutely modern in its aim to create a new society, nevertheless subsumed the auratic vestiges of past traditions within its aesthetic. In

this manner the organic and dynamic could coexist within a political aesthetic premised on regeneration. This Janus-faced aesthetic serves to confirm Kaplan's conception of the "polarity machine" operative in fascist theory as well as the palingenetic model developed by Griffin. It also bears directly on the criticism of literary historian Jeffrey Schnapp, who has focused on such polarities in essays devoted to futurist art and architecture. In an essay titled "Forwarding Address," Schnapp points to two aspects of the politics of Italian fascism—its call for the reconstitution of Italy and its embrace of a politics of imperialist expansion as resulting in conflicting "ideological/cultural leitmotifs" of organicist closure and dynamic expansion and fragmentation.[49] Thus, in Marinetti's orations he will "preach a gospel of cultural revolution without boundaries" while positioning each audience "in relation to their national origin" and grounding his futurism in the rhetoric of Italian racial nationalism.[50] In the aesthetic realm, this dualism results in the conflation of irredentist nationalism, symbolized by the pervasive use of the Italian flag in futurist painting, with an aesthetic that breaks the boundaries of the picture frame as a way of signifying the expansive force of futurist energy, and the resulting instability of Italy's own borders. "Just as in the founding manifesto the arrival of the word 'Italy' signalled a nationalist localization and literalization of the allegory that preceded it, so the appearance of the Italian flag in futurist pictorial space defines the drama of the expanding and multiplying subject as a specifically national one," corresponding to a "nationalist politics of expansionism and war."[51] In works such as Carlo Carrà's *Interventionist Demonstration* of 1914 the centrifugal expansion of Italian nationalist energy beyond the picture frame signals the denial of political as well as aesthetic closure and any stasis that might be acheived through the irrendentist reconstitution of Italy; instead Italy's borders are forever unstable, and organicist motifs in the realm of painting, as well as politics, are actively defied.[52]

Turning to architecture, Schnapp has brought similar insights to bear on an analysis of the 1932 Exhibition of the Fascist Revolution, held in the Palazzo delle Esposizioni in Rome.[53] Schnapp begins his essay by asking whether the triumph of fascism entailed "a decisive break with the past or, instead, the recovery of a lost origin (for instance, of the glory of Imperial Rome)," before arguing that, in keeping with Mussolini's cultural strategies, fascism marked "both a rupture and a return, at once a reassumption of a historical legacy and

the transcendance of that very legacy."[54] This transcendance, we are told, "required an aesthetic overproduction—a surfeit of fascist signs, images, slogans, books, and buildings—to compensate for, fill in, or cover up its forever unstable ideological core."[55] Fascism's new "image politics" thus sought to "sustain contradiction" and in so doing "make of paradox a productive principle"; furthermore it did so by combining futurist collage techniques with auratic and historicist symbols linking fascism to a Roman, imperial past and to what Emilio Gentile terms fascism's "secular religion." For instance, in the 1932 exhibition celebrating the tenth anniversary of the fascist revolution in Italy, that mixture took the form of fifteen rooms that masked the palazzo's "orderly sequence of rectangular room plans" behind "an unpredictable progression of asymmetrical rooms with irregular spatial relations and proportions."[56] The visitor was expected to pass through a visual cacophany of collage elements relaying the events leading to the March on Rome, before proceeding to a series of central rooms, culminating in the so-called Sacrarium of the Martyrs. Designed by the rationalist architect Liberia and theatre designer Valente, the focal point of this cylindrical room was a huge cross, commemorating those fascists who had died for the cause. The use of the Latin term *sacrarium* to describe this sanctified space served to connect fascism's martyrs with what Romke Visser calls the fascist doctrine of "the cult of the Romanità,"[57] thereby conflating "ritual symbols from Roman antiquity and Christendom."[58] Through the transition from the spatial dynamism of the earlier rooms to the auratic stasis of the Sacrarium, states Schnapp, the exhibition's designers "transformed the narrative of fascism's triumph [into] an allegory in which the emotions of awe and terror associated with the revolutionary violence of fascism-as-movement are transmuted into feelings of order and solemn elation associated with fascism-as-regime."[59]

The studies of Weber, Sternhell, and other historians of fascism have recently been followed by fresh interpretations of the operation of fascist ideology within the domain of the fine arts.[60] In addition Benjamin's model of fascism, and the conception of fascism's "polarity machine" outlined above, have also influenced architectural historians who have studied the relation of French and Italian architecture to fascism. Thus in her analysis of the French architect Le Corbusier's affiliation, during the 1930s, with the Sorelian Hubert Lagardelle, Mary McLeod notes that the architect's "organicist" designs for such

cities as Algiers served to aestheticize the doctrine of "Planism" and regional syndicalism advocated by Lagardelle.[61] Lagardelle's and Le Corbusier's reconciliation of art and politics "in the name of an organic, natural order superior to the artificial caprices of modern democracy" amounted to a mere "image of cultural reconciliation," a masking of class divisions with the aestheticized politics of corporatism. Although McLeod does not follow Zeev Sternhell in correlating Lagardelle's doctrine of "Planism" with fascism,[62] her analysis of Le Corbusier's aestheticized politics echoes that of Walter Benjamin. Diane Ghirardo and Richard Etlin in turn have attributed the conflation of traditionalist and modernist themes in the architecture of the Italian rationalists to the Gruppo Sette's wholesale endorsement of fascist ideology.[63] In contrast to Italian architectural historians who would cite the rationalists' embrace of the modernism of Le Corbusier as proof of their distance from fascist political aims, Ghirardo and Etlin demonstrate the integral relation of Italian rationalism to an ideology that, in Ghirardo's words, vacillated "between an apparently adventurous modernism and a recalcitrant traditionalism."[64] The rationalists, argues Ghirardo, "straddled modernity and tradition" no less deftly than Mussolini, an ambivalence evident in the interrelation of their architecture and fascism's precepts as well as the architecture of Le Corbusier. This conflation of modernist forms with references to Italy's past is evident in the ground plan for rationalist Giuseppe Terragni's *Casa del Fascio* in Como, which, in Ghirardo's words, "resembles that of the Palazzo Farnese in Rome."[65] Concurrently both Ghirardo and Etlin have noted the Gruppo Sette's appropriation of Le Corbusier to their ideological ends, which "corresponded to the elitist model of society promulgated by fascism."[66] As evidence, Ghirardo observes the rationalists' assimilation of Le Corbusier's authoritarian pronouncements in *Vers une architecture* (1923) to the fascist imposition of a corporate hierarchy (*gerarchia*) on Italian society, while Etlin has charted the Gruppo Sette's relation of Le Corbusier's classical aesthetic to the fascist doctrine of *mediterraneità*. By arguing that Le Corbusier was a modernist wedded to Mediterranean culture, the rationalists effectively countered claims that they favored internationalism over an indigenous Italian tradition, reflective of a "Latin" and imperial past. In this manner the rationalists could take their place alongside architectural advocates of *Romanità* and *Latinità* in supporting an ideology that laid claim to the cultural legacy of Imperial

Rome as a springboard to colonial conquest in Africa. "The cult of Romanness," to quote Emilio Gentile, served to justify "political action" and as such "was celebrated modernistically as a myth of action for the future."[67]

In Italy and in France, and in contrast to Germany after 1933, fascist aesthetics were heterogeneous in nature; that is, the messages of fascism were articulated across a spectrum of sensibility that ranged from various abstract trends through many versions of historicist and traditionalizing figuration. Nevertheless, a fascist aesthetic can be effectively defined, at a formal level, through the same characteristic structure of polarization that informs our study of fascist ideology. That is to say, fascist aesthetics, though revolutionary and modernist, comprised progressive and traditionalizing currents, and were both elitist and populist in its logic. It is important to note, furthermore, that fascist aesthetics brought together these opposed terms in such a way as to challenge, on the theoretical level, any simple parallelism between progressive aesthetics and utopian and revolutionary ideologies, on the one hand, and reactionary art and authoritarian politics, on the other. Indeed, the study of fascist aesthetics has helped to call into question a central precept in the theory of the avant-garde, according to which the concepts of "modernism" and "fascism" were generally seen as mutually exclusive and diametrically opposed.[68]

Given the absence of any single fascist style, how do we evaluate the complex interrelation of art and fascist ideology? The eight essays that follow, all of which were written for this volume, have responded to that question in a variety of ways. Some authors examined the politics of style by considering the political motivations behind an artist's choice of aesthetic idiom. As Emily Braun shows in her study of Mario Sironi's urban landscapes, this painter used a severe historicist style to communicate a spirit of nationalist, populist, and antibourgeois insurgence during Italy's "Red Biennium" of 1919–20. In contrast, the French-born dancer and writer Valentine de Saint-Point, the subject of Nancy Locke's essay, placed a futurist sensibility at the core of a violently antimaterialist and nationalist gender politics. Other authors have examined how artists, critics, and political theorists interpreted contemporary aesthetics in the light of fascist ideology and theorized the contribution of modern artists to fascist culture. Emilio Gentile traces the symbiosis of politics and culture in Italy between the Risorgimento and the fascist era, demonstrating how the

myth of "national regeneration" grounded the shifting relation of nationalist politics and avant-gardist aesthetics throughout that period. Walter Adamson brings Gentile's definition of fascist ideology to bear upon the evolving art criticism of Ardengo Soffici, for whom, from the prewar period through the 1920s, the question of modernist aesthetics was crucial to his secular-religious fascist consciousness. Matthew Affron traces the interwar career of the French critic Waldemar George who, in the 1930s, interpreted Italophilic and neoclassical currents in contemporary art as the harbingers of a fascism that, he hoped and believed, was the destiny of France and Europe as a whole. Third, the authors investigate the ways in which political groups, parties, or state agencies made political use of art. In fascist Italy, art was employed by the state as an element in the building of political consensus. Marla Stone, in her essay on the eclectic patronage strategy of Mussolini's government, demonstrates the logic of the relationship between cultural producers, state institutions, and the public in Italy. Mark Antliff studies the theories of urbanism and aesthetics that were advocated by sympathizers of the Faisceau, the fascist movement of the 1920s, showing how these French fascists adapted concepts from the architect Le Corbusier to the requirements of their own antimaterialist and Sorelian program for the construction of a national socialist society. In tracing official attempts to remedy the ostensible decadence of the luxury decorative arts, Michèle Cone demonstrates how elements of fascist ideology emerged in the arts policy of the Pétain regime of 1940–44.

Taken together, the essays in this volume demonstrate the variety of ways in which we can address the problem of fascism and art. They illuminate the complex and often tense dialogue between innovation and tradition in fascist visual culture. Consequently, and most important, they help us see some of the fundamental problems inherent in efforts both to aestheticize politics and to politicize art in the first decades of the twentieth century. By considering these issues across national boundaries and over almost half a century of European history, this volume seeks to elucidate not only the impact of fascism on art in France and Italy, but also the importance of the visual arts in the construction and consolidation of one of the most destructive political ideologies of this century.

1. In this anthology we have focused on the cultural politics of artists, art critics, political theorists, and the institutional policies of fascist regimes in France and Italy; we have largely excluded study of fascism and aesthetics as it pertains to architecture because this subject is already well represented in the literature. For a recent survey of Italian architecture that seeks to summarize the literature on fascist architecture, see Richard A. Etlin, *Modernism in Italian Architecture, 1890–1940* (Cambridge: MIT Press, 1991); for an invaluable study of the impact of fascist-related ideologies on architects in France, see Mary McLeod, "Le Corbusier: From Regional Syndicalism to Vichy," Ph.D. diss., Princeton University (Ann Arbor: University Microfilms, 1985).

2. For instance, see Richard J. Golsan, ed., *Fascism, Aesthetics, and Culture* (Hanover, N.H.: University Press of New England, 1992); George L. Mosse, *International Fascism: New Thoughts and New Approaches* (London: Sage Publications, 1979); and selected essays on fascism in Germany, Great Britain and Italy in Peter Collier and Edward Timms, eds., *Visions and Blueprints: Avant-Garde Culture and Radical Politics in Early Twentieth-Century Europe* (New York: St. Martin's, 1988).

3. For instance, see Sandro Briosi and Henk Hillenaar, eds., *Vitalité et contradictions de l'avant-garde. Italie–France 1909-1924* (Paris: J. Corti, 1988); Mariella Colin, ed., *Polémiques et dialogues. Les échanges culturels entre la France et l'Italie de 1880 à 1918* (Caen: Centre de recherches en langues, littératures et civilisations du monde ibérique et de l'Italie, 1988); Jean-Baptiste Duroselle and Enrico Serra, eds., *Italia e Francia dal 1919 al 1939* (Milan: Istituto per gli Studi di Politica Internazionale, 1981); and Pierre Milza, *Le fascisme italien et la presse française 1920–1940* (Brussels: Editions Complexe, 1987). Related material is listed in part two of our selected bibliography under the subheading "France and Italy: Cultural Relations."

4. Richard Golsan rightly acknowledges this in his recent anthology on fascism and aesthetics. See Golsan, *Fascism, Aesthetics, and Culture*, x; for a survey of fascist variations, see Eugen Weber, *Varieties of Fascism: Doctrines of Revolution in the Twentieth Century* (New York: Van Nostrand, 1964).

5. Eugen Weber, "Nationalism, Socialism, and National-Socialism in France," *French Historical Studies* 2, no. 3 (Spring 1962), 273–307, rpt. in *My France: Politics, Culture, Myth* (London: Harvard University Press, 1991).

6. For instance, see Eugen Weber, *Action Française: Royalism and Reaction in Twentieth-Century France* (Stanford: Stanford University Press, 1962); and Hans Rogger and Eugen Weber, eds., *The European Right: A Historical Profile* (Berkeley: University of California Press, 1965).

7. For a list of Sternhell's publications see the section of our selected bibliography titled "Fascist Ideology and Politics in France and Italy."

8. Weber, "Nationalism, Socialism, and National-Socialism in France," 273–307.

9. Ibid.

10. Zeev Sternhell, "The 'Anti-Materialist' Revision of Marxism as an Aspect of the Rise of Fascist Ideology," *Journal of Contemporary History* 22, no. 3 (1987), 379–400. The combined relation of technological production to antirationalism, and attack on speculative capitalism as the materialist counterpart to Enlightenment rationality contributed to the rise of national socialism in Germany. For a study of this dimension of fascism, see Jeffry Herf, *Reactionary Modernism: Technology, Culture, amd Politics in Weimar Germany and the Third Reich* (Cambridge: Cambridge University Press, 1984).

11. Sternhell, "Fascist Ideology," in Walter Laqueur, ed., *Fascism: A Reader's Guide* (Berkeley: University of California Press, 1976), 315–76.

12. See Emilio Gentile, *Storia del partito fascista, 1919–1922. Movimento e milizia* (Rome and Bari: Laterza, 1989), 496.

13. We disagree here with Martin Jay's reading of Walter Benjamin's concept of aestheticized politics as derivative "from the *l'art pour l'art* tradition of differentiating a realm called art from those of other human pursuits, cognitive, religious, ethical, ecomomic, or whatever," which leads Jay to conclude that politics aestheticized "will be equally indifferent to such extra-artistic claims, having as its only criterion of value aesthetic worth." See Martin Jay, " 'The Aesthetic Ideology' as Ideology: What Does It Mean to Aestheticize Politics?," in *Force Fields: Between Intellectual History and Cultural Critique* (New York: Routledge, 1993), 72–73.

14. For Griffin's definition of fascism as a form of "palingenetic ultra-nationalism," permeated with Sorelian mythic structures, see Roger Griffin, *The Nature of Fascism* (1991; rpt., London: Routledge, 1994), 27–28, 32–39. Griffin defines "palingenesis" as follows: "Etymologically, the term 'palingenesis,' deriving from palin (again, anew) and genesis (creation, birth), refers to the sense of a new start or of regeneration after a phase of crisis or decline which can be associated just as much with mystical (for example the Second Coming) as secular realities (for example the New Germany)." Griffin employs it "as a generic term for the vision of a radically new beginning which follows a period of destruction or perceived dissolution." His term has been widely adopted as specifying a key concept of fascist ideology.

15. This argument is fully elaborated in Zeev Sternhell, with Mario Sznajdar and Maia Asheri, *Naissance de l'idéologie fasciste* (1989), published in English as *The Birth of Fascist Ideology: From Cultural Rebellion to Political Revolution*, trans. David Maisel (Princeton: Princeton University Press, 1993).

16. Reed Way Dasenbrock, "Paul de Man: The Modernist as Fascist," in Golsan, *Fascism, Aesthetics, and Culture*, 235.

17. See A. James Gregor, *Young Mussolini and the Intellectual Origins of Fascism* (Berkeley: University of California Press, 1979).

18. See the section titled "Fascist Ideology and Politics in France and Italy" in the selected bibliography.

19. See Jacques Juillard, *Autonomie ouvrière: Études sur le syndicalisme d'action directe* (Paris: Editions du Seuil, 1988), 269–85. Robert Soucy has summarized much of the literature on the "Sternhell Controversy" in his recent book outlining his version of French fascism in the 1930s. See Robert Soucy, *French Fascism: The Second Wave, 1933–1939* (New Haven: Yale University Press, 1995), 1–25.

20. Soucy, *French Fascism: The Second Wave*, 10.

21. This thesis is developed in an earlier volume devoted largely to the Faisceau. See Robert Soucy, *French Fascism: The First Wave, 1924–1933* (New Haven: Yale University Press, 1986).

22. Ibid., xv–xvi.

23. Soucy lists the following scholars as among those who reportedly uphold his view: William Sheriden Allen, Denis Mack Smith, S. William Halperin, Arno Mayer, Michael Kater, Charles Meier, John Weiss, William Irvine, Reinhard Kuhnl, Otto Bauer, and Jacques Juillard; they are in turn pitted against a list of proponents of the "leftist" reading of fascism that includes J. R. Talmon, Renzo de Felice, Eugen Weber, Ernst Nolte, René Remond, Philippe Machefer, Zeev Sternhell, Pierre Milza, Jean-Paul Brunet, Philippe Burin, Serge Bernstein, and Paul Mazgaj. See Soucy, *French Fascism: The Second Wave*, 3.

24. See the chapter devoted to Valois's Faisceau in Zeev Sternhell, *Neither Right nor Left: Fascist Ideology in France*, trans. David Maisel (Berkeley: University of California Press, 1986).

25. For an analysis of Valois's differences with these industrialists, see Allen Douglas, *From Fascism to Libertarian Communism: Georges Valois against the Third Republic* (Berkeley: University of California Press, 1992). Soucy, in *French Fascism: The First Wave, 1924–1933*, concedes that Mathon clashed with Valois over his recruitment of leftists and his rebuttal, in the name of corporatism, of Mathon's attempt to have "workers' unions directly under management's control"; however, he claims that Coty supported Valois because he "was less bothered by Valois's rhetoric than Mathon," the inference being that Valois's leftism was mere rhetoric, not to be taken seriously. See Soucy, *French Fascism: The First Wave*, 191.

26. See Robert O. Paxton, "Radicals," *New York Review of Books* (23 June 1994), 51–54.

27. See the introduction to Pierre Milza, *Le Fascisme français: passé et présent* (Paris: Flammarion, 1987).

28. Paxton, "Radicals," 52–53.

29. For Walter Benjamin's famous formulation of fascism as aestheticized politics, see Walter Benjamin, "The Work of Art in the Age of Mechanical Reproduction," in *Illuminations*, trans. Harry Zohn (New York: Schocken, 1969), 217–52; for a succinct analysis of that formulation, see Russell A. Berman, "The Aestheticization of Politics: Walter Benjamin on Fascism and the Avant-Garde,"

in *Modern Culture and Critical Theory: Art, Politics, and the Legacy of the Frankfurt School* (Madison: University of Wisconsin Press, 1989), 27–41.

30. Alice Yeager Kaplan, "Theoretical Voices," in *Reproductions of Banality: Fascism, Literature, and French Intellectual Life* (Minneapolis: University of Minnesota Press, 1986), 3–40.

31. Ibid., 33.

32. Griffin, *The Nature of Fascism*, 47.

33. Emilio Gentile, "The Conquest of Modernity: From Modernist Nationalism to Fascism," trans. Lawrence Rainey, *Modernism/Modernity* 1, no. 3 (September 1994), 74. As Gentile has argued in *Il culto del littorio: La sacrilizzazione della politica nell'Italia fascista* (Rome and Bari: Laterza, 1993), fascists identified the myths, rites, and symbols that served to mobilize the Italian populace during World War I with a willingness to sacrifice one's life in the name of "secular religious" values that were destined to transform the nation. It was the wartime valor of the Italian combatant that had produced the fascist "new man," whose values were antithetical to the rationalism of parliamentary democracy.

34. See Benjamin, "The Work of Art in the Age of Mechanical Reproduction," 219–54.

35. Berman, "The Aestheticization of Politics," 27–41.

36. Ibid., 38.

37. Ibid., 39.

38. Benjamin, "The Work of Art in the Age of Mechanical Reproduction," 242.

39. For a comprehensive study of French literary fascism that makes valuable use of Benjamin's thesis, see David Carroll, *French Literary Fascism: Nationalism, Anti-Semitism, and the Ideology of Culture* (Princeton: Princeton University Press, 1995).

40. See Jay, "'The Aesthetic Ideology' as Ideology," 71–83.

41. Historians should consult Christine Poggi's recent study of futurist collage, relating that aesthetic to futurism's prewar and wartime political aims. See Christine Poggi, *In Defiance of Painting: Cubism, Futurism, and the Invention of Collage* (New Haven: Yale University Press, 1992).

42. Andrew Hewitt, *Fascist Modernism: Aesthetics, Politics, and the Avant-Garde* (Stanford: Stanford University Press, 1993), 134–35.

43. Ibid., 135.

44. Ibid., 137.

45. Ibid., 135–36.

46. George L. Mosse, "The Political Culture of Futurism: A General Perspective," in *Confronting the Nation: Jewish and Western Nationalism* (Hanover, N.H.: University Press of New England, 1993), 91–105.

47. Ibid., 93–94.

48. Ibid., 94–95.

49. Jeffrey T. Schnapp, "Forwarding Address," *Stanford Italian Review* 8,

nos. 1–2 (1990), 53–80. For a reading of futurist collage that also relates that aesthetic to the futurists' desire for Italian military intervention in World War I, see Poggi, *In Defiance of Painting*, 164–251.

50. Schnapp, "Forwarding Address," 63–64.

51. Ibid., 71–73.

52. Ibid., 77.

53. Schnapp, "Epic Demonstrations: Fascist Modernity and the 1932 Exhibition of the Fascist Revolution," in *Fascism, Aesthetics, and Culture*, ed. Richard J. Golsan, 1–37.

54. Ibid., 2.

55. Ibid., 2–3.

56. Ibid., 27.

57. Romke Visser, "Fascist Doctrine and the Cult of the Romanità," *Journal of Contemporary History* 27, no. 1 (January 1992), 5–22.

58. Schnapp, "Epic Demonstrations," 30.

59. Ibid., 25.

60. For instance, much work has been published on the impact of Sorelian antimaterialism in the Italian context, specifically in futurist circles and among the Florentine intellectuals Giovanni Papini, Ardengo Soffici, and Guiseppe Prezzolini. See Stephen Sharkey and Robert S. Dombroski, "Revolution, Myth, and Mythical Politics: The Futurist Solution," *Journal of European History* 6, no. 23 (1976), 231–47; Giovanni Lista, "Marinetti et les anarcho-syndicalistes," in *Présence de Marinetti*, ed. Jean-Claude Marcadé (Lausanne: L'Age d'Homme, 1982); Mark Antliff, *Inventing Bergson: Cultural Politics and the Parisian Avant-Garde* (Princeton: Princeton University Press, 1993); and Walter L. Adamson, *Avant-Garde Florence: From Modernism to Fascism* (Cambridge: Harvard University Press, 1993). Mark Antliff has recently explored the impact of neo-catholicism on the aesthetics of Georges Sorel and the critics associated with the Cercle Proudhon as part of a larger study on Sorel's impact on protofascist and fascist aesthetics in France. See Mark Antliff, "The Jew as Anti-Artist: Georges Sorel, Antisemitism and the Aesthetics of Class Consciousness," *Oxford Art Journal* 20, no. 1 (1997): 50–67.

61. Mary McLeod, "Le Corbusier and Algiers," *Oppositions*, nos. 19/20 (Winter/Spring 1980), 53–85. For an overview of the debates between proponents of functionalism and regionalism in France during the 1930s, see Rémi Baudouï, "L'architecture en France des années 1940: Conflits 'idéologiques' et continuités formelles de la crise à la Libération," in *Art et fascisme: totalitarisme et résistance au totalitarisme dans les arts en Italie, Allemagne et France des années 30 à la défaite de l'Axe*, eds. Pierre Milza and Fanette Roche-Pézard (Brussels, 1989), 79–100.

62. For Sternhell's analysis of the "planism" of Lagardelle, see his *Neither Right nor Left*, 202–20.

63. See Diane Y. Ghirardo, "Italian Architects and Fascist Politics: An Evaluation of the Rationalist Role in Regime Building," *Journal of the Society of Archi-*

tectural Historians 39, no. 2 (May 1980), 109–27; Ghirardo, *Building New Communities: New Deal America and Fascist Italy* (Princeton: Princeton University Press, 1989); and Etlin, *Modernism in Italian Architecture*. Other valuable studies on the relation of fascism to architecture include: Henry Millon, "The Role of the History of Architecture in Fascist Italy," *Journal of the Society of Architectural Historians* 24, no. 1 (March 1965), 53–59; Millon, "Some New Towns in Italy in the 1930's," in *Art and Architecture in the Service of Politics*, eds. Henry Millon and Linda Nochlin (Cambridge: MIT Press, 1978), 53–59; Cesare de Seta, *La cultura architecttonica in Italia tra le due guerre* (Rome, 1972); Spiro Kostof, "The Emperor and the Duce: The Planning of Piazzale Augusto Imperatore in Rome," in *Art and Architecture in the Service of Politics*, eds. Henry Millon and Linda Nochlin, 270–326; Giorgio Ciucci, *Gli Architetti e il fascismo: Architecttura e città 1922–1944* (Turin, 1989); Dennis Paul Doordan, *Building Modern Italy: Italian Architecture, 1914–1936* (New York: Princeton Architectural Press, 1988); and Doordan,"The Political Content in Italian Architecture during the Fascist Era," *Art Journal* 43, no. 2 (Summer 1983), 121–31.

64. Ghirardo, "Italian Architects and Fascist Politics," 114; Richard Etlin, "The Rationalist Discovery of Fascism," and "The Casa del Fascio, Como," in *Modernism in Italian Architecture*, 377–90, 439–79.

65. See Ghirardo, "Italian Architects and Fascist Politics," 118; Richard Etlin in turn has related the Casa to Le Corbusier's architectural theories as well as to the fascist function of the Casa as a Sacrario. See Richard Etlin, "The Casa del Fascio, Como," in *Modernism in Italian Architecture*, 377–90, 439–79.

66. See Ghirardo, "Italian Architects and Fascist Politics," 122–26; and Etlin, "Le Corbusier, Choisy, and French Hellenism: The Search for a New Architecture," *Art Bulletin* (June 1987), 264–78.

67. Gentile, "The Conquest of Modernity," 74.

68. Scholars of Italian art and literature have made this point in particularly vivid terms. See Schnapp, "Forwarding Address," 53–54; Hewitt, *Fascist Modernism*," 1–19; and Gentile, "The Conquest of Modernity," 55–87. Roger Griffin has analysed fascism's restriction of its critique of modernism to those elements considered to be degenerative, and its palingenetic drive to create a new (hence modern) society. See Griffin, *The Nature of Fascism*, 47.

The Myth of National Regeneration in Italy:
From Modernist Avant-Garde to Fascism

Emilio Gentile

The myth of national regeneration occupies a central place in Italian political and cultural history, from the Risorgimento to fascism. It principally inspired Italian nationalism which, in all its manifestations, assigned a palingenetic function to both culture and politics as important means to realize a national revolution. This revolution would lead to the creation not only of a unified state, but also of a new Italian nation. From the very beginning, this myth was associated with the myth of a Great Italy, based on the belief that a united and regenerated Italy would achieve a new primacy in modern civilization. The myths of regeneration and primacy also greatly influenced the modernist avant-garde movements that rose in Italy in the early twentieth century and that, in the years of the Great War, were determinant for the politicization of cultural modernism and the rise of fascism.

However, the myth of national regeneration did not belong solely to nationalist culture. It was also present, in various forms, in other political movements: in liberalism, democracy, and socialism. Benedetto Croce, for instance, declared in 1914 that he was attracted to Marx's socialism and to Sorel's syndicalism, hoping that they both might contribute to "a regeneration of present social life."[1] Piero Gobetti's idea of liberal revolution was based on the concept that, in Italy, the lack of a religious reform movement like the Protestant Reformation had prevented the moral regeneration of the Italians; therefore they still lacked the modern consciousness of freedom. Gobetti, in contrast to proponents of nationalist myths, expected this regeneration from the revolutionary initiative of the working class and of a new liberal elite. The regeneration myth was also a fundamental aspect of revolutionary syndicalism, which conceived of social revolution as the moral palingenesis of the proletariat, rather than simply a means of destroying bourgeois society. For Antonio Gramsci, perhaps the most apoca-

lyptic of Italian communists, the communist revolution was a great plan of intellectual and moral regeneration that would lead to the birth of a new humanity. These movements, however, contained an important variant of the regeneration myth: whereas nationalist culture concerned only the Italians, these broader political myths had a humanistic and universal character, considering the Italians not only as a nation but as part of an entire humanity to be regenerated.

The myth of national regeneration can coexist with either nationalism or socialism, liberalism or totalitarianism. It can fit into a reformist and rationalistic concept of politics, but presents itself more often in revolutionary and eschatological forms. National regeneration is often messianic, assuming an apocalyptic character when the myth is conceptualized as a collective sacrificial experience, through a palingenetic catastrophe—war or revolution—destroying the old world and the "old man," and creating the new world and the "new man."

This essay will be concerned with the myth of national regeneration only in the orbit of nationalist culture, with particular attention to the period from the early twentieth century to fascism. In this period, the regeneration myth became almost an obsession for the new generations that were active in avant-garde movements. In fact, the members of the new generations fought for a cultural and aesthetic revolution that was also to initiate a moral regeneration and to create a New Italy. Thus the myth of national regeneration contributed to the politicization of Italian modernism, especially at the time of the Great War. The First World War will occupy a central part of our analysis because it represented the climactic moment in the struggle for national regeneration. Although they solicited Italian intervention for different ideological motivations, artists, intellectuals, and politicians shared the opinion that the war experience would finally realize the regeneration of the Italians.

During the twentieth century, national regeneration was presented as a total revolution to be achieved by one of two means: by new culture or by new politics. Until the Great War, the first method prevailed. After the war, with fascism, the new politics—totalitarian politics—claimed for itself the task of regenerating the nation. However, in the analysis of the myth of national regeneration, it is not possible to draw a clear line of separation between culture and politics. Even when it manifested itself in the spheres of philosophy or art, in fact, this myth had a political value, because, through it, different

forms of symbiosis between culture and politics occurred. There was, nevertheless, an important element that united the two versions of the myth: the common tendency to conceptualize regeneration as the consequence of a new secular religion. In reality, the myth of national regeneration itself had a religious matrix and character, whether it manifested itself in the world of politics or of art.

Ever since the American Revolution, and principally with the French Revolution, this myth was an important manifestation of the phenomenon of "sacralization of politics," which developed during the nineteenth century and culminated in the political religions of the twentieth century.[2] This term does not refer to the political mobilization of traditional religions, but rather to the political ideologies and movements which adapted religious rituals to political ends, elaborating their own system of beliefs, myths, rites, and symbols by which they intended to interpret the meaning of life and the ultimate goal of existence. Politics claimed its own religious character, proposing not only to govern human beings but to regenerate them in order to create a new humanity. In this way, political revolution became total revolution, permeating all aspects of human life and abolishing any distinction between the personal and the political. Cultural movements like the modernist avant-garde aimed for the same results: they proposed a spiritual revolution that, starting from a philosophy or art, should affect all areas of life, including the world of politics. The encounter between two revolutions, the political and the cultural, under the banner of the myth of national regeneration, represented the most radical form of symbiosis between culture and politics, when developed within the context of totalitarian regimes. In a more or less explicit way, all ideologies that contain a regenerative myth tend to become lay religions, either in the form of a "civic religion" proper to democratic regimes, or as a "political religion" typical of totalitarian regimes.[3]

The symbiosis of culture and politics under civic and political religions should not, however, lead us to suppress distinctions between democratic and totalitarian ideologies, for their divergent approaches to the regenerative myth have vastly different consequences for the average citizen.

The history of the myth of national regeneration in Italy offers numerous examples that confirm the need for such distinctions. In Italy, a first form of symbiosis between culture and politics occurred during the Risorgimento. The first preachers of the Italian regenera-

tion were such poets as Vittorio Alfieri and Ugo Foscolo. Their appeal was repeated by a great number of poets and writers who participated in the Risorgimento and who, in many cases, were also political agitators and statesmen. A second, and more intense, form of symbiosis occurred in the early twentieth century with such modernist avant-garde movements as *La Voce* and futurism. These movements advocated the cultural and moral regeneration of the character, mentality, and customs of the Italians, in order to create the new Italian fully adapted to the modern era.[4]

Another constant preoccupation for proponents of the myth of national regeneration in Italian political culture was the relation of the myth to modernity. The diversity of mythic constructs was the result of different perceptions of modernity and differing attitudes toward the social transformations produced by industrialization and modernization. But the connection between modernity and the myth of national regeneration also goes back to the Risorgimento. In fact, the principal goal of the patriots who fought for Italy's independence and unity was the civic and moral renewal of the Italians, who had been corrupted by centuries of division and enslavement, in order to transform them into a modern nation, capable of providing an original contribution to the progress of civilization.

The theory of Giuseppe Mazzini was the Risorgimento's most complex elaboration of the myth of national regeneration. Not only was he the principal prophet of a great Third Italy; his political messianism had a lasting influence on the subsequent elaboration of the myth before the rise of fascism. Mazzini envisioned an Italy regenerated and united through a political revolution based on faith in freedom and on the religion of the fatherland. He attributed to the Third Italy the divine mission of leading humanity as a whole toward a new era of the Spirit, the civilization of the Third Rome. The ethical concept of life as service to the fatherland; the messianic vision of politics as a new lay religion; the belief that only a collective palingenetic experience, through struggle, sacrifice, and martyrdom, would foster the birth of a new Italian people—these were key aspects in Mazzini's regeneration myth. For Mazzini, the national revolution was essentially a religious revolution, because, whereas politics "affirms men in what they are and where," only "a religious thought is capable of transforming them."[5] Independence and unity would be achieved by Italians regenerated by faith in the religion of freedom and fatherland, and

only the autonomous struggle of the Italian people would make them worthy of accomplishing the civilizing mission assigned by God to the Third Italy.

The nationalist movements that emerged in the early twentieth century were influenced by Mazzini's doctrine. Some of these movements associated, as Mazzini did, the national myth with faith in freedom as a regenerative factor; others instead associated the national myth with the myth of imperial power, and sacrificed freedom to it, considering political freedom a factor of nation degeneration.

After Italy's unification in 1861, the myth of national regeneration continued to dominate the country's culture and politics, especially through the radical nationalism of the new generations that adhered to Mazzini's ideal of the Third Italy. "We are Mazzini's men," Ardengo Soffici asserted in 1908.[6] The young intellectuals who gave birth to the Italian avant-garde were rebels against the state, whose very existence was a sign of the betrayal of Mazzini's national revolution. Unified Italy had not, for them, originated in a collective experience of sacrifice. "Look back at our past fifty years," wrote Giovanni Amendola in 1911, "and you will see this Italian revolution made entirely of politics, diplomacy, even literature, and so terribly lacking in collective effort, popular sacrifice, bloodshed, and sanguinary affirmation of the national will to rise."[7] As a consequence, Italy was a state without a soul; the Italians were a people without common faith in the religion of the fatherland; the liberal ruling class had abandoned the myth of Great Italy, creator of a new civilization; and Italy, not yet a nation in the modern sense, was leading a mediocre existence among the great powers that were conquering the world and transforming it through industrialization.

This new generation thought it could complete the national revolution and, at the dawn of the new century, gave new strength to the myth of national regeneration, which became the war banner of the modernist avant-garde. All the protagonists of the cultural renewal that accompanied the development of the industrial revolution in that period believed that Italy was going through a deep spiritual crisis, produced by modernization, which infiltrated and transformed virtually every aspect of society. Industrialism, urbanization, and mass society were new forces that were shaping modern civilization, but at the same time they threatened to destroy the sources of human spirituality and creativity. Modernization, upsetting the foundations of faith and tra-

ditional certainties, isolated individuals from the nation and immersed them in the anonymous crowd. The existence of the nation itself could be in danger if a regenerative movement did not halt the crisis, accomplish the national revolution, and give the Italians the moral cohesion, modern conscience, and strong national character that would enable them to overcome the challenge of modernity.

At the beginning of the twentieth century, many believed that Italy's institutions were unequal to the task of modernizing Italy. In 1911, Croce, alarmed, denounced the decay of the feeling of moral unity in Italian society. "The great words that expressed this unity: King, Fatherland, City, Nation, Church, and Humanity have become cold and rhetorical" and with the "disuse of those words goes a general decadence of the feeling of social discipline," because "the individuals no longer feel bound to a great whole, part of a great whole, subject to it, cooperating in it, drawing their value from the work they accomplish in the whole."[8] To combat this degenerative condition which he identified with mysticism, imperialism, and decadence, Croce called for an intellectual and moral regeneration, and emphasized the religious sense of life, based on lay humanism, and the liberal tradition of the Risorgimento.

The young rebels who gave birth to the movements of the Italian avant-garde shared with Croce the diagnosis of a national crisis and the necessity of regeneration, but the prescriptions they proposed did not accord with the philosopher's. Their search for a new religion went beyond the tradition of liberal Italy. Italian avant-gardists considered the separation between culture and politics the principal cause of the nation's decay in the face of modern challenges and argued that a new symbiosis between culture and politics was needed in order to renew the intellectual and moral energies of the nation. The struggle of the Italian modernists against bourgeois society, even when devoid of immediate political objectives, inevitably collided with the world of politics. The futurists, especially, believed in the regenerative mission of a new art capable of radically renewing all aspects of life, and therefore politics. The regeneration of politics would be the consequence of a new art and a new culture, capable of overcoming decadence by releasing the energy of a new creative spirituality, which would also be violent in its youthful and almost barbaric vitality.

Proponents of avant-gardism thought a cultural transformation could rescue the nation from the evils of past and present decadence,

and bring about a national revolution.[9] "Italy must be great because of the spirit, it must give life to a modern civilization," proclaimed Giuseppe Prezzolini, the director of *La Voce*, and his ambition was certainly shared by all the militants of the modernist avant-garde, even though their visions of Italy were different.[10] All the protagonists of Italian cultural modernism—philosophers, painters, writers—believed they had the mission of regenerating politics to form the national conscience of new Italy. Giovanni Papini, the main representative of the Florentine avant-garde, aspired to become "the spiritual guide of a young, very young, and future Italy. . . . I would like to be the spiritual reorganizer of this old race."[11] A similar ambition tormented a young historian, Adolfo Omodeo: "Garibaldi's dream is assailing me, I would like to affirm the soul of my people beyond the borders of Italy, in the presence of nations, wave the torch of a new civilization. . . . Will I have the strength to create the new fatherland, the conscience of the new Italy? The aspiration is immense, and sometimes I feel small and dismayed."[12] Marinetti and the futurists claimed the leadership of the cultural revolution which was to mold the modern Italians, freeing them from the cultural heritage of the past and the myth of tradition. On the opposite front, the young intellectuals, artists, and philosophers of *La Voce* strove to be the apostles of the intellectual and moral reform of the Italians by educating them according to the principles and ethical values of a new "religion of modern man."[13] These young people wished to "change the national character," because "in Italy there is little national dignity. We are shopkeepers, hoteliers, and servants."[14] They hoped to create a national conscience, by placing "some *organism* in this atomic chaos that is Italy."[15] Disgusted by the political conditions of the country under "Giolitti's dictatorship" (referring to the reign of old parliament member Giovanni Giolitti), they aimed at regenerating politics through culture, against and outside traditional parties. Thus, Amendola could conclude that "one does not surpass dead-end political roads with political means—a moral catharsis is needed—one must dig under the ground and walk down unsuspected paths."[16]

Italian modernists, much more than other European modernists, had a political vocation, with a strong nationalist connotation, that manifested itself principally in the myth of national regeneration. Their conception of new culture, new philosophy, new art, and new religion was inseparable from their belief in an Italian spirit, and their aspiration to be, as writers, philosophers, and artists, the spiritual

guides of a new and even greater Italy. Their regeneration myth origi-
nated in the will to accelerate the country's process of modernization
by adding intellectual and moral renewal to industrialization. Their
political orientation gave birth to a new nationalism, which I name
"modernist nationalism," and which manifested itself in the myth of
Italianism, the belief that Italy, regenerated and modernized, was des-
tined to play a dominant role on the world stage.

Modernist nationalism was characterized by enthusiasm for moder-
nity, perceived as an explosion of human energies and life expansion
without precedent in history, and by a tragic and activist sense of exis-
tence, which repudiated any nihilistic attitude with the exalted
sentiment of a new fullness of life and affirmation of vitality, for both
individuals and nations. For proponents of modernist nationalism, mod-
ernizing the nation meant not only providing it with new instruments of
economic and social development, but also freeing it from the archaic
customs assimilated during centuries of enslavement, and giving it,
through a new culture, a modern national conscience. For this purpose,
national modernism sustained the necessity to accompany industrial rev-
olution and modernization with a "revolution of the spirit," to form the
sensibility, character, and conscience of a "new Italian" capable of under-
standing and facing the problems and challenges of modern life. Mod-
ernist nationalism, in confronting the development of material and
technological forces, aimed at sustaining the superiority of spiritual
forces that gave unity and collective identity to the nation, in contrast
with disruptive effects of the crisis of traditional society, which, in Italy,
aggravated the defects inherited from an unfinished national revolution.

Young modernists such as Giovanni Amendola felt the need "to
go clearly beyond present Italy," for "a profound need of resurgence"
which manifested itself "in the practical and daily search for the high-
est ethical value, which gives life a meaning going beyond the limits
of the individual, and which allows, rather encourages the sacrifice of
life itself." Without this "ideal passion capable of transforming life and
raising it on high. . .we have a collection of men, not a nation. In Italy,
now, this is our plight: that the nation is a little more than a myth
going down and a hope rising."[17] National modernism wished to build
the "new fatherland" as Omodeo wrote in 1911:

The new fatherland: this is what we need: not the old fatherland, the fatherland of
headmasters, but the live fatherland, sense and aspiration of the renewed soul,

because the fatherland, Mazzini said, is the conscience of the fatherland. . . . We should reforge everything: our nation, politically a badly fused aggregate of the old regions, our national life that is disintegrated into the single egoistic activities of individuals, our moral life that stagnates in vile interests; we should unite everything in a profound will that embraces everything, that binds everything, in which everything converges; we should create the fatherland also with the torch of civil war.[18]

This disposition was also part and parcel of the call for a new religion and for an ethical and idealistic conception of life as a totality and communion of the individual with the national collectivity, considered the only force able to react to the decadence produced by positivistic rationalism, individualistic egoism, and hedonistic materialism. Many young people, having abandoned the Catholic faith, thought that a new lay religion should, in the conscience of modern Italians, replace traditional religion; others proposed to integrate traditional faith with the religion of the nation. The "new generation of Italy," Prezzolini stated in 1912, felt "that a vast and serious movement. . .could not take place but in a *total* form. . .must have a foundation, an ethical, metaphysical, and in a certain way religious line. . . .A movement must be *total*, speak to man, to today's man, to today's Italian."[19] The young intellectuals and artists who gave life to *La Voce* thought that the problem of national regeneration had to be faced first of all with the formation of a new religious conscience. Giovanni Amendola wrote in 1911:

[We want] to found in the granite of moral life, with a religion that connects us to the most profound and most total purpose of humanity, the solid and ethical edifice of the new Italian history [and] emerging from our daily humility be fit to fight in the centuries. . . . Our future as a nation will depend on this choice: and this choice is slowly maturing in the depth of national conscience. If we could influence this profound operation of the Italian spirit, we would also create tomorrow's Italy, an Italy that will cause the miseries of our past to be forgotten forever.[20]

A new national religion was also thought to be a crucial aspect of the education of the masses and their integration in the national state, for in this way a collective consciousness, founded on shared values and a sense of destiny, could be nurtured.

The rebellion of the young against the existing order, which originated in the world of culture and art, necessarily entered the field of politics. The nationalist avant-garde attacked internationalist social-

ism, positivistic reformism, clericalism, and conservative nationalism, as well as the liberal democracy, which the young rebels identified with Giolitti. Unopposed master of political life in the first decade of the century, Giolitti was considered, by the young modernists, the incarnation of Italian degeneration and the symbol of the old skeptical and faithless ruling class, incapable of guiding the nation in the conquest of modernity, and in the creation of a new Italian civilization. On the eve of the Italian intervention in the war, Omodeo declared that he would prefer "to die in the battlefield, notwithstanding the thousand ties which make me love life, than feel the shame of being Italian under the regime of Giolitti's peace. But let's hope that destiny is fulfilled for Italy's best; everything now admonishes us that the world is not made for the weak and the cowardly."[21]

Anti-Giolitti protests were conducted under the sign of the cult of youth as regenerative force. The myth of youth became another important element of the myth of national regeneration. The young considered themselves a force, revolutionary in itself, entering the fight against the liberal bourgeois society they judged decadent and corrupt, materialistic and conformist, lacking great ideals and great visions of the future. The myth of youth postulated the existence of peculiar regenerative qualities in the new generations. The young attributed to themselves the prerogatives and attitudes of the new ruling class, capable of guiding the country in the tempestuous ocean of modern life. The liberal ruling class was the custodian of the past. The young rebels were the avant-garde of the new Italian "builders of the future."[22] Of all the groups opposed to Giolitti, the futurists more than the others shared the cult of youth, interpreting the struggle of the young, healthy, and vital, against the old, senescent, and corrupt, as a necessary phase in the conquest of modernity.

The liberal and bourgeois ideal of the nation, handed down by the founding fathers of the national state, appeared to most young militants of the modernist avant-garde as outmoded, inadequate to mold the New Italy and guide it in the whirl of modern life. In the culture of the avant-gardes, criticism of the enlightened, rationalistic, and individualistic liberal tradition was widely diffused. This criticism, however, did not inevitably move toward an antimodern reaction; it did not propose political projects for the transformation of the national state, destined to result in the totalitarian state. The only project of national regeneration to be realized through an author-

itarian state, before fascism, was elaborated by a nationalist movement that considered the liberal democracy "in contradiction with the movement of modern life."[23] The development of mass society, socialism, and capitalist economy, by itself, was leading to the assertion of "the primacy of force and the need for a wider and deeper domination, renewing some characteristic conditions of ancient dominant civilizations."[24] The nationalists believed that modernization required new forms of authoritarianism for mass society, and looked at Germany and Japan as models of authoritarian modernization to be followed in forging a modern nation.

The cultural avant-gardes, such as the *La Voce* group and the futurists, sought other ways to integrate the masses in the national state and to insure a system of government fit to guide the nation through the turmoil of modern life. The myth of Great Italy, which determined the political attitude of most militants of the Italian avant-garde, did not necessarily lead to an authoritarian political nationalism. The case of futurism, which, from the beginning, had a political attitude opposed to parliamentary democracy, is typical. Although it exalted nationalism and imperialism, futurism professed itself individualistic, libertarian, and cosmopolitan, ready to favor the most radical social reforms, but in the recognition of the nation's primacy as collective value. The futurist democracy envisioned by Marinetti and by the political futurist party after the Great War was conceived as a semi-anarchic community of free individuals, not as a military regime and even less as an authoritarian state.[25] For the *La Voce* group, the necessity of reconciling nationalism and cosmopolitanism, freedom of the individual and authority of the national State, prevailed. The *vociani* proposed a new national democracy of the masses based on moral cohesion and social discipline spontaneously accepted. Their concept of democracy remained rather vague in the various interpretations proposed in the review. *La Voce*, however, sustained the need for some concrete democratic reforms, such as universal suffrage, administrative decentralization, and free trade. In *La Voce* an empirical reformist tendency coexisted with a stronger idealistic tendency, which assigned to the new idealistic culture the regeneration of the character of the Italians, in order to free them from the evils of a long-lasting habit of subjection, conformism, and rhetoric, and to educate them to live in freedom and with the dignity of conscious and responsible citizens. Unlike the futurists, who at the end of 1918 decided to form a

political party, the *La Voce* group dissolved before the Great War and never formed a political movement. Most of the *vociani*, however, entered the political arena to sustain Italian participation in the European war, seeing involvement in the conflict as a true "test of modernity" for the nation, the decisive trial for its ascent to great power. Some of them became political leaders in the opposite sides of fascism and antifascism.

With the Great War, the myth of national regeneration acquired a decisively political character. It became for many young people a revolutionary myth, inspiring active, not only cultural, struggle against the existing order. Whereas liberalism had conceived of regeneration as a gradual process of collective education, the young people of the modernist avant-garde were increasingly inclined to conceive regeneration as violent revolution to "radically change the whole soul of many men,"[26] as Papini announced in 1913, when he was engaged in the futurist campaign to prepare "in Italy the advent of this new man."[27] The futurists aimed at giving Italy:

a conscience that would drive it more and more to hard work and fierce conquest. Let the Italians finally experience the inebriating joy of feeling alone, armed, very modern, at war with all, and not drowsy great-grandchildren of a greatness which is no longer ours. We must come to a decision, inflame our passion, exasperate our faith for our future greatness, which every Italian worthy of this name feels deeply but desires too weakly! There is a need for blood, for casualties. . . . We should hang, shoot those who deviate from the idea of a great futurist Italy."[28]

The myth of revolution made the apology of violence an integral part of the ideal of national regeneration. The belief that Italy, in order to become a great modern nation, had to experience war was at the origin of the interventionism of many young intellectuals. Participation in the Great War represented for Italy the entrance "in the great history of the world,"[29] the philosopher Giovanni Gentile declared at the end of the conflict. Marinetti used the term "conflagration" to define the Great War, perhaps meaning to actualize the Stoic myth of the palingenetic "great fire" from which Great Italy was to rise. In the futurist concept, war was "the great and sacred law of life," the periodic "bloody and necessary test of the force of the people."[30] Italy's participation in the Great War was exalted by the futurists as the sanguinary rite of collective regeneration of the nation: "The War will rejuvenate Italy, will enrich it with men of action, will compel it to no

longer live on the past, the ruins, and the mild climate, but on its own national force."[31]

As we have seen, the myth of national regeneration had always been accompanied by the idea of the morality of war. Amendola ascribed a moral significance to war, seeing it as a collective test of discipline and sacrifice in which the character of the individuals and of the nation was probed and tempered.[32] For the interventionists, the Great War would be the collective sacrificial experience by which Italy could conquer the status of a great nation. "It is a matter of passing *our test*. Until now we were a nation aspiring to the role of the great. Today, it is not even about this, but about much more: it is about knowing whether we are a nation," *La Voce* stated in 1914.[33] The participation of the Italians in the war would be the *expiation* of the whole past, a rite of purification and regeneration. The Italians, Omodeo stated, did not deserve "a rapid, triumphal success" but only a victory springing "from the full maturity of the national conscience." Prior to victory, the war "must be a long purgatory of our national sins."[34] Even Croce, who had been a neutralist, had faith in the regenerative power of war: "We will exit the war with a higher, graver, and more tragic sentiment of life and of its duties: and we will burn in its flames many miseries of our politics of the last decades." Tested by war, the Italian army, according to the philosopher, demonstrated "that the Italian people has finally reached national and political compactness, whose expression is the army's force."[35] Through the war, the myth of national regeneration also infected the conscience of some Catholic interventionists, including Luigi Sturzo.[36] "Our holy war," declared Sturzo after Italy entered the conflict, revealed new moral energies, "which the touch of purifying fire and killing iron has aroused with great heroism and with the great explosion of sentiments of strong faith, indifferent to the supreme sacrifice of life. Thus the war has raised the value of the divine and eternal principles of morality, right, and religion."[37]

For many interventionists, faith in regenerative war was not shaken by even the most bitter disillusionments of the front experience. As often happens in the history of myths, especially political ones, many fighters who believed in the myth of regenerative war drew from the experience of mass carnage the motivation to renew their faith in the myth of national regeneration. The war appeared to them as a realized prophesy. Mass death and the suffering of millions of sol-

diers were interpreted and sublimated as necessary ordeals through which the Italians regenerated themselves. The "purifying fire" of the war must destroy in order to regenerate; the wider and deeper the destruction, the more certain the success of its regenerative function. Thus the myth of national regeneration, instead of being destroyed by the war, received fresh nourishment from it, and could exercise a wider influence, especially through the war's contribution to the sacralization of politics.

The Great War itself represented a sacred revelation. The war could be perceived by the fighter, in communion with his comrades, as a mystical experience of participation in a fascinating, terrible, and tragic reality. This led the fighters to live "in a unique atmosphere," as Theilard de Chardin wrote, "penetrating, dense, enveloping all that luxury of violence and majesty," in a "superhuman state to which the soul is uniformly driven at the front, notwithstanding the diversity of the sectors and the vicissitudes of the struggle."[38] This perception of the sacredness of war was associated with a mystique of comradery, which gave religious value and sentiment to the community of fighters, initiates to the new life, united by common destiny and by a common drive toward the realization of a transcendent goal. *La Voce* author Scipio Slataper wrote from the front:

It is the community of men that succeeds. It is the collective effort of joined assistance, of reinforcement, of coordination, that enthralls and which is true war. Military discipline has this sense, and therefore proceeds like any human labor, but in an endeavor and a condition that transcend the human. Digging a tunnel is cooperation and order reinforcing each other, like teams on duty; but storming a position is a desperate and sacred cooperation that resembles the rhythmic verses of an invocation in which nobody reasons any longer but rather acts as if all were inspired by sacred terror. God feels near in the battlefield.[39]

Many combatants lived the experience of the trenches as the sanguinary rite of initiation to a new life, the entrance into a world apart. This was the world of the trenches, a world defined by the front line, that "great mystic line along which so much blood flowed"[40]: a *sacred* world which, in the course of the war, became ever more distinct from the *profane* world of the rear guard of the civilians. With the baptism of fire occured the *metanoia* of the old man into the fighter or the new man. The soldier at the front experienced a "second birth" and became part of the community of the trench, united with

his companions by the ties of comradery. The life of the trenches, the sense of comradery, the soldiers' reciprocal dependence and loyalty in battle became the basis of a new sentiment of national communion imbued with lay religiosity.

The Great War reinforced the myth of national regeneration. Many aspects of the Italian political crisis of the postwar period, including the birth of fascism, cannot be understood without considering the part that this myth, now in the new version produced by the mythicization of the war, had in them. The war experience had important consequences for the structure of the myth, not only because it enriched it and strengthened it, but most of all because it transformed the myth's meaning and influence on the course of Italian history. Until the war, as we saw, politics was considered the object of regeneration, whereas the spiritual revolution of the new culture was its subject and maker. After the war, and as an effect of it, a substantial change took place as politics itself assumed the role of protagonist and maker and claimed the function of regenerating the nation. Born from the experience and the myth of the war, the new politics became the expression of a spiritual revolution inspired by a total conception of life, and, as a religion, claimed to have the monopoly in the definition of the meaning and ultimate goal of life, at least on this earth.

The mysticism of the trench reinforced the need for a national regeneration especially in the "aristocracies of *combattentismo*," that is, in the fighters who had sublimated their war experience as means to a superior humanity. The fact of having lived and overcome the war conferred to this type of fighter an exaltation of himself as new man regenerated both by the sacrificial test and participation, through mystic communion, in the sacredness of war; he thus became, through the *metanoia* of the trench, part of a greater soul, identifiable with the Nation.

After the end of the conflict, this mixture of sentiment and myth gave birth to the phenomenon of *combattentismo*, the cult of combatants—including *arditismo*, the movement of the black-shirted *arditi* of the commando units, and *fiumanesimo*, the movement for the conquest of Fiume—and to fascism itself, all united by the myth of national regeneration. These movements were nationalist, but their nationalism was shaped by a new palingenetic logic. From the experience of the trench, there rose what we can call existential nationalism, characterized principally by the tendency to define itself in the

forms of a new lay religion, in which the myths born with the war combined with the ideas and myths of avant-garde culture. This type of nationalism conceptualized New Italy as a living and lived reality that was identified with the *combattenti*. They were the new Italians regenerated by the war and future regenerators of the nation, the new ruling class capable of accomplishing the national revolution and finally giving birth to Great Italy. In a letter from the front, Ferruccio Parri, a future leader of the Italian Resistance, anticipated the themes which, in the postwar years, would form a new version of the myth of national regeneration: "Is this a dawn? To lay the foundations of our politics and of our 'politeia'?. . . For those that hope, as I do, the perspective of tomorrow's work is enormous. A labor of foundation and reconstruction. But who will be able to reconstruct if not we young people—those whom the war will spare; we young people who are the purest, who must and want to be the strongest. . . we will be able to sweep Augia's fetid stables of our political life: because we will know how to rebuild."[41] The *combattenti*, stated a journal of intellectual war veterans, were the "new men," morally and spiritually united by "a common vision of life, of Italy, and of their task as men and citizens." They alone could feel in a pure and true way the need for a "new life," because they alone were aware that they must perform a "task common to the men of the war, a moral task of today and tomorrow," that of forming the "soul of the Italians," of educating a new man, inspired by a decalogue of principles in which one found the essence of the myth of national regeneration. "Only this man can truly have a fatherland, can be a citizen in the full sense of the word: a man who lives the spiritual solidarity between himself and his people, who finds his interests in the increment of common interests, and not in their opposition, who has a strong sense of social unity and discipline. We need to become men, more and more. The Italians need to build Italy in their spirit."[42] Movements born from the war experience, including political futurism, *arditismo*, *fiumanesimo*, and fascism, represented a synthesis between the myth of national regeneration and the myth of *combattentismo*. For these movements, the Great War began a new phase for the regeneration of the Italians. The war, according to Giovanni Gentile, had been fought "for the renewal of the inner life of Italy,"[43] had killed "old skeptical Italy," and had begun the "redemption of old Italy from the past, a byword to the European nations because of its unwarlike character, its individualism, its scarce sense of

state, its tendency to confine itself in the circle of private egoism, or in the infinite abstraction of art and intellectual speculation. . . . The old man is not dead: he snares and entices us, and crosses our way. We must fight him and defeat him; the struggle is harsh because this man is a great part of us."[44]

Modernist nationalism, *interventismo*, and *combattentismo* established the conditions for the encounter between the avant-garde movements and the fascist movement. Born from the experience of the Great War, fascism was a manifestation of *political modernism*, an ideology that accepted modernization and thought it possessed the formula by which to give human beings, swept by the whirl of modernity, the power to face the challenges of history and create a new civilization. Fascism was not antimodern, but rather had its own vision of modernity which opposed the visions of liberalism, socialism, and communism, and which claimed the right to impose its own form of modernity on the twentieth century.

Many myths and ideas of the modernist avant-garde flowed into fascism and contributed to its ideology, mixing with the myths and ideas; rising from *squadrismo*, the punitive expeditions of fascist squads; with the new idealistic culture; and with myths and ideas of more recent radical movements on both the right and the left. Once again the element of symbiosis between culture and politics was the myth of national regeneration.

Fascism proclaimed itself the only authentic movement of the "new Italians" regenerated by the war, whom destiny had entrusted with the mission of accomplishing the national regeneration that had begun with the Risorgimento. Fascism was born as a charismatic movement, that is, a movement originated by the lived experience of an extraordinary event. What united fascists was not a doctrine but rather a state of mind, an experience of faith which took shape in the myth of a new political religion that was identified, with fascism itself, in the "cult of the lictorian fasces." The fascists considered themselves the prophets, the apostles, and the soldiers of the new "religion of the fatherland," risen through the purifying fire of the war, consecrated by the blood of the heroes and martyrs. They were the elite of the "regenerated regenerators" and would lead Italy in the conquest of modernity.

Fascism had the ambition of accomplishing the national regeneration through a totalitarian revolution which, like the "spiritual revolution" of the avant-gardes, aimed at being a total revolution,

penetrating all aspects of individual and collective life, custom, and character, in order to regenerate the nation, forge the new Italian, and build a new civilization. Mussolini did not have a high opinion of the Italians whom he ruled, notwithstanding public declarations of esteem. In reality, he felt he was in a permanent state of war against the character of the Italians. "His antagonist," Bottai observed, "is this nation whose history he would like to revise, to refashion it in his way."[45] The attitude of the duce toward the Italians was determinant in defining the objectives of the totalitarian state as regenerator of the Italians. Like all modern revolutionaries, Mussolini despised the real man and fanatically believed that only through the discipline of a *heroic pedagogy*—the radical transformation of character—could habits, mentality, and sentiments be effected to create *a new man*. Italians had to undergo a true *anthropological revolution*:

We must scrape and pulverize, in the character and mentality of the Italians, the sediments deposited by those terrible centuries of political, military, and moral decay, that ran from the seventeenth century to the rise of Napoleon. It is an immense labor. The Risorgimento was but the beginning, because it was the work of tiny minorities; the world war, instead, was profoundly educational. Now it is a matter of continuing, day by day, this remaking of the national character of the Italians.[46]

Fascism envisioned the new Italian according to the militaristic model of "citizen-soldier" dedicated, soul and body, to the cult of the state, like the ancient Romans. The highest ambition of the duce and fascism was to transform Italians into the new Romans of modern times, capable of challenging time by creating a new civilization. As Mussolini said, "If I succeed, and if fascism succeeds in shaping, as I wish, the character of the Italians, be confident and certain that, when the wheel of destiny passes at our hands' reach, we will be ready to catch it and bend it to our will."[47] The fascist state entrusted the party with the function of the *great pedagogue*, who was to regenerate the Italians by educating them in the faith and cult of the lay religion of the nation. "Under the regime the nation is born," the *Popolo d'Italia* announced in 1927. ". . . Fascism creates the custom from which the nation is born, the Fascist nation. . . . Fascism is creating the custom and through and by the custom, the Nation."[48] The stages in this "anthropological revolution" of the Italian character were the campaigns for the reform of custom, antibourgeois polemic, the adoption of racism, and, under certain aspects, participation in the Second

World War. In these campaigns to forge the "new Italian" the duce and the secretaries of the party could rightly proclaim themselves zealous disciples of Giovanni Gentile, who, before the advent of fascism, had noted that "the Italian people" predicted by "prophets of the Risorgimento" like Mazzini, "was not the people one could see around, but the *future people* that the Italians themselves had to create."[49]

Fascism boasted having accomplished the national revolution initiated by the Risorgimento, by regenerating the Italians and by uniting the nation, spiritually and morally, in the cult of the fasces. Fascist regeneration, however, sacrificed the freedom of the Italians on the altar of politics and in the name of the absolute primacy of the totalitarian state. In the final analysis the fascists could not consider themselves the authors of the regeneration that had been envisioned by Mazzini, by the patriots of the Risorgimento, and by most militants of the modernist avant-garde. The revolution that they envisioned was to produce a nation of free men, masters of their destiny.

Translated by Maria Tannenbaum.

1. Benedetto Croce, *Pagine sulla guerra* (Rome and Bari: Laterza, 1928), 22. Unless otherwise indicated, all translations in this chapter are by Maria Tannenbaum.

2. Emilio Gentile, "Fascism as Political Religion," *Journal of Contemporary History* 25 (May–June 1990), 229–51.

3. On this distinction, see Emilio Gentile, *Il culto del littorio* (Rome and Bari: Laterza, 1993), 301–15.

4. Emilio Gentile, "The Conquest of Modernity: from Modernist Nationalism to Fascism," trans. Lawrence Rainey, *Modernism/Modernity* I, no. 3 (September 1994), 55–87.

5. Giuseppe Mazzini, *Scritti politici* (Turin: UTET, 1972), 452.

6. Giovanni Papini, "Ardengo Soffici," *Carteggio* I, 1903–8, ed. M. Richter (Rome: Edizioni di Storia e Letteratura, 1991), 162.

7. Giovanni Amendola, "La guerra," *La Voce* (28 December 1911).

8. Benedetto Croce, *Cultura e vita morale* (Rome and Bari: Laterza, 1955), 163.

9. See Robert Wohl, *The Generation of 1914* (Cambridge: Harvard University Press, 1979), 160–202. One of the best analyses of the relation between modernism and politics in early twentieth-century Italian culture is the work of Walter L. Adamson, *Avant-Garde Florence: From Modernism to Fascism* (Cambridge: Harvard University Press, 1993).

10. Giuseppe Prezzolini, "Il risveglio italiano," *La Voce* (30 November 1911).

11. Papini, "Ardengo Soffici," *Carteggio*, 78.

12. Adolfo Omodeo, *Lettere 1910–1946* (Turin: Einaudi, 1963), 13–14.

13. Emilio Gentile, *"La Voce" e l'età giolittiana* (Milan: Pan, 1972).

14. Giuseppe Prezzolini, *Amendola e La Voce* (Florence: Sansoni, 1973), 138 (Amendola's letter to Prezzolini, 9 October 1910).

15. Ibid., 58 (Amendola's letter to Prezzolini, 16 February 1908).

16. Ibid., 141 (Amendola's letter to Prezzolini, 18 October 1910).

17. Giovanni Amendola, "Il convegno nazionalista," *La Voce* (1 December 1910).

18. Omodeo, *Lettere 1910–1946*, 13–14.

19. Giuseppe Prezzolini, *Italia 1912* (Florence: Vallecchi 1984), 85–86.

20. Amendola, "La guerra."

21. Omodeo, *Lettere 1910–1946*, 100.

22. The expression is from the futurist manifesto "Contro Venezia passatista," published on 27 April 1910, reproduced in F. T. Marinetti, *Teoria e invenzione futurista* (Milan: Mondadori, 1971), 32.

23. Mario Morasso, *L'imperialismo nel XX secolo* (Milan: Treves, 1905), 10.

24. Ibid., 11.

25. Emilio Gentile, "Il futurismo e la politica. Dal nazionalismo modernista al fascismo (1909–1920)," in *Futurismo, cultura e politica*, eds. Renzo De Felice and George L. Mosse (Turin: Fondazione Giovanni Agnelli, 1988), 105–59.

26. Giovanni Papini, "La necessità della rivoluzione," *Lacerba* (15 April 1913).

27. Giovanni Papini, "Il discorso di Roma," *Lacerba* (1 March 1913).

28. Umberto Boccioni, "Contro la vigliaccheria artistica italiana," *Lacerba* (1 September 1913).

29. Giovanni Gentile, "La data sacra," *Il Resto del Carlino* (24 May 1918).

30. Marinetti, "Distruzione della sintassi (11 May 1913)," in *Teoria e invenzione futurista*, 59.

31. Marinetti, "Contro Vienna e contro Berlino," *L'Italia futurista* (25 July 1916).

32. Giovanni Amendola, "La grande illusione," *La Voce* (2 March 1911).

33. "Facciamo la guerra," *La Voce* (28 August 1914).

34. Omodeo, *Lettere 1910–1946*, 142.

35. Benedetto Croce, *Pagine salla guerra* (Bari: Caterza, 1928), 74.

36. Gabriele De Rosa, *Luigi Sturzo* (Turin: UTET, 1977) 177ff.

37. Francesco Piva and Francesco Malgeri, *Vita di Luigi Sturzo* (Rome: Cinque Lune, 1972), 193.

38. Teilhard de Chardin, *La vita cosmica. Scritti del tempo di guerra (1916–1919)* (Milan: Il saggiatore, 1982), 238–39.

39. Cited in Giuseppe Prezzolini, *Tutta la guerra* (Milan: Longanesi, 1968).

40. D. Dupouey, *Lettres et essais* (Paris, 1953), 180, cited in Annette Becker,

La Guerre et la Foi, De la mort à la memoire, 1914–1930 (Paris: Armand Colin, 1994), 110.

41. Cited in Giuseppe Prezzolini, *Sul fascismo* (Milan: Pan, 1976), 16.

42. *Volontà* (5 September 1918).

43. Giovanni Gentile, *Dopo la vittoria* (Florence: Vallecchi, 1920), 71.

44. Ibid., 61–62.

45. G. Bottai, *Diario 1935–1944*, ed. G. B. Guerri (Milan: Rizzoli, 1982), 187.

46. Benito Mussolini, *Opera Omnia* (39 vols.), eds. Edoardo and Duilio Susmel (Florence: La Fenice, 1951–63), vol. 19, 283.

47. Ibid., vol. 22, 100.

48. "Il divenire del Regime," *Il cegionàrio* (1 September 1927).

49. Giovanni Gentile, *La riforma dell' educazione* (Florence: Sansoni, 1955), 12.

Ardengo Soffici and the Religion of Art

Walter L. Adamson

The end of art is to reveal and celebrate the perpetual infancy of the universe and to reintegrate the soul, by mysterious roads, into the infinite uniformity of the whole, that is, to lead it again to the bosom of God. Art is the sole trustee on earth of the divine secret.

—Ardengo Soffici, 1907

The only essential reality of art, what defines it and distinguishes it from every other creative human activity, is its religiosity. Religiosity, not in the sense of a stimulus to belief and piety, but in the more profound sense of a guide to the mystery of the divinity animating the universe.

—Ardengo Soffici, 1928

Recent studies detail what classical interpreters such as Walter Benjamin suggested long ago: that Italian fascism sought to define itself as a secular religion within state and civil society, and that it supported this effort with an extensive aesthetic politics of symbols, myths, and rituals.[1] Moreover, contrary to a view still widely held, these studies establish that secular-religious and aesthetic-political motifs were so deeply rooted in the rhetoric of the young Mussolini and the early fascist movement that it is implausible to regard them as merely manipulative.

Less appreciated is the fact that fascist rhetoric, though nurtured by the complex emotions of Italy's engagement in the First World War, was also deeply indebted to prewar avant-garde culture, especially the Florentine circle that produced the journals *Leonardo* (1903–7), *La Voce* (1908–16), and *Lacerba* (1913–15) during the dozen years politically dominated by liberal prime minister Giovanni Giolitti.[2] Italian fascism was not simply imposed as a dictatorship, nor was it merely a social pathology that grew out of World War I. It had deep roots in the political and cultural life of the Italian state that was born in 1861, as

well as in the response by the intellectual movements of the immediate prewar period to the form of social, political, and cultural life promoted by that state.

To appreciate fascist political aspirations, it is helpful to view them against the general background of the problem of religion and politics in modern life. All modern politics must necessarily respond to the erosion of cultural meanings associated with traditional, precapitalist ways of life, but while liberal democracies mostly limit themselves to using aesthetic-religious symbolism as a way of infusing aura into the otherwise deprecated activity of professionalized, electoral politics, fascism and Nazism responded to the problem of secularization by seeking to resacralize politics altogether, breaking down every barrier between religion and politics and using their own rhetoric and institutions as the basis of a new, totalitarian politico-religious public sphere.[3] This was a very ambitious objective and, in its pioneering effort to carry it out, Italian fascism made ample use of aesthetics and an aesthetic understanding of the public sphere.

The fact that fascist politics emerged first in Italy undoubtedly owed something to the strength of that nation's aesthetic and religious traditions, but it was primarily indebted to the elitist character of its post-independence liberal state, in particular to that state's failure even to attempt a nationalization of the masses.[4] In taking such a cautious (and, for many intellectuals, profoundly cynical) course, Italian liberalism was rejecting the religious concept of mass politics advocated by Giuseppe Mazzini and his many followers during the Risorgimento. Mazzini's resulting critique of the Risorgimento as "incomplete" became a major myth for opposition intellectuals during the first half-century after independence. Yet it was only with the prewar Florentine circle around *La Voce* that this advocacy of a spiritual nationalizing of the masses was linked with an aesthetics, in particular with a belief in the transformative potential of avant-garde, modernist art. Unlike avant-gardes in Germany, who felt marginalized socially and ethnically (many of these intellectuals being Jewish) and thus threatened by any "volkish" nationalizing of the masses, Italian intellectuals generally, and the *La Voce* group in particular, felt no contradiction between nationalism and avant-gardism. Indeed, they actively cultivated their fusion—a fusion that would later become the core project of Mussolini's fascism.

Defining themselves against both establishment liberalism and the art-for-art's-sake *decadentismo* that prevailed within the generation

of their older brothers, intellectuals born around 1880 like Giuseppe Prezzolini, Giovanni Papini, and Ardengo Soffici, sought to develop a secular-religious consciousness that could energize a cultural renewal of Italian society. Yet while they saw themselves as new Mazzinians, they made their strongest cultural identifications with the Parisian world of Henri Bergson, Charles Péguy, Romain Rolland, Pablo Picasso, and Guillaume Apollinaire. Indeed, as we will see, this identification was so strong for Soffici that, in the *Lacerba* years, it cut him off from nationalism and led him into a more complex dialectic between avant-gardism and nationalism than was typical for his circle. This complexity makes his work especially interesting for an understanding of the sources of Italian fascism and its project of an aesthetic-religious recasting of public life.

In its broadest sense, European avant-garde culture may be understood as one of several "lifestyle" responses within the more secular and mass-oriented societies of nationalism, industrialism, and consumer capitalism that began to emerge after the French Revolution.[5] In opposition to the vulgarity of bourgeois and mass values, avant-gardists sought to define themselves as superior individuals, as a new aristocracy of taste. So long as they were content to hold themselves above mainstream society or withdraw from it, this self-definition was unproblematic. But when they adopted a modernist program of cultural renewal and spiritual reawakening, they had to face up to a paradox: how could they lead the masses toward such goals when their own culture was defined against the masses?[6]

In the two years immediately preceding the First World War, the futurists achieved great notoriety in seeking to overcome this paradox precisely by embracing it: their *serate* were staged spectacles in which the avant-garde and its mass audience acted out their mutual contempt. Soffici and his friends participated in the *grande serata futurista* held at Florence's Teatro Verdi in December 1913. Their flirtation with the Milanese futurists would prove brief, however, and it never entirely replaced the mode of aligning themselves with the popular masses that they had established as early as 1907. This mode was based on an aesthetic ideal of *toscanità*, the centuries-old folk "essence" of the region's peasant life and natural beauty, a simultaneously aesthetic and nationalist construct that allowed them to define themselves as the avant-garde guardians of real, profound populism against its contemporary, vulgarized manifestations, and as the new

secular priesthood sowing Rimbaudian and Nietzschean seeds in the local spiritual substrate.

As the first formulator of the ideal of *toscanità*, Soffici offers us an excellent vantage point for appreciating the continuities between the spiritual quests of Italian intellectuals in the post-independence period that culminated in the prewar avant-garde and the spiritualized, aesthetic politics of postwar fascism. A self-declared fascist in 1921, Soffici was never the great cultural promoter of the regime that Margherita Sarfatti was. Nor would his own art ever be monumental enough to serve as an artistic standard for the regime, as was that of Mario Sironi. Yet, despite the individualism that characterized his cultural-political practice, Soffici was deeply loyal to Mussolini, following him even into the ill-fated Republic of Salò, and, most important in the present context, he was the regime's preeminent aesthetic theorist, at least through the 1920s.

Born in 1879 to a farm manager (*fattore*) and his wife in the tiny hamlet of Bombone east of Florence, Soffici studied briefly with Giovanni Fattori in Florence in the late 1890s and came under the influence of the symbolist Arnold Böcklin, who then lived nearby in San Domenico. But it was in Paris, where he spent the first seven years of the new century, that Soffici truly became an artist.[7] Already in 1901 his freehand drawings and art-nouveau designs were gracing the covers of the *Revue Blanche* and various lesser satirical reviews such as *L'Assiette au Beurre*, *Le Rire*, *Gil Blas*, *La Caricature*, and *Frou-Frou*. In 1902 he joined the Société des Artistes Indépendants, participated in their spring exhibition with seven of his works, and met Auguste Rodin, Picasso, and Max Jacob.[8] By 1903 he was attending the "soirées de *La Plume*," hosted by the review's editor, Karl Boès, and fraternizing with poets such as Apollinaire, Paul Fort, Alfred Jarry, Mécislas Golberg, and the elder statesman of the symbolist movement, Jean Moréas.[9] When the Editions de la Plume reissued the latter's *Les Cantilènes*, Soffici designed the cover.

Photographs of Soffici in this period depict an unabashed dandy who looked remarkably like the young Baudelaire, with whom he was often compared.[10] Yet already by the summer of 1903, when he returned to Florence in what would thereafter become an annual event, he was finding that his creativity was dependent upon a Tuscan stimulus. Cézanne became his idol and Fiesole's Monte Ceceri, his Mont Sainte-Victoire.[11] Increasingly, he felt spiritually isolated when

he returned to Paris, and by 1906 he appears to have shifted his focus from educating himself as a cosmopolitan artist and participating in the international inter-arts alliance centered there to becoming a European artist and writer in Tuscany and adding Tuscany to the range of cultures represented in the international avant-garde.

Soffici made his first contribution to *Leonardo* when his woodcut depicting "Don Quixote in Tuscany" appeared as the cover of the August 1906 issue. The main theme of the issue was Papini's announcement of his populist "campaign for a [cultural] reawakening by force," and the implication of Soffici's design was that the campaign was being spearheaded by lone-crusading, idealist intellectuals who would eventually make contact with the peasant masses, restoring to prominence the Italy they represented and, at the same time, restoring genuine spirituality to the world. In 1907 Soffici published a renunciation of his Parisian life in *Leonardo*, held a farewell show of large, brightly colored oil paintings of Tuscan peasants at Salon des Indépendants, and decided to return home for good.[12] The vigor and quiet strength of the Tuscan *popolo*, in contrast with the rutilant decadence of Paris, had become the basis for an aesthetic ideal of *toscanità*, a cardinal point of faith that he communicated repeatedly in his letters.[13]

For Soffici, the Paris of early 1907 was a deeply disturbing place. It had brought upon him a "spiritual crisis," and he appears to have seriously contemplated suicide.[14] One book that made a deep impression upon him then was "*Le Désespéré* by Léon Bloy, a novel of sad loves whose protagonist, Marchenoir, professed a very intransigent Catholic orthodoxy that allowed him in times of torment to act with such secure determination as to inspire my own move out of darkness."[15] Soon after reading the book, Soffici wrote Bloy, who invited him to visit his home in Montmartre. Despite Bloy's reputation as a deeply spiritual Catholic convert who had successfully preached spiritual regeneration through suffering and poverty to a variety of Parisian intellectuals, the visit proved a disappointment. Bloy turned out to be narrow-minded, irascible, and so traditionalist and evangelical as to leave Soffici laughing inwardly as they parted.[16]

Although the visit did not lead to a Christian conversion, it did have an important effect on Soffici. Responding to Bloy's questioning, he had clarified for himself the idea that "original sin is the pride that makes men believe they can discover truth by means of reason."[17] Religion, he and Bloy agreed, could not be based on reason; but

whereas the latter sought its power in the virgin birth and in miracles, Soffici now recognized that he could find similar support in art, which came to "represent for me the true and supreme anchor of salvation."[18] A few months later he published a long article on ancient Egyptian painting and sculpture in *Leonardo* that proposed the understanding of art that is summarized in the first of the epigraphs to the present essay.[19]

Still more seminal for Soffici's concept of a religion of art was an article he wrote in the spring of 1908 on Cézanne, a "painter who left Paris and its *vie de bohème* wavering between literature and dilettantism, and who exiled himself in Aix-en-Provence, his native region." There, "amid the solitude of the provincial slopes and beaches inundated with sun and swept by the ample breezes of the Mediterranean," he opened himself to the "waves of maternal sympathy emanating from nature" and learned to "love nature in its divine essence" as a "colossal hieroglyph that only the ecstatic soul can decipher." His art flowered as a synthesis of his own (masculine) "internal will" and the (feminine) vision of divine nature that his "crazy and primitive" self-constitution put him in position to receive. Overcoming the objectivism of the impressionists, he learned how to condense an "internal image" of nature based on observation but translated into his own pictorial language and thus, ultimately, "with external truth subordinated to the truth of his internal vision." Like Michelangelo, he came to appreciate "the mystical force that bursts from silent things"; like Aeschylus, he sensed "the savage power that erupts from the naïve hearts of the people."[20]

Two aspects of this account were of special significance. One was the concept of the divine essence of nature that becomes available to the artist who, like the philosopher Bergson, allows his intuition to lead him to the things themselves. The artist for Soffici is in a privileged position to experience nature because, like the child, he or she is especially open to the mystical aura of the simplest objects and events. These concepts of nature and the artist remained central to Soffici's thinking for the rest of his life.

The other significant aspect of the article was the way he perceived the recent history of art as a progressive, science-like inquiry into the problems of representation. In contrast to his article on ancient Egypt, in which he maintained that "art is immutable in its essence, does not progress but simply is," he now characterized the

impressionists as having taken up the "problem of light" and as having "solved" it, albeit in an overly "empirical and descriptive" manner. Cézanne's achievement was to have superseded them by recognizing the importance of the internal moment in aesthetic creation. Yet Cézanne's work, he argued, "is not always perfect—to the contrary it is often distressing and full of torments—but it is frank and suggests roads that are full of hopeful possibilities."[21] It comes as no surprise, then, that Soffici would soon be writing of the cubists as having superseded Cézanne and, later, of the futurists as having superseded the cubists.[22] This historicist notion of art, however, would be abandoned in 1918, as he began to shed his avant-garde identification and to return to the timeless concept of art he had articulated in 1907.

The concept of a religion of art common to both his major articles of 1907 and 1908 was, however, by no means merely a matter of aesthetic theory. The spring of 1908 saw dramatic agricultural strikes led by the syndicalists at Parma, and Soffici was involved in intense cultural and political discussions with Prezzolini and Papini that would soon lead to the founding of the avant-garde journal *La Voce*. In this context the political implications of the idea of a secular religion of art were clearly central. In a letter to Papini a few months after the Cézanne article, Soffici compared the cultural politics they should adopt with that of their "democratic" rivals rather in the way Cézanne had been compared with the impressionists:

The invisible idea is in Art and in Love and thus in *us*; the visible, palpable idea is in Democracy. And if you want to experience the signs of this [invisible] idea, look at socialism—pure and innocent—where simple people embrace Sacrifice and enthusiastically welcome the children of the strikers and aid the strikers themselves with money and with the enthusiasm that their Faith gives them. . . . Popular idealism! That is precisely what we ought to champion; but are we not ourselves a religious fact, the noblest and most solemn of religious facts, the custodians of the Flame? . . . The people [however] cannot believe in our God; their God is a master with a beard, good and terrible, an immense *Padrone* who watches over everything; a kind of dazzling Minos who judges and dispatches them as he wishes. If this God no longer commands belief, he is finished—and today he is no longer believed in, and that is good. But the people are never daunted, and when they find themselves without a God, they create Gods. Now they have in their hands various ones: Science, Political Economy, Progress generally, etc. It is for us to work to see that they cease this polytheism and atheism and become like us. Is this not perhaps the most ethical of purposes and the most beautiful hope in Culture?[23]

Although it is too much to say that the aesthetic basis of Soffici's fascism is already clear in 1908, the letter certainly helps us to appreciate why he might later have been tempted to see Italy's best hope in a political movement with a religious aura, led by a charismatic former socialist. Despite his intentions, however, Soffici proved unable to transform his aesthetics of *toscanità*, or his religion of art more generally, into a concrete, populist politics in the prewar period. While his desire to mount a challenge to the Giolittian establishment appears genuine, his cultural politics remained much more oriented toward Paris than toward Rome.

Thus, his major discussion with Papini that summer involved a debate on poetry in which Soffici championed Baudelaire over Papini's Walt Whitman. The discussion cast further light on the approach to nature that Soffici saw as exemplary for the modern artist. To penetrate to the religious essence of nature, he argued, one had to avoid the romantic attitude of identifying with nature; such a subjective approach merely found in nature a mirrored reflection of the self. What Baudelaire had understood was that there is a more objective approach to nature, a kind of "magical realism" that involves "becoming unknown to ourselves" (abandoning our sense of a fixed, bourgeois self-identity) by "plunging into the abyss" (merging with nature) and, in effect, learning to see reality *qua* reality and, thus, finding "the new" in both art and life. To take such a plunge was thus also to transcend realism of the naturalist sort, one too external and detached to permit more than intellectualistic description. To reenter the world in Baudelaire's immanent way was to become open to a new mythos, one that alone could provide a source of religious comfort in a world in which Christianity was long dead.[24]

By 1910 Soffici was engaged in a book on the poet Rimbaud, whose provincial origins in the Ardennes made him the perfect practitioner of Baudelaire's magical-realist approach to nature. Soffici's Rimbaud had grown up dreaming of Paris as "the far-off Eldorado, the promised land," and yet even after he had come to know its charms, he had always remained at heart a "*campagnolo*," a "simple plebeian." Rimbaud's "plebeianism" gave his "paganism" real roots and ensured that his disgust with bourgeois, Christian society would have a positive yield in a poetry of "infinitely complex and interpenetrating sensations and images."[25] In one sense he had even transcended Baudelaire, for while *Les Fleurs du Mal* offers "magnificent, funereal

psalms on the tragedy of being a man, of living, loving, and having to die, we find in the end only the same old saw from Ecclesiastes made even more desperate by a Catholic idealism." But in Rimbaud, "who makes his way through the world of sensations joyously, we find the sense of exhaustion after the orgy, in the depths of which, however, laughs the hope of the spiritualist and of the atheist who adores life as the exteriorization of his own ego, and who will immerse himself there tomorrow in order to play once again his appointed role—be it Hamlet or Yorick."[26]

For Rimbaud life meant a deregulation of sensory experience, and thus an "indiscipline," "an aversion to obedience," a spiritual anarchy. Yet he did not leave matters there, as had the young D'Annunzio. At sixteen he saw the Franco-Prussian War fought nearly at his doorstep, and the "intensely violent moral life" he led thereafter was always governed by "sincerity" and by the need "to destroy every weakness, to trample upon and harden everything delicate . . . , to cultivate the most difficult form of courage." Rimbaud had understood, as D'Annunzio had not, that anarchy and order were dialectical twins, that he who, "in the words of Friedrich Nietzsche (who was almost his brother), 'has the hardest, the most frightening vision of reality, who has the "most profound thought," still does not find in it any objection against existence,'" and that to live so as to arm oneself with this knowledge was to take the only true path toward "interior order and repose."[27] Rimbaud's anarchy, then, was a willful anarchy lived with deeply moral and religious motives. In him there was no contradiction between avant-gardist indiscipline and the will to defend one's own vital connection to the natural order of one's provincial homeland. For Soffici, the mystical paganism of Rimbaud was made to serve as an avant-garde justification for *toscanità*.[28]

When Soffici turned to an analysis of cubism in 1911, he argued that the "spiritual revolution" Baudelaire and Rimbaud had accomplished for poetry had been undertaken for painting by Cézanne and brought to fruition by Picasso.[29] While the impressionists had rediscovered the "panpoeticity" of things, and had rightly rejected the received view of the world as a fixed hierarchy, it was Cézanne who had first learned to become immanent to his landscape, to feel the solidity of objects, their volume, density, and chiaroscuro effects as part of his own body and soul, and to begin to plumb their depths for a pure logic of art. Only with Picasso, however, had the decisive step

toward understanding that logic been taken. For it was Picasso who had turned to the art of ancient Egypt and Africa in order to learn again how artists might "interpret nature realistically by deforming it in response to an occult, lyrical necessity." Even if others such as Gauguin had looked to the same "primitive" sources, their appropriations of them had remained mired in intellectualism and thus merely decorative. Picasso had proceeded systematically, working through such technical problems as volume, design, and light, in order to grasp nature as a totality, as a set of essences, and then to "deform" it as art.

Under Picasso's influence Soffici had turned his own art toward cubism in 1911 and, during the *Lacerba* years, he experimented with collages very much like the ones Picasso had begun in 1912.[30] Indeed, his reverence for Picasso was so great that it overrode his self-declared allegiance to futurism in this period; he seems never to have been tempted to emulate futurist artists such as Umberto Boccioni despite their association and futurism's alliance with *Lacerba*. Among the virtues of cubism for Soffici was the fact that it "reconnects itself perfectly with tradition"; its deep sense of the materiality of objects gives it "that severe, tormented realism, that sense of tragedy that belongs to Western art and that I would be tempted to call Christian if that word were not so discredited."[31] Unlike the scientist, the cubist does not stop at the "character of truth that lies before him" but "senses beyond these forms something substantial, an internal plenitude, a structure" that implies "an infinity of other surfaces and planes" and that invests his artistic vision with spiritual depth. Yet, like the scientist, the cubist is motivated strictly by a search for truth; he is a practitioner of a "pure painting" that interprets "reality in itself" and in conformity with a "disinterested end."[32]

As such language suggests, there was another, more philosophical influence at work in Soffici's thinking on art in this period, that of Henri Bergson.[33] In March 1910 Soffici had visited Bergson at his home in the Villa Montmorency and, after pointing out the affinity between recent developments in art and Bergsonian concepts such as intuition and *élan vital*, he noted that the philosopher "appeared very struck by my thesis [and] agreed in large part with my reasoning."[34] Later the same year, Soffici cited a "beautiful page" in Bergson's *Le Rire* to support the notion that the "pure artist" ought not to follow "rigid rules of scientific perspective" but ought to allow the canvas to reflect the relative values of objects as they are perceived in the artist's own experience.[35] Thus, the fact that Giotto may paint "a bird larger

than a shrub" is not an "error of perspective" but a statement of spiritual value. Similarly, for Picasso and Braque, "planes, masses and the contours of things can have proportions, relations and movements very different from those that the common man perceives; [they can be] independent from their connections as aspects of a reality conceived practically or scientifically; in sum, they can be considered as simple pictorial elements, transformable, movable, capable of being distorted in light of a purely artistic harmony."[36]

By the winter of 1912, when Soffici again visited Paris, Apollinaire was making major use of a similar (and perhaps also Bergsonian) concept of "pure painting" in his new journal, *Les Soirées de Paris*, which quickly established itself at the center of the Parisian avant-garde in the years immediately preceding the war.[37] Although Apollinaire and Soffici had known each other for a decade and had begun an intense correspondence on art the previous November, it is clear that the phrase "pure painting" was initially Apollinaire's and that Soffici then adopted it in order to crystallize his own ongoing discussion of the ideas to which it referred.[38] It was also something of a slogan through which he could assert his identification with the Parisian avant-garde, even as he pursued an independent Tuscan variety. Yet how was any such Florentine movement to make its mark in an art world so dominated by Paris? It was in answer to that question that Soffici was led to Marinetti's futurism.

Between 1909, when he first learned of Marinetti's Milanese movement, and 1911, Soffici's attitude toward futurism had been intensely antagonistic, so much so that the futurist painters made a "punitive expedition" to Florence and assaulted him at the Giubbe Rosse Café one July afternoon in 1911.[39] But he took more favorable notice when his 1912 visit to Paris coincided with an exhibition of Italian futurist paintings at the Bernheim-Jeune Gallery. The fact that an Italian creation had, for the moment at least, captured center stage seemed to be a reassurance that Italians, too, could forge autonomous avant-garde expressions and could therefore work as equals with their Parisian counterparts. As Soffici stated it in an article in *La Voce* that July: "Who takes it [the art of the futurist movement] seriously? No one. But, still, it did manage to shatter the legend-truth of an Italy dead and buried under the stupidity of its conservatism and its academy." That was why, even if Italian futurism was mediocre as art, it was "excellent in its essence as a movement of renewal."[40]

It was above all his recognition of futurism's power as a style around which to shape an avant-garde movement that led Soffici to reconcile himself with his old antagonists at the Giubbe Rosse and to proclaim himself a follower of Marinetti for much of 1913 and early 1914. Yet, from the beginning, Soffici and his Florentine friends on *Lacerba* were never interested in becoming part of an Italian avant-garde led by Marinetti. Rather they sought an alliance with Marinetti to help build their own independent Tuscan avant-gardism. In Soffici's field of vision there were always three points on the horizon: Apollinaire's Paris, Marinetti's Milan, and his own Florence. Each had its own distinctive cultural heritage, values, and style; each was to operate from a position of independence, even if their shared interests and concerns might lead them to converge in a common cultural politics.

In Soffici this idea of a common cultural politics of avant-gardism was quite strong—strong enough to turn him against nationalism in this period.[41] As he once declared in *Lacerba*, it was ridiculous to think he would ever follow "patriotism" and allow the interests of the "fat and sweaty Tuscans" he might meet on the local tram to be put higher than his allegiance to Parisian friends like Apollinaire, Jacob, or Picasso.[42] Art is what Soffici held most dear, and it was clear to him that the masses could not comprehend art, that they inevitably approached objects in terms of their utility, luxuriousness, and other material values rather than in terms of their spiritual essence, which, for the artist, was all that mattered.[43] The artist alone was capable of aesthetic disinterestedness, of being a true Bergsonian.

In contrast to Soffici, however, Marinetti always thought in terms of two competing avant-gardes—the Italian and the French—which enabled him to reconcile his avant-gardism with nationalism more easily, as well as to justify his grandiose ambitions as a leader.[44] Almost from the beginning, Soffici and Papini had resented Marinetti's egoism and political heavy-handedness. By the time of their return from another trip to Paris in the spring of 1914, they broke with him publicly. Initially, this break was an assertion of their right to pursue their own Florentine futurism independently rather than a rejection of the idea or the movement as a whole.[45] The experience of the war, however, would lead both of them to break with futurism altogether.[46]

In the first issue of *Lacerba* after Europe was plunged into the chaos of August 1914, the journal abandoned its avant-garde cultural

role and rededicated itself to politics, specifically to the cause of Italian intervention. Soffici made the transition unblinkingly. Though only a year and a half before he had been proud to have his work displayed in the Berlin journal *Der Sturm*, he now argued that "Italy has but one duty: to merge all its forces with the civilized Europe represented by France, England, and Russia (yes, even Russia) in order to crush and silence once and for all the ugly Austrians and Germans, those two disgusting peoples who have always represented barbarism, imbecility and ugliness."[47]

In December 1915, six months after Italian entry in the First World War, Soffici joined the infantry as a second lieutenant. Later he would recognize that "with the war a world also ended," the world of avant-garde reviews and modernist dreams.[48] Yet, at first, Soffici was able to transfer enough of that world into his new one to keep himself endlessly fascinated by it and, for the most part, exhilarated as well. Soffici spent two and a half years in the army, much of it at the front. Twice wounded, he was decorated for bravery, and his three war diaries of 1917 are among the most vivid and detailed descriptions we have of life on the Italian front.

The second of the diaries, *Kobilek*, which covers two intense weeks in August between Soffici's return from one hospital stay and his departure for another, has been called "a 'ludic' vision of the war events" and, with its images of the beauty and speed of battle, a specifically "futurist" vision as well.[49] Yet *Kobilek* contains none of the irony and brazenness that so permeated Soffici's futurist contributions to *Lacerba*. The tone of the war diary is softer, more reflective, and much more reverent, especially in its awestruck depiction of the silent majesty of the Alpine landscape as a setting for so much death and destruction. Throughout, Soffici seemed to want to immerse himself in natural and human immediacies and to plumb their symbolic significance. It was as if he sought to become immanent to reality in the manner of Baudelaire and Rimbaud. *Kobilek* is a celebration of war as a poetic fusion of art and life, a plunge into the primal that seeks to escape all traces of bourgeois identity. For Soffici, the war was the moral equivalent of Rimbaud's move to Africa, and *Kobilek* is better described as a Rimbaudian text than a futurist one. Like Rimbaud, Soffici was determined not only literally to merge himself with the natural world of sensations, but also to make his way through it joyously, however hellish it might prove.[50]

Despite his military responsibilities, Soffici found the time in 1916 to write most of a treatise on futurist aesthetics that would appear as a book in 1920.[51] Here he continued to develop many of the same themes that had preoccupied him in *Lacerba*, while also arguing more explicitly for the "necessity of a new aesthetic." Like Bergson's intuition, this aesthetic would be "purged of every utilitarian, civil, or political residue . . . , a purified art having no other end than its own splendor." It would leave the artist entirely free and autonomous, and Soffici nowhere sought to define his futurism in specific stylistic terms. He did suggest, however, that "disinterestedness" meant an interest in the "arbitrariness" of nature, its undefinable and unbounded character that the artist must simply experience by "plunging into reality, growing fat with it, and rendering it transfigured." Disinterestedness also meant that "art is not a serious thing"; it ought to be "ironic," an "amusement," though "an amusement of a spiritual and absolute order." Art must not be religious in the sense of supporting dogmatism, but it must honor its inherent attachment to "spiritual contemplation." Above all it must avoid abstraction. An art that "reposes exclusively on theoretical and cerebral presuppositions" will be sterile; true art need not necessarily be mimetic but it must be realist in the deeper sense of experiencing nature's manifold presence. "When it is said that the modern artist ought to emancipate himself from nature, what is meant is nature as it is seen and felt by the common people."[52]

Yet, in an "intermezzo" written in 1918, Soffici abruptly reversed himself on the élitist aspect of his futurist aesthetics and made plain the profound effect of the war on his concepts of the *popolo*, art, and their relation:

I returned to observe the workers around me. And I recognized that, if the gestures they made while at rest were harmonious, the movements that they made while at work were still more beautiful. There was a rhythm in every one of their movements; evidently it was even a law of an aesthetic nature. He who hammered at stone, he who mixed lime in a barrel and then ladled it over stone, he who shoveled earth and loaded into the wheelbarrow, all acted with order, with care, according to a principle that is not natural but originates in a spirit refined by a long civilizing process. . . . Having arrived at this view, I concluded that, since every civilized people had absorbed little by little and put into action the principles of art, all men were destined to become artists over time, and therefore that artistic expression in the proper sense of the word would ultimately become useless and cease.[53]

Having fought side by side with peasants, Soffici now recognized him-
self in them, and his own work in their work. He claimed to have had
"a vision of *Tutto-Arte*," and though he did not yet explicitly overthrow
his ideal of disinterested "pure painting," he did declare that "works
of politics, economics, agriculture, industry and commerce . . . are all
works of art."[54]

Despite one recent reading that treats Soffici's *Tutto-Arte* as
implying that "art should remain free of utilitarian and political con-
cerns," what Soffici actually meant was precisely the reverse: that art
was embedded in life and that artists should express their solidarity
with life by reintegrating their art with politics.[55] The world of 1918
was profoundly different from the one in which the avant-garde had
taken shape. Not only had the cultural avant-garde itself largely col-
lapsed in the war, but the sense of political crisis in Italy was so great
as to create not simply the hope but the expectation of an impending
system change in politics. Moreover, for Soffici the socialists loomed
as a far larger threat in the shadow of Bolshevism than they had in
their prewar collusion with Giolitti. Given these developments, it
made sense to rethink avant-gardism on a new model. Not unlike the
Lukács of 1918 who wagered on Lenin, the Soffici of 1918 bet on
Mussolini. His model became that of a mass movement incorporat-
ing the modernist spiritual revolution as the basis for a genuinely
populist aesthetic politics, and thus nationalist rather than interna-
tionalist. In aesthetics, the new model implied that experimentalism
should give way to a communal celebration of heritage and to a
restoration of those aesthetic values associated with the great moments
of the Italian past.

Despite this major shift in his outlook, Soffici wrote the remain-
der of his aesthetics as if the futurist ideal were still intact. But, in a
preface added in 1920 when his *Primi principî di un'estetica futurista*
was published as a book, he distanced himself sharply from the futurist
movement and declared that "the problem of art presents itself to me
in a very different and much simpler way" than it had earlier. Although
he did not further clarify the nature of this change, he did rather
lamely suggest that the "futurist art" he had characterized as a reality
in 1916 might yet be realized in "a time to come."[56]

Soffici devoted most of 1920 to producing singlehandedly four
issues of a new journal, *Rete mediterranea*, and here his new aes-
thetic-political standpoint emerged quite clearly. Looking back upon

his avant-garde years, he took very evident pride in its achievements—above all, the renewed visibility of Italian art and fashion on the European scene. Yet he also contrasted that epoch with "today [when] we can concern ourselves seriously with serious and grand things, without distractions, with our minds free of petty preoccupations" and "let others break their necks on the road to the abyss where they have arrived following us, and where we now see them tumbling among their 'dadas,' while we have stopped to build our own house."[57] Privately, he went so far as to argue that, the fundamental need of contemporary culture being restorative, the best hope was for a "retro-garde" art that celebrated the activities of everyday popular life in the natural world and emphasized the integration of art and life.[58]

Soffici now explicitly traced this conservative and nationalist turn to the effect of the war, from which he had returned "another man." Although before the war he had been in a "period of uncontrolled Dionysian liberty," believing "as Rimbaud had, and perhaps even more than he, that the disorder of our own spirits was sacred," the event itself had taught him that the common people were not "stupid, base, vulgar, and cowardly" but full of "humanity, beauty, [and] spontaneity of life." In consequence he had begun to ask himself "if the negation of so many traditional principles might have been, in essence, an act of recklessness, a tremendous mistake."[59]

His first move to rectify this "mistake" may have come in 1918 when he began to edit a humor magazine for the soldiers of the Italian Fifth Army entitled *La Ghirba* (a slang term meaning "skin" or "leather"). Not only do extant photographs of Soffici and his coworkers on *La Ghirba* reveal them as a closely knit group spanning ranks and ages, but the journal itself, with its many cartoons, jokes, and ribald dialogues drawn from the daily experience of the common soldiers, was clearly designed to appeal to a mass audience.[60] Soffici got his principal collaborators from among the soldiers, yet both corporal Giorgio de Chirico and infantryman Carlo Carrà helped occasionally.

In 1919 Soffici published several inflammatory articles in Mussolini's newspaper, *Il Popolo d'Italia*, and some of his old friends noticed that he had taken an abrupt turn toward political "fanaticism."[61] To their dismay he supported D'Annunzio's occupation of Fiume with enthusiasm. He became an ardent antisocialist. He wrote

for Florentine fascist journals like the *Sassaiola fiorentina* (whose editor would murder Giacomo Matteotti in 1924). And he welcomed the fascist March on Rome in terms that seem unmistakably linked with his own religion of art:

It is no small glory for fascism that it has brought the religious sense into its ceremonies, along with that picturesque touch of theater which so disgusts our more funereal and Quakerish Italians. One sees that the leaders of fascism have profoundly understood the spirit of our race, as well as the usefulness that every kind of liturgical pomp can have and has had. Until now, only Roman Catholicism and the army have known how to captivate the hearts and imaginations of the Italian people in their functions and parades, and thereby blend the souls of the people together in a communion of ardent unity. Fascism, following tradition, renews the miracle of human solidarity around austere and magnificent symbols.[62]

Still, old attitudes and habits are not easy to break, and it must be said that while Soffici admired this new religion, he did not practice it with great collectivist commitment. Unlike the younger Ottone Rosai, he seems never to have been a *squadrista* or to have participated in the Florentine *fascio*. He did play a role as a journalist within fascist cultural politics, spending much of the fifteen months after the March on Rome in the capital as editor of the cultural page of the new *Corriere italiano* and contributing many important pieces to *Il Selvaggio* (Tuscany's foremost fascist journal in the late 1920s) during its years in Florence (1926–28). Yet his personal position within the circle of *selvaggi* (savages) was rather aloof, and he seems to have been regarded by its younger, more activist contributors primarily as their link with tradition, as a kind of grand old man of Florentine avant-gardism.

Certainly when Soffici wrote on the subject of fascism and art in the early 1920s, he was at least as insistent on the need to safeguard the independence of the artist as he was to define what a fascist art might be. In his fullest examination of such questions, which appeared in Sarfatti's *Gerarchia* a month before the March on Rome, he argued that any "political control over the free manifestation of the genius who creates beauty" would be inappropriate. On the other hand, he also argued that no genius who creates beauty could possibly embrace the "vulgar materialist" and "sentimentalist" forms associated with artists of "socialist" inspiration, a standard presumably designed to declare off limits all those naturalists and realists who were insuffi-

ciently "spiritual," as well as to make fascism congenial to those like himself who had been reared in the "spiritual revolutionary" traditions of Italian avant-garde modernism.[63]

Although privately Soffici had become quite critical of artists who continued to work in a self-consciously avant-garde or modernist vein, he did not at this point turn against them in print. In *Gerarchia* he suggested that fascism ought to "love the past and antiquity" but without becoming the "enemy of modernity." It was in fact "our social adversaries [who are] the sworn enemies of every artistic innovation, boldness, revolution. . . . Fascism is a revolutionary movement but not a subversive or extremist one," and it should therefore foster an art that is "neither reactionary nor revolutionary, since it unifies the experience of the past with the promise of the future." In short, while fascism should not perhaps encourage avant-garde art, it had no reason to discourage it either.[64]

In his own art, Soffici settled upon what might be called a Tuscan impressionism, a pleasant if rather predictable celebration of local life and its spiritual qualities. Yet there were some deeply troubling matters that lay behind these apparently complacent images. Over the course of the decade, he became increasingly fearful that Italy was being overrun by an *americanismo* that threatened its cultural identity and that Italian fascism was showing itself to be too confused, disorganized, and corrupt to fend it off.[65] Increasingly, his writing distinguished between Mussolini, to whom he remained loyal, and fascism, which he perceived more and more as based on "slovenliness, ignorance, and vulgar social-climbing" as well as on a "mentality" derived from "Germanizing and Americanizing" influences.[66] Unfortunately, actually existing fascist culture had become part of the problem, and Italian artists with very few exceptions (Giorgio Morandi was one) were contributing to it. Neoclassicists like Carlo Carrà were escapist and academic, while the futurists had become mere publicists, sterile and commercial.[67]

Had it not been for the threat of *americanismo*, Soffici might even have broken with fascism in the late 1920s. Its presence, however, only reinforced the choices he had made in the immediate postwar period. This is fully evident in Soffici's *Periplo dell'arte* (1928), the most important statement of his views on art and cultural politics in these years and his last major attempt to formulate an aesthetics.

Here Soffici decried the "progressive decline of Europe" and expressed his fear of a "total barbarization" to come. Italian art had become a "pictorial Babel" in which the "revolutionary extremism of the futurists" and the "reaction of the self-styled neoclassicists" compete in "stupidity, vanity, and dishonesty." The idea of creating a modern aesthetic, of following Courbet's dictum of "being absolutely modern," had become stupid and banal, an excuse for constructing meaningless "theories" that led away from the real world, the only true source of artistic inspiration. Only by returning for inspiration to the "great masters" of the early Italian Renaissance could the "synthetic realism" of true art be restored.[68]

One index of the magnitude of Soffici's worries about the rise of a mass culture of consumerism was the new historical account he developed to explain the complicity of art within it. European art, he now argued, had taken a fundamental wrong turn in the sixteenth century, when with "the invention of oil painting the possibility presented itself of an intrusion of the material into the pure spirituality of the artistic act." Although the "best artists" of the day "had only adopted the new technical ingredient with caution," by the seventeenth century the temptation to fall into an art of opulent sensuality and materialist luxury had proven too great and, by the eighteenth, "critics were taking the material phenomena of artistic technique almost solely into account."[69]

Although some nineteenth-century artists, like the Macchiaioli and even a few impressionists, had managed to avoid the technological temptation and to maintain a "pure and healthy conception of art," in recent years their successors had been overtaken by another source of the corruption of art: influences from non-Latin nations, especially Germany. "So-called Fauvism, Cubism, and Futurism presented patent examples of a continually increasing inclination toward that deprecatory and frightening bad taste of the Germans." Fin-de-siècle Paris had been "invaded by entire legions of foreign painters—Germans, Scandinavians, Swiss, Russians, Poles, Slavs, Armenians, Americans, Japanese, Africans, many of them Jewish—who were ruled by a universalist charlatanism." (Soffici did not mention Italians such as himself.) The rootedness of all good art in the "aura" and folkways of a particular region was lost, and art became prey to theory and abstraction.[70]

Only by resituating themselves in their native countryside, away from cities and their materialism, could artists hope to restore the

genuine "religiosity" characteristic of all great art. To do so, Soffici now argued, was necessarily to reject the ideal of a "pure aesthetic, which in other times I myself professed and proclaimed, but which leads inevitably to the decadent cult of formal delicateness and undermines the human and heroic plenitude of the work." As such language suggested, modern art had been seduced by feminine charms that had deprived it of its deeper "heroic" and religious mission. To put it back on the true path, to restore to art its rightful function as a "guide to the mystery of the divinity animating the universe," indeed, to save modern culture from being overrun by the forces of urbanization, consumerism, and international commerce, forces that threatened to destroy the social conditions in which genuine artistic creation was possible at all, one had to advocate an explicitly political function for art.[71]

In its essential elements, then, Soffici's analysis of the situation of modern aesthetics in 1928 was strikingly similar to the one Walter Benjamin would offer eight years later: the religious aura of traditional art had been progressively undermined by modern technological development.[72] Benjamin thematized this development in terms of the advance of forms of "mechanical reproduction" like photography and film, while Soffici emphasized the increasing opulence of the technology of painting, but both agreed that modern technological society had brought the European artistic tradition to an end. Yet whereas Benjamin applauded this development as opening up unprecedented democratic possibilities for artistic creation, Soffici recoiled from it because he identified democracy with the end of all authentic artistry. For him the cinema was a "mechanical form of art that is the negation of art," which is precisely why the Americans excelled at it.[73] To save the social conditions in which genuine art was possible necessarily meant supporting the religiosity of Italian fascism—whatever its shortcomings in practice—against the scourge of "atheist materialism" arriving from across the Atlantic.[74] Modernity had become inhospitable to art; fascism should politicize art in order to restore it.

In his complex dialectic of avant-gardism and nationalism, then, Soffici had come full circle. In 1907 he had rejected the Parisian avant-garde in favor of *toscanità*; six years later he had rejected a populist *toscanità* in favor of the Parisian avant-garde. By the end of World War I he had returned to a nationalist politics and his earlier embrace of *toscanità*, and this shift quickly led to a negative reevaluation of

artistic avant-gardism. The negativity of this reevaluation deepened as he gradually discovered the dangers of Americanist consumer culture. Yet the problem that he was attempting to resolve with these continuous reevaluations was always the same. As illustrated by this chapter's two epigraphs, that problem was how to re-auratize art by locating the conditions within which art could once again express its religious essence for the community. Even as Soffici turned against avant-garde art in the postwar period, he did so because he believed that Mussolini's fascism was ideally suited to a restoration of the religious essence of art for Italian life. Fascism, he believed, would give primacy to a new, re-auratized art. Even when he had doubts in this regard, the existence of Americanism convinced him that Mussolini's regime was the best hope for a social institutionalization of the religion of art. This understanding of fascism's purpose was certainly one that Mussolini very much shared.

1. See Emilio Gentile, *Il culto del littorio: La sacralizzazione della politica nell'Italia fascista* (Rome and Bari: Laterza, 1993), and Simonetta Falasca-Zamponi, *Fascist Spectacle: The Aesthetics of Power in Mussolini's Italy* (Berkeley: University of California Press, 1997). Gentile's findings are summarized in his "Fascism as Political Religion," *Journal of Contemporary History* 25 (1990), 229–51. Benjamin's view is best presented in his "The Work of Art in the Age of Mechanical Reproduction," in *Illuminations*, trans. Harry Zohn (New York: Schocken Books, 1978), 217–42; see also Augusto Del Noce, "Idee per l'interpretazione del fascismo," in Costanzo Casucci, *Il fascismo: Antologia di scritti critici* (Bologna: Il Mulino, 1961), 370–83.

2. I have developed this argument in *Avant-Garde Florence: From Modernism to Fascism* (Cambridge: Harvard University Press, 1993); "The Language of Opposition in Early Twentieth-Century Italy: Rhetorical Continuities between Prewar Florentine Avant-Gardism and Mussolini's Fascism," *Journal of Modern History* 64 (1992), 22–51; "Modernism and Fascism: The Politics of Culture in Italy, 1903–1922," *American Historical Review* 95 (1990), 359–90; and "Fascism and Culture: Avant-Gardes and Secular Religion in the Italian Case," *Journal of Contemporary History* 24 (1989): 411–35. For the relation of Milanese futurism to fascism, see George L. Mosse, "The Political Culture of Italian Futurism: A General Perspective," *Journal of Contemporary History* 25 (1990), 253–68; and Renzo De Felice and George L. Mosse, eds., *Futurismo, cultura e politica* (Turin: Fondazione Giovanni Agnelli, 1988).

3. In their solutions to the problem of religion and politics, twentieth-century communisms have generally trod a middle path between the liberal-democratic and fascist extremes.

4. On the concept of the nationalization of the masses and its role in German history, see Mosse, *The Nationalization of the Masses* (New York: Howard Fertig, 1975), and *Masses and Man* (New York: Howard Fertig, 1980).

5. On avant-garde culture in relation to consumerism, see Rosalind Williams, *Dream Worlds: Mass Consumption in Late Nineteenth-Century France* (Berkeley: University of California Press, 1982), and Debora L. Silverman, *Art Nouveau in Fin-de-siècle France: Politics, Psychology, and Style* (Berkeley: University of California Press, 1989). On the elite construction of nationalism, see Benedict Anderson, *Imagined Communities: Reflections on the Origin and Spread of Nationalism* (London and New York: Verso, 1983), and Eric Hobsbawm and Terence Ranger, eds., *The Invention of Tradition* (Cambridge: Cambridge University Press, 1983).

6. For a general discussion of this issue in avant-garde modernist culture, see Peter Jelavich, "Popular Dimensions of Modernist Elite Culture: The Case of Theater in Fin-de-Siècle Munich," in Dominick LaCapra and Steven L. Kaplan, eds., *Modern European Intellectual History: Reappraisals and New Perspectives* (Ithaca and London: Cornell University Press, 1982), 220–50.

7. On Soffici's years in Paris, see Mario Richter, *La formazione francese di Ardengo Soffici, 1900–1914* (Milan: Vita e pensiero, 1969). The best overall source on Soffici's life and art is Luigi Cavallo, *Soffici: Immagini e documenti (1879–1964)* (Florence: Vallecchi, 1986), but there are also many acute observations in Eraldo Bellini, *Studi su Ardengo Soffici* (Milan: Vita e pensiero, 1987). See also Luigi Cavallo, ed., *Ardengo Soffici* (Milan: Mazzotta, 1992).

8. See Soffici's *Il salto vitale*, the autobiographical volume he devoted to these years, in his *Opere* (Florence: Vallecchi, 1959–68), vol. 7 (part 2), 192, 216, 225, 243. He would become good friends with Picasso and Jacob in 1905 and had an active correspondence with Picasso beginning in 1909.

9. Ibid., 235, 296, 298–301.

10. Soffici himself commented upon the resemblance in a letter to Papini of 28 August 1908. See their *Carteggio, I, 1903–1908: Dal "Leonardo" a "La Voce,"* ed. M. Richter (Rome: Edizioni di Storia e Letteratura, 1991), 332.

11. Soffici, *Il salto vitale*, 181–82.

12. Soffici, "Ultima lettera agli amici," *Leonardo* (February 1907), 64–67. Unless otherwise indicated, all translations in this chapter are my own.

13. A quintessential expression came in a letter to Papini of 31 May or 1 June 1908: "I am becoming ever more enthusiastic about our country and our people [*popolo*], the only one in Europe that is healthy in mind and body, clean, and capable of doing something. . . . I have been thinking about this while looking at our children—our marvelous children with their strong limbs, well-tanned and well-formed; their hair strong, full of curls, and smelling like pigeon feathers; their faces well-carved; their eyes pure and large; their whole persons straight and solid like bronze." See Papini and Soffici, *Carteggio*, 237–38.

14. Soffici so claimed in his *Ricordi di vita artistica e letteraria*, in *Opere*, vol. 6, 151. Mario Richter has supported this idea with a citation about suicide from Soffici's *Arcobaleno*, an autobiographical poem of 1915, which, in Richter's view, refers to 1907. See his *La formazione francese di Ardengo Soffici*, 97.

15. Soffici, *Il salto vitale*, 438.

16. See Soffici, *Opere*, vol. 6, 150–67.

17. For Soffici's original notes from his conversation with Bloy, including this citation, see Cavallo, *Soffici*, 80–81.

18. Soffici, *Fine di un mondo* (Florence: Vallecchi, 1955), 18; this autobiographical volume covers the years 1907–15.

19. Soffici, "Pittori e scultori sacri," *Leonardo* (April–June 1907), 183–200.

20. Soffici, "Paul Cézanne," *Vita d'Arte* (June 1908), 320–31, reprinted in Papini and Soffici, *Carteggio*, 467–73, and in Soffici, *Trenta artisti moderni italiani e stranieri* (Florence: Vallecchi, 1950), 354–62.

21. Soffici, "Paul Cézanne," 473.

22. Soffici, "Picasso e Braque," *La Voce* (24 August 1911), 635–37, and "La pittura futurista," *Lacerba* (15 December 1913), 282–84.

23. Letter of 7 September 1908 in Papini and Soffici, *Carteggio*, 341–42; emphasis in original.

24. See Soffici's letter of 8 August, the reply by Papini of 12 August, and the reply to that by Soffici of 16 August 1908 in their *Carteggio*, 286–311.

25. Soffici, *Arthur Rimbaud*, now in *Opere*, vol. 1, 101, 126, 142.

26. Ibid., 111, 183, 187.

27. Ibid., 65, 68, 78, 91, 98.

28. Another avant-garde poet who served Soffici in the same way was Jean Moréas [Yannis Papadiamantopoulos], who returned to his native Greece before dying in 1910. See Soffici's eulogy, "Moréas minimo," *La Voce* (13 April 1911), 549.

29. Soffici, "Picasso e Braque."

30. On the relation of Soffici's collages to those of Picasso, see Christine Poggi, *In Defiance of Painting: Cubism, Futurism, and the Invention of Collage* (New Haven: Yale University Press, 1992), esp. 187–91.

31. Soffici, "Cubismo e oltre," *Lacerba* (1 February 1913), 18. In another article written at the same time, Soffici went so far as to accept the label "classicist," so long as it was used in the general sense of "every full expression of a particular vision of the world" and avoided every taint of "objectivism, the academy, and archaism." See his "Arte francese moderna: Maurice Denis," *La Voce* (30 January 1913), 1003.

32. Ibid., 31, 11.

33. In his interest in Bergson, Soffici was participating in a more general trend among Cubists, especially the Puteaux cubists, Albert Gleizes and Jean Metzinger. For a full discussion, see Mark Antliff, *Inventing Bergson: Cultural*

Politics and the Parisian Avant-Garde (Princeton: Princeton University Press, 1993).

34. Soffici, *Fine di un mondo*, 383–84.

35. Soffici, "Divagazioni sull'arte: Le due prospettive," *La Voce* (22 September 1910), 399. The year before Soffici had already called Bergson "the most profound philosopher of our day"; see his "Ugo Foscolo," *La Voce* (30 December 1909), 233. By 1913 he was suggesting that each philosophy has it counterpart in the history of art and that the philosophical counterpart to futurism was Bergson; see his "Giornale di bordo," *Lacerba* (15 June 1913), 130.

36. Soffici, "Picasso e Braque."

37. Many of Apollinaire's writings on pure painting are now available in translation in Leroy C. Breunig, ed., *Apollinaire on Art: Essays and Reviews* (New York: Da Capo Press, 1988); see especially, "On the Subject of Modern Painting," 197–98; "The New Painting: Art Notes," 222–25; and "Reality, Pure Painting," 262–65. The first two appeared respectively in the February and April 1912 issues of *Les Soirées de Paris* and subsequently became sections two and three of the first part of his *Méditations esthétiques: Les peintres cubistes* (1913); the last appeared in *Der Sturm* in December 1912. For a passage which suggests that Apollinaire may also have been influenced by Bergson, see the *Méditations esthétiques* (Paris: Hermann, 1980), 61.

38. Soffici later reprinted this correspondence in his journal, *Rete mediterranea* (September 1920), 208–37. For an earlier discussion of the virtue of "purity" in painting, see Apollinaire, "The Three Plastic Virtues" (1908), in Breunig, ed., *Apollinaire on Art*, 47–49.

39. The incident is retold in Soffici, *Fine di un mondo*, 196–204, and in Carlo Carrà, *La mia vita* (Milan: Feltrinelli, 1981), 149–51. The futurists were responding to Soffici's polemic, "Arte libera e pittura futurista," *La Voce* (22 June 1911), 597.

40. Soffici, "Ancora del futurismo," *La Voce* (11 July 1912), 852.

41. Soffici's prewar antinationalism made him very much the exception within his circle in Florence. For a wider discussion of the prewar cultural climate in Florence, see Adamson, *Avant-Garde Florence*, 143–203.

42. Soffici, "Giornale di bordo," *Lacerba* (15 March 1913), 56.

43. Soffici, "Divagazioni sull'arte. Di due visioni: del disegno, del colore e dell'incomprensione del pubblico," *La Voce* (29 August 1912), 881. Sometimes Soffici found the same incomprehension in critics; see his "Ojetti e il cubismo," *La Voce* (21 November 1912), 936.

44. For Marinetti's view of the "two avant-gardes," see his letter to Soffici of 1 June 1913, reprinted in Maria Drudi Gambillo and Teresa Fiori, *Archivi del futurismo* (Rome: De Luca, 1958), vol. 1, 257–58. For Marinetti's fusion of nationalism and avant-gardism, see Antliff, *Inventing Bergson*, 160–63.

45. On Florentine futurism, see Gloria Manghetti, ed., *Futurismo a Firenze*

1910–1920 (Verona: Bi & Gi, 1984), and Adamson, *Avant-Garde Florence*, 153–203.

46. In a letter of 24 November 1921 to Carlo Carrà (by then no longer a futurist either), Soffici claimed that he had "aided the movement because of its will to renew and its research. I *never* believed in the fertility of Marinetti's and Boccioni's ideas. The former does not know what art means, while Boccioni was neither a painter nor a sculptor exactly, but made of art a kind of political discipline." See Carrà and Soffici, *Lettere 1913–1929* (Milan: Feltrinelli, 1983), 148; emphasis in original.

47. Letter from Soffici to Giuseppe Prezzolini of 15 August 1914, reprinted in their *Carteggio*, ed. M. Richter (Rome: Edizioni di Storia e Letteratura, 1977), vol. 1, 255.

48. Soffici, *Fine di un mondo*, 464.

49. Bellini, *Studi su Ardengo Soffici*, 176.

50. "If someday I should receive a prize attesting to my courage, I would like it to be justified neither in terms of my hard work nor in view of the dangers I confronted; I would have it say only this: 'He was happy in the trenches of Kobilek.'" Soffici, *I diari della grande guerra*, eds. M. Bartoletti Poggi and M. Biondi (Florence: Vallecchi, 1986), 173–74.

51. Soffici, "Principî di un'estetica futurista," *La Voce* (31 January, 29 February, 31 March, 31 May, 31 July, and 31 December 1916), 42–45, 119–21, 140–43, 229–32, 303–8, 429–33, respectively. Another installment, probably also written in 1916, appeared in *L'Italia futurista* (27 January 1918). The book is *Primi principî di un'estetica futurista* (Florence: Vallecchi, 1920), reprinted in *Opere*, vol. 1, 679–741.

52. Soffici, *Opere*, vol. 1, 684, 687, 693, 695, 703, 711–12.

53. Ibid., 723–24; the passage appeared originally in Soffici, "Principî di un'estetica futurista," *La Raccolta* (15 August–15 October 1918), 95–98.

54. Soffici, *Opere*, vol. 1, 722.

55. Poggi, *In Defiance of Painting*, 244. Focused as her work is primarily on 1912–18, Poggi misreads Soffici as essentially apolitical (he "did not always succeed in neutralizing politics"). Yet even in these years in which he advocated a Bergsonian view of "pure painting" removed from all utilitarian (and thus all political) concerns, he was not so much apolitical as antipopulist; his main political hope was for an international avant-garde that could become a counter-bourgeois elite. Moreover, as Poggi herself recognizes, Soffici was a rabid interventionist from the day World War I began. For her, this is an inexplicable anomaly. My view is that he was always a profoundly political person, but that he became fanatically political in the fascist period.

56. Soffici, *Opere*, vol. 1, 682–83.

57. Soffici, "Apologia del futurismo," *Rete mediterranea* (September 1920), 197–207.

58. Letter to Prezzolini of 27 November 1920 in their *Carteggio*, eds. M. E. Raffi and M. Richter (Rome: Edizioni di Storia e Letteratura, 1982), vol. 2, 19–20.

59. Soffici, "Dichiarazione preliminare," *Rete mediterranea* (March 1920), 3–20.

60. On *La Ghirba*, see Cavallo, *Soffici*, 278 (includes a photograph), and Isnenghi, *Giornali di trincea (1915–1918)* (Turin: Einaudi, 1977), 152–54.

61. Some of the articles were reprinted in Soffici, *Battaglia fra due vittorie* (Florence: Soc. An. Ed. "La Voce," 1923). For indications of Soffici's new political fervor, see Papini's letter to Prezzolini of 4 October 1919 in their *Storia di un'amicizia* (Florence: Vallecchi, 1966), vol. 1, 318; and Prezzolini, *Diario 1900–1941* (Milan: Rusconi, 1978), 328.

62. Soffici, "Religiosità fascista," *Il Popolo d'Italia* (7 November 1922), now in *Battaglia fra due vittorie*, 206–7.

63. Soffici, "Il fascismo e l'arte," *Gerarchia* (25 September 1922), 504–8.

64. Ibid.

65. Soffici greatly feared the "Americanism that is being diffused in Europe, which after having ruined Germany, pushing it to the point of collapse, is now contaminating England, France, and almost every nation on our continent. It is the paradigm of the contaminating force of modern plutocracy. Americanism is the plague that advances vulgarizing, making stupid, bestializing the world, humiliating and destroying high, luminous, glorious, millenial civilizations." See Soffici, "Aforismi a buon mercato," *Il Selvaggio* (7 October 1926), 5. On *americanismo* among Italian intellectuals more generally, see Emilio Gentile, "Impending Modernity: Fascism and the Ambivalent Image of the United States," *Journal of Contemporary History* 28 (January 1993), 7–29. On the economic realities behind the fear, see Geminello Alvi, *Dell'estremo occidente: Il secolo americano in Europa. Storie economiche, 1916–1933* (Florence: M. Nardi, 1993).

66. Soffici, "Arte fascista," *Critica fascista* (15 October 1926), 383–85; on Mussolini, see Soffici, "Rosario," *L'Italiano* (3 June 1926). For corroboration that Soffici had become increasingly critical of fascism, see Prezzolini, *Diario 1900–1941*, 416.

67. For more on the critique of Italian art, see Soffici, "La cantonata di Volt," *L'Italiano* (11 February 1926); and "Morandi," *L'Italiano* (March 1932), reprinted in Soffici, *Trenta artisti*, 36–47.

68. Soffici, *Periplo dell'arte: Richiamo all'ordine* (Florence: Vallecchi, 1928), v, 1, 3, 32, 46, 63–64, 66, 99. In contrast, Soffici had written approvingly in 1911 of Courbet's "passionate preoccupation" with "reproducing modern reality grandly, without deforming in either the classical or romantic manner"; see his "Gustave Courbet," *La Voce* (18 May 1911), 572–73.

69. Soffici, *Periplo dell'arte*, 65–70.

70. Ibid., 15–19, 27–33, 81–83. See also Soffici, "Semplicismi," *Il Selvaggio*

(30 January, 15 February, 15 March, 30 April, and 31 May 1927), 5, 9–10, 17–18, 29, 37, respectively.

71. Soffici, *Periplo dell'arte*, 55–57, 87.

72. Benjamin, "The Work of Art in the Age of Mechanical Reproduction," 217–42.

73. Soffici, "Aforismi a buon mercato," *L'Italiano* (24 December 1926).

74. Soffici, *Periplo dell'arte*, 70.

Valentine de Saint-Point
and the Fascist Construction of Woman

Nancy Locke

To put on a dress, to cover oneself with clothing, leaves the primacy of communication to the face, with which the human being essentially speaks. And the mask, then? It makes the body the instrument of communication. Some schools of mime are founded on this reversal. But where does the subject reside, then?
—Eugénie Lemoine-Luccioni, *La Robe*

The mask for the face, however, should never be doffed. It is the face and the words that issue from the mouth that make all the wars and all the racial disputes. Covered, nothing would stand in the way of the symbolic beauty of the individual's conception of life.
—Valentine de Saint-Point, interview with Djuna Barnes

It would appear, to judge from Lemoine-Luccioni's thinking, that Valentine de Saint-Point's insistence on wearing a mask during her dance performances was part of an effort to make the body take on new and particular expressive tasks, that the mask took the focus away from distracting and even divisive individual traits.[1] It might even appear that in this focus on the body, Saint-Point articulated a language of female sexual liberation; such an impression would be borne out by a cursory examination of Saint-Point's "Futurist Manifesto on Lust," which she wrote and performed in 1913. "We must stop scorning Desire, this subtle and brutal attraction of two bodies, of whatever sex, two bodies who desire each other, straining for unity," proclaimed the manifesto.[2] Lust is a force, she claimed; she reacted against the futurist exclusion and indictment of woman as "the voluptuous lure" who "weights down man's steps and prevents him from breaking his fetters, from surpassing himself" by reclaiming the territory of woman's sexuality as the source of power and activism.[3]

Yet the imagery of woman's body and woman's sexuality in Saint-Point's work is anything but liberated. In the era of Isadora Duncan's

body-revealing dance and Nijinsky's simulation of sexual acts onstage, Valentine de Saint-Point's theory and practice of dance performance seem curiously arid. In one of her epic poems, the female body is imagined as a wound in the male body, or a girdle around his loins. As often as Saint-Point evokes images of the woman warrior or the woman who uses sexual exploits to wield imperial power, she also suggests an image of the utterly passive woman, the woman who takes pleasure in being dominated: "I have desired / The gentleness of being prisoner," she declaimed to a New York audience in 1917.[4]

As Lemoine-Luccioni queried, we too might ask where the subject—woman—resides in Saint-Point's work. In fact, her virulent anti-individualism finally locates the female subject in a combative arena of reaction against feminism and antifeminism alike. The case of Saint-Point provides a fascinating opportunity to explore constructions of woman in fascism, and an examination of the representations of women in her work would complement analyses already done on nations and individuals.[5] Saint-Point came to the futurist movement from domains the futurists either spurned or attacked. Whereas they wanted to burn the art of the museums, she—a great-grandniece of Lamartine—argued that the art of the future could be rooted only in a knowledge of the art of the past. Whereas they celebrated the machine and the airplane, she clung to a Parisian symbolist vocabulary of mysticism and ancient mythology. Whereas they "had nothing but scorn for women," Saint-Point made woman the focal point of her art. Yet despite all the ways in which Saint-Point could have fashioned a critique of futurism and despite the fact that at times she did fashion such a critique, her notion of woman remained embedded in a language of male domination.

The very idea of "male domination" is so endemic to the topic of fascism and sexual politics that it can be difficult to analyze. Barbara Spackman speaks eloquently to this problem in her essay, "The Fascist Rhetoric of Virility."[6] The political culture surrounding Mussolini stressed "virility," yet as Spackman points out, a rhetoric of virility is not unique to a fascist political figure's campaign. As she confronts the temptation to oversimplify the gendering in fascist discourse of the (hypermasculine) leader and the (feminine) masses, she also resists the notion of taking a rhetoric of virility so seriously as to regard it as pathological. Spackman faults several thinkers for seeing a rhetoric of muscle-flexing bellicosity as a sexual deviation.[7] To "demonize" fascist

culture as a behavioral aberration, she says, is also to view it as a historical aberration, and that would be productive neither as gender analysis nor as social analysis.

Spackman's arguments are key to an understanding of Saint-Point's construction of woman. Clearly one cannot simply extract a rhetoric—or an imagery—of the virile male or of the woman warrior and label it along gendered lines; moreover, Saint-Point's writings on lust could easily become a target for the kind of analysis Spackman attacks—an account which would see Saint-Point as a mere sexual aberration. Although Spackman criticizes Klaus Theweleit for considering fascism in terms of pathological sexuality, it is his massive study, *Male Fantasies*, that presents the most complex model for an understanding of gender and fascism.[8] In a foreword to the first volume, Barbara Ehrenreich explains, "As Theweleit says, the point of understanding fascism is not only 'because it might "return again,"' but because it is already implicit in the daily relationships of men and women."[9] For Theweleit, fascism is not a political theory; it is a matter of bodies, desires, relationships; it is what shapes his subjects' fears and imaginings. Such an association between fascism and sexuality, including its fantasies of violence, does not make fascism a historical aberration, as Spackman would claim. It sees fascism in its everyday forms, in ways that can help us trace its roots in earlier periods and its continued appearances in our own.

Male Fantasies is a rich, porous, speculative, incisive study of the members of the Freikorps, volunteer armies in post–World War I Germany. Theweleit analyzes the recurring imagery, from soldiers' diaries and from songs and novels of the period, of soldiers who imagine their bodies as hard-shelled weapons and the enemy (whether the Russian Red Army or the German working class) as a soft, dirty, feminine morass; their own bodies must remain hard, phallic, and machinelike to fend off the enemy flood. Theweleit concentrates on male subjects, and on the ways they imagine and represent women.

A particular image in Theweleit's book can help us to understand how a woman would become part of a movement that basically subjectified women. It is the image of a large and powerful machine. Theweleit quotes Ernst Jünger: "Our generation is the first to begin to reconcile itself to the machine; to perceive it as containing not utility but beauty."[10] This aestheticization of the machine is of course central to futurism. "The machine must be made more than a mere means

of production to satisfy our pitiful basic needs; it should provide us with a higher and deeper satisfaction," writes Jünger.[11] Theweleit explains that Jünger's "technological machine" has "individual components [that] occupy and fulfill prescribed positions and specific functions. [. . .] Components within the human totality-machine are hierarchized, functionalized, individual; the machine connections are standardized and unified."[12] The machine can perform without succumbing to the temptations of the flesh, and the machine has a power which the individual subject does not possess. Although much of the imagery of force and velocity is calculated to appeal to the male subject, the female subject is also implicated. The machine offers the female subject a mastery of the means of production (of pleasures, of feelings) as well as the means of reproduction (of artistic arts, of bodies). All softness, emotiveness, unpredictability of physical states and experiences can be regularized and subsumed within the machine's operation. The aestheticization of the machine results in a kind of naturalization of its power, which then extends to the way the individual subjects in fascism feel about their access to power.

The machine's power is exhilarating to the subjects who are slotted to function within it: "Their status as components within totality-machines gives them the feeling of being-in-power."[13] Wartime guarantees that the machine will erupt frequently, and it is these eruptions or explosions that give the components the feeling of power. But the machine—which represents "a larger social power"—needs stimuli so that it would erupt even in peacetime.[14] The eruptions provide the needed excitement to keep the components functioning smoothly in their allotted places.

If we think of the futurist movement as an aestheticized totality-machine à la Theweleit, it is not so difficult to see how a woman like Saint-Point would function within it. She becomes part of the machine and feels its exhilarating power. She even invents a way to get the machine to explode and erupt: she performs her "Futurist Manifesto on Lust," and what could produce more sparks than a woman speaking out on lust in the 1910s?

If an analysis of gender and fascism invariably finds male domination at the core, then how do we conceive of Saint-Point's sexual politics? Maria-Antonietta Macciocchi makes an important distinction: "there is no *femme en soi*, but rather a feminine content, atoms in motion, millions of subjects, a feminine universe."[15] Certainly Saint-

Point makes the mistake of imagining a *femme en soi* (a female essence) and fails to acknowledge a feminine universe, a larger matrix of women with different interests—in short, a universe of *difference*. Saint-Point's construction of woman is based on a myth of woman, not on a concrete or historical account of women; her notion of woman creates a mythic collectivity in place of what would be "disparate subject positions."[16] Saint-Point's "woman" is thus analogous to Sorel's version of the collective will. The implications for full-blown fascism of this exaltation of collective violence, with its attendant effacement of individual subjects, should not be ignored in favor of the superficial excitement of Saint-Point's enthusiasm for feminine lust as a force.[17]

Saint-Point's work, and in particular her construction of woman, is typical of the protofascist cultural politics of the early twentieth century in several ways. One can detect in her writings a distinct antimaterialism: along with the futurists, she launches a critique of bourgeois society, but her thinking replaces the rationalist theory of social struggle and its economic base (the Marxist critique of capitalism) with a heightened irrationality, with what Zeev Sternhell calls a search for "sentiments, myths and images."[18] Although her writings strike the modern reader as sentimental, Saint-Point expresses distrust in the subject's reflexive emotional responses, because these come to be associated with what is to be changed about the contemporary condition of women: for instance, women's embeddedness in the domain of private emotions and family ties which prohibits women from participating fully in the interests of the collectivity. Saint-Point's notion of the women's realm, however, is not that it should be entirely public; like Barrès, she takes stock in the unconscious, as she proclaims the importance of psychological and other invisible phenomena.[19] Her notion of the woman warrior possesses an easily discernible appeal to tribalism and to that social Darwinist strand of nationalism that was prevalent in the thinking of Barrès, Drumont, Maurras, and the group Action Française.[20] Like many of the followers of Barrès, she had a background that was privileged enough to encourage her indulgence in ideas of decadence and extravagance; as Weber has shown, the reaction against nineteenth-century positivism and materialism in the fin-de-siècle comes from an educated, bored *rentier* class that sought action and excitement.[21] There is also in Saint-Point's work a virulent anti-individualism, a tendency to glorify the crowd or the collectivity (and more important, the *energy* of the crowd),[22] although she does

hold onto a Nietzschean concept of the artist-genius. This apparent contradiction helps to illustrate how fascism could, in avant-garde circles, style itself as being egalitarian even while maintaining the allure of an elitist mysticism.[23]

The type of nationalist thinking that informs Saint-Point's construction of woman was supposed to transcend social class and political affiliation; it was tribalist in its conception of a race of new women inspired by an imagery and a mythology of female violence. This, too, typifies the early history of fascist cultural politics. Just as Barrès attempted to "[ensure] the integration of the most disadvantaged strata of society" in his "national socialism," so too, Sorel came to realize that the proletariat of the first decade of the twentieth century was not, and would not become, the agent of a Marxian revolution.[24] For Saint-Point, women were the disadvantaged group who would be instrumental to the envisioned social change. As we shall see, however, just as the interests of the working class do not coincide with those of the "nation," the fiction of the nation and its interests would ultimately override the interests of women in Saint-Point's theory and body of work.

Valentine de Saint-Point was born Anna-Jeanne-Valentine-Marianne Desglans de Cessiat-Vercell, in Lyon in 1875.[25] Her father, an insurance agent, died when she was eight, but her mother, the daughter of Lamartine's nephew, apparently had a great love of literature and did her best to encourage such interests in the young girl. At fourteen, Saint-Point published some poems in a review of parochial circulation. At eighteen, she married a nervous, awkward lycée instructor. A year after his death, Saint-Point married a colleague of his, Charles Dumont, a philosophy instructor rising rapidly in the academic ranks. She was twenty-five. Saint-Point in this period was described as a superb woman with blond chignon and auburn tresses. She seems to have convinced him to move into politics, which he did with great success, as a legislative representative on the radical ticket, and eventually as a cabinet minister. The pair divorced, however, in 1904, Saint-Point assuming fault for abandoning domestic duties in order to live as a woman of letters. A scandal had occurred when she posed nude for the art-nouveau artist and designer Alphonse Mucha—an activity eminently unsuitable for the wife of an elected official. She went on to assume the name Valentine de Saint-Point, a name evocative of her Lamartinian ancestry.

As early as 1903 she made the acquaintance of the Italian aesthete and Left Bank intellectual Ricciotto Canudo.[26] They were both regulars at such period events as seances and Theosophical Society meetings; they were both friendly with Rodin. They began a long collaboration and romantic liaison. Canudo, champion of the cinema, which he called the "seventh art," was as taken with mysticism as was Saint-Point. The pair shared many ideas: a fascination with the power of the collectivity and the effacement of the individual—Nietzschean ideas popular with many in avant-garde circles at this time; an interest in androgyny and in the notion of sex as a fundamental drive of civilization; and a commitment to a kind of Wagnerian synthesis of the arts. Canudo was particularly enthralled with Wagner. The composer's ability to manipulate the medium of music to encompass—if not overpower—the audience was a source of considerable interest to the symbolist artists around Canudo. The leitmotiv, endless melody, and chromatic transitions wove a complex but self-familiarizing web around an easily identifiable mythic story line centered on ritual sacrifice, usually the self-sacrifice of a female for a male hero. The devices worked together to affect the collectivity of listeners in ways that appealed profoundly to the symbolists. Canudo wrote that Wagner's techniques and his theory of the *Gesamtkunstwerk* should be translated into the new art of the film.[27]

Literary gatherings as well as the publication of numerous small reviews were the main activities of the avant-garde that Saint-Point and Canudo entered. Over three hundred small art reviews circulated in Paris between 1900 and the outbreak of the war.[28] When Saint-Point and Canudo met, he was attending the *soirées* of the group involved with the journal *La Plume*. At a reunion of the members in the Soleil d'Or tavern, he made the acquaintance of Apollinaire, André Salmon, Eugène Montfort, Paul Fort, Maurice Raynal, and others. Canudo also frequented the *Soirées de la Closerie*, which included many of the above, as well as Max Jacob, Marie Laurencin, and F. T. Marinetti.[29] The group published *Les Soirées de Paris*, a journal of poetry, criticism, and drawings—often of one another.

Between 1905 and 1910, Saint-Point remained in correspondence with the founder of the Italian futurist movement, Marinetti, while publishing articles in journals such as *La Nouvelle Revue Française*. One of her main interests was her literary ancestor, and she edited some unpublished letters by Lamartine.[30] Some of Saint-Point's

projects in this period appear to be almost feminist (in the late twenti-eth-century sense of the word) in contrast with Canudo's overt Wag-nerism. In one article in *La Renovation esthétique*, Canudo described the museum as a kind of temple and the museum experience as char-acterized by a group feeling reminiscent of the sexual drive—an *oubli esthétique* in which the individual forgets himself and the group is reconnected with the metaphysical base of society.[31] Saint-Point fol-lowed a few months later with an essay on the dearth of convincing images of women in the paintings at the Prado.[32] She praised the supreme elegance of the male race as depicted by Velázquez, for instance, but found his women to be somewhat foreign. Around this time Saint-Point's literary interests began to lean toward representa-tions of women. On 6 November 1910, the *Paris-Journal* announced a program of study in Italian literature at the Université-Nouvelle of Brussels.[33] Courses included Apollinaire on Aretino, Canudo on medieval Latin poetry, and Saint-Point on women in literature.

Saint-Point published several volumes of poetry in this period. *Poèmes d'orgueil* of 1908 was more ambitious in its historical refer-ences than the naive *Poèmes de la mer et du soleil* of 1905. Her play *Le Déchu*, a short drama about mystical self-immolation, was published and staged in 1909 at the Théâtre des Arts.[34] *La Guerre*, an epic poem of 1911, revealed her passion for evocations of violence and suggested a reactionary set of social beliefs. *L'Orbe pâle*, prose poems of 1911—perhaps her best effort at pared-down, unsentimental, straightforward language and imagery—intertwined themes of war and the collectivity with the mystical isolation of the artist.

Her play *L'Ame impériale, ou L'Agonie de Messaline* (1907), demonstrates the manner in which, for Saint-Point, claims for women's power are made almost exclusively through the channels of sexuality.[35] The Roman Empress Messalina asserts power over her subjects with her own sexual prowess: "I will also wear out your sons, your brothers, your lovers, your husbands! [. . .] My insatiable flesh still reigns over all. . . ."[36] The power she wields within the imperial court is also based in skillful sexual intrigue (pending victory, she promises herself to some-one engaging in combat with her husband.)[37] The female warrior (*inci-tatrice*) can position herself only from the imaginary point of view of male desire.[38] The heroine remains an object with no power of her own.

Saint-Point later characterized *Messaline* as an example of a tragedy that recovered the ancient Greek communalizing power of

drama. The audience she described as having "a will, a tendency," which it was the task of the artist to intuit. "The individual must disappear, individuals must dissolve themselves" into this "expression of the crowd," which was the work of art. The highest achievement of art would be the accomplishment of the "multitude-One," a singularity or homogeneity of humankind, "one heart, one soul, and maybe someday one spirit."[39] As Sorel adapted Le Bon's theory of the crowd, so too did Saint-Point form a notion of the crowd or "multitude-One" as possessing an admirable energy that needed to be harnessed by the artist: Saint-Point dreamed of consolidating the power of the crowd, but not of unleashing its desires.[40]

L'Orbe pâle abounds in the kinds of representations of male and female that would surface in the futurist manifestos. The narrator is female, and she meditates on desire, which she likens to an interminable and insatiable waiting (*l'attente*).[41] The very atmosphere is permeated with lust; even the sun is "hot with Desire" (p. 33). Although she describes desire as unsatisfiable (p. 11), she fills the text with objects of cathexis: whether she introduces the shadow of an invading foreigner, fishermen on a beach, a body, a ship, flowers or stones, all are heavily invested with affect and sensuality. Yet the figure saturated with desire—the central female figure—delights in her body more as a lure than as a sentient entity. She observes three silent young men who are waiting for "the Woman." "Did they perhaps, from far away, distinguish my feminine form, my shape whose femininity hides my virility?" she asks.[42] The female body is nothing but a misleading shell: it hides her true nature, which is virile and violent. Although it might appear that some women are passive and sensitive whereas others are aggressive, it is but one woman, says Saint-Point, who contemplates the mysteries of the moon and stars, and also flexes muscle to vanquish foes: "The same woman who always has only one goal: through dreaming, acting and creating, to triumph over passive waiting."[43]

In Saint-Point's narrative, woman triumphs over desire and passivity by refusing to be an object, by refusing to be possessed, and by basing her actions on her virile instincts. Yet this apparent focus on the body and physicality proves to be deceptive. Out in the desert, the female character suddenly sees "a superb Arab" mounted on an aristocratic horse. "He was handsome, divinely handsome. He was so good-looking that I blushed," she recounts.[44] He sees her, and a light appears in his eyes. He wishes to possess her, "because all males of all

time, of every country and every religion, have confused and will always confuse admiration with desire." She asserts, "I am the one who will not be possessed." She resolves this potential conflict with her sword. "In the heart, I stabbed the handsome Arab. The handsome Arab, I killed him."[45]

What follows reveals a great deal about Saint-Point's theory of the virile woman. After she relies on her instincts for the swift kill, she keeps watch over the body: "But all day and all night and every night of a lunar orb, I watched over his body, because, sleeping beside him, I drank his blood to the last drop—his blood the reddest of the red."[46] Saint-Point's narrator conjures a vision of violence and vigilance that verges on necrophilia. Yet, moments later she reveals, "It was only a dream, it seems."

It is tempting to dismiss the entire episode as the work of a novice writer—a scene added for its shock value, resolved with the cheap trick of "it was only a dream." Yet I would argue that this trumped-up oneiric moment in the text is highly suggestive of the text's real concern: that the naive tone and tedious, simplistic narrative are the stylistic hallmarks of the effective fascist text. As Alice Kaplan has written, it is the very banality of fascist texts that plays a key role in their ideological dissemination; it is because fascist texts are banal, she argues, that we must read them.[47] And in this case, the mirage of the superb Arab who is killed on account of his gaze and his desire is a necessary illusion. Saint-Point's construction of the virile woman depends on yet another Other who can be easily vanquished.[48] As such, this notion of woman never transcends the male domination that provoked its formation. Saint-Point's woman, in her opposition to a condition of cultural otherness, designates a further sort of alterity: in this case, the sexualized Arab.

Although men and women are "equal" in their mediocrity, woman falls into one of two categories in Saint-Point's agitative "Manifesto of the futurist Woman," written in March 1912 and performed that summer in Brussels and Paris.[49] She is either a warrior or a nurse. She is either a lover or a mother. The prostitute servicing a soldier and spurring him on, says Saint-Point, is superior to the lover who tries to hold back the beloved on the morning of departure for battle. These binary systems are attributable to the fact that for Saint-Point, "It is absurd to divide humanity into women and men," when society "is only composed of *femininity* and *masculinity*." She posits essential mascu-

line and feminine qualities and the need for all human beings to partake of both. Typical of her interest in representations of women is her suggestion that societies in different historical periods have suffered from an excess of masculinity (belligerence) or femininity (weakness). She argues both with those qualities of sentimentality and inferiority in women which the futurists despised, and with the feminist movement, which was trying to claim political rights for women rather than invoking women's natural instincts.[50] She urges women to renounce the domains of morality and cultural prejudice, and "return to your sublime instinct, to violence, to cruelty."[51]

The manifesto is paradoxical, at once suggestive of a radical equality and similarity between men and women, and of an essentialist and extremist polarization of masculine and feminine attributes. As Marie-Antoinetta Macciocchi argues, fascism installs itself as at once a repression of the battle of the sexes and an imposition of sexual difference to the point of absurdity.[52] This paradox can be clearly seen as Saint-Point rejects the feminist clamor for political equality for women as "a political error" and "a cerebral error" that woman will instinctively recognize. The instinct Saint-Point implies is, it appears, both that of essential motherhood and that of the virility and aggression that women had for too long suppressed or ignored.

Approaching Saint-Point's "Futurist Manifesto of Lust," of 1913, one might expect to find an articulation of the body—male if not female—in an embrace of the physical and the sensual. One might expect to find Saint-Point, the admirer of Rodin, imitating him, constructing a femininity which is "urgently, insistently genital," as Anne Wagner writes of the sculptor's "imagining and reimagining the site of desire."[53] Instead, one finds a glorification of violence and warfare, and a normalization of the rape and pillage that accompany the military conquest. "*Art and war are great manifestations of sensuality; lust is their flower*," she claims. "After a battle in which men are killed, *it is normal for the victors, proven in war, to go so far as to commit rape in the conquered country, in order to re-create life*."[54] What would appear to be a celebration of physical desire for men and for women ("we have but one body and one spirit," she writes of both sexes; "woman is the great galvanizing principle," she says of women) ends as a naturalization of violence against women.

Saint-Point's reading of her manifesto at the traveling futurist *soirée*, "Zang Tumb Tumb," was billed as an element of "Azione fem-

minile."[55] Venues for this show ranged from cabarets to galleries, from university campuses to skating clubs in at least ten European cities, including Berlin, Rome, Rotterdam, Pisa, Florence, Paris, and London. Marinetti hoped that conferences held by Boccioni, by Saint-Point, and by himself would cause the "definitive shakeup" in Rome.[56] He sent a bundle of copies of the piece on lust to his friend Palazzeschi to distribute in Florence at the Giubbe Rosse, the café where the Solaria group gathered.[57] The manifesto on lust became the most sensational collaboration between Saint-Point and the futurists. Lust must be seen as a creative force in civilization; it furthers natural selection by helping the robust to reproduce and the weak to die. She calls for an end to morality and sentimentality in relationships between persons of either sex who are attracted to each other. She asks for an end to hypocrisy surrounding something which is a crucial part of life, as important as the spiritual part. On the one hand, her arguments resemble other avant-garde rejections of bourgeois values, such as Marinetti's attack on the *passéiste monsieur* and his bourgeois mistress who survives on sexual favors.[58] On the other hand, the "natural instincts" touted for women in the "Manifesto of the Futurist Woman," and developed in the "Futurist Manifesto on Lust," turn out to be the irresponsibility and violence that were hailed as masculine values by the futurists.

On Christmas Eve, 1912, Saint-Point was by Canudo's side as he signed a pact with one Mme Zekowaïa to found the publication of *Montjoie! Organe de l'impérialisme artistique Français.*[59] Its first issue was dated 10 February 1913, and Saint-Point wrote a regular column for it. Saint-Point was achieving more prominence in 1912 on account of the number of literary *soirées* she organized; some were known as *Soirées Apolloniennes* and were held at her own atélier; others boasted the participation of Marinetti.[60] Canudo was with her when she read her "Manifesto of the Futurist Woman" in Brussels, but during the war the couple was separated. Canudo was drafted and, with other Italians, joined a French foreign legion of Garibaldians under the hero's grandson. Canudo and Saint-Point were to see each other again in Barcelona, in 1916, when she was with the Picabia group. At that point, she had toured with the futurists and set forth her theory of synthetist performance art, and was preparing for a voyage to the United States.[61]

For *Montjoie!*, Saint-Point wrote a literature column, reviewing such books as Camille Mauclair's *De l'Amour physique* and Alexandre

Mercereau's *Paroles devant la vie.* She was enthusiastic about Mau-
clair's serious treatment of this favorite subject of hers; she was
intrigued with his insights on the mother, the lover, the courtesan; she
especially liked his remarks on the brothel as a discreet site of lust.
But the review was also an opportunity for her to further her own
agenda on the subject:

If we limit sensuality to a need which must immediately be satisfied (that to which the
brothel responds), then sensuality, lust cease to be a force; they are no more than a
weakness. What newfound energy or resuscitation, what exaltation or rare recollec-
tion has the man walking out of a bordello ever known?[62]

As in the manifesto on lust, Saint-Point argued that lust is a
force; it must be rescued from the domain of nineteenth-century mate-
rialism and positivism and put into a realm of metaphysical and cre-
ative energy. Her review of the Mercereau book was likewise
enthusiastic about his transformations of the physical into the meta-
physical. It is somewhat extraordinary that Saint-Point comments more
extensively on Mercereau's vision of the Poet than on his account of
the pregnant woman and the mother. The pregnant woman, in Mer-
cereau's book, carries her womb "like a reliquary, like the sovereign
throne of heaven"; her pregnancy washes away her sins because it is
"the divine mission of our existence"; he tells her that by being preg-
nant, "you no longer belong to yourself."[63] It is here that we see the
artists and writers in the *Montjoie!* circle defining woman as Other
through the lens of an "us": the interests of this imaginary "us" over-
ride the autonomy of the circumscribed Other. These explicitly nation-
alist interests, Theweleit might say equally of Mercereau's audience as
he has of Wilhelmine society, inscribe themselves on women's bodies,
causing women to "[experience] their lack of social power as a lack of
power over specific areas of their own bodies."[64] Hence we find Saint-
Point welcoming the imprint of domination on the female body, the
notion that a woman's body no longer belongs to her.

Saint-Point's poetry, her performances, and even her public per-
sona lent themselves to the *Montjoie!* writers' nationalistic program
and to their own agenda concerning femininity. In 1912, Jacques
Reboul, one of the *Montjoie!* contributors, published a book on Saint-
Point called *Notes sur la morale d'une "annonciatrice."*[65] Reboul sees
Saint-Point's work as evocative of the moral situation of the ancient
Celtic woman: the "lost lyricism of our race," "wildness, joy with pity—

our fundamental ethnic character."[66] The artist, for Reboul, is a prophet who will lead art back to its sources. Since women aided in the ancient resistance to Roman imperial domination, a young woman writer such as Saint-Point would make an ideal prophetess to lead art back to its racial roots.[67] In an article in *Montjoie!* a few months later, Saint-Point becomes, for Reboul, the modern woman who stands for an ideal associated with chivalry. He deplores modern manners toward women, especially toward those who seek employment; he invokes a traditional set of manners which had been part of the French diplomatic heritage for centuries. He writes:

In literature and in art, where pretentiousness abounds today more than anywhere else, it has also become fashionable to insinuate that when a woman does not keep to housework, she's a "creature." [. . .] Think of it! A woman who creates a body of work, a woman who appears publicly. . . . Those sorts flaunt themselves, my good woman! . . . And Morality? How many times have we not heard these spiteful reflections, even when in regards to a poetess, dignified above all by her character and belonging to the best blood of France![68]

He clearly implies a set of attacks on the character and reputation of the flamboyant Saint-Point; one thinks of gossip such as Diego Rivera's remark that Saint-Point was Margherita Sarfatti's lover (Rivera later retreated from this probable concoction, describing her as the companion of Canudo).[69] Nevertheless, Reboul's commentary seems directed not only to some personal attack against Saint-Point, but also to a general way of speaking of women at the time. His proposed remedy was his own brand of Celtic nationalism. He continues:

The Cult of the Woman was the honor of our antique Celtic cities and the patriarchal Roman law never extinguished this religion. Chivalry is proof of it. We have imposed this cult on Europe with our cathedrals. The French youth, which has taken up again the thread of a secular effort, understands to keep its soul intact. They will display it in honoring Woman, guardian of the Ideal and of the hero's rest, forging it with serenity, the hard glory of the next triumph.[70]

Reboul's reference to Saint-Point as "belonging to the best blood of France," as being above the fray of the deprecation of the modern, public woman, becomes enmeshed in a dream of the revival of chivalry. Woman would again be placed on a pedestal. Saint-Point's opposition to feminism, her mystical exaltation of lust can here be seen in their proper context. Under a guise of chivalry and invented

cultural heritage conjured by the *Montjoie!* circle, Saint-Point was making a certain kind of feminism safe for France. Her Lamartinian lineage and nationalist politics were used by Reboul to moderate her controversial public persona and to make the cultural and sexual chauvinism of the *Montjoie!* group seem palatable.[71]

In 1913, she was not only touring with the futurists; she was also onstage performing *La Métachorie*—her "beautiful theory. . . that part of action that is gesture, that part of music that is song, that part of line that is pictorial, and that part of movement that is dance. . . that which is beyond dancing," as she described it to Djuna Barnes.[72] Her explanation of her synaesthetic dance performance stressed the notion of the "dance of ideas," a dance that would be "spontaneously more spiritual than sensual."[73] Figure 1 shows some of the poses from Saint-Point's *La Métachorie*, danced at the Théâtre Léon-Poirier in Paris.[74] After one of these early performances, the critic Georges Casella had more to say about Saint-Point's figure than about her dancing: after describing her beautiful breasts, arms, and legs, he noted: "A 'Métachorie' which unveils such charms to us can't be an art without merits."[75] The word *dévoile*, with its nuances of an erotic revealing of the body, seems striking in light of Saint-Point's veils and heavy drapery, which can be seen in the photographs. The review, which complained that Saint-Point copied Isadora Duncan too much and not very well, and which compared her abstract dance to "physical education class [*culture physique*]" and to "Swedish gymnastics," was to have been the subject of a lawsuit about the rights of the critic.[76]

Saint-Point's performances of *La Métachorie* featured such works as her 1911 epic poem *La Guerre*. For *La Guerre*, Marinetti facilitated the composition of a futurist musical score by Pratella.[77] Like the manifestos, the work claims that the eternal needs of society are to dominate and to destroy, but here the violence takes on new proportions. As the Poet, whose character is to be understood as that of the synthetic artist, "the voice of the Race," declares:

> In order to stem the tide of individual crimes
> Serving the individual,
> We must authorize a great, collective crime
> Serving the collectivity;
> In order to shun cowards, let us foment heros.[78]

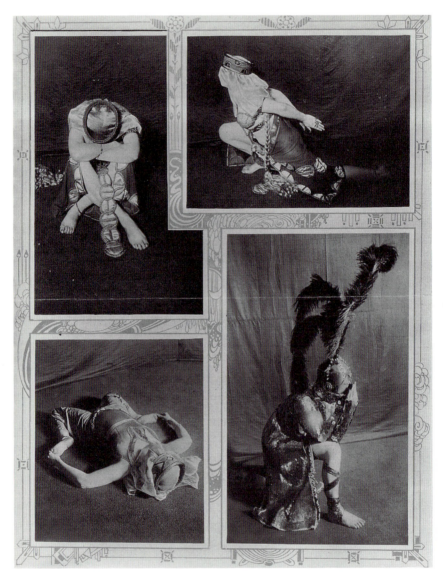

1. Photographs of Valentine de Saint-Point from her performances of *La Métachorie* at the Théâtre Léon-Poirier in Paris, 1913–14. Reproduced in the *Sketch Supplement*, 7 January 1914. Courtesy of the Dance Collection, New York Public Library

The aggression of warfare in the poem turns to regression, to the conception of a "collective crime," to genocide.

What is striking about this articulation of reactionary politics, this justification of barbarism, is its way of involving women. In *La Guerre*, the dominant collectivity is described as feminine, as a large wound that cools the strife-ridden armies with its blood.[79] One thinks of similar fantasies in Klaus Theweleit's Freikorps officers, of the "gigantic, filthy-red wave" that breaks over the soldier, the wave that represents femininity, Bolshevism, filth, animality; the wave that threatens to drown him.[80] The social order envisioned in *La Guerre* is not very different than the one imagined by Theweleit's subjects: it not only neutralizes rape, but determines and controls human reproduction. Once again, the Poet: "So that women, heretofore sterile / Remake children, we must destroy it in them."[81] Saint-Point's woman warrior is denied autonomy. If she has gained a certain measure of liberation from bourgeois morality, she has certainly lost fundamental individual freedoms. There is no distance between *La Guerre* and Marinetti's pronouncements on marriage and the family in 1919, when, ally of Mussolini, he was a parliamentary candidate for the Fascist Party: "Woman does not belong to a man, but rather to the future and to the race's development."[82] Whereas Saint-Point and Marinetti argued in print about the subject of lust, they agreed about the politics of reproduction: coitus must be regarded as necessary to the maintenance of civilization. As Andrew Hewitt argues, Marinetti proposes a degenitalization of sexuality, an antierotic "futurism" "of the species."[83] Walter Benjamin's description of fascism, that it aestheticizes the destruction of civilization,[84] can be seen clearly in Saint-Point's 1911 futurist work.

Saint-Point performed *La Guerre* in a suite of works to a bewildered Metropolitan Opera audience in 1917, in a "Festival de la Métachorie."[85] On a day otherwise dominated by news of suffragette demonstrations and of President Wilson's declaration that the United States was entering World War I, Saint-Point appeared onstage—bathed in colored lights, clad in the armor of the *incitatrice*—reciting the love poem in which the woman says to her lover, "I wanted / The sweetness of being prisoner." Music included Debussy's "Nuages" and "Fêtes," his prelude to the "Blessed Damozel," Erik Satie's "Hymn to the Sun" orchestrated by Ravel, as well as pieces by Rudyard Chennevière and others; the prominent Pierre Monteux conducted. The

critic Pitts Sanborn, writing for a New York newspaper, noted that poems were read aloud before each interpretive dance. "I won't pretend to psycho-analyze the 'festival' or to explain the cryptic meaning of the strange figures shown as transparencies in the background before each dance," he wrote. He nevertheless found that Saint-Point had "great skill in folding and unfolding her body, and that, together with the beauty of the light effects, the richness and originality of the costumes (especially the glistening armor-casing of war), and the music, stirred the audience to genuine enthusiasm."[86] No doubt it was a singular, if cryptic, experience.

Saint-Point began her futurist pursuits by asserting women's place in an art movement that oppressed women. In doing so, however, she never changed the terms of the oppression. Whereas she scorned the suffragettes and feminist demands for women's rights, her friend Marinetti supported the suffragettes, though in an underhanded way.[87] He reasoned that feminine hysteria and illogic would only help to undermine the parliamentary system. He also opposed Saint-Point's articulation of feminine lust as a dangerous, potentially emasculating phenomenon.[88] Yet over and again we find femininity, not masculinity, under attack in Saint-Point's work. The photographs from late 1913 or early 1914 included in figure 1 display several poses from *La Métachorie*: "The Youth of Botticelli," "Alias, the Purple Muse," "Alias, the Young God," "Alias, the Daughter of the Sun." A cult of youth prevails in the titles, one which would later become prominent in full-blown fascist propaganda. The caption in the *Sketch Supplement* reads:

At last futurist dances—given by the well-known Mme. Valentine de Saint-Point, whom d'Annunzio has called "The Daughter of the Sun," whom Rodin has compared with "The Youth of Botticelli," and whom others have called "The Purple Muse" and "The Young God." Amongst other things, it is her idea to veil, for her dances, all parts of the body save those which are essentially muscular. This, she believes, hardens the lines and reveals them as they should be.[89]

Saint-Point even theorizes the kind of muscular hardness of the body that is central to the imagination of Theweleit's Freikorps officers. Theweleit traces a complex imagery of towers, missiles, icicles, and rocky mountains in the language of the soldiers of this period in Germany. These hard, erectile structures are intended to defend the male against the boundless flood of messy bodily fluids associated with the proletarian and the feminine: they are the way "the man holds

himself together as an entity, a body with fixed boundaries."[90] Thus the masks and veils in Saint-Point's dances are not mere sartorial idiosyncrasies. They both conceal the dancer's individuality (a fact that fascism must banish) and facilitate the illusion of a female body with its softness, curves—in short, its femininity—armored and suppressed.

In Saint-Point's last novel, *Le Secret des inquiétudes* of 1924, the woman character is a sacred receptacle for the music composed by the main (male) character.[91] Her mystification of the female body resembles Marinetti's misogynist construction of the female body as a reproductive machine.[92] The novel's hero is a Nietzschean superhuman who alternates between states of unconsciousness and resurrections to feverish creativity. Unconscious phenomena are held up as the source of the hero's vitality. At the novel's close, he is shaken by a nightmare. He dreamed, he explains to his mother, "that the Other triumphed!"[93] His mother reassures him. The passage is extremely telling, even if one must attribute a later twentieth-century feminist meaning to the word *l'Autre*: the female character is the mother; the male character remains fixated on military conquests and the dream of the race. A militant nationalism and antimaterialism engulfs Saint-Point's writings and inscribes itself on Saint-Point's conceptions of woman.

Why is it that Saint-Point, from the position of the Other, remains Other; why does woman remain circumscribed by masculinity in Saint-Point's work? It is often the case that modernism concerns itself with an articulation of otherness. Yet its conception of otherness can remain embedded in myths, whether nationalist, militarist, or masculinist. Jacques-Alain Miller suggests, "Why does the Other remain Other? What is the cause for our hatred of him, for our hatred of him in his very being? It is hatred of the enjoyment in the Other."[94] In Miller's Lacanian analysis, "the root of racism is thus hatred of my own enjoyment," it is falsely attributing to the Other the theft of an enjoyment which we never really had.[95] There is no real feminine enjoyment, no female *jouissance* in Saint-Point's work. In *L'Orbe pâle*, the female character uses virility to hide her femininity, but does so only by positing an Other, an Arab she must kill on account of his gaze of pleasure and desire. In her performances of *La Métachorie*, a mask is worn and the body never revealed in order to suppress individual traits. In *La Guerre*, "a great collective crime" must be of service to the collectivity. There is a "we" running through Saint-Point's work, one which stands not for women, but for a collectivity hostile to the actual con-

cerns of women, one which is threatened by the Other's enjoyment—whether the enjoyment of the woman herself, absent from Saint-Point's text on lust, or whether the enjoyment in the gaze of the mythical Arab.

What should be made of the alliance between futurism and fascism? As it seems all too easy to condemn futurism, Claudia Salaris has argued that one should look more closely at futurism's playful aspect, in which its true revolutionary spirit lies.[96] Certainly there is a tremendous irreverence in Marinetti's manifestos, in Boccioni's paintings, in the group's spectacles. Yet the particular case of Saint-Point, I think, argues against Salaris's position. Because Saint-Point both participated in futurism and fashioned a critique of its stance on women, the work of Saint-Point is an ideal arena for the judgment of the movement's politics. Saint-Point's idiosyncratic flair and panache, and the controversy she generated with her manifesto on lust, do not by virtue of style change the meaning and content of the work, or its implications for women. Works of art *do* offer a view of the world, and the view of women we get from Saint-Point's futurism is one that privileges the concerns of the "race" over those of the individual female subject. That view has a context in the cultural politics of the early twentieth century, and it also has a later history under fascist regimes. To return to Theweleit's analysis: in fascism, the subject whose place is actually that of a cog in the machine identifies with the machine's exercise of power. Saint-Point's work is enamored with power and asks that its spectator identify with that power. Lust is a force, she writes, and a showing of force (lust) is a showing of power. To identify with that show of power is to create a situation in which what is desired is domination itself. Certainly the futurists wanted to shake things up, but what comes through in the end is not a revolutionary desire, but an identification with power which brings on repression.[97]

Saint-Point had already begun to detach herself from the official futurist movement in 1914.[98] Her New York performances followed a brief stint in the Red Cross and a trip to California. In the following years, she continued to travel extensively in Spain and Morocco, and converted to Islam. As her health declined, she decided to move permanently to the warm, dry climate of Cairo in 1924. She changed her name to Raouhya Nour el-Dine (zealot of religious light) and founded several Arab nationalist publications, including a review called *Le Phoenix*, "organe de la renaissance orientale."[99] The masks and veils

that were necessary in her performances no doubt made their way into her everyday life. If the veil remained an obligatory suppresser of individual traits, if it remained a necessary intermediary between Saint-Point and the world, the female body and its pleasures nevertheless remained absent.

I wish to thank Matthew Affron, Mark Antliff, Christopher Campbell, Matthew Fink, Stephen Grenholm, Lucy Locke, Christine Poggi, and Anne M. Wagner for advice and assistance; special thanks also to Patricia Rader and Rita Waldron at the Dance Collection of the New York Public Library. Some of the research for this essay was undertaken with a grant from Wayne State University, Detroit, Michigan.

1. See Lemoine-Luccione, *La Robe* (Paris: Seuil, 1983), 45–46: "Mettre une robe, se couvrir d'un vêtement, laisse la primauté de la communication au visage; avec lequel essentiellement l'être humain parle. / Alors le masque? Il refait du corps l'instrument de la communication. Certaines écoles de mime sont fondées sur ce renversement. Mais où le sujet gîte-t-il alors?" Barnes' 1917 interview with Saint-Point is reprinted in *Djuna Barnes: Interviews* (College Park, Md.: Sun & Moon Press, 1985), 230. The interview was conducted in English. For an analysis of Saint-Point's dance performances, see Leslie Satin, "Valentine de Saint-Point," *Dance Research Journal* 22, no. 1 (Spring 1990), 1–12; see also Günter Berghaus, "Dance and the Futurist Woman: The Work of Valentine de Saint-Point (1875–1953)," *Dance Research: The Journal of the Society for Dance Research* XI, no. 2 (Autumn 1993), 27–42. Unless otherwise indicated, all translations in this chapter are my own.

2. Dated Paris, 11 January 1913; translated by M. Barry Katz, "The Women of Futurism," *Women's Art Journal* 7, no. 2 (Fall 1986–Winter 1987), 13.

3. F. T. Marinetti, "Woman and Futurism," trans. André Tridon, p. 1. The translation appears in typescript in the Marinetti Archives, Beinecke Library, Yale University.

4. Barnes, *Djuna Barnes: Interviews*, 235.

5. Here, I have in mind Victoria De Grazia, *How Fascism Ruled Women: Italy, 1922–1945* (Berkeley: University of California Press, 1992); Philip V. Cannistraro and Brian R. Sullivan, *Il Duce's Other Woman* (New York: Morrow, 1993), and the theoretical work of Maria-Antonietta Macciocchi, "Les femmes et la traversée du fascisme," *Eléments pour une analyse du fascisme*, 2 vols. (Université de Paris VIII-Vincennes: Union générale d'édition, 1976), 1: 128–278.

6. Barbara Spackman, "The Fascist Rhetoric of Virility," *Stanford Italian Review* VIII, nos. 1–2 (1990), 81–101.

7. Ibid., 86–87. She addresses several "psychological studies," including those by Reich, Sartre, Theweleit, and John Hoberman.

8. Klaus Theweleit, *Women, Floods, Bodies, History*, vol. 1 of *Male Fantasies*, trans. S. Conway (Minneapolis: University of Minnesota Press, 1987), and *Male Bodies: Psychoanalyzing the White Terror*, vol. 2, trans. E. Carter and C. Turner (Minneapolis: University of Minnesota Press, 1989).

9. Theweleit, *Male Fantasies*, 1:xv.

10. Ibid., 2:197, quotes Jünger, *Feuer und Blut*.

11. Quoted in ibid., 2:197.

12. Ibid., 2:198. In this and other quotations, I have used bracketed ellipses to denote ellipses I have introduced into the text. Ellipses without brackets are found in the original text.

13. Ibid., 2:368.

14. Ibid., 2:369.

15. Maria-Antoinetta Macciocchi, "Sexualité féminine dans l'ideologie fasciste," trans. N. Famà, *Tel quel* 66 (Summer 1976), 27.

16. See Arthur Redding's analysis of Sorel in "The Dream Life of Political Violence: Georges Sorel, Emma Goldman, and the Modern Imagination," *Modernism/modernity* 2, no. 2 (1995), 4–7.

17. Although Ana Gabriela Macedo takes feminist issue with Saint-Point's "confusion" of lust and rape, she gives Saint-Point too much credit for being controversial in the area of sexuality without considering Saint-Point's politics on a larger scale. See Macedo's "Futurism/Vorticism: The Poetics of Language and the Politics of Women," *Women: A Cultural Review* 5, no. 3 (1994), 248–50.

18. Zeev Sternhell, with Mario Sznajder and Maia Asheri, *The Birth of Fascist Ideology: From Cultural Rebellion to Political Revolution*, trans. David Maisel (Princeton: Princeton University Press, 1994), 49.

19. Maurice Barrès' influential *Les Déracinés* was published in 1897. See Sternhell, *The Birth of Fascist Ideology*, 10.

20. Ibid., 9–10; see also Eugen Weber, "Nationalism, Socialism, and National-Socialism in France," *French Historical Studies* 2, no. 3 (Spring 1962), 273–307.

21. Weber, "Inheritance, Dilettantism, and the Politics of Maurice Barrès," *My France: Politics, Culture, Myth* (Cambridge: Harvard University Press, Belknap Press, 1991), 228–31.

22. Here, I have in mind the distinction made by Andrew Hewitt apropos of Marinetti's writings: "What is to be liberated in the Futurist text is energy itself, an energy that runs through the human body, that helps constitute the subject, but that nevertheless cannot be fixed upon that subject or be said to originate in it." See *Fascist Modernism: Aesthetics, Politics, and the Avant-Garde* (Stanford: Stanford University Press, 1994), 155.

23. Sternhell, *The Birth of Fascist Ideology*, 254.

24. Ibid., 11, 47–49.

25. Biographical information can be found in Abel Verdier, "Une étrange

arrière-petite nièce de Lamartine: Valentine de Saint-Point (1875–1953)," *Annales de l'Académie de Mâcon*, 3d ser., 50 (1970–71), 147–59, and *Bulletin de l'Association Guillaume Budé* 4, no. 4 (December 1972), 531–45. Shorter summaries include Claudia Salaris, *Storia del Futurismo* (Rome: Editori Riuniti, 1985), 53–56; and Giovanni Lista in Lea Vergine, *L'autre moitié de l'avant-garde, 1910–40* (Paris: Editions des femmes, 1982).

26. On Ricciotto Canudo (1877–1923), see P. A. Jannini et al., *Canudo* (Rome: Bulzoni, 1976); on the meeting with Saint-Point, 24.

27. Canudo, *Le Livre de l'évolution: l'homme. Psychologie musicale des civilisations* (Paris: Sansot, 1907), 244–45, as cited in Jannini et al., *Canudo*, 46.

28. André Billy, *L'Epoque contemporaine* (Paris: Tallandier, 1956), 125.

29. Jannini et al., *Canudo*, 25.

30. Valentine de Saint-Point, "Lamartine inconnu (Lettres inédites)," *La nouvelle revue* 32, no. 1 (1 January 1905), 3–11.

31. Canudo, "Episynthèse des musées," *La Rénovation esthétique* I, no. 2 (April 1906), reprinted (Geneva: Slatkine, 1971), 283–87.

32. Saint-Point, "La visite au musée de Madrid," *La Rénovation esthétique* II, no. 4 (January 1907), reprinted (Geneva: Slatkine, 1971), 152–54.

33. Jannini et al., *Canudo*, 28.

34. 27 May 1909, by the troupe "Les Essayeurs"; extract *La nouvelle revue* (1 June 1909).

35. *L'âme impériale, ou L'agonie de Messaline, tragédie en trois moments avec musique de scène, précédée du Discours sur la tragédie et le vers tragique* (Paris: Figuière, 1929). Saint-Point's play was clearly inspired by Alfred Jarry, *Messaline, roman de l'ancienne Rome*, which appeared in serial form in *La Revue blanche* from 1 July–15 September 1900, and which that house published as a book in 1901. See Keith Beaumont, *Alfred Jarry: A Critical and Biographical Study* (Leicester: Leicester University Press, 1984), esp. 227–43.

36. Saint-Point, *Messaline*, 161: "Je fatiguerai encore vos fils, vos frères, vos amants, vos époux! [. . .] Ma chair insatiable encore règne sur tous. . . ."

37. Ibid., 143.

38. The notion of the woman having value only as an object to be exchanged is explored in Luce Irigaray, "Women on the Market," *This Sex Which Is Not One*, trans. C. Porter with C. Burke (Ithaca: Cornell University Press, 1986), esp. 176–77.

39. Saint-Point, *Discours*, 49, 33.

40. On Sorel's debt to Le Bon, see Sternhell, *The Birth of Fascist Ideology*, 26, 65.

41. Saint-Point, *L'Orbe pâle* (Paris: Figuière, 1911), 11. Page numbers in the text refer to this edition.

42. Ibid., 47: "Peut-être, de loin, ont-ils distingué ma forme féminine, la forme si féminine qui cache ma virilité?"

43. Ibid., 51: "La même femme qui n'a toujours qu'un seul but. Par le rêve, l'action et la création, tromper l'attente."

44. Ibid., 77: "Il était beau, divinement. Il était si beau que j'ai rougi."

45. Ibid.: "parce que tous les mâles de tous les temps, de tous les pays et de toutes les religions, ont confondu et confondront toujours l'admiration avec le désir. . . . Je suis celle qu'on ne possède pas. . . . Au coeur, j'ai frappé le bel arabe. / Le bel arabe, je l'ai tué."

46. Ibid., 77–78: "Mais tout le jour et toute la nuit et toutes les nuits d'une orbe lunaire, j'ai veillé dignement son corps, car, couchée sur lui, j'ai jusqu'à la dernière goutte bu son sang, son sang rouge entre tous les rouges."

47. Alice Yaeger Kaplan, *Reproductions of Banality: Fascism, Literature and French Intellectual Life* (Minneapolis: University of Minnesota Press, 1986), esp. 21, 47–52.

48. I am thinking here of John Barrell's analysis of Thomas De Quincey's orientalism in *The Infection of Thomas De Quincey: A Psychopathology of Imperialism* (New Haven: Yale University Press, 1991), esp. his "Introduction: This/ That/the Other," 1–24.

49. Giovanni Lista, *Futurisme: Manifestes, Documents, Proclamations* (Lausanne: L'Age d'homme, 1973), 332.

50. For an overview of early twentieth-century feminist concerns in France, see Karen Offen, "Exploring the Sexual Politics of Republican Nationalism," *Nationhood and Nationalism in France: From Boulangism to the Great War, 1889–1918*, ed. Robert Tombs (New York: HarperCollins Academic, 1991), 195–209.

51. Lista, *Futurisme*, 331 (author's translation).

52. Macciocchi, "Sexualité féminine dans l'ideologie fasciste," 37.

53. Anne M. Wagner, "Rodin's Reputation," in *Eroticism and the Body Politic*, ed. Lynn Hunt (Baltimore: Johns Hopkins University Press, 1991), 234. Wagner refers to Saint-Point's reactionary feminism as well as to her writings on Rodin: 241 n. 41.

54. Saint-Point, "Futurist Manifesto of Lust," trans. M. Barry Katz, 13; Lista, *Futurisma*, 333: "*L'Art et la Guerre sont les grandes manifestations de la sensualité; la luxure est leur fleur.* . . . Après une bataille où des hommes sont morts, *il est normal que les victorieux, sélectionnés par la guerre, aillent, en pays conquis, jusqu'au viol pour recréer de la vie* [italics original]."

55. Marinetti, *Teoria e invenzione futurista*, ed. L. De Maria (Milan: Mondadori, 1968), cliv–clv. Includes complete program and dates, Berlin to Bologna.

56. Letter, Marinetti to Pratella, Milan, 10 January 1913, *Lettere Ruggenti a F. Balilla Pratella* (Milan: Quaderni dell'Osservatore, 1969), 41.

57. Letter, Marinetti to Aldo Palazzeschi, January 1913, *Marinetti-Palazzeschi Carteggio*, intro. P. Prestigiacomo (Milan: Mondadori, 1978), 75.

58. The collage, "Lettre d'une jolie femme à un monsieur passéiste,"

exists in many versions, 1914–19. See Anne Coffin Hanson, ed., *The Futurist Imagination* exh. cat. (New Haven: Yale University Art Gallery, 1983), cat. 85. Although Marinetti maintains a binary opposition between the dynamic, prowar futurist and the bourgeois, sentimental *passéiste*, the roles do not always divide predictably along gendered lines. He does, for instance, conceive of a female reader or viewer "as a futurist comrade," as Christine Poggi reasons in her analysis of Marinetti's "In the Evening, Lying on Her Bed, She Reread the Letter from Her Artilleryman at the Front," 1917. See Poggi's *In Defiance of Painting: Cubism, Futurism, and the Invention of Collage* (New Haven: Yale University Press, 1992), 234. What is constant, then, is the binary opposition and its constraints.

59. Jannini et al., *Canudo*, 30. Analyses and indexes of every issue of this short-lived but fascinating periodical can be found in Anna Paola Mossetto Campra, *"Montjoie!" ou la ronde des formes et des rythmes*, pref. M. Décaudin (Fasano, Italy: Grafischena, 1979).

60. Lista, *Marinetti et le futurisme* (Lausanne: l'Age d'homme, 1977), reproduces the program, 210.

61. Jannini et al., *Canudo*, 33. She was in Paris at some point in 1916 before her New York trip. Letter from Saint-Point in Paris to Alfred Stieglitz, undated, Marinetti Archives, Beinecke Library.

62. Saint-Point, "Les Livres," *Montjoie!* I, no. 5 (14 April 1913): 7: "Si nous limitons la sensualité à un besoin qu'il faut immédiatement satisfaire (ce à quoi répond la maison close), la sensualité, la luxure cessent d'être une force, ne sont plus qu'une faiblesse. Quelle énergie nouvelle ou ressuscitée par l'exaltation ou le rare souvenir a jamais connu l'homme sortant du bordel?"

63. Alexandre Mercereau, *Paroles devant la vie*, 3d ed. (Paris: Figuière, 1913), 119–20: "Ah! porte ton flanc, Femme! [. . .] porte-le comme un reliquaire, comme le trône souverain du ciel [. . .] c'est nous qui t'avons confié notre charge la plus sacrée, la mission divine de notre existence, et par là t'avons purifiée. / Tes péchés se sont effacés si jamais tu en commis [. . .] / En revanche, tu ne t'appartiens plus. [. . .]"

64. Theweleit, *Male Fantasies*, 1:414.

65. Jacques Reboul, *Notes sur la morale d'une "annonciatrice,"* (Paris: Figuière, 1912). The work focuses on Saint-Point's *Un Inceste* (Paris: Messein, 1907).

66. Ibid., 43. Reboul here refers to his larger commitment to Celtic nationalism, which can be seen in *L'Impérialisme français: Sous le chêne celtique*, 3d ed. (Paris: E. Sansot, 1913). For a penetrating analysis of the relationship between cubism (à la Gleizes and Metzinger) and the Celtic nationalist movement, see Mark Antliff, "Cubism, Celtism, and the Body Politic," *Art Bulletin* 74, no. 4 (December 1992): 655–68, and *Inventing Bergson: Cultural Politics and the Parisian Avant-Garde* (Princeton: Princeton University Press, 1993), 106–34.

67. Reboul, *Notes sur la morale*, 44.

68. Reboul, "Sur le Haut de Beffroi: 'Les Mufles,'" *Montjoie!* I, no. 3 (14

March 1913), 3: "En littérature et en art, où plus que partout le cabotinage abonde aujourd'hui, c'est devenue aussi un genre d'insinuer que lorsqu'une femme ne s'en tient pas aux travaux du ménage, c'est une «créature». [. . .] Pensez donc! Une femme qui fait une oeuvre, une femme qui se montre. . . Ces espèces-là s'affichent, ma bonne!. . . Et la Morale? / Combien de fois n'avons-nous pas entendu de ces réflexions malveillantes, même lorsqu'il s'agissait d'une poétesse digne entre toutes par le caractère et appartenant au meilleur sang de France!"

69. See Cannistraro and Sullivan, *Il Duce's Other Woman*, 101.

70. Reboul, "Sur le Haut de Beffroit," 3: "Le Culte de la Femme fût l'honneur de nos antiques cités celtes et la législation patriarcale romaine n'a jamais étouffé cette religion. La chevalerie en est une preuve. Ce culte, nous l'avons imposé à l'Europe avec nos cathédrales. La jeunesse française, qui a renoué le fil de l'effort séculaire, entend garder son âme entière. Elle le montrera en honorant la Femme, gardienne de l'Idéale et du repos des héros, comme en forgeant avec sérénité, le dur gloire du triomphe prochain."

71. Compare this text by Reboul to the Drumont text concerning the death of Marie Blondeau analyzed by Eugen Weber ("Nationalism, Socialism and National Socialism in France"). Reboul's enthronement of the aristocratic Saint-Point looks downright quaint next to the rabid text by Drumont, but Weber's analysis remains applicable: "Social indignation here, like anti-Semitism, becomes a question of *noblesse oblige*, and thus acceptable to men who might otherwise reject it."

72. Barnes, *Djuna Barnes: Interviews*, 226–27. Berghaus, "Dance and the Futurist Woman," discusses *La Métachorie* and includes his own reconstructions, using modern dancers, of some of Saint-Point's gestures and poses.

73. Saint-Point, "La Métachorie," originally published in *Le Miroir*, n.s., 7 (11 January 1914); reprinted in Lista, *Futurisme*, 256.

74. These photographs were published in the *Sketch Supplement*, 7 January 1914. The short article can be found in a clipping file of the New York Public Library's Dance Collection at Lincoln Center. Several of the photographs are reproduced, and all are discussed, in Satin, "Valentine de Saint-Point"; Berghaus, "Dance and the Futurist Woman," includes additional photographs.

75. Georges Casella, "Au théâtre Léon-Poirier: La Métachorie et Mme Valentine de Saint-Point," *Comoedia* (21 December 1913), 3. "La Métachorie qui nous dévoile de tels charmes n'est pas un art sans mérites."

76. See Georges Delaine, "Les Lettres et les arts," *L'Homme libre* (3 May 1914), 3.

77. See letters, Marinetti to Pratella, February and March 1913, *Lettere a Pratella*, 41–42.

78. Saint-Point, "La Guerre: Poème héroïque," 2d ed. (Paris: Figuière, 1912), 23–24: "Pour éviter les crimes individuels / Servant l'individu, / il faut con-

sentir un grand crime collectif [sic] / Servant la collectivité; / Pour éviter les lâches, fomentons les héros."

79. Ibid., 30–31.

80. Theweleit, *Male Fantasies*, 1:233–44.

81. Saint-Point, "La Guerre," 29: "Pour que les femmes désormais stériles / Refassent des enfants, il faut qu'on leur en tue."

82. R. W. Flint, *Marinetti: Selected Writings* (New York: Farrar, Straus, Giroux, 1972), 78.

83. Hewitt, *Fascist Modernism*, 108, 150–53. The words in quotation marks are from Marinetti, "War, the World's Only Hygiene," 1911–15; see Flint, *Marinetti*, 72.

84. Walter Benjamin, "The Work of Art in the Age of Mechanical Reproduction," *Illuminations*, trans. Harry Zohn (New York: Schocken Books, 1969), 239.

85. *New York Times* (4 April 1917), and *Poèmes, drames idéistes du premier festival de la Métachorie, offert gracieusement par l'auteur au public de New York sur la scène du Metropolitan Opera House, le 3 avril 1917*, New York Public Library.

86. "Valentine de Saint-Point in her Metachorie," *Commercial Advertiser* (4 April 1917).

87. Flint, *Marinetti*, 73–74.

88. See his manifesto "Contre le Luxe Féminin" of 1920, in Lista, *Futurism*, 335–36, and the analysis by Spackman, "The Fascist Rhetoric of Virility," 92–95.

89. "Is the Sun Proud of His Daughter? Futurist Dancing," *Sketch Supplement* (7 January 1914), 5–7.

90. Theweleit, *Male Fantasies*, 1:244. Theweleit discusses such imagery throughout volume 1; see esp. 244–49; 402–5. Compare these texts with Marinetti's famous "Tours canons virilité volées érection télémètre extase," quoted in Michel Delon, "Futurisme et feminisme," *Europe* 53, no. 551 (March 1975), 124.

91. Saint-Point, *Le Secret des inquiétudes* (Paris: Messein), 227. She says this to him on their parting.

92. Hewitt, *Fascist Modernism*, 151.

93. Saint-Point, *Le Secret*, 239: "que l'Autre avait triomphé!"

94. From Jacques-Alain Miller's 1985 lecture "Extimité," as recounted in Slavoj Žižek, *Tarrying with the Negative: Kant, Hegel and the Critique of Ideology* (Durham: Duke University Press, 1993), 203.

95. See Žižek's analysis of the lecture, 202–4.

96. Claudia Salaris, "En finir avec le futurisme?" *Rome 1920–1945: Le modèle fasciste, son Duce, sa mythologie*, ed. F. Liffran (Paris: Éditions Autrement, 1991), 156–62.

97. See Gilles Deleuze and Félix Guattari, *Anti-Oedipus: Capitalism and Schizophrenia*, trans. R. Hurley, et al. (Minneapolis: University of Minnesota Press, 1983), 113–22.

98. Salaris, "En finir avec le futurism?" 56.

99. Verdier, "Une étrange arrière-petite nièce de Lamartine," 153–54. On her ancestor Lamartine's affinity with the culture, see Moënis Taha-Hussein, *Le Romantisme français et l'Islam* (Beirut: Dar al-Maaref, 1962), 106–90. Interestingly, Marinetti was born in Egypt, and remained a student there until he moved to Paris at age seventeen. See James Joll, *Three Intellectuals in Politics* (New York: Pantheon Books, 1960), 135.

Mario Sironi's *Urban Landscapes:*
The Futurist/Fascist Nexus

Emily Braun

Mario Sironi, a painter, sculptor, architect, and political cartoonist, is both the exceptional and the exemplary artistic figure of Italian fascism. A committed fascist, Sironi realized his generation's goal of cultural intervention in politics, while maintaining a commitment to aesthetic modernism as a means of ideological persuasion. This essay argues for Sironi's key position as the link between the prewar and postwar avant-garde, between futurist activism and fascist revolution in the years 1919–22. I situate Sironi in a generational context, detailing his dissatisfaction with both Marxism and liberalism and his sympathies for radical left (futurism and syndicalism) and nationalist ideologies. My research departs from the now-established premise that Italian fascism was a legitimate, highly original mass politics, with its roots in the late nineteenth century, and in a radical revision of Marxism.[1]

In particular, I am indebted to recent studies that have elaborated on the burgeoning of fascist ideologies in the years preceeding World War I. The most extreme view has been taken by Zeev Sternhell, who privileges the role of France, and specifically the theories of Georges Sorel, in the gestation of European fascism. Disillusioned with Marxist materialism and the ineffectiveness of the proletariat, Sorel shifted the agent of revolution from class conflict to the regeneration of the nation. One of his key contributions to the new mass politics was the concept of myth as a "system of images," used by the elite to motivate action and determine history. In Sternhell's view, the subsequent ascendancy of totalitarianism did not depend on the crisis of the Great War, but was an inexorable fulfillment of Sorelian ideas, of the transformation of nineteenth-century realpolitik into cultural praxis and mass psychology.[2]

While Sorel's influence on Italian revolutionary syndicalists, the futurists, and the Florentine circle of *La Voce* is indisputable, Stern-

hell's thesis falls short when applied to the national and historical particulars that led to Mussolini's rise to power. It was in Italy, not France, that the cult of nation as a means of circumventing class conflict led to the actual practice of authoritarian politics. The work of the historian Emilio Gentile provides a needed corrective to Sternhell's totalizing approach. Gentile had previously emphasized the prewar origins of fascist ideologies, but unlike Sternhell, he has reasserted the importance of the Great War as a catalyst for the political upheaval of 1919–22. My interpretation of Sironi's life and art draws heavily on Gentile's argument for the direct link between the experience of trench warfare and the myths that informed the founding *fasci*.[3]

Gentile, as well as Walter Adamson, has furthered the view that Italian fascism presented itself as a "secular religion" that bound the masses to the state through traditional forms of collective rites and worship.[4] Here, too, it was the prewar avant-garde of futurism and *La Voce* whose "modernist nationalism," in the terms of Gentile, provided the theoretical basis for the new politics as well as the foundation for official fascist culture. By pinpointing the origins of fascist ideology in the years before World War I, and within the cultural (as opposed to the political) realm, we may now speak of a fascist modernism: one that disavowed the modernity of Enlightenment reason for another modernity of activism, instinct, and irrationalism. This approach also establishes a prestigious pedigree for both elitist attitudes toward the masses and the cult of violence in the avant-garde, whose own countercultural position is usually associated with progressive liberal politics.

The cultural histories on which this essay depends, however, are limited by the theoretical discourses of their own field. Writing on the visual arts, I am thoroughly aware of another debate beyond the purview of the history of fascism proper: that surrounding the definitions of avant-garde and of modernism. For in the historical texts cited above, the avant-garde is synonymous with modernization and cultural renewal, and the coercive nationalization of the masses by the elite is seen as an essentially modernist project. In Italy, at least, radical politics and political activism, not radical aesthetics, constitute the avant-garde. For with the *La Voce* circle, in particular, the project of cultural renewal readily availed itself of tradition.

The difference between avant-garde and modernism has been a point of contention in the visual arts since the publication of Peter

Bürger's *Theory of the Avant-Garde*.[5] Bürger effectively dismantled the formalist-modernist paradigm made orthodox by Clement Greenberg and Theodor Adorno in Anglo-American cultural studies. Here avant-garde was equated with transgression on the level of stylistic hermeticism. Pure form became the content, as high art had to withdraw from the contaminating effects of mass culture to salvage its own autonomy. Bürger shows that the historical avant-garde did not aim at separating art from life but wanted to restore its social and political function. For Bürger, the essence of avant-garde ideology is a constant critique of the notion of the autonomy of art. Hence, the stylistic innovation and linguistic defamiliarization associated with modernism are not ends in themselves, but means of attacking the institution and commodification of art in bourgeois society. Moreover, popular culture, instead of being the enemy of the avant-garde posited by Greenberg, becomes, in Bürger's line of reasoning, its chief ally.

More than any other historical movement, futurism fulfills the criteria of direct political activism, the desacralization of the art object, and the boundless reach of aesthetic experience, yet it is noticeably absent from Bürger's discussion. One can only assume that the taint of authoritarian politics, by contrast to the left-wing affiliations of dada and surrealism, which Bürger favors, account for this exclusion. Futurism thus finds itself in the peculiar position of being central to studies of Italian fascist culture and ignored in histories of the European artistic avant-garde. Indeed, Bürger states that the avant-garde cannot operate under fascist politics "that liquidate the autonomous status" of art. He implies what Renato Poggioli explicitly argues in his earlier book on the avant-garde, namely, that it depends on the liberal values of the bourgeois society it chooses to attack. The avant-garde can exist only in a society that tolerates artistic autonomy and a margin of dissent.[6]

Yet if taken to its logical conclusion, was not the avant-garde ideal of merging art and life realized in totalitarianism, in the aestheticization of politics and daily existence? As Boris Groys argues in his book on the Russian avant-garde, "reality itself became the material for artistic construction," as absolute artistic control became synonymous with total political control.[7] Is the avant-garde project realized in the aestheticization of politics or the politicization of aesthetics? A study of the Italian situation is critical in moving toward an answer: here artists dedicated their art to politics in rebellion against art for

art's sake, but the fascist state left the bourgeois values of artistic autonomy firmly in place. Unlike the Nazi or Stalinist regimes, fascism allowed the avant-garde and modernist styles a place in the artistic life of the nation—a story of survival that is at once most troubling and most telling.

Though the severing of modernism from the avant-garde has been useful indeed, we are still far from defining the latter. Perhaps the avant-garde eludes any theoretical closure, since, like fascism, it spouted antibourgeois rhetoric while acting in elitist and contradictory ways toward the masses and mass culture. Hence we should speak of many avant-gardes, according to the specifics of nation, history, class structure, and respective "institutions" of art. Moreover, we need to examine the transformation of prewar theories of politicized culture that have been discussed by Sternhell, Gentile, and Adamson, into the actual practice of totalitarianism. We need to account for the relationship—at times a dialogue, at times a mutual refutation— between the avant-garde and aesthetic modernism during the *ventennio*, as fascism itself changed from a revolutionary movement to a reactionary regime. The essay that follows addresses both the means and agenda of the futurist avant-garde, before the fascist rise to power, at the precise moment of transition between the theory and practice of the new politics.

In the years immediately following World War I, Mario Sironi concentrated on the *paesaggio urbano*, or urban landscape, rendering the Milanese periphery in scores of rapid sketches, detailed drawings, and some two dozen paintings (figs. 2–8).[8] The habitat of the industrial worker is characterized by a random sprawl of densely accumulated structures punctuated by monotonous rows of fenestration. Using a limited vocabulary of stalwart, cubic forms, aggressively modeled with swaths of somber chiaroscuro, Sironi endows the factory sheds and public housing with a monumental bearing. The empty, silent streets are disturbed only rarely, by the presence of a lone truck, tram, or mannequin-like figure. Sironi's city spaces are at once alienating and authoritative, or as one critic put it when the paintings were first exhibited in 1920, they give rise to a mood both "energetic and grave."[9] The visual tension inherent in the urban landscapes derives from the apparent convergence of two diverse idioms: futurism and metaphysical painting. Sironi focuses on the

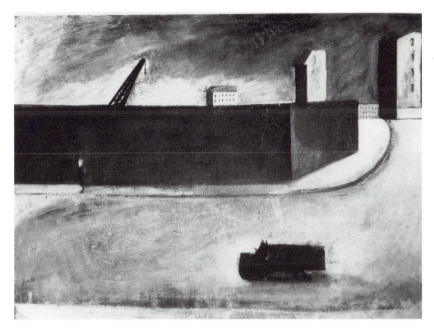

2. Mario Sironi, *Urban Landscape*, 1920, Pinacoteca di Brera, Milan

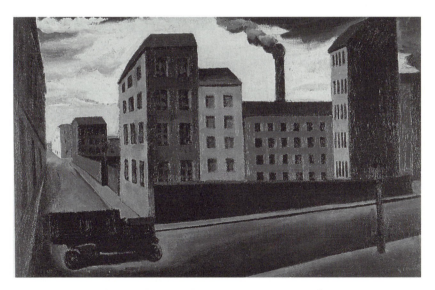

3. Mario Sironi, *Urban Landscape with a Truck*, 1920, Private collection

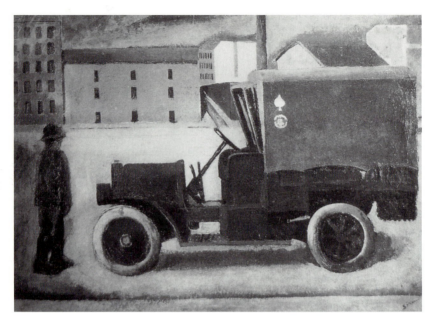

4. Mario Sironi, *The Truck*, 1920, Private collection

aggression and grandeur of the modern city, the central futurist sub-
ject of the prewar years, but the vitality of the industrial terrain has
been arrested by the unsettling silence and immobility of de
Chirico's city squares. Railway yards and smokestacks—beacons of
futurist worship of the new that signaled the destruction of the past
in the name of progress—are here grounded in permanence and
represented as historical types. A brooding wasteland has replaced
the vibrant metropolis, yet the workers' desolate quarter is elevated
to epic proportions through the visual terms of the grand Italian
tradition.

Sironi painted the urban landscapes at the beginning of his
career and went on to become, as a dedicated fascist, one of the most
patronized artists of Mussolini's regime. They have remained his most
critically favored works, largely because the balance of interpreters find
them an genuine indictment of working-class conditions.[10] The grimy
streets and desolate vistas would seem incompatible with the hygienic
modernism of fascism, not to mention Sironi's own rhetorical alle-
gories of fascist Truth and Justice in his public murals a decade later.

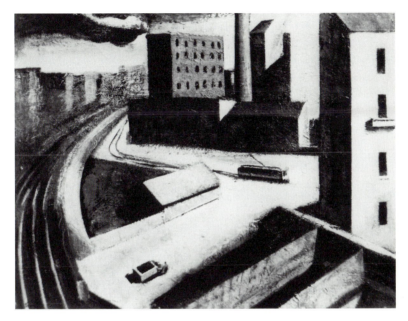

5. Mario Sironi, *Urban Landscape*, 1920, Private collection

Yet the content of the urban landscapes is not so much a contradiction of the later policies of the regime as it is a confirmation of the composite ideology of the early fascist movement in the years immediately following the war.

The social commentary contained within the urban landscapes corresponds to the left-wing elements of fascism in its early manifestations, in which the futurists, Sironi among them, were key participants. They bear specific references to a period of labor unrest when the possibility of proletariat revolution seemed imminent: Sironi began his series of the industrial periphery in 1919–20, during the so-called Red Biennium, which culminated in the widespread occupation of the northern Italian factories by organized workers. His exactly contemporary political illustrations for the trade journal *Le industrie italiane illustrate—Rassegna della produzione industriale (I.I.I.)* make explicit his position on current social crises.[11] Both the urban landscapes and their journalistic counterparts identify the workers' quarter as the site of the strikes and violent demonstrations that futurists—along with other radical groups, including the interventionists and revolutionary

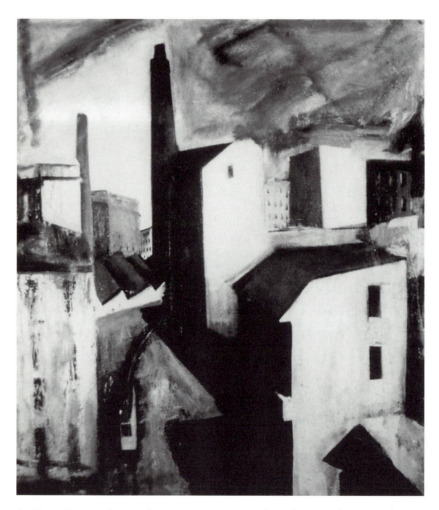

6. Mario Sironi, *Urban Landscape*, 1921, Civica Galeria d'Arte Moderna, Boschi
Collection, Milan

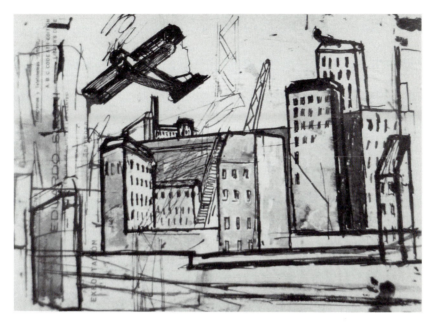

7. Mario Sironi, *Urban Landscape*, 1919–20, Private collection

syndicalists—believed would lead to the overthrow of the existing bourgeois order.

The urban landscapes must be understood in the context of futurist art and politics, for they represent both a reaction to, and extension of, avant-garde principles. On the one hand, they reject the style of "plastic dynamism" in favor of "plastic values," which evoked the classical tradition and early Renaissance art. On the other, they are a direct continuation of futurism's antisocialist, antibourgeois political position and its hope to foment revolution in the wake of war. Although the urban landscapes have no specific didactic content, their ideological resonance lies in their ambivalence toward technological progress, with its potential for alienation, and toward its political corollary, the new society of the masses.

Sironi's affiliation with the futurist movement was based on ideological rather than stylistic affinities. Though he had briefly experimented with analytic cubism, following the example of his close friend and mentor Umberto Boccioni, Sironi was predisposed to figurative and solidly modeled forms. His futurist calling was based, instead, on a

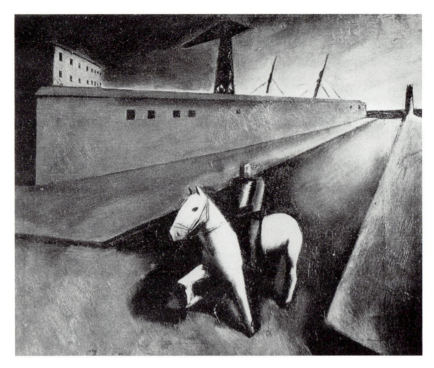

8. Mario Sironi, *The White Horse: The Pier*, 1920, Private collection, Rome. Courtesy Claudia Gian Ferrari, Milan

thorough contempt for materialist, bourgeois culture; on solidarity with the working class; on the cult of the irrational; and on a desire for war. Like his peers, Sironi was convinced that only a profound cultural and moral revolution—necessarily achieved through violent and heroic means—could transform Italian society. At the invitation of Marinetti, he officially joined the core futurist group in 1915, signing the wartime manifesto *L'Orgoglio Italiano* (Italian pride). The bellicose text typified the radical nationalism of the avant-garde, condemning the "internal" socialist enemy for its neutralist stance, and exalting the superior, creative genius of the Italian people.[12]

Sironi and the futurists volunteered for the Lombard Battalion of Cyclists and Drivers, through which they saw action at the Alpine front and several lost their lives; Sironi continued active duty until the armistice and experienced the humiliating defeat at Caporetto. Dur-

ing the war Sironi also drew biting political cartoons for the journal *Gli Avvenimenti* (to which several futurists contributed), establishing a name for himself as an artist. He exhibited with the futurists for the last time in 1922, before breaking ranks to join Margherita Sarfatti's rival *Novecento* group. Yet long after he and Marinetti parted ways, the latter continued to favor Sironi's urban landscapes (and his "futurist" political illustrations).[13]

Social activism had been an essential credo of the Italian avant-garde since its origins, but it was only as interventionists haranguing for war, pamphleteering and burning Austrian flags in the *piazze*, that the futurists came into their own political style.[14] War represented the long awaited catalyst for total rupture, the opportunity for Italy to redeem herself in the international arena, and the trial by machine-gun fire that would produce the steely, heroic, new man. In their interventionist stance, the futurists joined heretical socialists (Mussolini foremost among them), revolutionary syndicalists, and nationalists, all of whom, despite individual differences, were ideologically invested in Sorel's myth of the revolutionary war. Indeed, as the historian Emilio Gentile has remarked, the futurists were the "most radical and coherent in viewing the war as the possibility for social transformation," and "the first to transform the myth of war into the myth of *combattimentismo*."[15]

In September 1918, Marinetti opportunely announced the founding of the Futurist Political Party with the publication of a manifesto in the new propaganda journal, *Roma Futurista*.[16] The program was largely left-wing in practical reforms, and typically strident in its cultural nationalism.[17] Consistent with earlier futurist proclamations, there would be no room for a parasitic bureaucracy, the monarchy or the reviled clergy. It called for the improvement of the workers' lot through educational reform, the right to organize and strike, the institution of the eight-hour workday, minimum wage, equality of pay between men and women, universal (including women's) suffrage, social welfare, and pensions. On the method of government, the futurists borrowed from the revolutionary syndicalists, conceiving of a new form of parliament with representatives from the various sectors of the economy.[18] Similarly, the futurists were antibourgeoisie, but never anticapitalist, seeking to keep the forces of production intact, while eliminating class antagonisms through the unifying religion of nation.

The futurists were swift to organize supporters—the *fasci politici futuristi*—in some twenty cities around Italy, and allied themselves

with the unruly *arditi*, or "daring" assault troops, recently returned to civilian life. Together with Mussolini's revolutionary interventionists, they formed the *Fasci di combattimento*, taking an oath at the piazza San Sepulchro in Milan on 23 March 1919.[19] These radical factions shared a disdain for the materialist bent of reformist socialism, as well as pretense to leadership of the masses. They conceived of a new ruling class—a guiding light of Italian rejuvenation—that had nothing to do with traditional class divisions based on economic privilege and everything to do with the preeminence of intellectual ability. As Mussolini proclaimed in his speech at San Sepolcro: "We recognize only the dictatorship of the will and intelligence."[20] The "intellectual proletariat" or that element of a disenfranchised *bohème*, comprises an important ideological component of early fascism. In that same year, Gabriele D'Annunzio occupied Fiume, adding to the energy of the postwar crises, and confirming the futurist ideal of the poet-hero as charismatic leader.

In the prewar years the interventionist spirit inspired Balla's images of unfurling flags and the sensory assaults of Carra's *guerrapittura* collages. But Sironi alone, among all the futurist artists, created a body of painting—the urban landscapes—that responded to the tense postwar years and the tumultuous agenda of the *Fasci di combattimento*. Sironi's images take to the streets in a new kind of political battle wrought by the advent of the masses. The repetition of carefully chosen motifs acknowledges the plight of the working class, the occupation of the factories, and the activities of the fascist squads. And the pictorial devices of oblique perspectives, aggressive cubic massing, and looming shadows establish a narrative frozen in expectation. Though not a literal explication of a political program, the urban landscapes evoke that *stato d'animo* of a generation of intellectuals returning from the trenches who viewed war and strikes as catalysts for revolutionary insurgence.

After the armistice, Sironi made his way back to Milan, via Rome, by the end of July 1919. As *spostato*, like other veterans of the trenches, he found housing in a modest pension on via Pisacane outside central Milan, and survived on the meager earnings from his illustrations. Although none of the urban landscapes is dated, the series of paintings was begun between late summer 1919, when Sironi arrived in the Lombard capital, and April 1920, when they were first exhibited. This period corresponds with the futurists' most intense involve-

ment in politics and the unprecedented organization of urban factory workers. In a diary entry from October 1919, Marinetti records Sironi's presence at the meeting of the local *fascio*.[21] That same month, during his address at the Fascist Congress in Florence, Marinetti included Sironi, along with other futurist artists and writers, as part of the *proletariato dei geniali*, destined to lead the new Italy.[22]

Sironi's urban landscapes depict a specific area spanning southwest Milan: the pielike wedge between the Porta Vittoria and the Porta Romana, extending from two major arterial avenues beyond the old city walls, and the adjacent Ripamonti quarter. Historic Milan had a distinctive concentric plan, with its center formed by the circle of an interior canal system, and later extended to a second ring defined by the Spanish walls. Until the mid-nineteenth century the center was an organic fabric of residences and shops of craftsmen and small manufacturers, and the working population was integrated inside the city walls. With the onslaught of a late and rapid industrialization in the 1880s, factories rose in the open countryside, and long boulevards connected the peripheral district to the city hub.[23]

Around the same time that industrial growth began to enlarge the concentric plan of the city, the Comune di Milano adopted the Beruto Plan and began to restructure the urban core, including the area around the Duomo and the building of Giuseppe Mengoni's Galleria Vittorio Emanuele (completed in 1878). The razing of old housing quarters within the historical center and unprecedented property speculation continued to push the lower classes outside the city walls.[24] In addition, labor demand was increasing the population; unparalleled numbers of rural immigrants settled in the burgeoning outskirts of Milan. In 1911 some 234,000 lived in the center and 372,000 outside the Spanish walls; by 1921 the figures were 255,000 and 463,000 respectively.[25] The beauty of the historic center, now almost exclusively inhabited by the bourgeoisie and upper classes, provided a stark contrast with the bleak and homogeneous periphery where the lower classes lived. The city's monocentric plan further emphasized the gulf between rich and poor.

The rapidly developed southwest quarter, with its distinctive sprawl of metallurgical factories and public housing was first captured by Boccioni in works such as *Workshops at the Porta Romana* of 1908 (fig. 9). Painted a decade before Sironi's images, they show industrial development encroaching on the open fields outside the Spanish

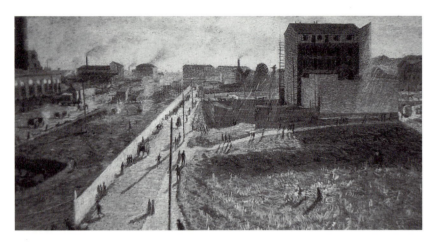

9. Umberto Boccioni, *Workshops at the Porta Romana*, 1908, Banca Commerciale
Italiana, Milan

walls. Tiny human figures are dwarfed by the power of a new city ris-
ing, and enveloped in the surging continuum of the divisionist style.
Like other early futurist paintings, such as Balla's *The Working Man's
Day* (1904, private collection), the shimmering accumulation of
brushstrokes served as a multiple metaphor of construction, of the
exhilarating pace of urban growth, and the role of artist as social engi-
neer.[26] In the postwar perspective of Sironi, however, scaffolding has
given way to suburban sprawl, and the vitalistic cityscape has petri-
fied into a desert of cement and asphalt. A leaden atmosphere settles
over the city, merging with the ochres and grays of the unadorned
stuccoed facades (figs. 3, 4, 6). Sironi renders a searing indictment
of the values of economic materialism, and his exclusive focus on the
underbelly of the futurist city draws attention to social polarization
and the potential for political unrest.

In the urban landscapes, the segregation of the lower class out-
side the historic city walls is made apparent by the repeated image of
the tram, whose ominous profile cuts across the canvases, confronting
and traversing the bleak terrain (figs. 5, 6). The ever-expanding net-
work of electric tramlines, whose passengers more than doubled
between 1900 and 1915, defined the radial plan of Milan and marked
the growth of the anonymous outskirts.[27] In Sironi's images it is an
index of urban expansion and marginalization of the city poor, the

linking and division between center and periphery, the bourgeois and the worker.

The gritty realism of the urban landscapes casts a sympathetic eye on the plight of the worker, one consistent with the social altruism found in the 1918 political program of the Futurist Party. Sironi's architectural descriptions, in particular, draw attention to the inadequacy of public housing, which became one of the most prominent social issues affecting Milan in the first decades of the century.[28] Lack of zoning regulations led to high density and random construction, while the units themselves were cramped and unsanitary. To remedy the housing crises, the socialists introduced the *Istituto per la Casa Popolare*, to plan a number of government-financed housing units modeled after the English "garden cities." The politics of the *casa popolare* became a central symbol of reformist socialism on the municipal level, but ultimately failed to relieve the housing shortage or improve the quality of residential life in the periphery.[29]

Though more advanced design brought some improvement, the situation was aggravated immediately after the war with the crises of government, inflation, and increased population. The crane, omnipresent in Sironi's sketches is never working; it stands inactive as a symbol of both profligate construction and futile effort (figs. 2, 7). He accentuates the bleakness of the dwellings by painting their monotonous rows of black fenestration and by removing any extraneous, ornamental details, such as the tiny balconies that typically adorned alternating windows of the facade.

Sironi was well aware of issues of housing and quality of life endemic to the periphery. Several of his circle, including Margherita Sarfatti and the writer Ada Negri, were involved in the Società Umanitaria, which was founded in 1905 for the purpose of improving the environment of the worker.[30] Sironi himself lived and worked in the area of the Porta Vittoria and Porta Romana, where housing projects were first developed by the Comune di Milano.[31] In July 1921, after spending two years in the modest pension on via Pisacane, he moved to public housing (reserved for artists and veterans) on via Fratelli Bronzetti, a project which was actually featured in an article on popular housing in Mussolini's official newspaper, *Il Popolo d'Italia*. The Ufficio Tecnico del Istituto Case Popolari was located on the same street.[32] A veteran trying to resume normal life without secure employment and living on the outskirts, Sironi readily identified with the eco-

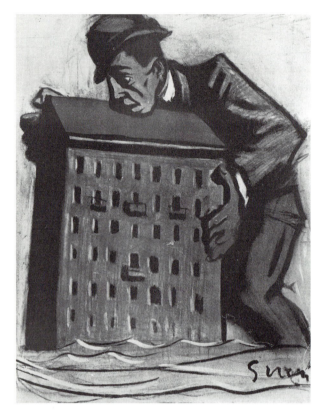

10. Mario Sironi, *The Italian Bureaucracy Has Finally Resolved the Housing Crisis,* reproduced in *Le Industrie italiane illustrate* (*I.I.I.*) IV, no. 9 (1st week of March 1920)

nomic marginalization of the lower classes. In his political caricatures for *I.I.I.*, such as *The Italian Bureaucracy Has Finally Resolved the Housing Crisis* and *State Production,* both of 1920, he specifically addressed the bungling and incompetence of the state that led to shortages and substandard housing (figs. 10, 11).

In many ways Sironi's visual commentaries for *I.I.I.* provide a code for a reading of the urban landscapes. Founded in 1917, the weekly tabloid paper addressed industrial policy and production in the war economy and after. The publisher, Umberto Notari, had also been responsible for the journal *Gli Avvenimenti* (1915–17) with its interventionist slant. Notari's Milanese salon was a principal draw for intel-

11. Mario Sironi, *State Production*, reproduced in *I.I.I.* IV, no. 7 (2nd week of July 1920)

lectuals of radical nationalist convictions, and he was a key political advisor to Marinetti.[33] Sironi contributed weekly illustrations between January 1920 and September 1921; their full-page format and the heading "*I consuntivi di Mario Sironi*" attest to his growing reputation as both a caricaturist and political commentator. Caustic captions on greed and inefficiency accompany brute renditions of speculators, bureaucrats, and government ministers. In many examples, his characteristic housing blocks and smokestacks form the backdrop for production slowdowns, strikes, and unemployment, confirming Sironi's vision of the periphery as the site for social disintegration and class warfare (figs. 12, 13).

12. Mario Sironi, *English Saturday*, reproduced in *I.I.I.*
IV, no. 3 (2nd week of March 1920)

The urban landscapes, however, are far less explicit; here issues of policy are replaced by a fatalistic vision of modern industrial civilization and the resulting polarization of the classes. The architectonic massing and sheer physicality of the paintings' surfaces impart an epic significance to the proletariat domain. Indeed, the style of monumental forms in miniature, with their tactile volumes and stark shadows, deliberately recalls the Quattrocento primitives, Tommaso Masaccio and Piero della Francesca. Sironi conceived the urban landscapes according to the dominant postwar aesthetic of "plastic values," or the innately Italian style of solidly modeled, cubic forms. The revival of a classicizing style had largely been prompted by the influence of Giorgio de Chirico's work in Italy after 1917.[34] Though de Chirico had

13. Mario Sironi, *Anti-Bourgeoisie,* reproduced in *I.I.I.* IV,
no. 3 (4th week of March 1920)

intended an ironic use of the past that only underscored the bank-
ruptcy of absolute values in the modern world, his disciples, primarily
Carlo Carrà, invested the new emphasis on architectonic form with a
nationalistic significance. In an imperialistic discourse that merged
futurist ideology with the primacy of the Italian artistic tradition, Carrà
asserted that Italians were the "race of great constructors" whose
indigenous sense of geometry was responsible for the whole of Western
European art.[35]

Hence, in the urban landscapes, Sironi empowers the represen-
tation of the workers' quarter and, by extension, their political role by
using a pictorial language of heroic dimensions: his reference to the
prestigious style of the fourteenth century acknowledges the dominant

status of the masses in the twentieth. Though the return to past styles contradicted the teleological drive of prewar futurism, nationalistic sentiment had always been rooted deep in futurist ideology. Marinetti glorified, above all, the inherent (and therefore traditional) "creative genius of the Italian people." In addition to universal suffrage, the eight-hour day, and the right to strike, "patriotic education of the pro-letariat" and "Italian pride" were among the top priorities of the futur-ist political program.

By depicting the contemporary wasteland in the prestigious lan-guage of the past, Sironi pursued a body of imagery for and about the worker that was at once popular and elitist—a paradoxical position masked by strident nationalism and antibourgeois sentiment. His embodiment of radical messages in a self-consciously traditional style necessitates a rethinking of the notion that the immediate postwar period was one of reaction. For the return to figuration in the context of these images is not a programmatic attempt at conservative restora-tion, but an ironic use of tradition to serve the ends of the new mass politics. In Marinetti's rhetoric, as in Sironi's images, the cause of the worker is now bound to that of the *patria*.

The urban landscapes provide a series of compelling images, a mobilizing idea that is the essence of political myth in Sorelian terms.[36] The inhumane, segregated environment of the urban land-scapes represents the site of the most potent political catalyst: the gen-eral strike. The futurists had earlier depicted mass uprisings, notably Carrà's *Funeral of the Anarchist Galli* (1911, Museum of Modern Art) and Luigi Russolo's *The Revolt* (1911, The Hague, Haags Gemeente-museum), which render the workers in the act of political violence, as a surging, vitalist force.[37] Instead of an anecdotal scene of collective uprising, however, Sironi captures a mood of continual tension and imminent revolt: his representation addresses the psychological func-tion, rather than the mere narrative, of myth. Here the unsettling strategies of de Chirico's metaphysical art served Sironi well, for the empty streets of the urban landscapes are similarly filled with a sense of suppressed action, or of something about to happen. Whereas de Chirico's sense of expectation, like his statue of the sleeping Ariadne, languished in an enigmatic, atemporal space, Sironi's broods in a dis-tinctly contemporary context.

In fact, Sironi conceived the urban landscapes during a period of labor activity that culminated in worker occupation of factories, which,

in turn, produced a backlash against the political left.[38] The economic crises were intensified at base by setbacks in the sector of heavy industry: production stagnated with the end of the war and workers reacted with strikes and slowdowns. Increased bread shortages, inflation, and unemployment added to the growing discontent of the general population. By the end of 1919 organized labor had increased fivefold from prewar numbers to almost four million members, and the Socialist Party scored unprecedented victory at the polls that November, emerging as the largest party in Italy.

In the following year, as the owners and management refused labor's demands, workers began to organize factory councils on the model of the Soviets. The labor agitation peaked in September 1920, when the militant metalworkers locked out management; other workers followed suit in factories all over northern Italy.[39] At this decisive moment, however, the left-wing coalition did not support the independent organization of the workers and failed to act on the opportunity to establish a socialist republic. The industrialists called on the government to use force, but Prime Minister Giolitti preferred to wait out the volatile situation. After three weeks he successfully negotiated a settlement, on the whole favorable to the metalworkers' union. As a result, both sides felt betrayed: the workers were demoralized, and industrialists and middle classes increasingly feared a Bolshevik revolution.

The urban landscapes of 1919–20 evince a pictorial tension that sets them apart from Sironi's subsequent images and captures the postwar climate of insurrection. The depopulated streets are filled with a violent edge that emanates from the airless atmosphere, the aggressively stark forms of the factories, and a peculiar iconography. The main motif of these pictures, as in many of the sketches, is a truck, black and menacing, that passes, like a sentinel, before silent factories or confronts a tram or personage (figs. 2–5). In its general appearance, the truck resembles the Fiat 18 BL model, which was manufactured for commerical and army use. Though such vehicles were everywhere in the city outskirts, the obsessive repetition of the truck in Sironi's sketches and its compelling role in the paintings argue that he invested it with a special significance.[40]

The 18 BL was the type of truck used by *squadristi*, who for the most part, borrowed them from the army and then decorated the vehicles with their own emblems. In one urban landscape, Sironi rendered a club and spade on the truck's canvas roof, and although these do not

correspond to any known military insignia, symbols of this type were used by local fascists (fig. 4).[41] The squads had supported the proletariat at the beginning of the occupation of the factories, but by the end of 1920, they began to attack workers as part of the reaction against unions, Socialists, and the perceived threat of a Bolshevik revolution.[42] Some twenty years later, in an illustration of 1943 entitled *March 23, 1919*, for the commemorative book *Viva il Duce*, Sironi employed the very same truck, now filled with fascist blackshirts in the course of a punitive expedition. Though it is difficult to assign them an exact identity, the trucks of the urban landscapes—be they army, factory, or fascist vehicles—serve as potent symbols of civil disorder.

For specific commentary on the crises that opened the way for the fascist ascent to power, one must look to Sironi's work for *I.I.I.* Reflecting on the events of the Red Biennium, Sironi's illustrations serve to clarify the relationship between futurist and fascist politics in the critical years 1919 and 1920. Rendered with heavy washes of black and red chiaroscuro over massive, squared forms, they approximate the brute and implacable presence of the urban landscapes. "Violent," "authoritarian," and "brutal" were commonly used by critics to describe the gestural force and stark tonal contrasts of Sironi's style.[43]

It is important to note that Sironi's caricatures always attack parliament and bureaucratic mismanagement for creating economic chaos and worker unrest; the private sector is never to blame. Moreover, anti-Bolshevik propaganda dominates the illustrations from October through the spring of 1921, corresponding to the period of reaction following the collapse of the workers' uprising. Though the futurists hoped for proletariat insurrection, they opposed the Marxist-Leninist model. On one level, Marinetti claimed that futurists and Bolsheviks shared a revolutionary spirit, proudly asserting that "the Russian Futurists are all Bolsheviks," and that "Futurist art, for a time, was the art of the Russian State."[44] But although he admitted Bolshevism may have been suited for the Slavic peoples, he viewed communism as a form of cultural barbarism inimicable to the individualistic Italian genius. For the Italian avant-garde, Marxist doctrine denied the inequalities inherent in man and threatened to level the human spirit to its lowest common denominator, reducing all that was colorful to a mass of gray.[45] Sironi takes the same position in his caricatures; he renders Lenin as a despot with the blood of

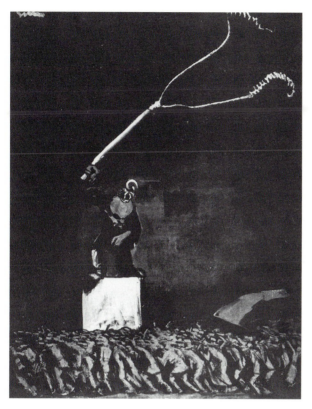

14. Mario Sironi, *Intensive Cultivation of the "Radishes,"* reproduced in *I.I.I.* V, no. 22 (4th week of July 1921)

thousands on his hands, and as a little emperor who leads the workers down into a realm of dark confusion (fig. 14). In other images, Sironi shows the Russian revolutionaries wreaking havoc on the industrial infrastructure—a terrible crime, for the futurists wanted to keep the machines of capitalism, if not its materialistic values, intact (fig. 15). Overall in Sironi's illustrations of the period, the workers appear as pawns in the struggle between two larger forces: governmental ineffi\-ciency and Bolshevik destructiveness.

Whereas Sironi's illustrations offer pointed commentary, the inherent political content of the painted urban landscapes is more elliptical. Certainly his harsh depiction of the periphery condemns the ill effects of speculation and exploitation, as well as the wasteland created

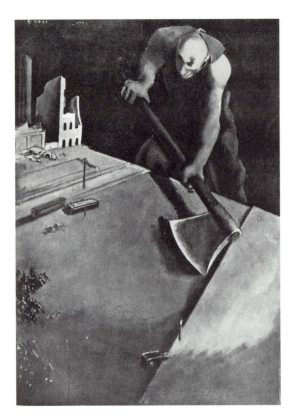

15. Mario Sironi, *The Builder of the Third International*,
reproduced in *I.I.I.* V, no. 22 (1st week of June 1921)

by industrial growth. His seemingly realistic documentation of urban blight can be compared to the left-wing Verist and the proletarian revolutionary factions of the *Neue Sachlichkeit* movement, which were born in a similarly radicalized postwar environment.[46] George Grosz distilled the spectral city of de Chirico even further, reducing it to a land of mass-produced, standardized structures, populated by automatons (fig. 16). While Grosz's work championed the worker by launching a blistering attack on the state bureaucracy and the middle classes, Otto Griebel, Conrad Felixmüller, and other artists of the German left dedicated themselves to faithfully rendering the material conditions and misery of the proletariat as a demonstration of their solidarity.

16. George Grosz, *Untitled*, 1920, Kunstsammlung Nordrhein-Westfalen, Düsseldorf

Though Sironi situates his art in the workers' neighborhood, workers themselves are notably absent from the urban landscapes. Sironi's paintings are far less literal than contemporary German images made during the November Revolution and after, which show actual laborers in didactic narratives and argue a specifically Marxist line. Instead, Sironi produces a more general mood of tension and alienation, provoked by his pessimistic view of the city's "other side" and the class struggle it signifies. Pessimism was a key ingredient of the radical nationalism of Sironi's generation: Sorel extolled it as the motivating force of historical greatness, the stimulus to revolt against decadent materialist values. As Zeev Sternhell has noted of Sorel, "pessimism gave birth to the idea of apocalypse and originated the idea of myth."[47] The heroic despondency underlying the urban landscapes accounts for their pervasive psychological edge and confirms the irrational ideology at the base of Sironi's seemingly realist critique.

The paradoxical absence of the worker in the theater of revolution depicted by Sironi also finds its parallel in Marinetti's descriptions of the city. Throughout Marinetti's exaltation of modern life, technology takes center stage. The protagonist of the factories is the sleek, churning machine, while the worker functions as the embodiment of violence. Invoked at the moment of strike, he becomes, in Sorelian terms, the mere agent of revolt who presages actual revolution. Proletarian strife is merely the means to achieve a new order, one based on a mystical "aristocracy of the spirit."[48]

One of the very few urban landscapes to contain a human figure depicts none other than the *condottiere* of this breed of new men (fig. 8). The figure, posed imperiously on a white horse, undoubtedly refers to D'Annunzio at Fiume, with the port setting indicated by the pier and masts in the distance. D'Annunzio and his combatants had occupied Fiume in September 1919, in defiance of the Allied Powers who refused to give Italy the promised region of Dalmatia after the war. A daring aviator, war hero, and charismatic poet, D'Annunzio dominated the public imagination during this period, whereas Mussolini played but a modest role in Italian politics until the end of 1920.[49] The futurists officially lent their support to the Fiume enterprise and the poet's leadership, though their enthusiasm was ultimately not reciprocated. Nonetheless, D'Annunzio's belligerent occupation of Fiume was the first successful manifestation of that *combattentismo aristocratico* which cut through political stalemate

with decisive individual action.[50] If Sironi's urban landscapes capture the postwar mood of crisis, this one arresting image suggests a solution in the authoritarian figure of the Nietzschean superman. The ultramasculine torso—more armor than flesh—and marching steed symbolize the force and discipline of the leader who will carry out the long-awaited moral revolution.

The years 1918–20 were those of a discernable futurist-fascist nexus, when the two movements joined, above all, in the conviction that the revolutionary moment was at hand. They shared a hatred of both the bourgeoisie and the compromised Socialist Party, as well as a desire for the liberation of the worker and for the ascent of a new Italy, a strong nation purified by violence and shaped by an elite. Conceived during the height of the postwar crisis, Sironi's urban landscapes betray that contradictory mix of proletarian sympathies and strident nationalism held uneasily together by their revolt against the values of parliamentary democracy.

The occupation of the factories in 1920 marked the "watershed between revolution and reaction."[51] Because the socialists had failed to act decisively at the moment of opportunity, the unions were demoralized, and violent reprisals escalated against the political left. Fascism entered a new phase: it sought to gain power by preserving rather than overturning the status quo. Mussolini gathered new support from the newly threatened lower middle classes, as well as from disgruntled landowners and wealthy peasants in the countryside. At the same time, Mussolini also lost much of the core of the original *fasci*, including the futurists and many of the *arditi*.

Marinetti officially broke with Mussolini in the Fascist Congress of May 1920, ostensibly because of the latter's compromising acceptance of the monarchy and clergy. As Emilio Gentile has shown, however, elements of incompatibility were evident months before: the anarchic individualism at the base of futurism was irreconcilable with Mussolini's pragmatic political drive for a mass power base, and eventually, the restoration of order.[52] Though Marinetti would return to the fascist fold in 1924, it was as an artist operating in a politicized culture rather than as an avant-garde politician. Sironi, instead, along with other futurists, supported what he perceived as a revolution in progress: the fascist revolution. The ambivalence of the urban landscapes gave way to unflinching support of the Duce's policies, as Sironi continued to direct his art in the service of politics.

This essay derives from a paper given at the Annual Conference of the College Art Association, February 1994, in the session "The 'New Man' and His Shadow: Ambivalence toward Technology between the Two World Wars." Both owe, in turn, to the chapter, "The Urban Landscapes," from Emily Braun, "Mario Sironi: Art and Politics in Fascist Italy, 1919–1945" (Ph.D. diss., Institute of Fine Arts, New York University, 1991). Photographs of Sironi's political caricatures are courtesy of Andrea Sironi, Rome.

1. George L. Mosse, *The Nationalization of the Masses* (New York: Howard Fertig, 1975); and Renzo De Felice, *Mussolini*, 5 vols. (Turin: Einaudi, 1965–81).

2. Zeev Sternhell, *Neither Right nor Left: Fascist Ideology in France*, trans. David Maisel (1986; reprint, Princeton: Princeton University Press, 1995); Sternhell, with Mario Sznajder and Maia Ascheri, *The Birth of Fascist Ideology*, trans. David Maisel (Princeton: Princeton University Press, 1994); "The 'Anti-Materialist Revision' of Marxism," *Journal of Contemporary History* 22 (1987), 379–400. For a critique of Sternhell's approach, see Robert Wohl, "French Fascism, Both Right and Left: Reflections on the Sternhell Controversy," *Journal of Modern History* 63 (March 1991), 91–98.

3. Emilio Gentile, *Le origini dell'ideologia fascista (1918–1925)* (Rome and Bari: Laterza, 1975); *Il mito dello stato nuovo dall'antigiolittismo al fascismo* (Rome and Bari: Laterza, 1982); "Fascism as Political Religion," *Journal of Contemporary History* 25 (1990), 229–51 and *Il culto del littorio: La sacralizzazione della politica nell'Italia fascista* (Rome and Bari: Laterza, 1993).

4. Walter L. Adamson, "Modernism and Fascism: The Politics of Culture in Italy, 1903–1922," *American Historical Review* 95 (1990), 359–90; "Fascism and Culture: Avant-Gardes and Secular Religion in the Italian Case," *Journal of Contemporary History* 24 (1989), 411–35; *Avant-Garde Florence: From Modernism to Fascism* (Cambridge: Harvard University Press, 1993).

5. Peter Bürger, *Theory of the Avant-Garde* (1974), trans. Michael Shaw (Minneapolis: University of Minnesota Press, 1984).

6. Renato Poggioli, *The Theory of the Avant-Garde*, trans. Gerald Fitzgerald (Cambridge: Harvard University Press, 1968).

7. Boris Groys, *The Total Art of Stalinism: Avant-Garde, Aesthetic Dictatorship, and Beyond*, trans. Charles Rougle (Princeton: Princeton University Press, 1992), esp. 21.

8. Views of the periphery appear in Sironi's work as early as 1916, though the series proper of urban landscapes does not begin until 1919. He also continued to depict the city outskirts after 1922, until around 1925, but in a decidedly different tenor and with the introduction of suffering figures—mendicants and women and children. For problems in Sironi dating and a chronology of the urban landscapes, see Braun, "Mario Sironi," 129–34.

9. Enrico Somarè, reviewing the group exhibition at the Galleria delle

Mostre Temporanee (Milan, April 1920), in "Arte d'avanguardia," *Il Mondo* (1920); reprinted in *Cronache d'Arte Contemporanea* (Milan: Edizioni dell'Esame, 1932). Unless otherwise indicated, all translations in this chapter are my own.

10. See, for example, Cesare De Seta, *La cultura architettonica in Italia tra le due guerre* (Rome and Bari: Laterza, 1983), 150.

11. Sironi contributed to *I.I.I.* from January 1920 until September 1921. The images are fully reproduced in the catalogue raisonné of his illustrations by Fabio Benzi and Andrea Sironi, *Sironi illustratore: Catalogo ragionato* (Rome: De Luca, 1988), 40–46.

12. F. T. Marinetti et al., *L'orgoglio italiano*. The manifesto appeared in a flyer dated January 1916 published by the *Direzione del movimento futurista*, Milan, and is reprinted in Mario Sironi, *Scritti editi e inediti*, ed. Ettore Camesasca (Milan: Feltrinelli, 1980), 9–11.

13. Preface by Marinetti in *Mostra di trentatré artisti futuristi*, exh. cat. (Milan: Galleria Pesaro, 1929).

14. A brief summary of futurism and the interventionist movement is given by Crispolti in *Storia e critica del futurismo* (Rome and Bari: Laterza, 1986), 193–97. Marinetti gives his own account of the history of the futurists' involvement in the interventionist movement in *Marinetti e il futurismo* (Rome: Edizioni "Augustea," 1929), reprinted in Marinetti, *Teoria e invenzione futurista*, ed. Luciano De Maria (Milan: Mondadori, 1968), 164.

15. Gentile, *Le origini dell'ideologia fascista 1918–1925*; and Gentile, "Il futurismo e la politica: Dal nazionalismo modernista al fascismo (1909–1920)," in *Futurismo, cultura e politica*, ed. Renzo de Felice (Turin: Edizioni della Fondazione Giovanni Agnelli, 1988), 118. On the influence of Sorel's thought on the futurists and fascism, see Gentile, "La Politica di Marinetti," in *Il mito dello stato nuovo dall'antigiolittismo al fascismo*, 140–42; and Adamson, "Modernism and Fascism," 362, 372.

16. Marinetti, *Manifesto del partito politico futurista* (1918), published in *Roma Futurista* (20 September 1918) and reprinted in *Archivi del futurismo*, vol. 1, eds. Maria Drudi Gambillo and Teresa Fiori (Rome: De Luca, 1958), 34–37. Renzo De Felice, *Mussolini il rivoluzionario 1883–1920* (Turin: Einaudi, 1965), 474, writes that the manifesto was perhaps the most significant document of "that confused but sincere desire for radical political social and moral renewal" that characterized the *fasci di combattimento* in 1919–20.

17. A smaller body of literature considers futurism as fully right-wing, and fascist *in anticipo*, for example, Stephen Sharkey and Robert S. Dombrosky, "Revolution, Myth and Mythical Politics: The Futurist Solution," *Journal of European Studies* 6 (1976), 231–47. A more objective summary of the complex ideological composition of futurism is found in Judy Davies, "The Futures Market: Marinetti and the Fascists of Milan," in *Visions and Blueprints: Avant-Garde Culture and Radical Politics in Early Twentieth-Century Europe*, eds. Edward Timms and Peter

Collier (Manchester: Manchester University Press, 1988), 82–97. The most thorough analyses of the relationship between futurism and fascism in the years 1919–22, based on analysis of contemporary texts and internal politics within the *fasci*, is that by Emilio Gentile, "Il futurismo e la politica. Dal nazionalismo modernista al fascismo (1909–1920)," 105–59. For Marinetti's own analyses, written just after his return to the fascist fold, after having broken with Mussolini in 1920, see Marinetti, *Futurismo e fascismo* (Foligno: Campitelli, 1924).

18. On the relationship between futurism and revolutionary syndicalism, and Sorel's thought, see Sternhell, *The Birth of Fascist Ideology*, 28–30, 234–37.

19. De Felice, *Mussolini il rivoluzionario*, 419–544.

20. Benito Mussolini, "Atto di nascita del fascismo," in *Il Popolo d'Italia* (24 March 1919), reprinted in Benito Mussolini, *Opera omnia*, 35 vols., eds. Edoardo and Duilio Susmel (Florence: La Fenice, 1951–63), vol. 12, 327.

21. Marinetti, diary entry for 5 October 1919, in *Taccuini 1915–1921*, ed. Alberto Bertoni (Bologna: Il Mulino, 1987), 446.

22. Marinetti, "Il discorso di Firenze," improvised speech at the Congresso fascista di Firenze (early October 1919); reprinted in *Teoria e invenzione futurista*, 537.

23. Maurizio Boriani, Corinna Morandi and Augusto Rossari, *Milano contemporanea: Itinerari di architettura e urbanistica* (Turin: Riuniti, 1986), 206; M. Cerasi and G. Ferraresi, *La residenza operaia a Milano* (Rome: Officina, 1974), 176–78; and Ornella Selvafolta, "La casa operaia a Milano 1860–1914," *Parametro* 11 (January–February 1980), 13.

24. The dramatic social and economic consequences of the expansion of the periphery are discussed in detail in Giancarlo Consonni and Graziella Tonon, "Casa e lavoro nell'area milanese: Dalla fine dell'Ottocento al fascismo," *Classe* 14 (October 1977), especially the section "Il blocco Giolittiano sperimenta la politica della casa come strumento per dividere la classe operaia," 184–217.

25. Ibid., 199, table 13. Between 1901 and 1931 there was zero growth in the center but a 130 percent increase beyond the Spanish walls.

26. Gerald D. Silk, "Giacomo Balla's *The Worker's Day*," *Artsmagazine* 53 (January 1979), 130–36.

27. The number of passengers carried grew from 64,000 in 1900 to 163,000 in 1915. *Storia di Milano*, vol. 16 (Milan: Fondazione Treccani, 1962), 139.

28. Consonni and Tonon, "Casa e lavoro nell'area milanese: Dalla fine dell'Ottocento al fascismo," 165–258.

29. Maurizio Grandi and Attilio Praccchi, *Milano: Guida all'architettura moderna* (Bologna: Nicola Zanichelli, 1980), especially the chapter "Le case popolare (1900–1932)," 111–35; and Selvafolta, "La casa operaia a Milano," 12–63.

30. On the specific housing developments and the social work of the Societa Umanitaria, see Selvafolta, "La casa operaia a Milano," 28–30.

31. Grandi and Pracchi, *Milano*, 116; and Selvafolta, "La casa operaia a Milano."

32. Via Bronzetti and the entire area was the subject of the promotional article on public housing, "Istituto per le case popolare di Milano e le sue opere," in *La rivista illustrata del popolo d'Italia* (November 1925), 81–88, figs. 162, 163.

33. On Notari and Marinetti, see Claudia Salaris, *Storia del futurismo* (Rome: Riuniti, 1992) 109–10.

34. De Chirico invented his new style in Paris in 1912, but it was only when he returned to Ferrara in 1917 that his work came to be known in Italy, and even then, largely through the mediation of the theory and art of Carrà. Ardengo Soffici published the first article on the artist in Italy, in *Lacerba* (July 1914), while the first de Chirico image was published in Italy only three years later, in the October–November 1917 issue of *La Brigata*. It is doubtful that Sironi saw much of metaphysical painting before late 1917–early 1918 when Carrà had his first one-man exhibition in Milan (Galleria Paolo Chini, 18 December–10 January 1918), which was followed by the first illustrated monograph on Carrà by Giuseppe Raimondi. The history of the influence of metaphysical painting within Italy is recounted in detail by Joan Lukach, "De Chirico and Italian Art Theory 1915–1920," in *De Chirico*, ed. William Rubin, exh. cat. (New York: Museum of Modern Art, 1982), 35–54.

35. Carlo Carrà, "L' 'Italianismo artistico,'" *Valori Plastici* 1 (April–May 1919), 1–5; and Carrà, *Pittura metafisica* (Florence: Vallecchi, 1919).

36. Sternhell, *The Birth of Fascist Ideology*, 56–71.

37. As Mark Antliff has argued in *Inventing Bergson: Cultural Politics and the Parisian Avant-Garde* (Princeton: Princeton University Press, 1993), 164–65, the futurist painters merged Henri Bergson's notion of intuition with Sorel's theory of myth. Irradiating contours, rhythmic undulations, and penetrating force lines—all stylistic devices of prewar futurist painting—were used to evoke sensations of collective emotion and action, while also drawing the viewer into the center of the picture.

38. That Sironi painted his urban landscapes during the period of the occupation of the factories, the formation of the Communist Party, and the rise of fascism was noted first by Raffaele De Grada, *Mario Sironi* (Milan: Club amici dell'arte, 1972), 22; De Grada, however, does not elaborate on this relationship of the images to either the political context or Sironi's personal ideological stance in detail.

39. Paolo Spriano, *L'occupazione delle fabbriche: Settembre 1920* (Turin: Einaudi, 1964).

40. The multiple functions of the 18 BL played into the propaganda of fascist mythology years later. *18 BL* was the title of a fascist mass spectacle performed in 1934, in which an actual truck, in an outdoor theater environment, served as the martyr-protagonist in a narrative of the Fascist Revolution. With its

origins as a hero in World War I (Act 1) the truck drove on to rally the workers against the common enemy of socialism and parliament (Act 2), uniting the war effort and the rise of fascism, proletariat, and squadristi in a deliberate obsfucation of historical reality. The history of 18 BL and its implications for fascist propaganda are found in Jeffrey T. Schnapp, "*18 BL: Fascist Mass Spectacle,*" *Representations* no. 43 (Summer 1993), 89–125. Schnapp also gives examples of the truck in Sironi's work, and argues that Sironi "merged the iconography of industry with the evocation of fascism's 'outlaw' origins" (p. 99).

41. This information was given to me by Brian R. Sullivan, Senior Fellow for the National Strategic Studies at the National Defense University, Washington, D.C., and coauthor, with Philip V. Cannistraro, of *Il Duce's Other Woman: The Untold Story of Margherita Sarfatti* (New York: Morrow, 1993).

42. In many ways, the futurist cult of political violence found its legacy in the activities of the squads, and Marinetti's squad participated directly in early punitive expeditions against the socialists, notably in the 1919 assault on the press of the socialist newspaper *Avanti!* The futurists, however, were dismayed by the spreading squad violence against the workers during the aftermath of the occupation of the factories. See Gentile, "Il futurismo e la politica," 153–54.

43. See, for example, Margherita Sarfatti, "Dove va l'arte Italiana," *La rivista illustrata del popolo d'Italia* (April 1924), 48–49; and Ugo Nebbia, "Artisti d'oggi: Mario Sironi," *Emporium* 79 (January 1934), 4–7. The critical discourse surrounding Sironi's work, which linked his style with that of the "Fascist revolution," began in the early 1920s, and continued throughout his career into post–WWII assessments of his art. These issues are discussed in Emily Braun, "Illustrations of Propaganda: The Political Drawings of Mario Sironi," *Journal of Decorative and Propaganda Arts* 3 (Winter 1987), 84–106.

44. Marinetti, *Al di là del Communismo*, special volume of "La Testa di Ferro" (15 August 1920), cited in Crispolti, *Storia e critica del futurismo*, 214.

45. Such was the antisocialist diatribe of the artist Ardengo Soffici articulated in "Per la guerra," *Lacerba*, no. 18 (15 September 1914) and *Lacerba*, no. 19 (1 October 1914), reprinted in Schiavo, *Futurismo e fascismo*, 61–65: "L'idea che i socialisti si fanno del mondo è questo: un capitalista borghese è sfruttatore alle prese con un magro popolano sfruttato. La cultura, le scienze, le arti, la bellezza, i sentimenti, gli amori, le passioni—tutto ciò insomma che fa la vita così terribilmente complessa, così colorita, così varia, multiforme, incoercibile—non è nulla per loro. Tutto è grigio. . . ."

46. Peter Selz, "The Artist as Social Critic," in *German Realism of the Twenties: The Artist as Social Critic*, exh. cat. (Minneapolis Institute of Arts, Minneapolis, 1980), 29–40; Joan Weinstein, *The End of Expressionism: Art and the November Revolution in Germany, 1918–19* (Chicago: University of Chicago Press, 1990).

47. Sternhell, *The Birth of Fascist Ideology*, 71.

48. Roberto Tessari, *Il mito della macchina: Letteratura e industria nel primo Novecento italiano* (Milan, 1973), 249–52.

49. Gentile, *Le origini dell'ideologia fascista*, 167–68, 186–87.

50. Adrian Lyttelton, *The Seizure of Power: Fascism in Italy, 1919–1929* (London, 1982), 17.

51. Ibid., 36.

52. Gentile, "Il futurismo e la politica," 137–57.

La Cité française:

Georges Valois, Le Corbusier, and Fascist Theories of Urbanism

Mark Antliff

For some time now art historians have recognized that Le Corbusier's participation after 1925 in Ernest Mercier's organization Redressement Français, and subsequent endorsement of the regional syndicalism of Hubert Lagardelle during the 1930s, allied him in both cases to reactionary tendencies within French culture. In the early 1920s Le Corbusier adapted his rationalist aesthetic, exemplified by his 1922 plans for the rebuilding of Paris publicized in the text *Urbanisme* (1925) (fig. 17), to Mercier's promotion of a Taylorist, capitalist order. His later shift from the politics of Mercier to regional syndicalism led him to repudiate his rationalist modernism in favor of architectural forms whose curvilinear structure exemplified Lagardelle's "corporatist" and "organic" definition of the nation state.[1] It is my intention to consider another reactionary aspect of Le Corbusier's career: his enthusiastic reception within the French fascist party in the late 1920s and his understudied impact on the aesthetics of that movement. To date, analyses of Le Corbusier's relations to French fascism have focused on his equivocations over the merits of the Faisceau, with little attention being given to the fascists' own theories or to their evaluation of Le Corbusier.[2] In taking up the latter theme I will define exactly what nonetheless separated Le Corbusier from his fascist sympathizers in the late 1920s and establish the manner in which French fascism adapted Le Corbusier's modernist aesthetics to what Zeev Sternhell has termed fascism's "antimaterialist" ideology.[3] By analyzing the fascists' voluntarist conception of a "productivist" ethic I will demonstrate the profound gulf that separated fascists like Georges Valois from Le Corbusier and his technocratic allies in the Redressement Français. Whereas the former conceived of Le Corbusier's plans in terms of the historically grounded, socioeconomic public space the French refer to as *la cité*, Le Corbusier had a more abstract conception of urban space,

17. Le Corbusier, *La Ville contemporaine* (1922), reproduced in Le Corbusier, *Urbanisme* (1925)

defining the city as a sociotechnical environment. Paul Rabinow has argued that Le Corbusier's urbanism served to separate him from more traditional town planners who retained an idea of *la cité*; I will argue that this view of urbanism also separated Le Corbusier from Valois, who from 1910 on upheld the concept of *la cité* developed by his mentor, the anarcho-syndicalist Georges Sorel.[4]

Founded on Armistice Day, 11 November 1925, the French fascist movement was the vehicle of Georges Valois (fig. 18), an interesting figure whose career ranged from fascism in the 1920s to libertarian communism in the 1930s.[5] For Valois fascism was a volatile combination of progressive and reactionary positions, and in the 1920s Valois's doctrine of national socialism was designed to rid France of what he saw as the decadent effects of parliamentary democracy. By the time of the demise of Valois's organization in 1928, his plans for a fascist state called for the rebuilding of Paris to facilitate the corporatist structure undergirding his fascist vision. Thanks to the work of Mary McLeod we now know that Le Corbusier was attracted to this fascist orbit in 1927.[6] As early as May 1926, Le Corbusier's friend Pierre Winter cited the architect's 1925 book, *Urbanisme*, in an article in Valois's journal *Nouveau siècle* on the hygienic dimension of fascist town planning. By January 1927, Le Corbusier's ideas had become so popular among the fascists that he made the *Nouveau siècle*'s front page (fig. 19) as one of the "organizers" or "animateurs" of the French Faisceau. In March of the same year the fascist Charles Biver published an article praising Le Corbusier's "Voisin Plan" for the rebuilding of Paris and, with the

18. Photograph of Georges Valois,
reproduced in *Nouveau siècle*
(19 November 1925)

19. Photograph of Le Corbusier,
reproduced in *Nouveau siècle*
(9 January 1927)

Les Animateurs

Le Corbusier

Le Corbusier (Edouard-Jeanneret),
né à la Chaux-de-Fonds en 1887, fon-
dateur et directeur de l'Esprit Nou-
veau est l'un de nos architectes les
plus remarquables.
Travailleur acharné et clairvoyant,
ennemi de toute routine, ses idées, in-
comprises pendant quinze ans, le pla-
cent maintenant à la tête du mouve-
ment urbaniste.
En collaboration avec Pierre Jean-
neret, dans le domaine de l'habitation,
qu'il s'agisse de villas, de villes entiè-
res ou de son plan du centre de Paris,
Le Corbusier a fait beaucoup pour la
standardisation du bâtiment.
Allez un jour à Pessac, près de Bor-
deaux, et visitez le quartier Fruges,
vous y verrez : sobre de lignes, admi-
rable de confort, éblouissante de lu-
mière la cité future enfin réalisée par
le génie d'un homme enthousiaste, sûr
de sa science, qui a su rompre avec les
procédés traditionnels.

architect's encouragement, urged his colleagues to study Le Corbusier's model for the city of Paris.[7]

That effort apparently met with success, for the paper celebrated May Day with the inclusion of a drawing and extracts from the architect's own commentary in *Urbanisme* on the "Voisin Plan" (fig. 20). Le Corbusier's association with the fascists was solidified on 20 May, when he gave a slide presentation of his urban designs at a fascist rally.[8] During the following months Valois published a series of essays in *Nouveau siècle* in which he allied his conception of the fascist "New Order" with Le Corbusier's "New City."[9] Valois declared Le Corbusier's architectural ideas to be "an expression of our profoundest thoughts," before admitting that Le Corbusier's own political sympathies still separated him from the fascist creed.[10] Thus while Valois openly acknowledged his political differences with the architect, he clearly identified Le Corbusier as a potential convert. An exploration of the political dimension of Le Corbusier's and Valois's views on urbanism should help us to understand why.

As Mary McLeod has noted, Le Corbusier endorsed American models of industrial rationalization and managerial reform throughout the 1920s, and became dissolutioned with American-style capitalism only after the market crash of 1929. Among those American models Le Corbusier found most compelling was Taylorism, a developing system of scientific management, the stated aim of which was to increase efficiency in the workplace by means of the rational organization of factory production and worker movements in the production process. For Le Corbusier (and as we shall see, for Valois) the sociopolitical implications of Taylorism were of primary importance, for the movement's founder, Frederick Taylor, thought that class divisions between management and workers could be overcome once both groups recognized their mutual interest in increasing production. The ultimate result of rationalization, argued Taylor, would be the creation of goods for all at affordable prices; the Taylorist social engineering would serve to unite classes in the pursuit of material well-being. Taylor's French advocates thus came to admire the American Taylorist Henry Ford for his self-proclaimed aim to lower the cost of goods through increased production, thus democratizing purchasing power. For Le Corbusier, the government-sponsored application of Taylorist and Fordist methods during World War I was proof of the constructive role of both systems in unifying the nation behind the productive dimension of the

LE PLAN VOISIN

Le « Plan Voisin » de Paris comporte la création de deux éléments neufs essentiels : *une cité d'affaires et une cité de résidence.*

La *cité d'affaires* fait une emprise de 240 hectares sur une zone particulièrement vétuste et malsaine de Paris, — de la place de la République à la rue du Louvre, et de la gare de l'Est à la rue de Rivoli.

La cité de résidence s'étend de la rue des Pyramides au rond-point des Champs-Elysées et de la gare Saint-Lazare à la rue de Rivoli, entraînant la démolition de quartiers en grande partie sursaturés et couverts d'habitations bourgeoises abritant aujourd'hui des bureaux.

La gare centrale se trouve entre la cité d'affaires et celle des résidences. Elle est souterraine.

L'axe principal de ce nouveau tracé du centre de Paris va d'est à ouest, de Vincennes à Levallois-Perret. Il rétablit l'une des grandes traversées indispensable qui n'existe plus aujourd'hui. C'est une artère

ouvre au point stratégique de Paris un étincelant réseau de communications. Là où des rues de 7, 9 ou 11 mètres se recoupent tous les 20, 30 ou 50 mètres, il établit un quadrillage de grandes artères de 50, 80 et 120 mètres de large se recoupant tous les 350 ou 400 mètres et élevant des gratte-ciel de plan cruciforme au centre des vastes îlots ainsi créés, il crée une ville *en hauteur*, une ville qui a ramassé ses cellules écrasées sur le sol et les a disposées loin du sol, en l'air et dans la lumière.

Proposer la démolition du centre de Paris et sa reconstruction pourrait tout aussi bien être une plaisanterie de mauvais goût. Mais si des raisonnements successifs ont affirmé fortement, et de *divers côtés*, à *divers points de vue*, qu'il faut en agir ainsi ? D'abord, qu'il faut tailler au centre et reconstruire en hauteur.

Voici les raisonnements « Chiffres » et « Réalisation » :

bien : « *Quelle fabrique à capitaux quelle production de milliards et de milliards, devient une telle manœuvre de revalorisation du sol !* »

Revalorisation possible à condition *seulement* d'établir un plan magnifique d'aménagement du centre de Paris.

Des milliards ? beaucoup, un bénéfice énorme ? combien ? Voilà ce que dirait l'économiste qui peut rechercher les données numériques du problème. L'économiste, ce jour-là, intéresserait prodigieusement un ministre des Finances.

Le ministre des Finances peut trouver dans le centre de Paris des ressources immenses.

Spéculation menaçante alors ? Impossible ; voici comment :

Au jour du décret d'expropriation générale du centre de Paris, la valeur de la propriété foncière a été cotée (A). Il est facile de l'établir à dire d'experts, sur les indications fournies par les ventes qui se sont faites à cette époque en divers points

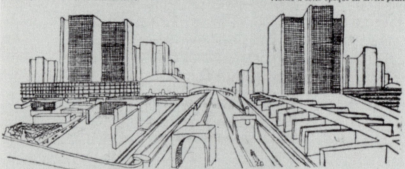

principale de grande circulation, large de 120 mètres, munie d'un autodrome surélevé pour circulation à sens unique, sans recoupement. Cette artère capitale aurait pour effet de vider les Champs-Elysées ; ceux-ci ne peuvent, en effet, demeurer une voie de grande circulation, puisqu'ils aboutissent à un cul-de-sac : le Jardin des Tuileries.

Ce plan s'attaque aux quartiers les plus infects, aux rues les plus étriquées ; il ne cherche pas à « opportuniser », à céder ici et là un pouce de terrain sous la poussée violente des artères congestionnées. Non. Il

Le centre des grandes villes représente la valeur foncière la plus importante. Désignons cette valeur par (A). Haussmann démolit des quartiers pourris de Paris et les remplace par des quartiers somptueux. Les opérations d'Haussmann sont des mesures d'ordre financier. Haussmann remplit d'or les caisses de l'Empereur. A la valeur (A) il conférerait une valeur cinq fois plus grande par exemple (5A).

Conclusion. Ne dites pas : « Oui, mais... quels capitaux immenses faudrait-il consacrer à l'expropriation et à la construction, etc, etc. », mais

de Paris. Valeur (A). Par la construction d'une cité d'affaires, on valorise (A) jusqu'à (5A) par exemple ; en quadruplant la densité, voici : (5A). Votre puissance d'achat pour l'expropriation est de 4 fois × 5 fois la valeur A. Rabaissez cette valeur rassurante aux limites les plus raisonnables, il n'en demeure pas moins que vous disposez d'une puissance d'achat énorme et que vous paierez (A) sans discussion et que l'expropriation devient ainsi équitable et rapide.

Bâtir sur 60 étages nous apporte cette richesse immense...

20. Le Corbusier, *Le Plan voisin*, reproduced in *Nouveau siècle* (1 May 1927)

war effort. Under the auspices of a new journal, *L'Esprit nouveau* (1920–25), Le Corbusier and his ally Amédée Ozenfant propagandized Taylorist social engineering in the postwar period, so as to ensure continued prosperity and social cohesion.[11]

Thus Le Corbusier opted for the politics of reform, putting his faith in an improved capitalist structure, premised on efficiency and economy, as a vehicle for social change. For the architect, productivism was a value-neutral form of social engineering, a technocratic tool that would bolster the Republican status quo by alleviating the material needs of all classes.[12] In fact Le Corbusier extended this paradigm beyond France's borders when, in *Urbanisme*, he called for the reconstruction, with foreign capital, of Paris and its environs. Foreign investment in the French infrastructure, he reasoned, would ensure that the city would not be subject to attack by a foreign power; on a global scale Le Corbusier hoped that the extension of capitalist rationalization worldwide would result in the creation of a world federation able to guarantee political stability.[13] In short, while Le Corbusier envisioned no political change within France, his theories had international implications that potentially put him at odds with his erstwhile allies in the Redressement Français and in the Faisceau. Both these groups were ardently nationalist and saw industrial rationalization as a means of bolstering French industry in the face of foreign competition.[14] However, whereas the Redressement Français, like Le Corbusier, thought rationalization could be enacted within the framework of the republic, the Faisceau subsumed Fordism and Taylorism within a blueprint for total revolution. Not surprisingly, Le Corbusier found Mercier's program more conducive to his own more conservative agenda, with the result that he published two brochures promoting his Taylorist plans under the auspices of the Redressement Français in 1928.[15] Since Le Corbusier's differences with the fascists were primarily ideological, analysis of the philosophical roots of Valois's fascism are in order, so that we may better understand the fascist leader's urbanism.

Valois's embrace of Le Corbusier's technocratic modernism cannot be understood apart from the moral values and antimaterialist precepts animating his fascist politics. Historians have numbered Valois among the followers of Georges Sorel, an anarcho-syndicalist theorist whose ideas played a seminal role in the development of a rapprochement between political movements on the left and right before and

after World War I.[16] Before the war the monarchist Valois had been instrumental in drawing a group of Sorelians together with followers of the monarchist Charles Maurras to form a study group known as the Cercle Proudhon. Between 1912 and 1914 the study group published *Cahiers du Cercle Proudhon*, a journal in which they developed a theory of "national syndicalism" designed to unite French citizens from all classes in a revolt against republican ideology and its institutions. Zeev Sternhell has described the ideological mixture emanating from the Cercle as "a synthesis of a certain trend of ethical and spiritual socialism with radical nationalism," whose common denominator was "antimaterialism."[17] Drawing on Sorel's critique of the deterministic, mechanistic, and materialist aspects of parliamentary democracy and Marxist thought, Cercle members Gilbert Maire, Edouard Berth, and Valois posited an antimaterialist and spiritualist road to revolution meant to galvanize both the bourgeoisie and the proletariat. As Paul Mazgaj has demonstrated, the Sorelians' primary concern was with the decadence of French society, for Sorel in his various writings viewed class conflict as the means by which bourgeois and proletarian alike could be rejuvenated and the corrupting effects of parliamentary democracy successfully resisted.[18]

In his *Reflections on Violence* (1908) and *Illusions of Progress* (1908), Sorel outlined the ethical decline resulting from the mixture of classes promoted by party politics under the parliamentary system. According to Sorel, republicanism had produced an atomized, abstract conception of the citizen modeled after the positivist theories of the Enlightenment; in the process an individual's identity with any collective entity, whether it be a professional syndicat or even the concept of nationhood, had been lost.[19] Sorel drew on the antimaterialist philosophy of Henri Bergson in his critique of republicanism and declared the atomized conception of the citizen the product of an overly intellectualized theory, unable to appreciate the intuitive and vitalist roots animating all societies. These roots had their basis in the collective consciousness of a class or of citizen soldiers about to embark on war, for both groups, in Sorel's view, were inspired by moral values of heroism, altruism, and sacrifice, all of which indicated an intuitive state of mind. Moreover, since that state of mind was a catalyst for creativity, the productive capacity of each individual would be enhanced in a vitalist society, and the atomized, intellectual assumptions that gave self-interest priority over collective good would dissipate.[20]

For the Sorelians, Bergson's insights had profound consequences, both for their vision of society and the means by which they sought to change it. Thus in the politicized interpretation of Bergson developed by Sorel and his allies in the Cercle Proudhon, Bergson's intellectualized conception of the universe had its political equivalent in republican and Enlightenment ideology.[21] Sorel and his colleagues sought to identify the qualitative differences within the body politic ignored by democratic demogogues, the most significant of these being class. In Sorel's theory each class had its own *élan vital*; the error of democracy was that it subsumed all classes into its abstract conception of citizenship, thereby denying the heterogeneity of class difference and the vital qualities intrinsic to each class. At its worst democracy spawned political entities such as the Socialist Party, whose sole aim, according to Sorel, was to reduce "capitalist energy" among the bourgeois and "revolutionary energy" among the proletariat, by encouraging both groups to compromise their class interests.[22] Socialism denied the absolute differences that separated classes; furthermore, it promoted conciliation between classes in the name of abstract homogenizing values such as universal brotherhood. Sorel's primary aim then was to reinvigorate the energy of each class by instilling forms of thought that awakened the intuitive capacities intrinsic to class consciousness. In so doing he not only intuited the energetic capacities native to both bourgeois and proletarians, he also charted the history of those forms of representation—myths—that had inspired these classes to fullfill their regenerative and creative mission. As the product of intuition, myths were designated "historical forces," modes of intuitive representation able to inspire the "individual effort" and "spirit of invention" crucial to social regeneration. Quoting Bergson, Sorel defined myth as a "body of images" capable of evoking "the noblest, deepest and most moving sentiments" unique to a particular class.[23] Ultimately myths inspired individuals to recognize the spiritual traits that allied them with a particular class, so that qualitative differences between classes could be maintained.

The special mission of the proletariat in Sorel's theory was to awaken the bourgeoisie from its intellectual stupor and make that class recover the "serious moral habits," "productive energy" and "feeling of its own dignity" that had been lost under the impact of democatic ideals.[24] Before the advent of democracy the bourgeoisie had adhered to its own sense of values. Animated by a "conquering, insatiable and

pitiless spirit," that made business competition "a battlefield," there was a similarity "between the capitalist type and the warrior type." It was this militant bourgeoisie, solely concerned with "the great problem of the organization of labour," that inspired Marx to declare revolution inevitable, for militant capitalism according to Sorel throws "the working class into revolutionary organizations by the pressure it exercises on wages." "The more ardently capitalist the middle class is," declared Sorel, "the more the proletariat is full of a warlike spirit and confident of its revolutionary strength."[25] Thus the intuitive nature of each class was subject to mutual reinforcement which culminated in revolution—as long as the "productive energy" of the bourgeoisie inspired the "revolutionary energy" of the proletariat. However, with the disappearance of this militant bourgeoisie under the impact of intellectualized parliamentary democracy, the working class alone possessed the necessary "energy" to bring about the cataclysm envisioned by Marx. The pressure exerted on the bourgeoisie by a revolutionary proletariat, fully conscious of its class interests, was the only means by which the bourgeoisie could regain its class consciousness, and with that, its productive energy. In Sorel's words:

The dangers which threaten the future of the world may be avoided, if the proletariat, by their use of violence, manage to re-establish the division into classes, and so restore to the middle class something of its former energy; that is the great aim towards which the whole thought of men . . . must be directed. Proletarian violence, carried on as a pure and simple manifestation of the sentiment of the class war, appears thus as a very fine and heroic thing; it is at the service of the immemorial interests of civilisation. . . . Let us salute the revolutionaries as the Greeks saluted the Spartan heroes who defended Thermopylae and helped to preserve the civilisation of the ancient world.[26]

The creation of class consciousness through institutions "owing nothing to middle class thought"[27] was crucial to the maintainance of an energetic proletariat; Sorel saw evidence of that consciousness in the antiparliamentary policies of the syndicats and the decision of the *Confédération générale du travail* to employ strike action to further proletarian ends. Indeed, the C.G.T.'s promotion of the general strike as a vehicle of revolution was, to Sorel's mind, an ideal means of instilling an intuitive and thus revolutionary state of mind in the worker.[28] The myth of the general strike therefore produced an intuitive class consciousness typified by militancy, heroism, and a spirit of

self-sacrifice comparable to that of the citizen-soldiers of ancient Greece. This *esprit de corps* was itself supplemented by what Sorel termed "the morality of the producers," a morality complemented by an artistic impulse. "Art," Sorel declared, "is an anticipation of the kind of work that ought to be carried on in a highly productive state of society."[29] As an expression of intuitive consciousness, the art of a given class must be unique to that class; for instance, proletarian art should not be the result of "an aesthetic education transmitted by the middle class" but based "on the feelings developed by the struggles of the workers against their masters. . . . The socialist solution, an aesthetic education of the proletariat under the tutelage of modern artists," was to be avoided since modern art was itself "a residue left to us by an aristocratic society, a residue which has, moreover, been greatly corrupted by the middle class."[30] Art should be circumscribed by class consciousness; to do otherwise would be to drain art of the intuitive force that serves to animate it. For this reason Sorel rejected the links forged between anarchists of an older generation and the neo-impressionist avant-garde, for the latter were primarily artists from the bourgeoisie.[31]

Thus myth in Sorel's theory served the dual function of invigorating both proletarians and the bourgeoisie, both of whom would be susceptible to degeneration were their class consciousness to be completely lost. Ideally these two classes should be equally animated by an intuitive spirit; in the case of the working class that spirit combined the valor of the Athenian citizen-soldier with the morality of the producer and the inventiveness of the artist. The bourgeoisie in turn should be composed of "captains of industry," leaders whose "productive energy" fueled competition on the industrial "battlefield." In either case, intuitive consciousness was lost if the distinction between classes dissolved "in the democratic marsh" exemplified by the parliamentary socialism of Jean Jaurès.[32] Sorel thought that the rise of intuitive consciousness would result in the downfall of democracy, since that system of government was antithetical to social regeneration. The assault on democracy could be maintained through class war, but other mythic events could also instill an intuitive spirit in the population and lead to a decline in democratic values. Since Sorel associated intuitive consciousness with military heroism, he exalted war as a means of social renewal, stating that not one but "two accidents" were capable of stopping the slide into unproductive decadence:

a great foreign war, which might renew lost energies, and which in any case would doubtless bring into power men with a will to govern; or a great extension of proletarian violence, which would make the revolutionary reality evident to the middle class, and would disgust them with the humanitarian platitudes with which Jaurès lulls them to sleep. It is in view of these two dangers that the latter displays all his resources as a popular orator. European peace must be maintained at all costs; some limit must be put to proletarian violence.[33]

For Sorel then, a war in the name of the appropriate values could reinvigorate the nation; examples included "the wars of Revolution and the Empire," which, by virtue of being "glorious," were a stimulus to "industrial production."[34] In short, the morality of the proletarian producers and that of the captains of industry found their raison d'être in the heroism of militant nationalism. War could simultaneously instill both heroism and productivity in each class. Like class war, war between nations served to reinvigorate the body politic, and could return French society to conditions operative in the Greek polis, when citizen-soldiers determined the destiny of the nation. These methods of social regeneration for both bourgeois and proletarian enabled monarchists like Valois and syndicalists like Berth to gain a political consensus in the form of a doctrine of national syndicalism. To promote this ideology the syndicalists Sorel and Berth joined forces in 1910 with the monarchists Jean Variot, Pierre Gilbert, and Valois in founding the journal *La Cité française*. Although the journal fell victim to internal dissention and failed to appear, the declaration of intent published by the group is of the utmost importance, since it gives us insight into the version of *la cité* the Sorelians were to promote in the journals *Indépendance* (1911–13) and *Cahiers du Cercle Proudhon* (1912–14), and which Valois endorsed in the postwar *Nouveau siècle*:

The founders of this journal are united in order to participate in the free organization of the French *cité*. . . . The founders of *Cité française* represent various forms of public judgment but are in perfect accord on this point: that if one wants to resolve in a favorable sense for civilization the questions that are posed in the modern world, it is absolutely necessary to destroy democratic institutions. Contemporary experience teaches that democracy constitutes the greatest social peril for all classes of the *cité*, principally for the working class. Democracy confuses classes, in order to allow a band of politicians, associated with financiers or dominated by them, to exploit producers.

It is therefore necessary to organize the *cité* apart from democratic ideas, it is necessary to organize classes apart from democracy, in spite of democracy and

against it. It is necessary to revive the consciousness that classes must possess of themselves and which are actually suffocated by democratic ideas. It is necessary to revive the virtues unique to each class, and without which neither can accomplish its historical mission.[35]

Clearly for Valois, Berth, and Sorel, *la cité française* stood not only for the geopolitical borders that defined France, but more importantly for the spiritual values held by citizens within those borders and the political systems expressive of those values. Above all else the constitution of *la cité française* was accomplished through the destruction of democratic values, and the substitution of values "unique to each class," intuitive values necessary for the moral revival of the nation. Thus Berth claimed that democratic "intellectualization" had created "a social space, where each individual is pronounced to be an isolated and closed monad, an atom," without "any spiritual unity, any *cité*." In contrast "the myth of the general strike" expressed "the resurrection of a people" who "had formed themselves around workshops, into syndicats" and so created "a spiritual unity, a new *cité*, a new justice, a new civilization."[36] As John Stanley has demonstrated, Sorel designated various social groupings within the *cité française* as qualitative *cités* in their own right, each with its own set of inherited values. For instance, the militant productivity found among modern syndicalists had its historical equivalent in the "*cité esthétique*," a medieval "artistic community" made up of craft guilds, whose productive élan created the cathedrals. This proletarian grouping had its counterpart in the *cité morale*, the spiritual values that served to unify the "captains of industry," the regenerated bourgeoisie.[37] Ultimately these modern *cités*, reflective of the productive energies of both proletarians and bourgeois, would replace democratic insitutions with a system of federated syndicats, freed from centralized control.

Furthermore, by contrasting "financiers" with a truly productive bourgeois *cité*, the national syndicalists wished to underscore the difference between productive and unproductive members of the bourgeois class. The Sorelians were in agreement that the decadent bourgeoisie, untethered from the morality of production and militant capitalism, sought to live off the labor of others and accumulate wealth by money-lending and fiscal speculation on the stock exchange. Not surprisingly the correlation of bourgeois decadence with usury spawned anti-Semitism: even in his *Reflections on Violence*, Sorel con-

trasted the vigourous bourgeois, whose warrior spirit resulted in an austere "galley slave existence," with the decadent members of the bourgeoisie, "leading a nobleman's life for themselves, as the Roth- schilds do."[38] Similar prejudices can be found in the writings of Edouard Berth who also separated "the really productive part of the bourgeoisie" from the "nonproducers," the "financiers" who reportedly joined the Jews in stock market speculation.[39] This racism reached its apotheosis in an article titled "La Bourgeoisie capitaliste," penned by Georges Valois for the *Cahiers du Cercle Proudhon*. In that essay, Val- ois contrasted "la bourgeoisie française," fully assimilable to a revivified *cité française*, with the decadent "la bourgeoisie judaisante," (Jewish bourgeoisie), which had "lost its pride, its professional honor" and its "love of its métier, of its function."[40] The decline of productive values among this class was matched by an obsession with the accumulation of wealth at any cost, which in turn led the Jewish bourgeoisie and their "judaizing" followers to invest in nonproductive "establishments of pleasure," such as bars and music halls.[41] Such pleasure palaces were both manifestations of bourgeois corruption and agents of degra- dation among the working class, who were the victims of prostitution and alchoholism. In their most degraded condition, the bourgeoisie descended into usury, and converted time itself into money, a homoge- nized, standardized commodity invested on the stock exchange. Thus the singular pursuit of wealth on the part of the "judaizing bourgeoisie" precipitated a decline in "the moral and vital reserves of the French nation," reserves that could only be renewed through a return to the ethics of class consciousness.[42] Citing Sorel's *Reflections on Violence*, Valois noted that revolutionary action on the part of an uncorrupted proletariat would convert the decadent "capitalist bourgeoisie" back into a "French bourgeoisie," aware of "their warrior qualities and sense of command."[43] Writing on the eve of World War I, Valois embraced the concept of *la cité* promoted by Sorelians, and called for a revival of the French body politic through assertion of the antimaterialist, intu- itive values intrinsic to class consciousness.

The Sorelian belief that such values could instill class conscious- ness in both the bourgeoisie and proletariat led Sorel to identify the spirit of collaboration uniting workers with the antimaterialism that had given birth to medieval cathedrals and the militant, Catholic nationalism of Joan of Arc.[44] Drawing on ideas first broached in an essay of 1901 titled "The Social Value of Art," Sorel, in his later writ-

ings, argued that an artistic consciousness should animate production in industry, and that Gothic artisans had set a precedent in this regard.[45] In his *Reflections on Violence*, Sorel exalted the builders of cathedrals as workers animated by a creative spirit that required no recompense, either in the guise of individual fame or material wealth; for this reason the creative spirit of these anonymous stonemasons was not unlike that of the revolutionary soldier, whose acts of heroism were selflessly performed in the name of victory rather than individual reward.[46] That correlation was reinforced in a 1910 appendix to his 1908 book *Illusions of Progress*. Having identified the creativity animating medieval artists guilds with the fervent Catholicism found in monastic communities, Sorel added that "art, religion and philosophy form the trilogy of the free spirit."[47] "During the Gothic period," argued Sorel, "the arts had an organization as solid as a system of production can have," for "they were integrated in the most intimate way with the trades. . . . The Renaissance completely changed the position of the artists, who no longer mixed with artisans and who were elevated to the status of literati" so that "the history of the masters replaced the history of art." Thus the individual personality of a Michelangelo or Raphael took precedent over the creative consciousness animating members of the medieval guilds.[48] Sorel identified the art of the Renaissance with the rise of rationalism and the creation of an atomized society, which valued individual autonomy as an end in itself. Appropriately when *Indépendance* made its appearance in 1911, the cultural correlate to that journal's national socialism was an art that emulated the medievalism and Pre-Raphaelite aesthetic championed by John Ruskin, a writer cited by Sorel on numerous occasions. By aligning the medievalism of his syndicalist period to his medievalism Sorel developed an aesthetic theory more conducive to his royalist allies. Simultaneously that discourse underscored his differences with monarchists like the art critic Louis Dimier, who never tired of exalting the Italian High Renaissance as an era of cultural and political renewal in Europe, or Maurras himself, who thought gothic art to be a manifestation of Germanic barbarism.[49]

Indépendance promoted painters and sculptors who exemplified Sorel's medieval ideal. Among those artists associated with the journal was the former symbolist Armand Point, a follower of the English Pre-Raphaelites who, in 1897, set up a studio for applied art near Fontainebleau, based on William Morris's principles. Appropriately the

21. Armand Point, *Casket*, n.d., reproduced in
Indépendance (1 June 1912)

works reproduced in *Indépendance* included a handcrafted casket
made in Point's studio workshop (fig. 21), and the July 1911 issue of
Indépendance had an article on the revived Catholic Salon de la Rose-
Croix which included Point among its membership.[50] In that article
Jean Variot described the Rose-Croix as made up of "good workers"
whose art was modeled after the Florentine "primitives" Giotto and
Fra Filippo Lippi. In a December 1912 article in *Indépendance* Sorel
proclaimed his own allegiance to the Trecento artist Giotto, who had
reportedly rejected humanism for Catholicism, with the result that his
art owed more to Byzantine ivories and medieval icons than to the art
of his contemporaries. Since Byzantine artists had emulated the art of
antiquity, Giotto, through the ivories, was able "to acquire a clear con-

sciousness of his genius by studying the Greeks."[51] Despite the subsequent decline of art under the effects of Renaissance humanism, Giotto's example remained, and Jean Variot in his essay on the 1911 Rose-Croix exhibition praised that group for having shown copies of Giotto's frescoes at Santa Croce.

In the realm of sculpture, the Sorelians favored Charles Despiau, whose *Bust of Paulette* was reproduced in a November 1911 edition of the journal (fig. 22). At the time Despiau was involved in a parallel revival of Italian "primitive" sculpture, modeled after fifteenth-century Italian portrait busts by artists such as the Florentine Antonio Rossellino. Despiau's portrayal of French peasants in the manner of Rossolino confirmed the correlation, in *Indépendance*, of medieval revivalism with an art of the people, while the religious fervor animating this art was conducive to the aesthetics of the Action Française. The relation of such work to militant Catholicism was made explicit in Emile Pompineau's design for a bust of Joan of Arc, executed in the style championed by Despiau and Point, and reproduced in the 15 June 1912 edition of *Indépendance* (fig. 23). Following his 1910 eulogy to Péguy's poem honoring Joan of Arc, Sorel had unceasingly praised the saint as the very embodiment of the spirit of *la cité française*, a figure whose peasant origins, fervent Catholicism, and militant nationalism gave her an exalted place in the Sorelian pantheon. As Michel Winock has pointed out, reactionaries such as Drumont and Maurras never tired of contrasting Joan, as the embodiment of plebeian, Catholic France, with the wealthy, rootless cosmopolitanism of the Jew; thus it is appropriate that this symbol of France should find a home in Sorel's *cité*.[52]

While Sorel drew parallels between the creativity stemming from technological innovation in the workplace and that which motivated the medieval mason, Berth, in *Les Méfaits des intellectuels* (1914), condemned those who would embrace medievalism in order to reject the machine technology of the modern workshop.[53] To his mind the glorification of handcraft production by William Morris and the English workers' movement was a retrogressive tendency that did not recognize the creative potential intrinsic to modern production methods. Thus national syndicalist aesthetics had a second trajectory that correlated inventiveness in the workshop with intuitive creativity, and envisioned modern technology as the expression of the morality of producers. It was this technological utopianism, rather than medieval revivalism, that

22. Charles Despiau, *Bust of Paulette*, n.d., reproduced in *Indépendance*
(15 November 1911)

23. Emile Pompineau, *Bust of Joan of Arc*, n.d.,
reproduced in *Indépendance* (15 June 1912)

led the Sorelian Georges Valois to praise the architecture of the mod-
ernist Le Corbusier when he founded the French fascist movement in
the postwar period. In Sorelian circles medievalism and technological
modernism were thus two sides of an intuitive spirit that simultane-
ously gave birth to religious faith and a productivist ethic.

To Valois's mind World War I had served to reinvigorate the bour-
geoisie in just the manner predicted by Sorel, with the result that the
spirit of the combatant had synthesized with that of the producer
among those bourgeois involved in production on the home front and
engaged in combat in the trenches. The task remaining for these rein-
vigorated classes was to overthrow the democratic regime that had

threatened their spiritual well-being: this was the function of the Fais-ceau. Thus *Nouveau siècle* was an "organe du faisceau des combattants, des producteurs et de chefs de famille,"[54] designed to promote the pro-ductive and combative spirit unique to each class, and to construct a social blueprint for *la cité française* conducive to Sorelian values. In this regard Valois's decision to ally his movement to fascism was no accident, for Mussolini, too, conjoined the Sorelian combatant with the producer in his conception of fascism: thus by 1919 Mussolini's paper *Il Popolo d'Italia* dropped all references to socialism from its masthead and became "the journal of combatants and producers."[55] Not surprisingly Mussolini traced the origins of fascism to the theo-ries of national syndicalism developed in the Cercle Proudhon.[56] The shared ideals animating Valois and Mussolini were dutifully noted by Valois; Valois's writings were quickly translated into Italian, and articles in Valois's journal praised the Italian fascists for having harnessed the bourgeoisie's productive capacity.[57] Industrial progress in Italy was cited as evidence of the renewed vigor of this class, and it was the fusion of construction with the productivist spirit of fascism that Valois consciously emulated in his own urban vision. At the same time Val-ois's group claimed that "French problems" demanded "French solu-tions," for French fascism could only encompass the French *cité*. Thus while *Nouveau siècle* praised the fascist spirit motivating Italian tech-nological advances, the newspaper did not eulogize Italian fascist architecture, but instead cited the work of the "French" Le Cor-busier—who was actually Swiss—as the proper model for *la cité française*.[58] To underscore the interrelation of French technological development, and bourgeois and proletarian élan, *Nouveau siècle* had a running column titled "Atelier et la cité," which defined the role of both classes in a fascist, corporate society. Thus the column's stated aim was to demonstrate "to the French the physiognomy of each social class which constitutes the nation . . . thus preparing for the reconcili-ation of people artificially separated by an abominable regime."[59] Recognition on the part of each class of its own productive and com-bative *esprit*, and the role of that spirit in the defense and reconstruc-tion of France, would lead, in the fascist paradigm, to mutual respect between classes for their roles in this collective effort. Whereas Sorel had condemned parliamentary democracy for promoting the mixture of classes, Valois's fascists condemned the same regime for instilling "artificial" divisions between classes, unreflective of the "natural" class

divisions fascism sought to resuscitate. The melding of classes in Sore-
lian theory was a result of the creation of an abstract, universal con-
cept of citizenship that failed to recognize the qualitative divisions
between classes; Valois claimed that abstract citizenship also precipi-
tated divisions unrelated to class, premised on false criteria such as
party affiliation, greed and self-interest.[60] These "artificial" divisions
were the product of democratic decadence rather than any qualitative
consciousness on the part of the bourgeois or working class, and Valois
sought to rekindle the "natural" divisions fundamental to class con-
sciousness. Thus Sorel and Valois were in agreement that the renewal
of class consciousness in both classes would ultimately reinvigorate
France through a warlike and productive "*élan vital.*" What made Val-
ois's version of the renewed *cité française* unique was the relation he
posited between the fascist spirit and the physical reconstruction of
France in the wake of World War I.

Valois, like Mussolini, wished to include town planning in the
orbit of fascist values.[61] Thus at the heart of Valois's approach to urban
planning is an association of technological development with a capac-
ity for creative invention he labeled "the spirit of victory." To under-
score that correlation, Valois's first book devoted to fascism, *The
Politics of Victory* (1925), contained a frontispiece by the former anar-
chist André de Székeley celebrating the technological advances that
had given birth to the modern city (fig. 24).[62] Subsequently *Nouveau
siècle* would describe this spirit as the product of the Great War, when
the French had abandoned the artificial class conflict created under
parliamentary democracy. Thus what Valois termed "the spirit of
defeat," a spirit typified by excessive individualism and divisive party
politics, had given way to the spirit of victory.[63] It was this effort that
created the *combattants*, the war-veterans who employed the heroic
values native to their respective class in the defense of France. Valois
had hoped that the same Sorelian spirit could overcome the "artificial"
class schism that had resulted from the reintroduction of party poli-
tics and democratic values in postwar France. In Valois's view, this war-
rior spirit, when united with the inventive spirit of production, would
awaken the energy intrinsic to all classes in the *cité française*, and
unite them in opposition against a moribund republic. Valois's fascist
revolution was then premised on the combative and productive spirit
inherent to both classes, who would identify the maintenance of their
class consciousness with the reconstruction of French values and insti-

24. André de Székeley, *Frontispiece*, reproduced
in Georges Valois, *La Politique de la victoire*
(Paris: Nouvelle Librairie Nationale, 1925)

tutions, and the assurance of the nation's health in times of peace as
well as war.[64]

Nearly two decades after Sorel formulated his theories Valois
asserted that the moral discipline and heroic action that animated the
French war effort had united all classes in defense of the nation. Thus
it was the heroism of the revolutionary citizen-soldier, rather than class
warfare initiated by the proletariat, that had reinvigorated those bour-
geois who had inhabited the trenches. When Valois announced the
founding of the fascist movement at its first rally on Armistice Day, he
was joined by 250 legionnaires who later marched with him to the Arc
de Triomphe and the tomb of the unknown soldier. The poster com-

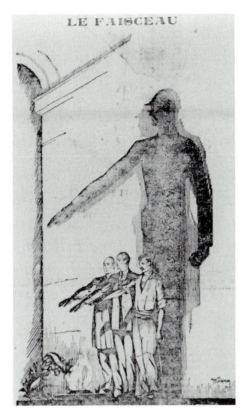

LE FAISCEAU

25. Miramey, *Le Faisceau,* reproduced in
Nouveau siècle (12 November 1925)

memorating the event (fig. 25) pictured a fascist, a bourgeois, and a
worker united by what the fascist Philippe Barrès called the "élan of
victory," the Bergsonian *élan vital* identified with the ethics produced
through heroic warfare, and signified in the poster by the ghostly
shadow of a fallen soldier.[65]

Valois, like Sorel before him, claimed that the spirit of battle
should also animate industrial production, with the result that fascism
was to fuse the soldier and the citizen, the combatant and the pro-
ducer. To Valois's mind, the task of fascism was to extend the energy
created through war into the postwar period. To do so required a
return to the ethics of production, reinforced through class conflict.

Thus the role of the fascist state would be to facilitate a collaborative but competitive relation between the proletariat, the peasantry, and the bourgeois owners of industry. "In Rome," declared Valois, "a national state, presiding firmly over the bourgeoisie, having the strong support of peasants and workers, limits and directs towards greatness the economic and social activity of the bourgeoisie." Valois then contrasted fascism's successful usage of proletarian and bourgeois energies with Soviet communism, which "suppressed the bourgeois" and proclaimed a "proletarian state." Lenin's support of one class to the detriment of another failed to realize a fundamental tenet of Sorelianism, namely that "an ardent, energetic proletariat" returns the bourgeoisie to "its creative energy."[66] In an article titled "Pour reconstituer la Cité," Valois proclaimed fascism to be hostile to the divisiveness of party politics and the domination of one class by another. Instead the fascist "national state" was "above parties and classes," and thus able to protect and preserve the "heroic values" intrinsic to each class that served as building blocks for "national values." By being neither right nor left (ni droite ni gauche), fascism would unite all classes in the construction of la cité française.[67]

Under fascism a strong working class would assure that the industrialist would put production at the top of the agenda, and properly compensate workers for their productivity. According to Valois, Henry Ford was exemplary of this collaborative spirit, for he had managed to increase production, lower the cost of goods, and simultaneously increase the wages of his workers.[68] Concurrently Valois criticized the Redressement Français, which was founded by the industrialist Ernest Mercier with the aim of emulating Ford's example in the arena of rationalized production. In a 1927 issue of Nouveau siècle Valois acknowledged his admiration for the "high discipline" entailed in the Redressement Français's focus on planned technological innovation, but condemned the group for failing to give workers a say in organizational planning. "Rational capitalism," Valois complained, "wants to make the boss the sole arbiter of change," while fascism alone "wants to realize change through the collaboration of producers issuing from all classes, and tending to form a single entity." "Fascism," Valois continued, "wants to organize worker pressure on the bosses to assure that the bourgeoisie accomplishes its historical mission, which is to help create a society of producers." Valois claimed that the very existence of Mercier's group was a healthy reaction to the success of

socialism in France and the Russian Revolution abroad, which served to vindicate Sorel's claim in *Reflections on Violence* "that capitalist productivity exists only as long as worker pressure remains, and is consciously organized."[69]

The true fascist organizer would take the worker's perspective into account in planning, a position in keeping with the unification of classes through the collective ethic animating all producers. The *cité morale* of the productive bourgeois would thus complement the *cité esthétique* of the proletariat, because both classes shared a productivist ethos. By designating Le Corbusier an "organizer" in the fascist sense (fig. 19), Valois wished to indicate that a balance should be struck between proletarian interests and those of the bourgeois, technocratic elite of which Le Corbusier was a representative. When Valois asserted that the fascist rank and file "saw their own thought materialized" on viewing Le Corbusier's urban plans, he claimed for the architect a profound understanding of the wishes of the proletariat.[70] As organizers, the proletariat had already envisioned the modern city; Le Corbusier's plans merely confirmed that vision.

The fascists, however, were very selective in their reading of Le Corbusier, emphasizing his compatibility with their conception of a society of producers and remaining silent about aspects of his plan that contradicted Valois's socioeconomic politics. Given the fact that the fascists had studied the economic implications of Le Corbusier's ideas, it is significant that the excerpts on the "Voisin Plan" in *Nouveau siècle* did not include Le Corbusier's own complex stipulations concerning social structure and class relations. Instead the extracts from *Urbanisme* quoted in *Nouveau siècle* were those most compatible with the fascists' own doctrine. Pierre Winter cited Le Corbusier's statements concerning the hygienic problems arising from urban congestion, which reveal further racist views by evoking a "zone of odors, terrible and suffocating zone comparable to a field of gypsies crammed in their caravans amid disorder and improvisation." The section quoted, taken from a chapter of *Urbanisme* titled "The Great City," was related to a larger thesis concerning humankind's progress from nomadism, exemplified by the "disorder" of gypsy encampments, to the creation of order in the form of sedentary rural and urban development: hence Le Corbusier's comparison of urban chaos to a regression to a nomadic condition, foreign to the "Cartesian" order native to the French populous.[71] In highlighting such themes Winter probably had

in mind Valois's own contrast between the nomadic Eastern "hordes" who constantly threatened France with invasion, and the sedentary French "Latins," the descendants of the Roman "legions" who had brought civilization and urban development to Gaul. This division between nomadic foreigners and civilized Latins ultimately took ideological form in the "Asian" embrace of rootless communism and the "Latin" peoples' turn to fascism. A perennial theme in Valois's writing was his condemnation of nomadism, illustrated with references to endless steppes. Allen Douglas notes that, for Valois, "the foremost value of property was that, along with the family, it fixed man geographically and broke the spirit of nomadism." To Valois's mind the communists' attack on private property was evidence of their nomadic impulse, instinctive to Asian cultures.[72] Thus in fascist imagery (fig. 26) the communists are presented as "*la horde*," the nomadic, restless masses who attack the propertied "combatant," the farmer rooted in the soil of France. Appropriately, when Winter wished to defend Le Corbusier's urban designs, the architect's implicitly racist condemnation of "nomadism" was highlighted as proof of the fascistic dimension of his town planning.[73]

That correlation also affected the fascist evaluation of modern art, for the movement's art critic, Jean-Loup Forain (son of Jean Louis Forain), condemned abstract art as a foreign incursion akin to Bolshevism, while promoting the rural landscapes of Maurice Vlaminck as the sincere expression of a French *sauvage rudesse* (fig. 27).[74] Forain's criticism echoed a widespread, racist distinction between an *Ecole de Paris*, supposedly made up of urban artists of foreign extraction, and an *Ecole Française*, whose chief representatives were Vlaminck, André Derain, Dunoyer de Segonzac, and Othon Friesz. Like other conservative critics Forain thought Vlaminck's rural landscapes, devoid of abstraction or machine-age imagery, reflected his sincere desire to "return to the soil," to rediscover the simplicity of French peasant culture.[75] Such criticism points to a paradox within fascist discourse, namely, *Nouveau siècle*'s simultaneous defense of machine-age modernism in architecture and condemnation of modernism in painting. While Le Corbusier's architecture reportedly expressed the antimaterialist and productive élan of the French combatant, its stylistic equivalent in the realm of painting was deemed a nomadic incursion, divorced from the *cité française*, and as a result Le Corbusier's purist aesthetic never won acceptance within fascist circles. The bifurcation

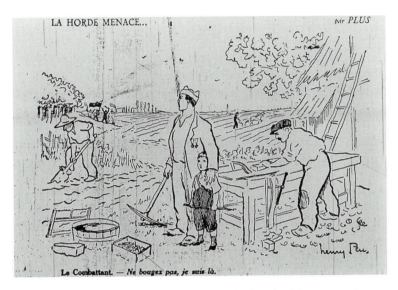

26. Henry Plu (Plus), *La Horde menace . . .*, reproduced in *Nouveau siècle* (30 April 1925)

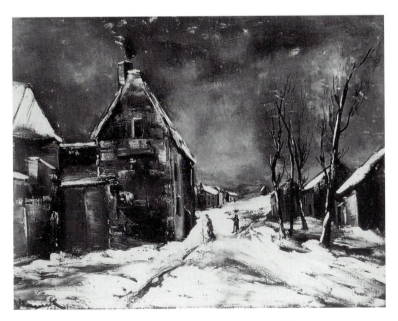

27. Maurice Vlaminck, *Neige à Auvers-sur-Oise*, 1925, oil on canvas, 90 × 116.5 cm, Private collection, France

between Forain's "return to soil" criticism and Valois's resolute embrace of modern architecture on the basis of Sorelian precepts points to an operative tension between right and left factions within the Faisceau that would eventually tear the movement apart.[76]

Fascist ideological precepts also permeated the response, in *Nouveau siècle*, to Le Corbusier's statements on class relations. Although the architect's social blueprint predicated social advancement on creative ability and expertise alone, Le Corbusier assumed that not all workers could become managers. In a section of *Urbanisme* not reproduced in *Nouveau siècle*, he stipulated that the managerial and technocratic elite—made up of engineers, industrialists, financiers, and artists—would work and live in buildings constructed in the city center, while workers would be dispersed in surrounding garden cities, far removed from the epicenter of organizational planning.[77] This scheme contradicted a fundamental tenet of fascism, namely that theory and praxis were to be merged in the guise of the producer. Since the separation of managerial and blue-collar functions contradicted Valois's aspiration to create a unified society of producers, the promoters of Le Corbusier within the fascist camp recast the architect's conception of the garden city. Under fascism, all classes would reside in the suburbs, where their constant contact would encourage a collaborative spirit. In his writings on the modern city, Valois stipulated that every region in France should possess "an economic bureau where the producers, industrialists, technicians, and workers, will be able to hold their local meetings, regulate their intersyndical affairs, and organise the social life of the sector." Since the organization of social life involved the creation of housing, each sector would likewise possess a "bureau of housing" where "construction societies" in tandem with "syndicats and communes" would plan garden cities.[78] Even before their exposure to Le Corbusier's theories, the readers of *Nouveau siècle* had encountered images of suburban utopia and familial joy meant to signal the worker's pride in his own handiwork (fig. 28). Far from isolating an urban technocratic elite from a general populous of manual laborers relegated to garden cities, Valois called for the merger of both groups in the formation of decentralized bureaus that would oversee the planning of urban development. In this manner the modern city would be "nothing other than the fasces of all energies, all the wills behind technical, social and national progress."[79] To Valois's mind the worker-producer admired Le Corbusier's modern city because it was

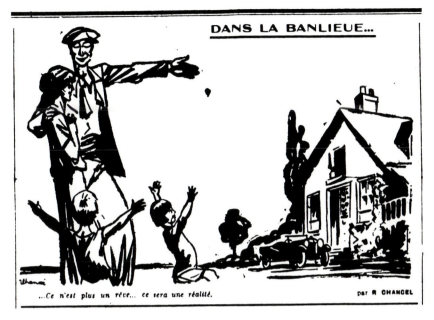

DANS LA BANLIEUE...

...Ce n'est plus un rêve... ce sera une réalité.

par R CHANCEL

28. Roger Chancel, *Dans la banlieue. . . ,* reproduced in *Nouveau siècle* (12 May 1926)

the product of that worker's own spirit of invention, a spirit denied to the proletariat in Le Corbusier's own technocratic hierarchy.

Since the architect's elitist vision had more in common with the politics of the Redressement Français than with the Faisceau, by 1928 Le Corbusier chose to promote his urban plans in that movement's journal, concurrent with the demise of Valois's Faisceau.[80] Valois's reading of Le Corbusier placed more emphasis on the spirit behind his designs than the social implications of his plans for the modern city, declaring the architect's structures to be an expression of productive *esprit* rather than technocratic elitism. Far from abandoning his faith in class conflict as an agent of national regeneration, or denying the bourgeoisie a regenerative role in *la cité française*, Valois wanted to utilize the warrior spirit and producer spirit of both classes in his fascist revolution.[81] For Valois combatants of all classes were also producers, and as such possessed the creative capacities Le Corbusier reserved for himself and his select peers. Despite Valois's seeming embrace of Le Corbusier's rationalized town planning, he claimed that all archi-

tectural ideas were the product of a vitalist "spirit of production," fully compatible with Sorel's conception of Bergsonian intuition. Bergson in his own writings had claimed that every human activity, even the most rational, was originally the product of a creative intuition, and for Valois rational planning was itself permeated with this same inventive spirit. Valois's vitalism led him to declare the garden city an organic and corporative expression of the collective will of *la cité française*; Le Corbusier, by contrast, likened the home to a monastic cell, ideally created for the single individual.[82] Thus Valois combined technological modernism and vitalism within the logic of what he termed the "mystique" of fascism, a spiritual and collective dimension to urban planning that Le Corbusier never entirely embraced.

A shorter version of this essay was presented at the Annual Conference of the College Art Association, February 1994, in a session organized by Romy Golan. My thanks go to Mathew Affron, Romy Golan, Patricia Leighten, Mary McLeod, and Anson Rabinbach for their comments on the paper. Unless otherwise indicated, all translations in this chapter are my own.

1. On Le Corbusier's political evolution over the 1920s and 1930s see Mary McLeod, "'Architecture or Revolution': Taylorism, Technocracy, and Social Change," *Art Journal* 43, no. 2 (Summer 1983), 132–47; Mary McLeod, "Le Corbusier and Algiers," *Oppositions*, no. 19/20 (Winter/Spring 1980), 53–85; and Mary McLeod, "Urbanism and Utopia: Le Corbusier from Regional Syndicalism to Vichy," Ph.D. diss., Princeton University (Ann Arbor: University Microfilms International, 1985).

2. Notable exceptions in this regard include Robert Fishman and Mary McLeod, who were among the first to explore this dimension of Le Corbusier's politics. Having noted that Valois's fascism was premised on corporatist models allied to the rational organization of production, McLeod rightly concludes that Le Corbusier "identified with the Faisceau's advocacy of technical innovation and was undoubtedly flattered by the group's admiration of his program." More recently, William Curtis has argued that while Le Corbusier's "brief flirtation" with the fascists was the result of an attraction for "the idea of a strong leader as a means to realize the true plan," he was "troubled by a system that might destroy individual liberty." Among historians, Zeev Sternhell has noted Le Corbusier's connection with Valois's group, concluding that the "taste for modernity" extant among the Faisceau leadership "was expressed as much in the Faisceau's admiration for Le Corbusier as in Valois's enthusiasm for the 'rational organization' of industrial production." See Robert Fishman, "LeCorbusier's Plans and Politics, 1928–1942," in *The Open Hand*, ed. Russell Walden (Cambridge: MIT Press),

245–83. McLeod, "Urbanism and Utopia," 99–102; William Curtis, *Le Corbusier: Ideas and Forms*, (New York: Rizzoli, 1986), 102, and Zeev Sternhell, *Neither Right nor Left: Fascist Ideology in France*, trans. David Maisel (1986; reprint, Princeton: Princeton University Press, 1995), 108.

3. For a summation of this theory, see Zeev Sternhell, "The 'Anti-materialist' Revision of Marxism as an Aspect of the Rise of Fascist Ideology," *Journal of Contemporary History* 22 (1987), 379–400.

4. On French conceptions of *la cité*, see Paul Rabinow, *French Modern: Norms and Forms of the Social Environment* (Cambridge: MIT Press, 1989), 289, 320–21, 335. The significance of the concept for Sorel has been explored by John Stanley and J. R. Jennings. See J. R. Jennings, *Georges Sorel: The Character and Development of His Thought* (New York: St. Martin's, 1985), 147–51; and John L. Stanley, *The Sociology of Virtue: The Political and Social Theories of Georges Sorel* (Berkeley: University of California Press, 1981), 260–66.

5. For the most recent study of Valois's political evolution, see Allen Douglas, *From Fascism to Libertarian Communism: Georges Valois against the Third Republic* (Berkeley: University of California Press, 1992).

6. See McLeod, "Urbanism and Utopia," 99–102.

7. See Pierre Winter, "Pour Le Grande Paris: La Ville Moderne," *Nouveau siècle* (16 May 1926), 4; "Les Animateurs: Le Corbusier," *Nouveau siècle* (9 January 1927), 1; Charles Biver, "L'Esprit Nouveau: M. Le Corbusier présente un plan de la Cité Moderne," *Nouveau siècle* (20 March 1927), 1.

8. See "Le Plan Voisin," *Nouveau siècle* (1 May 1927), 3; on Le Corbusier's slide presentation to the fascist rank and file at the inauguration of their new headquarters, see Georges Valois, "La nouvelle étape du fascisme," *Nouveau siècle* (29 May 1927), 1.

9. In May and June Valois proclaimed fascism to be a "new order" that aimed to construct a "new city" modeled after Le Corbusier's vision, while as late as July 1927, Le Corbusier was again numbered among "les animateurs," for having inspired the architecture of another modernist, Robert Mallet-Stevens. See Georges Valois, "Sur la voie glorieuse," *Nouveau siècle* (29 May 1927), 3; "Le Cycle des conférences hebdomadaires," *Nouveau siècle* (19 June 1927), 3; and "Les Animateurs: M. Mallet-Stevens," *Nouveau siècle* (31 July 1927), 1.

10. Valois, "La nouvelle étape du fascisme," *Nouveau siècle* (29 May 1927), 1.

11. McLeod, "'Architecture or Revolution,'" 133–41.

12. Ibid., 143.

13. Ibid., 137.

14. On the nationalism of the Redressement Français and the Faisceau, see, Richard Kuisel, *Ernest Mercier: French Technocrat* (Los Angeles: University of California Press, 1967), 59–61, 70–71. Mercier rejected the syndicalist and corporatist ideology that were the centerpiece of Valois's more radical program.

15. McLeod, "'Architecture or Revolution,'" 141–43.

16. The literature on Sorel is vast; particularly pertinent to the following discussion are these works: Jules Levey, "The Sorelian Syndicalists: Edouard Berth, Georges Valois and Hubert Lagardelle" (Ph.D. diss., Columbia University, 1967); Sternhell, *Neither Right nor Left*; Sternhell, "The 'Anti-Materialist' Revision of Marxism"; Paul Mazgaj, "The Young Sorelians and Decadence," *Journal of Contemporary History* 17 (1982), 179–99; Stanley, *The Sociology of Virture*; Pierre Andreu, *Notre Maitre, M. Sorel* (Paris: Grasset, 1953); and Jennings, *Georges Sorel*.

17. Sternhell, "The 'Anti-Materialist' Revision of Marxism," 379.

18. Mazgaj, "The Young Sorelians and Decadence," 179–92.

19. See the chapter titled "The Revolution of the Moralists" in Sternhell, *Neither Right nor Left*, 66–89.

20. On the interrelation of Sorel's theories and those of Bergson, see Mark Antliff, *Inventing Bergson: Cultural Politics and the Parisian Avant-Garde* (Princeton: Princeton University Press, 1993), 156–60; and Pierre Andreu, "Bergson et Sorel," *Les Etudes bergsoniennes* 3 (1952), 43–78, 170–80.

21. On Sorel's critique of Enlightenment ideology, and his opinion that proponents of "the illusions of rationalism" find their adversary in "the teachings of Bergson," see Georges Sorel, *Illusions of Progress* (1908), trans. Charlotte and John Stanley (Berkeley: University of California Press, 1969), 1–29; Georges Sorel, *Reflections on Violence* (1908), trans. T. E. Hulme (1915; reprint, New York: Peter Smith, 1941), 28–30, 157; for a good synopsis of Sorel's Bergsonism, see Richard Vernon, *Commitment and Change: George Sorel and the Idea of Revolution* (Toronto: University of Toronto Press, 1978), 50–61.

22. Sorel notes that, for rationalistic ideologies to succeed, the working class "must lose all revolutionary energy, at the same time that its masters will have lost all capitalistic energy." See Sorel, *Reflections on Violence*, 83. That Sorel drew parallels between human energy and life energy in general is made clear in the *Illusions of Progress*, wherein he compares the "spirit of invention" extant among the working class to the intuitive conception of material energy developed by Bergson in *Creative Evolution*; see Sorel, *Illusions of Progress*, 153–56.

23. Sorel, *Reflections on Violence*, 136–37.

24. Ibid., 70–71, 84.

25. Ibid., 84, 86.

26. Ibid., 98–99.

27. Ibid., 85.

28. Ibid., 130–31.

29. Ibid., 36, 39. On Sorel's fusion of the productive and artistic *esprit*, and separation of proletarian culture from a bourgeois "aesthetic education," see Jennings, *Georges Sorel*, 112–15.

30. Sorel, *Reflections on Violence*, 39.

31. Ibid., 39–40.

32. Ibid., 86–87, 90.

33. Ibid., 82–83. Ironically when Sorel wrote this he appended a footnote to the effect that "the hypothesis of a great European war seems far fetched at the moment." When war did arrive in 1914 Sorel condemned it for causing the left to capitulate to republican ideology. His association of World War I with "demogogic plutocracy" thus differed fundamentally from that of Valois. See Stanley, *The Sociology of Virture*, 293–97.

34. Ibid., 94.

35. Edouard Berth, Georges Sorel, Jean Variot, Pierre Gilbert, and Georges Valois, "Déclaration de la '*Cité française*,'" reproduced in Pierre Andreu, *Notre Maître, M. Sorel* (Paris: Grasset, 1953), 327–28. For a history of the *Cité française* project, see Jennings, *Georges Sorel*, 150–52.

36. Edouard Berth, *Les Méfaits des intellectuels* (Paris, 1914; 2d ed., Paris: Rivière, 1926), 261–64.

37. On the *cité esthetique* and *cité morale*, see Stanley, *The Sociology of Virture*, 262–66; Georges Sorel, *De l'Utilité du pragmatisme* (Paris: Rivière, 1921), 132–39, and Sorel, *Reflections on Violence*, 291–92.

38. Sorel, *Reflections on Violence*, 86–87.

39. Berth, *Les Méfaits des intellectuels*, 264–67, 211; quoted in Zeev Sternhell, with Mario Sznajder and Maia Ascheri, *The Birth of Fascist Ideology*, trans. David Maisel (Princeton: Princeton University Press, 1994), 106–7.

40. Georges Valois, "La Bourgeoisie capitaliste," *Cahiers du Cercle Proudhon* 7 (1913), 226.

41. Ibid., 232–33.

42. Ibid., 243.

43. Ibid., 245.

44. The argument that the Sorelians hoped to provoke regenerative renewal in all classes helps explain why *Indépendance* would include "bourgeois" monarchists and "proletarian" syndicalists: both groups hoped to regenerate their respective class by instilling them with Sorelian cultural values. Thus Sorel did not have to choose between an alliance with syndicalism or monarchism, but could embrace representatives of these movements under the umbrella of his cultural revolution. I would argue that Sorel saw in this cadre of monarchists and syndicalists bourgeois and proletarian representatives who could use such values to promote class consciousness within their constituencies.

45. See Sorel, "La valeur sociale de l'art," *Revue de métaphysique et de morale* (1901), 251–78; and Jennings, *George Sorel*, 113–15.

46. Sorel, *Reflections on Violence*, 290–92.

47. Sorel, *Illusions of Progress*, 182–83. Berth, in *Les Méfaits des intellectuels* noted Sorel's conclusion in "The Morality of Producers" that "revolutionary apprenticeship is identical to the apprenticeship of the producer and that the general strikers are only comparable to the artisans of cathedrals and to the soldiers of

the wars of liberty of which the epic of strikes must be the transposition on the work terrain." He attributes a decline in revolutionary fervor among the workers to their failure "to enact a moral split with bourgeois philosophy, that is the philosophy of the 18th century" (310). Sorel's 1906 essay "The Religious Character of Socialism" (*Mouvement socialiste*) compared religious feeling to socialism insofar as both are "activities of the free spirit" and unsusceptible to scientific analyses. See Georges Sorel, *From Georges Sorel: Hermeneutics and the Sciences*, ed. John Stanley (London: Transaction Publishers, 1990), x–xi.

48. Sorel, *Illusions of Progress*, 183.

49. As I have argued elsewhere, the embrace of Bergsonism on the part of Sorelians within the royalist camp created a rift between the ultrarationalist Maurras and his allies in the Cercle Proudhon. Sorel's claim that medieval corporative culture had its modern-day counterpart in an art of *le peuple* and his condemnation of the Italian Renaissance as the cultural progenitor of democratic ideals would have been anthema to Maurras, who thought the Renaissance a continuation of the Greco-Latin tradition. To Maurras's mind the gothic was Germanic in origin and thus foreign to the French Cartesian *esprit*, with its origins in the Mediterranean culture. Appropriately the royalist art critic Louis Dimier praised François I for favoring Italian art over the gothic in his designs for Fontainebleau, a discourse that provoked a heated response on the part of leftists who condemned the monarchy for corrupting an indigenous Celtic tradition allied to the medieval corporative culture of *le peuple*. The debate over whether France had its cultural origins in a Celtic or Greco-Latin tradition, an art of the Middle Ages or of the Renaissance, was cast, in Republican and syndicalist circles, in terms of a conflict between *le peuple* and their aristocratic overseers. Indeed at least one contributer to *Indépendance*, the symbolist poet Paul Fort, was a member of an organization known as the Celtic League, which actively campaigned against the Action Française in the name of medieval corporatism and gothic art. For a recent summation of Maurras's cultural politics, see David Carroll, *French Literary Fascism: Nationalism, Anti-Semitism, and the Ideology of Culture* (Princeton: Princeton University Press, 1995), 71–96; for an analysis of the role of the Celtic-Latin debate within French cultural politics before 1914, see Antliff, *Inventing Bergson*, 106–34.

50. Jean Variot, "L'exposition de la Rose-Croix catholique," *Indépendance* (July 1911), 399–401. Founded by Joséphin Péladan in 1892, the Salon de la Rose-Croix held six exhibitions between 1892 and its supposed demise in 1897; the reappearance of the salon in 1911 documented here is unrecorded in the secondary literature on the movement. Péladan's Rose-Croix exalted the art of the Italian Pre-Raphaelites and medieval Europe as evidence of the fervent Catholicism undermined by the advent of Renaissance humanism, and he numbered Puvis de Chavannes, Gustave Moreau, and Armand Point among his artistic allies. For a summation of Péladan's aesthetic theories, see Michael Marlais, *Conserva-*

tive Echoes in Fin-de-Siècle Parisian Art Criticism (University Park, Penn.: Pennsylvania State University Press, 1992), 139–47; and Robert Goldwater, *Symbolism* (New York: Harper and Row, 1979), 186–94. For an overview of the cultural politics of *Indépendence*, see Mark Antliff, "The Jew as Anti-Artist: Georges Sorel, Antisemitism, and the Aesthetics of Class Consciousness," *Oxford Art Journal* 20, no. 1 (1997), 50–67.

51. Sorel, "Histoire artistique des ordres mendiants (Louis Gillet)," *Indépendance* (December 1912), 223–40.

52. Michel Winock, "Jeanne d'Arc et les juifs," *Histoire* (November 1979), 227–37.

53. See Berth, *Les Méfaits des intellectuels*, 124–25, 149–50.

54. This subtitle was emblazened across the top of each edition of *Nouveau siècle*.

55. Sternhell, *The Birth of Fascist Ideology*, 224; and James Gregor, *Young Mussolini and the Intellectual Origins of Fascism* (Berkeley: University of California Press, 1979), 218–19.

56. According to Mussolini, Italian fascism came from "streams which had their source in Sorel, Péguy, in the Lagardelle of the *Movement Socialiste*." See Giovanni Gentile and Benito Mussolini, "The Doctrine of Fascism (1932)," in *Italian Fascisms: From Pareto to Gentile*, ed. Adrian Lyttelton (New York: Jonathan Cape, 1975), 45. Zeev Sternhell has dealt extensively with the Sorelian aspects of Mussolini's fascist ideology, noting that Mussolini embraced the Cercle Proudhon's conception of a corporatist society of producers. See the chapter titled "Mussolini at the Crossroads," in Sternhell, *The Birth of Fascist Ideology*, 195–232.

57. For instance, in an article titled "Origines françaises du fascisme," Valois noted Mussolini's stated indebtedness to Sorel, adding that the Italian fascists, unlike the Bolsheviks, had employed proletarian violence and corporatism to reinvigorate the "economic and social action of the Italian bourgeoisie." See Georges Valois, "Origines françaises du fascisme," *Nouveau siècle* (26 April 1927), 1. Evidence that fascism had "awakened" the "energies" of the Italian mercantile class was dutifully noted in an article of May 1926 charting the proliferation of private enterprise road construction under Mussolini: Fernand Rigny, "Les Autostrades Italiennes: Les créations de l'économie fasciste," *Nouveau siècle* (13 May 1926), 1–2. In 1924 a French translation of Mussolini's writings, along with an essay by Pietro Gorgolini, was published under the title *La Révolution fasciste*; it included a preface by Valois titled "Quelques Réflexions sur le fascisme." Two years later articles from *Nouveau siècle* were translated into Italian and collected into a volume with a preface by Mario Carli. See Georges Valois, "Préface," in Pietro Gorgolini, *La Révolution fasciste*, trans. Eugène Marsan (Paris: Nouvelle Librairie Nationale, 1924), vii–xii; and Georges Valois, *Il fascismo Francese* (Rome: Marino, 1926).

58. The Italian rationalists, who had adapted Le Corbusier's precepts to fascist ideology by the late 1920s, were not represented in Valois's newspaper. On

the reception of Le Corbusier among the Italian rationalists, see Richard A. Etlin, *Modernism in Italian Architecture, 1890–1940* (Cambridge: MIT Press, 1991), 249–54, 377–90.

59. Pierre Dumas, "L'Atelier et la Cité," *Nouveau siècle* (3 January 1926), 5.

60. Valois, *Le Fascisme* (Paris: Nouvelle Librairie Nationale, 1927), 12–14.

61. Mussolini's use of architecture in his campaign to associate fascism with the imperial glory of Rome has been thoroughly documented by Etlin. See Etlin, *Modernism in Italian Architecture*, 391–48.

62. Valois, *La Politique de la victoire* (Paris: Nouvelle Librairie Nationale, 1925).

63. See Valois, "La Politique de la Victoire," *Nouveau siècle* (12 November 1925), 3–4.

64. Ibid. Allen Douglas has argued that Valois thought the bourgeoisie incapable of ruling under a fascist regime, and restricted their role to the realm of production "in the service of state and nation under the combatant." While it is certainly true that Valois wished to contain and channel the regenerative energy of the bourgeoisie under a fascist state, he did not divorce the ethics of the combatant from those of the regenerated bourgeois. Thus Sorel's association of productivist energy and the *esprit guerrier* with the militant capitalist was not lost on Valois, who connected the ethics of the *combattant* with those of the *producteur*. In his 1927 address "Aux Associations de Combattant" Valois noted that the "esprit de la victoire" had not only saved France but allowed the combatants to take their place "in the country in order to fulfill their task as producers." See Valois, *Le Fascisme* (Paris: Nouvelle Librairie Nationale, 1927), 143–44; and Douglas, *From Fascism*, 68–69.

65. Philippe Barrès, "Le Sentiment de la Victoire," *Nouveau siècle* (12 November 1925), 3. For an account of the 11 November 1925 Armistice Day rally, see Douglas, *From Fascism*, 88–89.

66. Valois, "Origines françaises du fascisme," *Nouveau siècle* (27 April 1926), 1.

67. Valois, "Pour reconstituer la Cité," *Nouveau siècle* (30 July 1925), 3.

68. Valois, "Les Animateurs: M. Henry Ford," *Nouveau siècle* (13 March 1927), 1. Ford's status as an "animateur" was premised on the ethics Sorel identified with the bourgeois *cité morale*: "What Ford means is the least expensive car in the world and that the workers earn the highest wage in the world." On Sorel's correlation of the *cité morale* with the supposed ethics of American industrialists, see Stanley, *The Sociology of Virtue*, 164–65.

69. Valois, "Notre Politique Ouvrière: pour la nouvelle organisation économique," *Nouveau siècle* 1 (1 May 1927), 3.

70. Valois, "Sur la voie glorieuse et rude de la pauvreté et de la réussite," *Nouveau siècle* (29 May 1927), 1. In the same article Valois praised the "great army of technicians and this great team of constructors of the modern world

which goes from Baron Haussmann" to the "prodigious genius that is Le Corbusier." This technocratic elite, in conjunction with "the working class" were the force behind the "rational economic organization" which the Faisceau set out to develop.

71. For Pierre Winter's usage of Le Corbusier's theory of nomadism see Pierre Winter, "Pour le grande Paris: la Ville Moderne," *Nouveau siècle* (16 May 1926), 4; Pierre Winter, "La Ville Moderne," *Nouveau siècle* (8 May, 1927), 2; for the sections of Le Corbusier's *Urbanisme* reproduced in *Nouveau siècle*, see "Le Plan Voisin," *Nouveau siècle* (1 May 1927), 3, and Le Corbusier, *Urbanisme* (1925), trans. *The City of Tomorrow and Its Planning*, (1929; reprint New York: Dover, 1987), 95–99, 276–80, 294–96.

72. On Valois's theory of nomadism, see Douglas, *From Fascism*, 24–28; and Georges Valois, "L'Europe et L'Asie," *Nouveau siècle* (25 June 1925), 3. Valois's contrast between nomadic communism and latin fascism was enshrined in regular adjacent columns titled "La Horde" and "Les Légions," found on the third page of the newspaper.

73. It is rather interesting that the fascists did not emphasize Le Corbusier's association of his modernism with Greco-Latin culture, since Valois himself claimed a Greco-Latin geneology for the French *esprit*. I would conjecture that Valois's call for a total revolution, and hostility toward the Action Française, led him, in 1927, to emphasize the ultramodernism of Le Corbusier's project as the analog for a total break with past ideologies, including the Greco-Latinism of the monarchists. On Le Corbusier's "Hellenism," see Richard Etlin, "Le Corbusier, Choisy, and French Hellenism: The Search for a New Architecture," *Art Bulletin* (June 1987), 264–78; on the cultural policies of the Action Française, their impact on French modernism, and Le Corbusier's attempt to negotiate his own relation to monarchist ideology, see Kenneth E. Silver, *Esprit de Corps: The Art of the Parisian Avant-Garde and the First World War, 1914–1925* (Princeton: Princeton University Press, 1989), 17, 22–28, 103–4, 372–90.

74. For Forain's correlation of cubism with Bolshevism, and condemnation of modernists as so many "faux naïfs," vying for material success in the art market, see Jean-Loup Forain, "Promenades Artistiques: 37e Exposition des Indépendants," *Nouveau siècle* (20 March 1926), 4; for his exaltation of Vlaminck's rural landscapes as a sincere expression of his "naïveté," see Forain, "Vlaminck chez M M. Bernheim-Jeune," *Nouveau siècle* (17 December 1925), 3.

75. For a succinct analysis of the ideological and racial valences informing definitions of the *Ecole Française* and *Ecole de Paris* in French art criticism of the 1920s and 1930s, see Romy Golan, "The 'Ecole Française' vs. the 'Ecole de Paris': The Debate about the Status of Jewish Artists in Paris between the Wars," in Kenneth E. Silver and Romy Golan, *The Circle of Montparnasse: Jewish Artists in Paris, 1905–1945* (New York: The Jewish Museum/Universe, 1985), 81–87.

76. As Douglas has argued, Valois's attempt to unite both right and left

antiparliamentarians within the Faisceau dissolved by 1927, when his Sorelian idealism had succeeded in alienating those supporters who had been members of the Action Française, and powerful royalist sympathizers like the industrialist François Coty. See Douglas, *From Fascism*, 134–36.

77. Le Corbusier, *The City of Tomorrow and Its Planning*, 100–101. In addition the extracts quoted in *Nouveau siècle* did not include Le Corbusier's stipulation (on page 296 of *Urbanisme*) that plans to rebuild Paris could be financed by foreign capital, a scheme that would have been anathema to Valois.

78. Valois, "Il faut que le grande Paris ait une constitution une organisation dignes du siècle de l'automobile et de l'électricité," *Nouveau siècle* (12 May 1926), 3.

79. Ibid.

80. For an analysis of Le Corbusier's involvement in the Redressement Français, see McLeod, "'Architecture or Revolution,'" 141–44.

81. In this regard I would take issue with some aspects of Sternhell's anti-materialist thesis. In his essay on "The 'Anti-Materialist' Revision of Marxism," Sternhell claims that, on the eve of World War I, the proponents of Sorelian anti-materialism "lost faith in the revolutionary virtues of the proletariat," and therefore "turned towards the other historical force, the only one which could still serve as an agent of moral regeneration and social transformation: the Nation" (Sternhell, "The 'Anti-Materialist' Revision of Marxism," 380). As my discussion here makes clear, class conflict was still very much a part of Valois's postwar fascist plan for moral renewal, albeit "in order to reconstitute the cité." Under fascism, proletarian pressure was still to be exerted on the bourgeoisie, in order to galvanize the productive and warlike energies of that class. This conception of regeneration came directly from Sorel's *Reflections on Violence*, and serves to connect Valois's fascism to Sorel's revolutionary syndicalism. I would also question Sternhell's claim, in *Neither Right nor Left*, that Valois "waged a fierce campaign against the values and the way of life of the bourgeoisie's intellectual and moral dominance" or that fascism was to be "the gravedigger of all bourgeois virtues as of all the ills that the bourgeois order gave rise to" (95). As Valois's early distinction between the "bourgeois française" and "bourgeois capitaliste" made clear, there were virtues native to that class worth retaining; moreover for Valois, a reinvigorated bourgeoisie, animated by a productivist and combative *esprit*, was fundamental to the health of the greater whole, *la cité française*.

82. Le Corbusier, *The City of Tomorrow and Its Planning*, 70. For an analysis of this aspect of Le Corbusier's theory, see Peter Serenyi, "Le Corbusier, Fourier and the Monastery of Ema," *Art Bulletin* (December 1967), 277–78.

Waldemar George:

A Parisian Art Critic on Modernism and Fascism

Matthew Affron

I told M. Mussolini that contemporary art needs, without turning backward, to leave behind the painful dilemma of revolution and reaction. I alluded modestly to the case of Italy transgressing the rules of the game and annulling a historical law, that of materialism as defined by Karl Marx. Between communism and capitalism, that parody of individualism, between anarchy and blind restraint, Italy had found the *terza via*. The individual is free there, although governed by the law of the group. . . . Returning to the question of art, I stressed a necessity facing the twentieth-century painter: to rediscover the sense of Man. The end of a cycle, the bankruptcy of a civilization founded upon abstract ideas, upon doctrines and theories, imposes new duties upon us. Man, finally, has recourse to a human measure.

—Waldemar George

In 1933, fresh from a lecture tour in Italy, the art critic Waldemar George recounted one of the tour's main events: his audience with Benito Mussolini.[1] In that interview George had presented to the Duce a set of prescriptions and goals for contemporary European art. Specifically, he had rejected abstract and avant-gardist aesthetics as the cultural expression of an alienated and debased liberal culture ("a civilization founded upon abstract ideas, upon doctrines and theories"). He had, furthermore, called for the development of a new figurative art, an art which he believed to be more closely suited to the expression of a fascist subjectivity ("Man, finally, has recourse to a human measure"). George did not fail, in his report on the meeting, to acknowledge Mussolini's favorable response. "I thought I was dreaming," the critic commented, with evident satisfaction. "Between the visit of the British Ministers and the Meeting of the Grand Fascist Council, M. Mussolini had found the time to talk with an art critic who had come to see him in a purely private capacity." A Parisian art critic had come to Rome to present his vision for the regeneration of

contemporary art in Europe, and he used the account of the interview to convey his arguments back to a French readership.

Coming from a well-known and widely published writer on contemporary art, Waldemar George's antimodernist remarks were in themselves worthy of note. The logic of George's critique was particularly challenging because its sources and origins were actually modernist ones. As one of the critic's counterparts, Guillaume Janneau, observed in 1933: "We once knew him as a postwar recruit in small avant-garde magazines, doing battle in favor of certain arbitrary and systematic aesthetic views. . . . [Now] he attests to the persistence and power of the old classical culture. M. Waldemar George is a witness who recounts the miraculous cure of which he himself is the beneficiary."[2] Janneau applied the model of religious conversion to interpret the transformation in Waldemar George's critical positions. In fact, the circumstances of the long-term changes in the critic's viewpoint were simultaneously aesthetic and political. George had come to epitomize a distinct type of French fascist intellectual, bringing together in his art criticism the political principles of antirepublicanism, nationalism, racism, and antimaterialism. His trajectory thus sheds light on some of the specific ways in which fascist ideology intersected with the discourse of contemporary art in interwar France. If, as George's observers often noted, a prestigious critic could emerge from within the modernist camp as a fascist, this was a dangerous but very characteristic sign of the times.

Waldemar George (Georges Jarocinski) was born in 1893 in Lódz, Poland, of a Jewish family. Apparently under threat from the Russian authorities for publishing a volume of patriotic poems, George left Poland for France in 1911. There he undertook studies at the Sorbonne and collaborated on the periodical *Paris-journal* beginning in 1912. After receiving his French citizenship in 1914, George fought in the First World War.[3] The first major phase in his activity as a critic occurred between 1917 and 1922, when he wrote political commentary and cultural criticism for certain small Parisian magazines of anarchist-individualist and socialist orientation: *La Caravane*, *Les Cahiers idéalistes français*, and *La Forge*, for which he served as an editor in 1919. These small journals provided a forum for pacifist militants and intellectuals and were a point of contact for leftist politics and aes-

thetic modernism in France before the emergence of the periodical
Clarté in 1919.[4]

Thus in the immediate aftermath of World War I, at a moment
when the Allied Powers were imposing an economic blockade upon
the Soviet Union for the purpose of halting the spread of Bolshevism
in Europe, George worked to propagate the idea of revolution among
French intellectuals. Referring in one article to the recent, unsuccess-
ful Spartacist revolt in Berlin (January 1919), the critic observed that
the French public was increasingly anxious about a rising Maximalist
or Soviet wave in Europe. "Even the most narrow-minded bourgeois
has finally understood that France will not be able to remain a small
island of capitalist order and harmony. He fears Maximalism because
he knows that it corresponds to the aspirations of the masses and that
its progress will be as rapid in France as everywhere else."[5] Neverthe-
less, George asserted, artists had nothing to fear from either the revo-
lution or the proletariat whose interests it represented. Indeed, it had
come time for artists to liberate themselves from their traditional
dependence upon the leisure class.

Artists of France, instead of wailing over the fate reserved for Art, follow the example
of your Russian and German brothers, turn your gaze toward Socialism, because
the future belongs to it. And if in the bosom of the party, in the newspapers that it
publishes, in the meetings that it organizes, in the groupings that it founds, artistic
concerns seem to you to have been neglected, break open these doors, instill in the
working people a love of Beauty, work for their well being. And when the time comes
in the New City, you will have your place, which will be a place of honor. . . . The
conquests of Socialism will benefit all![6]

Waldemar George's ideal of intellectual and political engagement
was put into practice by the association that published *La Forge*, the
Ghilde des Forgerons. Adopting the Medieval blacksmith as their
emblem, the Forgerons called upon artists and intellectuals to work
for the enlightenment of workers and, in the process, help to construct
a socialist society: "On the anvil of Art, let us forge our body politic!"
From 1913 to 1920 this group sponsored various projects in the realm
of popular education, including painting exhibitions, lectures, and the-
atrical performances, and in 1920 it founded a short-lived mutualist
academy, the Université du Peuple, whose curriculum included
courses on politics, social questions, and the dramatic, musical, and
visual arts.[7] George argued strongly for the importance of this initia-

tive, referring to examples of collaboration between artistic and political avant-gardes in Central and Eastern Europe as models for an enhanced leftist engagement with modernist culture in France. "In Austria, in Germany, in Russia, the elites, who must be credited with walking hand in hand with avant-garde groups, know how to join the intelligence of popular aspirations with that of new works. One knows of the support given by the Bolshevik government to young Russian painters, and the profit that it derives from their efforts." These comments appear in an article on the cubist painter Albert Gleizes, a Ghilde des Forgerons associate who was assigned to lecture on the visual arts at the Université du Peuple.[8]

Like many other modernist sympathizers, Waldemar George based his defense of contemporary painting on a combination of aesthetic and political grounds. Making use of terms that were circulating as commonplaces within postwar discussions of modern culture, the critic interpreted the work of his favorite cubists—Gleizes, Georges Braque, Juan Gris, Jacques Lipchitz, among others—as an art of "pure conception," that is, as an idealist rather than as a naturalist art. One example of a work he praised was Gris's *Pierrot* of 1921 (fig. 29). Pierrot's form is thoroughly integrated with the elements of an abstract interior: the edge of a window curtain merges with the figure's upper arm, establishing a contour that rhymes with that of the flattened tabletop; Pierrot's mask and mouth make a shape that repeats in the glass on the table; muted blue, orange, and cream-colored overlays are linked in an independent sequence of visual relations. Through a principle of total visual metamorphosis, in other words, Gris synthesized spatial effects, material impressions, and formal structures into an intensified aesthetic totality. Yet George was no less interested in the painter's selection of subject matter. In depicting Pierrot, the melancholic mime of the *commedia dell'arte*, Gris took up a traditional symbol of artistic sensibility. He also revived a subject with a long precedent in the history of French art and literature and, in George's estimation, demonstrated cubism's positive links with the vital past of French culture.[9] Applying critical concepts commonly associated with the idea of a "return to order" after the war, Waldemar George thus identified Gris's cubism as the vehicle of a new classicism in contemporary art. Such an art, he believed, would incorporate values of "construction" and rigor into contemporary aesthetics without triggering a harmful lapse into academicism.[10]

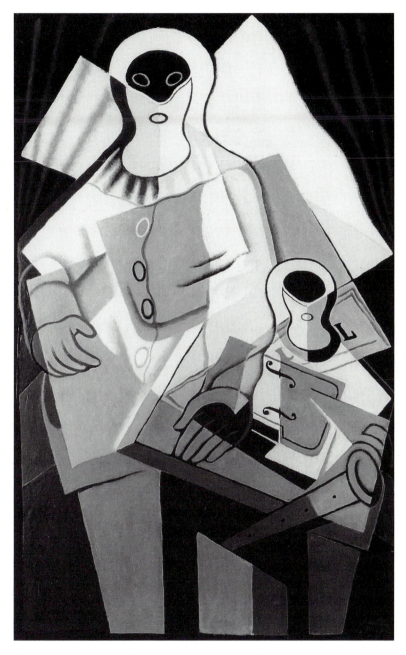

29. Juan Gris, *Pierrot*, 1921, oil on canvas, 115 x 73 cm, The National Gallery
of Ireland, Dublin

There was, furthermore, an overt political dimension to Walde-
mar George's interpretation of cubism. The critic identified the best
modernist painting, the art of "pure conception," as a mode of resis-
tance within the cultural sphere to what he saw as one of the most
alienating aspects of modern life: the progressive rationalization of
social relations and human consciousness. George located the sources
of this pernicious rationalism in certain strains of nineteenth-century
aesthetics and art practice, specifically, in Hippolyte Taine's determinist
and positivist philosophy of art and in impressionist painting. George
pursued a standard critique of impressionism, condemning the painters
of the "generation of 1867" for their use of a technique that was, he
maintained, essentially subjectivist in significance and which, he fur-
thermore asserted, tended to subsume all content to the play of formal
and visual values. "Man ceases to be, as in classic works of art, a given
painting's sole center of attraction. To the same extent as a blade of
grass, he is a part of the whole, particle, cell, tiny fragment in an
ensemble. He no longer lives by virtue of his own existence, but partic-
ipates in universal existence."[11] Seeking an antidote to the nineteenth
century's philosophical rationalism, George endorsed another tradition:
the vitalist and antirationalist political, ethical, and cultural doctrine
that was the intellectual legacy, within socialist thought, of thinkers
such as Friedrich Nietzsche, Henri Bergson, and Georges Sorel.[12] Con-
temporary abstract painting became the cultural expression of this anti-
rationalist ideal; cubism came to represent the destabilization of a
deadening and oppressive French positivism. Furthermore, George's
cultural and political analysis of cubist painting also functioned as a
challenge to the conservative agenda of a contemporary French oppo-
nent of socialist democracy: Charles Maurras, leader of the neo-royalist
Action Française. George reinterpreted the ideals of "classicism" and
"cultural order" in modernist and socialist terms specifically in order to
preempt the positions taken by the Action Française. "Contrary to what
one generally says, I believe that as a Socialist one can admire, with-
out reservation, Nicolas Poussin, Descartes, and Moréas. In our capac-
ity as lovers of order, we should even give preference to disciplined and
accomplished artists."[13] Thus George established the political force of
the modernist "return to order."

Waldemar George ceased writing in the socialist press after 1922 and
soon made his reputation as a critic in French and German contem-

porary art journals, including *L'Esprit nouveau, Das Kunstblatt*, and *L'Amour de l'art*, which he edited between 1924 and 1927. In this second stage of his career, George continued to develop a general defense of modernist styles in painting and sculpture which, together, were known under the general rubric of *l'art indépendant*.[14] George remained an advocate of the cubist painters, intervening on behalf of two of them in a controversy of 1925. Fernand Léger and Robert Delaunay had painted decorative panels for an exhibit at that year's Paris International Exposition of Modern Industrial and Decorative Arts—a project for the entry hall in a French embassy designed by the architect Robert Mallet-Stevens (fig. 30). Just prior to the opening, on the orders of one of the Exposition's organizing committees, the two works were removed; the authorities apparently found Léger's nonrepresentational composition and Delaunay's trademark abstraction on the theme of the Eiffel Tower unsuited to this particular context. After a public outcry, the works were put back on view. George wrote on behalf of Léger and Delaunay in *L'Amour de l'art*, reasoning that because these artists exemplified the best modernist interpretation of an industrialized civilization, they certainly deserved to be included in an exposition of industrial and decorative arts. The critic was subsequently thanked in print by Léonce Rosenberg, Léger's dealer and an influential backer of cubism, for his "disinterested and courageous" attitude in the matter.[15] Nevertheless, in the mid-1920s George's taste was relatively varied and inclusive. He was much interested in the post-cubist and classicizing figure painting of the late Roger de la Fresnaye, and he also defended a range of artists in whose work he recognized an expressionist and primarily emotive transfiguration of everyday appearances: Georges Rouault, Maurice Vlaminck, Amadeo Modigliani, and Marc Chagall.[16]

In the mid-1920s, George also continued to think prescriptively about art's social function. The critic believed, first, that modern painters needed not only to express the spirit of the age but also to establish a social or national rationale; that is, he believed that French modernists should work to mitigate their social isolation and should develop stronger links among themselves and in relation to the broader public.[17] Second, George constantly alerted his readers to the dangers of what he believed to be a French tendency toward the oversystematization of painting's formal elements; he regarded this incipient art-for-art's-sake attitude as a "forerunner of all academicism."[18] Thus

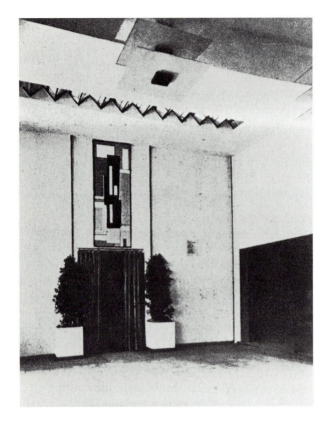

30. Robert Mallet-Stevens, Project for the entry hall in a French
Embassy at the 1925 Paris International Exposition of Modern
Industrial and Decorative Arts, with *Mural Painting* (1925) by
Fernand Léger. Photograph published in *L'Amour de l'art*
(August 1925)

George never failed to stress the artist's responsibility for avoiding a
deadening routinization of artistic technique. In other words the anti-
rationalist ideal, which had grounded George's writing during the
period of his involvement with the socialist press, persisted as the ide-
ological core of his critical program. George tended to connect partic-
ular trends within contemporary art to a broadly defined mystique of
revolt, the components of which included the ideal of political revolu-
tion, a celebration of the individual, mysticism, and an appeal to cul-
tural values thought to be foreign to, and thus potentially disturbing

to, an overly confining French rationalism. George identified the
elements of this spirit in 1927 as follows, adopting an extremely loaded
vocabulary to convey his notion of a positive revolt against the status
quo:

anarchy, a political and social system where the individual develops himself freely
without fetters, without tutelage, and without a leader, Russian Bolshevism which
has abolished a decrepit hierarchy and created a mystique, the imperialist Jewish
genius, messenger of the Orient infiltrating everywhere, contaminating the most
diverse forms of modern thought, slowly undermining the foundations of the city, Asia
the cradle of peoples that has more than once regenerated the Western spirit, Asia,
its slow but eternal force, its mysteries, its unconquered plains, its unreachable peaks,
Asia that awakens and whose call has been heard, spleen, Slavic nihilism, German
hysteria and its unending procession of *danses macabres* and its musical drama
that rocks the universe.

The marvelous, the fantastic, and the supernatural have once again bom-
barded us.[19]

While he continued to refer to political ideologies such as anar-
chism and communism, George was now particularly interested in the
problem of Eastern/Western interactions as a premise for the ideologi-
cal regeneration of France. Of course, he was hardly alone in taking
up the issue of national psychology and racial spirit during this period,
for especially in the wake of Oswald Spengler's *Decline of the West* of
1919, many European intellectuals were speculating on the fate of
Western culture and its relation to competing metaphysical, religious,
and moral systems, especially those coming from other world regions.[20]
Writing as an expatriate Pole, a naturalized French citizen, and a Jew,
George found himself well suited to advocate the dynamic and com-
pound nature of France's moral, ethnic, and demographic mix.

When one sums up the ethnic elements that form this synthesis that is France, one
soon observes that Latin blood makes up a tiny part of its composition. Even a cur-
sory summary of its demographic map is in this sense completely edifying. Peopled
by Celts in the West and Flemings in the North, France would be really ungracious
to demand the designation of exclusively Latin strength. (. . .) That said, we can rec-
ognize that the genius of France is not at all limited to a uniform mode of expression.
This genius is a god with two faces.[21]

The French genius, George asserted, had two sides: Latin and
Nordic, classic and romantic. Although he continued to treat favorably

neoclassically-inspired artists (La Fresnaye, for example), George, by 1927–28, was particularly enthusiastic about the works of those artists he associated with the romantic facet of the French spirit. He located the expression of this sensibility in various expressionist styles. One favored artist was the painter Marcel Gromaire, who worked in a Nordic and rustic mode and often painted the landscape and people of northern France. A 1924 work entitled *The Flemish Reaper* (fig. 31), to take a related example, depicts a seated peasant in the act of sharpening his scythe. The material tangibility of the peasant's body, which is set up by the blocky articulation of its parts and the studied awkwardness of its proportions, is dramatically enhanced by the severe compression of the outstretched legs against the lower edge of the picture. For George, Gromaire's rhythmic and "grotesque" figuration functioned as a salutary challenge to the material and conceptual ambiguities running through much postwar abstract art. Although we can readily imagine Waldemar George interpreting the very prominent scythe as a version of the communist sickle, it must be noted that Gromaire was not an orthodox communist and generally did not encode his images in such fashion.[22] Gromaire offered his modern archaism as a mode by which to commemorate themes of manual labor and popular sociability, and this populist streak alone would have been enough to attract George's sympathetic attention. Continuing his analysis of antirational trends in contemporary art, the critic also praised Paul Klee, Giorgio de Chirico, and the surrealists Max Ernst, Joan Miró, and Man Ray for their free investigation of matters supernatural, subconscious, and instinctual.[23] Finally, George discovered an antidote to prevailing cultural norms in works by the Jewish members of the so-called School of Paris, including Chagall, Modigliani, Lipchitz, and Chaim Soutine. Jewish art, George asserted, was by its very nature "antiformal" and elevated in spiritual terms and, for this reason, represented an expression of revolt against academic and hierarchized culture. "The Jews are the most active and dangerous agents of this effort of decomposition. Their nihilism [and] their cosmopolitanism help to chip away at the foundations of an excessively secular edifice," he wrote in 1929.[24]

By the close of the 1920s, therefore, Waldemar George tended ever more to characterize French modernism as a force of destabilization. A 1929 monograph on the art collection of Paul Guillaume, a collection whose assembly George had helped to supervise, provided

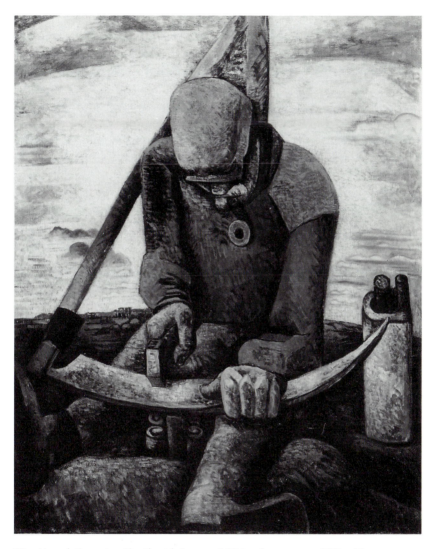

31. Marcel Gromaire, *The Flemish Reaper*, 1924, oil on canvas, 100 × 81 cm,
Musée d'Art Moderne de la Ville de Paris

an opportunity to apply this interpretive scheme to works covering an extended historical period. In this study, with a peculiar mixture of morose admiration and eagerness, the critic considered French artists from Pierre-Auguste Renoir to the young painter Jean Fautrier and perceived in their work both a dominant principle of negation and the portent of violent rupture with cultural conventions. Yet the implications of George's position plainly transcended cultural matters as such; for in this monograph, the Guillaume collection was treated as an expression of its proprietor's inchoate revolt against society at large and its standard institutions. In other words, by encouraging modern artists and by bringing their works together, this very cultivated collector actually engaged in a symbolic form of political rebellion. George sketched a dramatic portrait of Paul Guillaume: "His spirit of negation, his lofty skepticism, the scorn that he professes for the traditional order, for the political structure of his country, for laws, for the guardian institutions of the social edifice built by capitalism, make him a dangerous enemy of modern society."[25]

This provocative analysis could hardly have failed to generate a response. In his own text on the Guillaume collection, no less distinguished an observer than the French statesman Albert Sarraut—a senator affiliated with the centrist Radical Party, a former Minister of Beaux-Arts, and a noted art collector—proposed a fundamentally liberal reading of modern French art and explicitly rejected George's analysis. "If all he says were accurate, what terrible misgivings would be mine after I blindly bestowed my admiration and my friendship upon a perverse man like Paul Guillaume, who supposedly has combatted all that which I strive to defend, out of love for my country's artistic traditions as well as out of respect for its innate institutions!"[26]

Responding to Waldemar George's remarks on the Guillaume collection, Sarraut reacted to, but did not identify, a shift in agenda that was only beginning to announce itself in the critic's writing. Evidence of the precise nature of this changing agenda can be found in a short text of 1930 regarding Paul Vaillant-Couturier, the former editor-in-chief of the French Communist Party's daily newspaper *L'Humanité* and mayor of the "red town" of Villejuif. This communist politician had longstanding ties to leftist cultural and intellectual groups, having been associated around the time of the Great War with the Ghilde des Forgerons. He was also known as a modernist cultural sympathizer and, in one notable instance of 1924, took the floor in the Chamber of

Deputies to denounce the French government's meager support of contemporary art.[27] An amateur artist as well as a poet, Vaillaint-Couturier painted portraits, scenes of everyday life, and prison views, on the one hand, and on the other, archaeological and fanciful images based upon examples of prehistoric sculpture and cave painting, and imaginative depictions of biological organisms. Often loosely neo-impressionist in feeling, these compositions were alternately naturalist and primitivizing in content and form.[28]

The pretext for Waldemar George's 1930 essay was an exhibition of pictures by Vaillant-Couturier at the Galerie La Renaissance in Paris. In his text for the exhibition's catalogue, George stressed above all the imaginative and introspective elements in Vaillant-Couturier's compositions. "Fiction and reality skirt each other and sometimes collide in his works. The painter evokes the organic and biological world. . . . The rational order is, henceforth, abolished."[29] This bias toward the irrational fit squarely within George's aesthetic beliefs of the moment and, as ever, an explicit antimaterialist ideology underlined the critic's explanation of the paintings' ideological salience. George made his meaning plain in turning away from a description of Vaillant-Couturier's compositions in order to embark on a tribute to the political persona of their maker. As he had in the Paul Guillaume book, George described with enthusiasm the aesthetic self-realization of a personality in revolt. In the critic's view, the communist politician Paul Vaillant-Couturier became the incarnation of an activist and authoritarian political will. "Watching Paul Vaillant-Couturier act, I have dreamt more than once of those revolutionary workers who accomplish their task, who destroy and construct entire worlds without consulting Karl Marx." Neither dogmatist nor bureaucrat, Vaillant-Couturier, said the critic, "belongs to a generation of revolutionaries who, several long years ago, passed beyond the theoretical stage of the revolution." This political revolt, furthermore, properly took on the character of a holy crusade. "He goes to the Revolution, this ardent center, this hotbed of life that drains the forces of youth, as he would have departed, in another time, to conquer the Holy Sepulcher, the Holy Land, or another hemisphere."[30] The political implications of this analysis were unmistakable. In presenting the Communist Deputy as "justiciary of the revolution," as "tribune," as "*condottiere*," George demonstrated a new facet of his own thought: an affinity for the example and mystique of fascist Italy.

■　■　■

Waldemar George began a third stage in his career as a critic around 1930, taking up a fascist line in culture and politics. On the one hand, the critic's application of fascist terminology to pictures by Vaillant-Couturier, a man of the left, suggests that his adoption of fascism was, in effect, the continuation of the ideological trajectory that he had embarked upon more than a decade earlier. That is to say, George used fascism as a new gloss for his longstanding critique of liberal politics and his attack upon the empiricist and rationalist side of modern culture. On the other hand, the turn toward the Italian model also prompted the critic to reconsider many of his basic beliefs regarding modern art. Specifically, whereas he had recently celebrated many strains of modernist art as force for cultural destabilization and revolt, after 1930 he saw much of that same work as the expression of a liberal society irredeemably alienated and debased by its intellectualism, atheism, and materialism.

Modern art dodges the essential problems that impose themselves upon human consciousness; it levels the sacred character of the universe. It operates for its own sake only. It attests to the rupture between being and earth. . . . The dehumanized art of the machine age in which we live has produced, I will admit, some beautiful works. But just like the so-called culture of which it is the expression, this art, in contrast to the great "psychic constants" of Western man, is doomed to die out.[31]

After 1930, in other words, Waldemar George made an about-face from the mystique of pessimism and negation that had previously propelled his cultural revolt and went off in search of the "great psychic constants of Western Man." He found these expressed most purely in the classic arts of the Italian peninsula, Roman and Renaissance art, and in a "Neo-Humanist" art which, he claimed, would be the vehicle of a future spiritual, philosophical, moral, and political revolution. Defining it as a fundamentally anthropocentric and classicizing mode, Waldemar George saw this Neo-Humanism as the common destiny for contemporary art in Italy and France, and as the means by which to reshape an ethically, culturally, and spiritually diverse French civilization in authoritarian terms.[32] The critic made his most complete statements of these views in two books of the 1930s. *Profits et pertes de l'art contemporain*, a 1933 volume on nineteenth- and twentieth-century art, concluded with a short chapter attacking the League of Nations and proposing as a foundation for a new European order a modern Pax

Romana based on Roman military force, Italian culture, and the doc-
trine of the Catholic Church.[33] He followed this volume with *L'Hu-
manisme et l'idée de patrie* (1936), a strictly political tract on Italian
fascism and its consequences for Europe.[34]

George had commented on the special achievement and promise
of Italian fascism as early as 1928 when, in a monograph on the Paris-
based Italian painter Filippo de Pisis, he paid homage to the "Italian
ideology" and contrasted that system of thought to the French one.

Italy has created an ideology. Against the imperialism of French thought which rules
the universe in the domain of art, Rome today claims an opposing and properly Ital-
ian aesthetic. This exasperation of the national idea, this conscious and passionate
ethnic sentiment, this attachment to sources, can it give birth to a living, livable, and
active form of expression? I willingly believe it. Fervor has always offered a favor-
able terrain for the flourishing of artistic movements.[35]

George's negative assessment of French modernism was based on sev-
eral related points, the most notable of which were the following: first,
a critique of the avant-gardist theory of historical development in cul-
ture; and second, a repudiation of what the critic took to be the domi-
nant cultural and racial mystique of the Parisian artistic community.
The first objection rested upon George's reconsideration of the histor-
ical trajectory of successive cubist, expressionist, and surrealist trends
in French painting, the very trends that he had previously championed.
Each had incarnated, in its own time, an ideal of aesthetic revolt. Yet
the eventual institutionalization of all these currents within the cul-
tural systems of a liberal social order could only generate a fateful con-
tradiction; art was inevitably neutralized as a force of rupture and
change.[36] The critic's second objection indicated more clearly the qual-
ities that he would henceforth seek in contemporary art. Like most
observers, George regarded the Parisian art community's bohemianism
and cosmopolitanism as two of its characteristic features. As we have
seen, he had once regarded this racial heterogeneity as crucial to the
vitality of French culture. Now, from a fascist point of view, this het-
erogeneity translated into a negative effect of deracination and repre-
sented an impediment to the regeneration, in French art, of
fundamental national, religious, moral, and cultural values. Most
pointedly, George revised his views on the Jewish painters of the
School of Paris, recommending that these cultural "nomads" be fully
assimilated into the dominant culture so that their art might be safely

neutralized. The critic neatly reversed the positions that he had taken as late as 1929, posing the following question in *L'Humanisme et l'idée de patrie*: "Is the Jew's deficiency in the plastic arts the distinctive sign of the race? Was the Jew the promoter of cubism and expressionism, or did he merely find in these [artistic] movements a fertile terrain for action? Cubism complements the Jewish penchant for abstract thought. Expressionism favors the Jew's fits of pessimism."[37] If George characterized his own comments on what he called the "Jewish problem" as a "confession and a *mea culpa*," it was to acknowledge a personal conversion of a simultaneously spiritual and aesthetic sort.[38]

Waldemar George found his best examples of a Neo-Humanist painting in the work of contemporary artists who employed various Magic Realist or naturalist idioms and classicizing vocabularies. At the forefront of this trend was Giorgio de Chirico, whose meditations on Roman and Renaissance precedents, said the critic, had the effect of displacing the center of gravity of twentieth-century art and opening up new possibilities for it. *School for Gladiators: Combat*, one of several compositions executed by de Chirico in 1928–29 to decorate the Paris apartment of the art dealer Léonce Rosenberg, was a case in point (fig. 32). This image catches a dozen or so combatants in action, their bodies intertwined with the forms of several horses. While de Chirico's theme is battle, the picture's effects are finally static rather than dynamic, lyrical rather than fierce. Several of the competitors seem strangely absent-minded or lost in thought; the terrain is not a field of battle, but instead a featureless and apparently modern interior. For his part, when George considered this image, he detected effects of a sublime sort. The attenuated and elegant posing of nude bodies caused the critic to refer to the visual style of Late Antique sarcophagi and then to meditate on the moral lessons of late Roman art.

If [de Chirico] looks for instruction in the works of the "low period," it is because he discerns in these late messages from a culture on the verge of decline the generating principle of an order, a type of civilization that would transform the world. I believe with Riegl that the art of the late Empire was the product of a society nourished on neo-Platonist philosophy, a society that had ceased to believe in the reality of physical matter and no longer demanded from life or from art feelings of harmony or of happiness, [a society that] prepared a favorable ground for the victory of Christian doctrine.

According to this interpretation, the de Chirico of 1929, through the artist's pensive revival of an art in decline, paved the way for a modern

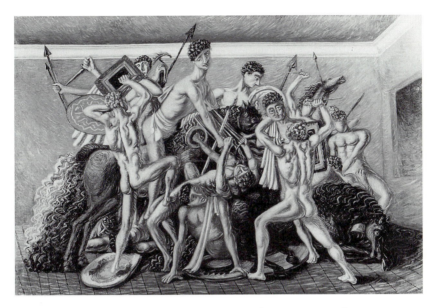

32. Giorgio de Chirico, *School for Gladiators: Combat*, 1928–29, oil on canvas,
160 × 240 cm, Museo d'Arte Contemporanea, Collezione Boschi, Milan

transformation of consciousness and, eventually, a new culture.[39] Meanwhile, putting aside consideration of any particular work by the painter, de Chirico was doubly useful to Waldemar George's Neo-Humanist argument; not only did this artist have a longstanding involvement with classical culture, but he also stood for the persistence of neoclassicism within the context of French and Italian modernism.[40]

Nevertheless, the force of the Neo-Humanist argument finally depended upon its framer's ability to demonstrate its broader development within the domain of contemporary art. George found one of his first opportunities to argue for an emerging French-Italian interchange in 1930, when he wrote a catalogue essay describing a room of some sixty paintings curated by the Italian painter Mario Tozzi for that year's Venice Biennale. In this gallery, which was given the title "Appels d'Italie" (Calls from Italy), works by Massimo Campigli, Alberto Savinio, Gino Severini, Tozzi, and other Italians were brought together with those of Paris-based artists including La Fresnaye, Amédée Ozenfant, Léopold Survage, and the younger painters Christian Berard, Eugène Berman, and Pavel Tchelitchew. George pro-

posed a collective critical and aesthetic program for these artists: "We seek above all to underscore the primacy and superiority of Italianess, considered as a cosmogony, as a style, as a manner, as an order."[41] The Neo-Humanist rubric would quickly expand to include, in addition to de Chirico and the artists seen in "Appels d'Italie," the metaphysical painter Carlo Carrà; Filippo de Pisis and other members of the so-called Groupe d'Italiens de Paris; and Mario Sironi and other painters associated with the Novecento Italiano, the modernized and Roman classicism that was defended by George's Italian colleagues Margherita Sarfatti and Ugo Ojetti.[42] The French artists that George discussed under the Neo-Humanist rubric included, apart from those involved in "Appels d'Italie," André Derain, Charles Dufresne, and the sculptor Aristide Maillol.[43] In 1929, the critic founded a fresh vehicle in which to promote his Neo-Humanist program: *Formes*, a new journal which he directed.[44]

The Neo-Humanist campaign quickly made Waldemar George a reference point within debates on modern art and cultural politics in France. An early response came from the critics Maurice Raynal and E. Tériade, who began a 1930 attack on George by recounting his recent aesthetic about-face.

Our colleague Waldemar George . . . who, two years ago, celebrated the triumph of full-scale and definitive Nordism over Latin ruins, seems for some time to have been doing penance in order to enter the orders, as it is, of Roman Art. . . . Does he wish to push further still the exteriorization of the model and does he want the painted subject always to reflect its immediate and essentially anthropomorphic preoccupations—for example the convulsions of a man hunted down by the crisis of the stock market, a domestic squabble, or the irrevocable fall of the last hair on his head? We see no difficulty in this.[45]

The mocking tone of their remarks does not obstruct Raynal and Tériade's accurate characterization of their colleague's position. For them, George exemplified a much broader trend within Parisian artistic and cultural circles: a general sense of cultural crisis that had developed in the wake of contemporary social and political difficulties, including the international economic slump of 1929, the instability of the French government, and the rise of fascism in Europe.[46] George proposed a radical solution to the dilemmas of that crisis moment—a turn toward fascism—and those who were interested in analyzing the cur-

rent cultural situation in political terms had little choice but to address his challenge. In a review of George's 1933 book, *Profits et pertes de l'art contemporain*, published in *Esprit*, a political and cultural journal representing certain younger Catholic intellectuals, Edmond Humeau, for example, offered a perspicacious analysis of the links between George's idealization of a humanist figuration, on the one hand, and his militarist and nationalist politics, on the other.

And the most significant part of this pamphlet is not, as the author imagines, a return to the living sources of the antique, but rather an apology for the force and prestige, the glorification of the portraitist, "this detective of souls," the enslavement of culture to a political myth whose reign it would accept, full-scale fascism with its nationalist "sex appeal." Art in the service of a conqueror, what human painter would not comprehend the trap into which this anthropomorphic mystique leads?[47]

Meanwhile, writing from the Marxist left, the philosopher and critic Walter Benjamin challenged George's totalitarian ideology as the extreme expression of an elitist bourgeois cultural system. "It is no accident that the Parisian critic who for years has had the most determinant authority, Waldemar George, . . . has taken the floor as a fascist. His snobbish jargon will retain its currency only as long as the art market persists in its current form. One can understand that he awaits the supposedly inevitable arrival of a 'Führer' to assure the welfare of French painting."[48] George's periodical also became a target for censure from the left. Speaking at a 1933 meeting of French antifascist writers and artists, the painter Amédée Ozenfant summarized the current state of affairs for modern art in Nazi Germany and fascist Italy in order to warn his audience about reactionary trends much closer to home. Ozenfant cited *Formes'* approbative account of the Nazi suppression of the Bauhaus as an example of the fascicization of the Parisian art press. "We used to have a so-called 'avant-garde' magazine. . .and beginning this month we can say that we have a fascist magazine. . . . I add that the magazine's director is a Jew and while they massacre the Jews over there, he publishes this article here. Well, you see, we are in Paris."[49]

During this period, on the other hand, George sometimes found himself in conflict with contemporary efforts to create a modernism compatible with totalitarian ideals. Most revealing in this regard was the critic's clash with F. T. Marinetti, the leader of Italian futurism, whose aesthetic beliefs were opposed to those of the French critic even

if his basic political loyalties were not.[50] The two debated each other on the occasion of an exhibition of Italian futurist painting at the Parisian Galerie Bernheim-Jeune in 1935. Marinetti had organized a lecture and debate in order to mark the occasion of the exhibition, and he calculated his theme in order to generate controversy: "Which will be the art of tomorrow? Futurism, cubism, surrealism, or plastic mural art inspired by these tendencies?" Marinetti convened many of the most prominent art critics in Paris—including George—and asked them "to express, if they deem it appropriate, their ideas on this important problem."[51] The proceedings opened with Marinetti's presentation of futurism within the framework of modernism. This statement was followed by a response from George, who, true to his by-now well-known positions, proposed the Neo-Humanist aesthetic as a refutation of Marinetti's views. "In a long and contemplative talk, the art critic Waldemar George developed his favorite thesis, which strives to accord the past and certain returns to classic art with the audacities of extremist innovators."[52] Under further questioning, George rejected the so-called machine style that had so strongly marked modern French and Italian art, from futurism to the work of a French artist whose painting he had previously advocated, Fernand Léger. As Marinetti recounted it, "Waldemar George replied that the Futurist-created machine aesthetic had limited the domain of art and, in order to prove his assertion, he addressed directly the painter Fernand Léger. . . ." Marinetti responded to George's challenge by instead acknowledging Léger as "a powerful aesthete of the machine."[53] Where was the disagreement? George would no longer accept aesthetic practices that looked to the machine as subject matter, as a gloss for modernity, or as a source for models of vitality, development, and progress in art.

Certainly, the George–Marinetti quarrel illustrated some of the major and recurrent tensions in the evolution of fascist cultural politics in Italy and France. Yet in a broader sense, the critic's intervention at the Galerie Bernheim-Jeune dramatized issues that touched every sector of modernist activity during the 1930s. George applied his fascist Neo-Humanism to fundamental problems of contemporary culture, two of which place him squarely in the mainstream of European debates.

The first issue sheds light on the broader resonance of the Neo-Humanist paradigm. By the early 1930s, George was only one of many French commentators and critics writing from a variety of political and

aesthetic standpoints who believed that after several decades of modernist experimentation in antinaturalist, abstract, and nonrepresentational painting, a "return" to the human subject, as art's subject matter, was now in progress.[54] Some relatively traditionalist observers, such as the critic Claude Roger-Marx, raised this topic in order to attack what they understood as the aesthetic excesses of recent decades.[55] Yet during the same period, many relatively more progressive painters and critics also engaged with the question of a "return to man"; they wished to assess emerging trends in art, and in particular to understand exactly how these new currents differed from those of the 1910s and 1920s. For quite distinct reasons, to take two examples, the painter-critic André Lhote and the art critic E. Tériade both investigated this issue. Lhote did so as part of what was for him a continuing effort to define postcubism, Tériade in order to evaluate the imaginative and often surrealist figuration typical of an emerging generation of artists.[56] The issue of a "return to man" took center stage at two conferences of 1937. In the first meeting, chaired by the poet Paul Valéry, a large group of European intellectuals met under the aegis of the League of Nations in order to discuss the theme of a "new humanism."[57] The second gathering took place during the Second International Congress on the Aesthetics and Science of Art, a conference that convened in Paris on the occasion of that year's International Exposition. One session was devoted to the problem of "humanism or formalism" as alternatives in contemporary artistic practice, and a large panel of artists, art historians, and critics—including Paul Eluard, Edouard Goerg, Albert Gleizes, Jean Lurçat, Jacques-Emile Blanche, and Waldemar George—presented papers reassessing the cultural, social, and political dilemmas stemming from the modernist doctrine of aesthetic autonomy. A single question, the issue of the human spirit's status within a mechanized culture, recurred throughout the discussion. For this reason, when George presented his Neo-Humanist doctrine to the group, he found himself at the center of a lively debate.[58]

The story of George's critical trajectory also focuses our attention on a second problem of significance within the general history of French art during the 1930s: the question of modern art's relation to state authority. Following the serious retrenchment in the French art market that was triggered by the economic slump at the beginning of the decade, commentators became increasingly concerned about the material difficulties experienced by painters, the social organization of

the profession, the education of the artist, and the government's role in patronage and in the management of culture.[59] The interventionist art policies of the Italian regime were often a point of reference in these discussions; one of the major occasions for debate was a conference sponsored by the League of Nations and timed to coincide with the 1934 Venice Biennale. The theme of this meeting was "The Arts and Contemporary Reality—Art and the State."[60] Speaking in Venice, George took the opportunity to demand, as he had many times before, that the policies of the Italian regime be regarded as the model for a new European cultural order. In a democratic system, claimed the critic, art could never break free of its alienating autonomy. Only under a totalitarian administration, he argued, could culture properly establish a profound social function.

The totalitarian state permeates the nation with an ideology. Art then becomes a function of national life. At least it can become one. . . . I think that art reassumes its rightful place in the social sphere when life in its entirety is orchestrated, has rhythm put into it, and is arranged like a beautiful work of art.

The antitheses beautiful and useful, form and theme, are some of the "conquests" of democracy. The era that is being born must put an end to this duality. The State of tomorrow will shape the soul of the people in such a manner as to make it accessible to plastic emotions.[61]

Waldemar George soon had his own chance to participate in the French state's patronage of culture, for he was appointed, along with his colleagues Claude Roger-Marx and Louis Cherronet, an Inspector attached to the Department of Works of Art at the Paris International Exposition of 1937. Remarkably, George now found himself working as an agent of the left-leaning Popular Front government, overseeing the production of decorative murals for the Palace of Discovery and Invention, a museum of science and technology, and reporting back to the Ministry of Commerce and Industry. George's opinion of the mural produced by a former ally, Fernand Léger, is not known.[62] He did find hopeful signs in some of the works that eventually decorated the Palace of Discovery, among them two panels for the museum's organic chemistry section by a painter formerly associated with cubism, André Lhote. The specifics of George's reaction are instructive. Able to set aside Lhote's liberal political stance, George admired the painter for what he saw as his humanization of an industrial subject through a modernization of Old Master technique. "The theme ['Oil, Gas, Coke Ovens'] that

was imposed upon the artist," George remarked, "was a particularly thankless one. M. Lhote has treated it with intelligence. He has avoided the impasse of a stale manner based upon mechanical elements. . . . A fantastic luminosity, a Carravagesque chiaroscuro animates his painting, some of whose parts evoke Le Nain's *The Forge*."[63] George was even more enthusiastic about the heroic and classicizing figuration that prevailed in other sections of the Exposition, notably in the sculptural and mural program of the new Trocadéro museum.[64]

In some ways, George's concept of a revolutionized French art was best represented in works by a rising generation of younger painters, and, after the conclusion of the 1937 Exposition, the critic was able to observe with satisfaction that some of those artists continued to win public commissions. Roger Chapelain-Midy's *The Grape Harvest*, a 1938 mural for the National Agronomic Institute, was one such work (fig. 33). This image is replete with classical and humanist elements. In a sober and Italianate landscape, several grape harvesters sit at a long table and are served the product of the surrounding fields. The figures are monumental, the composition's geometrical and spatial organization is measured and precise, and a feeling of stasis permeates the pic-

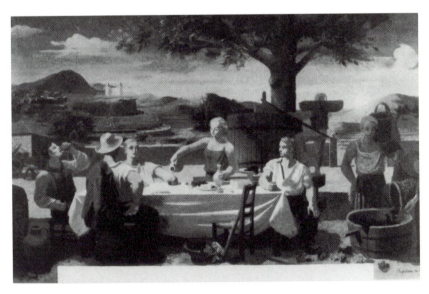

33. Roger Chapelain-Midy, *The Grape Harvest*, 1938. Reproduced in *La Renaissance* (April 1938). Institut National Agronomique Paris-Grignon

ture. Chapelain-Midy's French farmers, George declared, are descended from the peasants who appear in the works of the classical poets; this landscape, he furthermore asserted, reiterates those of a valued predecessor, Nicolas Poussin. Formally and conceptually, it appeared to George that Chapelain-Midy represented a new stage in the history of modern painting. If Giorgio de Chirico's art represented the melancholic prelude to a regenerated culture, the work of this younger artist confidently pointed the way to its realization. By the same token, if André Lhote deserved praise for reconsidering cubist technique, Chapelain-Midy seemingly reestablished vital contact with the art of the past by sidestepping the more radical dimensions of modernist practice entirely. George recommended *The Grape Harvest* as "a work [that is] healthy, powerful, replete with poetry, traditional, and brand new."[65]

Waldemar George's Neo-Humanism emerged as an explicit expression of fascist ideology rather suddenly, around 1930. It ceased to function in that way almost as abruptly, around the beginning of the Second World War. George did not have a public voice during the Vichy era, when his abundant critical output dwindled to almost nothing; little is known about his activities and circumstances during that time. He resumed work as a critic after 1945 and continued to write until his death in 1970.

The later criticism demonstrates certain elements of continuity with what came before it, from George's days as an associate of the Ghilde des Forgerons to his adoption of fascist politics. Most notably, George remained a critic of cultural crisis, viewing art as a spiritual haven in a world threatened by materialist habits of thought.[66] The critic also continued to defend artists who could be interpreted in humanist terms. Right after the war, for example, he wrote approvingly about Marcel Gimond and Robert Wlerick, two younger sculptors working the classicizing tradition of Maillol. In 1950 he coauthored a catalogue of works by Roger de la Fresnaye.[67] Nevertheless, in evident contrast to his criticism of the 1920s and 1930s, George's later writing was devoid of any specific political program. Instead, the critic adopted a more modest critical voice and simply claimed to offer a principled, rigorous, and inclusive assessment of a French culture that, at its best, would function to exemplify and to perpetuate the core values of Western art.[68] In other words, at the end of his complex trajectory, the former cultural revolutionary presented himself as a cultural conservative.

It is important to bear in mind, however, that this French art critic's fascist crusade of the 1930s was more than a passing phase within a volatile career. On the contrary, as George explained in *L'Humanisme et l'idée de patrie*, his political tract of 1936, fascism was for him the direct, organic outgrowth of the socialist and modernist positions he had taken after the First World War.[69] It was also the foundation of the aesthetic position that he was to champion later, in the years following World War II. During the 1930s George structured his aesthetic agenda according to the polarities of fascist ideology, synthesizing pessimism and idealism, bringing together modernist and anti-modernist impulses, and mixing revolutionary and reactionary themes.[70] His career as a critic provides a vivid example of the convergence of modernist visual sensibilities and fascism in interwar France.

This essay is based on research for a doctoral thesis that was supported by a Georges Lurcy Fellowship from Yale University and by a Samuel H. Kress Fellowship from the Center for Advanced Study in the Visual Arts, National Gallery of Art. Financial support for the writing of the article was provided by Grinnell College. All translations in this chapter are my own. For their help and advice, I thank Sophie Rosenfeld, Andrew Aisenberg, Robert Herbert, and Francesca Bandel.

1. Waldemar George, "Une Entrevue avec M. Mussolini," *La Revue mondiale*, n.s., 44, no. 5 (1 May 1933), 24–25. This text was republished in Italian as "Une Entrevue avec M. Mussolini," *Quadrante*, no. 3 (July 1933), 40–41. See also an unsigned report on the critic's Italian tour, "L'Art contemporain," *Formes*, no. 32 (1933), 373–74.

2. Guillaume Janneau, "'Profits et pertes de l'art contemporain.' Un bilan," *La Revue de l'art* 63, no. 343 (March 1933), 143–44.

3. Biographical information may be found in J. Janou, "Nécrologie," *Gazette des Beaux-Arts* (supplément), tome LXXIX, 114eme année, 1238ème livraison (1970), 43–44. I thank Alain Jarocinski for providing materials pertaining to the critic's career.

4. Regarding these pacifist reviews, see Jean-François Pessis, "Les Petites revues pacifistes politico-littéraires en France, 1916–1920" (Mémoire de Maîtrise, Université de Paris VIII, 1972); and Christophe Prochasson, *Les Intellectuels, le socialisme, et la guerre* (Paris: Seuil, 1993), esp. 71–93, 159–77.

5. George, "La Peur de la révolution, l'expansion de l'idée révolutionnaire et les travailleurs intellectuels," *La Forge*, no. 15 (May 1919), 355. See also George, "L'Enseignement de la défaite," *Les Cahiers idéalistes français*, no. 30 (July 1919), 150–54.

6. George, "La Peur de la révolution," 357.

7. The art historian Elie Faure inaugurated the programs of the Université du Peuple with a lecture entitled "L'Art et le peuple" at the Salle de l'Eldorado in Paris on 5 January 1920. The poet, playwright, and critic Iwan Goll describes the academy's opening session in his "Pariser Tagebuch" (1920), reprinted in Goll, *Gafangen im Kreise. Dichtung, Essays und Briefe* (Leipzig: Reklam, 1988), 322–23. For the history of the Ghilde des Forgerons, see Paul Desanges, "Chronique d'une communauté militante: Les Forgerons (1911–1920)," ed. Madeleine Rebérioux, *Le Mouvement social*, no. 91 (April–June 1975), 35–58.

8. See George, "Albert Gleizes," *La Forge*, no. 21 (November 1919), 225.

9. George, "Le Peintre Juan Gris," *Les Cahiers idéalistes*, n.s., no. 4 (December 1921), 271. See also George, "Juan Gris," *L'Amour de l'art* 2, no. 11 (November 1921), 351–52. Christopher Green analyzes the painter's adoption of the Pierrot theme in *Juan Gris* (London: Whitechapel Art Gallery, 1992), 130–35. On the importance of Pierrot within modern French art, see also Kenneth E. Silver, *Esprit de Corps: The Art of the Parisian Avant-Garde and the First World War, 1914–1925* (Princeton: Princeton University Press, 1989), 158–61; and Martin Green and John Swan, *The Triumph of Pierrot: The Commedia dell'Arte and the Modern Imagination*, rev. ed. (University Park, Penn.: Pennsylvania State University Press, 1993).

10. George, "Albert Gleizes," *La Vie des lettres* 7, no. 111 (January 1921), 353; see also "Réflexions à propos du Salon d'Automne," *Les Cahiers idéalistes*, n.s., no. 4 (December 1921), 272. Regarding the modernist "return to order," see the following: Jean Laude, "Retour et/ou rappel à l'ordre?" in *Le Retour à l'ordre dans les arts plastiques et l'architecture, 1919–1925* (Saint Etienne: Centre Interdisciplinaire d'Etude et de Recherches sur l'Expression Contemporaine, 1975); Benjamin H. D. Buchloh, "Figures of Authority, Ciphers of Regression," in *Art After Modernism: Rethinking Representation*, ed. Brian Wallis (New York: New Museum of Contemporary Art, 1984), 107–34; Silver, *Esprit de Corps*; and the essays in *On Classic Ground: Picasso, Léger, de Chirico and the New Classicism, 1910–1930*, eds. Elizabeth Cowling and Jennifer Mundy (London: Tate Gallery, 1990). See also Christopher Green's history of postwar cubism: *Cubism and Its Enemies: Modern Movements and Reaction in French Art, 1916–1928* (New Haven: Yale University Press, 1987).

11. George, "Albert Gleizes," *La Forge*, 226.

12. On this anarchist-individualist and socialist trend in twentieth-century French intellectual and artistic circles, see Prochasson, *Les Intellectuels, le socialisme, et la guerre*; and Mark Antliff, *Inventing Bergson: Cultural Politics and the Parisian Avant-Garde* (Princeton: Princeton University Press, 1993). Zeev Sternhell analyzes the politics of antimaterialist revolt in "The 'Anti-Materialist' Revision of Marxism as an Aspect of the Rise of Fascist Ideology," *Journal of Contemporary History* 22 (1987), 379–400.

13. George, "Albert Gleizes," *La Forge*, 224. On the Action Française and contemporary debates on modern art, see Silver, *Esprit de Corps*, 103–4 and passim. Waldemar George expressed anti-Maurrassian sentiments throughout the 1920s. See the following: "Le Salon des Indépendants," *Gazette des sept arts*, no. 3 (10 February 1923), 2; "Cinquante ans de peinture française," *L'Amour de l'art* 6, no. 7 (July 1925), 271; "Le Merveilleux dans l'art," *Les Arts plastiques*, no. 7 (March 1927), n.p.; and "Frankreich und die 'Neue Sachlichkeit,'" *Das Kunstblatt* 11, no. 11 (November 1927), 389.

14. George was closely associated with *L'Amour de l'art* beginning in 1920. He replaced Louis Vauxcelles as editor-in-chief of the publication in mid-1925. George was himself eventually replaced as editor by the critic François Fosca (1927–30), who later gave way to René Huyghe (1931–38). For a useful guide to the art periodicals mentioned in this essay, see Yves Chevrefils Desbiolles, *Les Revues d'art à Paris, 1905–1940* (Paris: Ent'revues, 1993).

15. See George, "L'Exposition des Arts Décoratifs et Industriels de 1925. Les Tendances générales," *L'Amour de l'art* 6, no. 8 (August 1925), 289. See also Léonce Rosenberg, "Un Incident à l'Exposition des Arts Décoratifs (suite)," *Bulletin de "L'Effort Moderne,"* no. 17 (July 1925), 13. On this project, see Christian Bonnefoi, "L'Architecture intérieure dans l'entre-deux guerres: Mallet-Stevens," in Yve-Alain Bois, Christian Bonnefoi, and Jean Clay, *Architecture arts plastiques. Pour une histoire interdisciplinaire des pratiques de l'espace* (Paris: Corda, 1979), 118–27. On the dispute surrounding the murals, see Christopher Green, *Léger and the Avant-Garde* (New Haven: Yale University Press, 1976), 298.

16. See George, statement in "Reponse à notre enquête: où va la peinture," *Bulletin de "L'Effort Moderne,"* no. 6 (June 1924), 12–13; "Etat de la peinture moderne," *Paris-journal*, no. 38 (3 July 1924), 5; and "Roger de la Fresnaye," *L'Amour de l'art* 7, no. 10 (October 1926), 317–23.

17. Here, once again, the counterexample was the Soviet one; in 1924, as a contrast to the situation in France, George cited the "concerted action" of the "Constructivists who labor in Russia to accomplish work of a collective nature." George, "Etat de la peinture moderne," 5.

18. George, "Etat de la peinture moderne," 5.

19. George, "Le Merveilleux dans l'art," n.p.

20. Chauvinist warnings concerning an ongoing European decline were put forth by thinkers associated with the Action Française, especially Henri Massis and Jacques Bainville. Others, like Paul Valéry, proposed a form of Eurocentric universalism. Still others—notably Romain Rolland, who proposed a Ghandist pacifism—were more open to influences from the East. See Spengler, *Der Untergang des Abendlandes* (Munich: Beck, 1919–22); Jacques Bainville, *Histoire de France* (Paris: A. Fayard, 1924); André Malraux, *La Tentation de l'Occident* (Paris: B. Grasset, 1926); Henri Massis, *Défense de l'Occident* (Paris: Librairie Plon, 1927); Gaston Gaillard, *La Fin d'un temps* (Paris: Editions Albert, 1932). In 1925,

a French publication undertook a broad survey of intellectuals in reference to this question: *Les Cahiers du mois, 9/10. Les Appels de l'Orient* (Paris: Emile-Paul, Frères, Editeurs, 1925). Waldemar George was not included in *Les Appels de l'Orient*, but he commented on this publication in his 1927 article entitled "Le Merveilleux dans l'art."

21. George, *Gromaire* (Paris: Editions des Chroniques du Jour, 1928), xii, xiii. George depended, in part, upon the work of the Austrian art historian and archaeologist Josef Strzygowski for his ideas about Nordic, Asiatic, and "barbarian" arts (*Gromaire*, xiv). For contemporary French-language texts by Strzygowski, see "Les Sources de l'art asiatique," parts 1–3, trans. A. Lejard and A. Prinz, *L'Art vivant* 2, no. 41 (1 September 1926), 649–52; no. 42 (15 September 1926), 712–14; and no. 43 (1 October 1926), 721–30. See also the essays by Strzygowski (1932) and Henri Focillon (1934) on the Nordic-Latin opposition, in Henri Focillon et al., *Civilisations. Correspondance, IV* (Paris: Institut International de Coopération Intellectuelle, Société des Nations, 1935), 75–127, 131–65.

22. For Gromaire's nonconformist views on contemporary politics and society, see the painter's diary, published as *Peinture 1921–1939* (Paris: Denoël/Gonthier, 1980); see also the essays that have been republished in *Marcel Gromaire* (Paris: Musée d'Art Moderne de la Ville de Paris, 1980).

23. See George, "Frankreich und die 'Neue Sachlichkeit,'" 393; *Gromaire*, xvi–xvii; and "Le Merveilleux dans l'art," n.p.

24. George, *Jüdische Künstler unserer Zeit* (Zürich: Salon Henri Brendle, 1929), 8.

25. George, *La Grande peinture contemporaine à la collection Paul Guillaume* (Paris: Editions des "Arts à Paris," n.d. [1929]), 14–16. Waldemar George was an advisor to Paul Guillaume during this period. On Guillaume, see Colette Giraudon, *Paul Guillaume et les peintres du XXe xiècle de l'art nègre à l'avant-garde* (Paris: Bibliothèque des Arts, 1993).

26. Albert Sarraut, *Variations sur la peinture contemporaine. Conférence faite à l'occasion de l'Exposition de la collection de M. Paul Guillaume à la Galerie Bernheim Jeune le 4 Juin 1929* (Paris: Editions des Quatre Chemins, 1930), 71. Sarraut's early career had been in journalism and, in the 1890s, he had published some art criticism in the Parisian journal *L'Artiste* and elsewhere. This politician was Minister of Public Instruction and Minister of Beaux-Arts in 1914–15, and was Minister of the Interior in 1926–28. See Institut de France, Académie des Beaux-Arts, *Installation de M. Albert Sarraut* (Paris: Typographie de Firmin-Didot et Cie, 1953), 4–5; and *Dictionnaire des parlementaires français*, vol. 8 (Paris: Presses Universitaires de France, 1977), 2960–62. Waldemar George devoted an article to Sarraut's art collection in 1939: "La Collection d'un homme d'état," *L'Art vivant*, no. 23 (July 1939), 28–32.

27. Vaillant-Couturier came from an artistic family, counting among his rela-

tives the painter Albert Besnard. He edited *L'Humanité* in 1926–29 and 1931–37 and, in addition to serving as mayor of Villejuif, served in the Chamber of Deputies between 1919–28 and 1936–37. Vaillant-Couturier's speech of 1924 is published in full in the *Journal officiel de la République Française. Débats parlémentaires, Chambre de Députés*, no. 136 (9 December 1924), 4256–60; it is exerpted in the *Bulletin de "L'Effort Moderne,"* no. 13 (March 1925), 7–11. For biographical information, see the *Dictionnaire des parlementaires français*, vol. 8, 3140–41. I would like to thank Marie-Claude Vaillant-Couturier for discussing her husband's work with me.

28. The prison views were painted at the Santé prison where Vaillant-Couturier was incarcerated, on three separate occasions, for producing antimilitarist publications. The primitivizing works are related to his activity as an amateur paleontologist near his home in the Ariège; among his publications was a report coauthored with Ida Vaillant-Couturier Treat on "La Grotte azilienne du 'Trou Violet' à Montardit (Ariège)," *L'Anthropologie* 38, nos. 3–4 (1928), 217–43. Paintings by Vaillaint-Couturier can be seen in the Salle Vaillant-Couturier at the City Hall in Villejuif.

29. George, [untitled essay], in *Exposition Paul Vaillant-Couturier* (Paris: Galerie La Renaissance, 24 March–5 April 1930), n.p. See also the following review of the exhibition: [Le Triangle rouge], "Ici et là," *Les Arts à Paris*, no. 17 (May 1930), 13.

30. George, in *Exposition Paul Vaillant-Couturier*, n.p.

31. George, response to a survey entitled "Art ancien—art moderne," *L'Intransigeant* (9 February 1931), 5.

32. See George, "Ex Roma Lux," *Formes*, no. 8 (October 1930), 21–24; "Homo Sum Humani Nihil A Me Alienum Puto," *Formes*, no. 11 (January 1931), 2; "Essai sur le portrait, suivi de quelques considérations sur l'art romain tardif et sur l'art de ce temps," *Cahiers de Belgique* 4, no. 3 (March 1931), 100–110. Christopher Green examines some of Waldemar George's positions in "Classicisms of Transcendence and of Transience: Maillol, Picasso, and de Chirico," in *On Classic Ground: Picasso, Léger, de Chirico and the New Classicism*, eds. Elizabeth Cowley and Jennifer Mundy, 278–80.

33. See the chapter entitled "Europe ou internationale" in George, *Profits et pertes de l'art contemporain* (Paris: Editions des Chroniques du Jour, 1933), 154–56. See also the critic's preface to the Italian edition of this 1933 volume, a prologue that takes the form of a letter to the book's Italian translator, Ardengo Soffici, in which Waldemar George comments on the meanings of a fascist culture of "Latin Humanism." George, *Profitti e Perdite dell'Arte Contemporanea*, trans. Ardengo Soffici (Florence: Vallecchi Editore, 1933), 7–10.

34. George, *L'Humanisme et l'idée de patrie* (Paris: Bibliothèque Charpentier, 1936). George addressed the meaning of Italian fascism in the second chapter, "Perspectives fascistes," as well as in his "Réponse à une enquête sur la dictature faite par la revue romaine *Antieuropa*," which was reprinted as the vol-

ume's first appendix. The long central portion of *L'Humanisme et l'idée de patrie*, "Valeurs françaises," presents an outline for the "national *redressement*" of France. See also, for a more concise presentation of George's authoritarian, nationalist, and spiritualist position, the interview by Bernard Champigneulle, "Témoignages sur l'art contemporain, X: Waldemar George," *Courrier royal* (11 July 1936), 7.

35. George, *F. de Pisis* (Paris: Editions des Chroniques du Jour, 1928), i.

36. George, "Retour de l'Italie (lettre ouverte à Georges Marlier)," *Cahiers de Belgique* 2, no. 6 (June 1929), 210–12. Waldemar George developed this critique of modernism in many other texts, notably the following: "Le Crépuscule des idoles. Lettre ouverte à M. Paul Guillaume," *Les Arts à Paris*, no. 17 (May 1930), 7–13; "La Crise de l'optimisme moderne et l'agonie d'un mythe," *Formes*, no. 12 (February 1931), 18–19; "Genèse d'une crise," *L'Amour de l'art* 13, no. 8 (September–October 1932), 267–77; and a 1934 commentary on the idea of *l'art indépendant*, "L'Art indépendant et la tradition," in *Exposition internationale. Paris 1937. Congrès international de l'art indépendant. Compte rendu des travaux du congrès 7,8,9,10 juin* (Paris: Comité d'Organisation, n.d. [1937]), 47–53.

37. George, *L'Humanisme et l'idée de patrie*, 218. The critic began making statements of this kind in 1931: see "Ecole française ou école de Paris," parts 1 and 2, *Formes*, no. 16 (June 1931), 92–93; no. 17 (September 1931), 110–11; the "Enquête sur l'art français," *Formes*, no. 20 (December 1931), 180–94; *Lasar Segall* (Paris: Editions 'Le Triangle' [1931]); and "L'Art français et les valeurs humaines," text published in *La Revue hebdomadaire* and excerpted in *Le Mois*, no. 41 (May 1934), 259. Romy Golan discusses Waldemar George's changing attitudes toward the Jewish artists of France in *Modernity and Nostalgia: Art and Politics in France Between the Wars* (New Haven: Yale University Press, 1995), 152–54. Golan compares George to the art critic Camille Mauclair in "From Fin de Siècle to Vichy: The Cultural Hygienes of Camille (Faust) Mauclair," in *The Jew in the Text: Modernity and the Construction of Identity*, eds. Linda Nochlin and Tamar Garb (London: Thames and Hudson, 1995), 156–73.

38. George, *L'Humanisme et l'idée de patrie*, 219.

39. George, "Appels du Bas-Empire. Georges de Chirico," *Formes*, no. 1 (January 1930), 13. Jean Clair alludes to de Chirico's "melancholy" sense of history in "Les Données d'un problème," in *Les Réalismes, 1919–1939* (Paris: Centre Georges Pompidou, 1980), 10.

40. See also George, *Chirico* (Paris: Editions des Chroniques du Jour, 1928). On the gladiator pictures and the project for the Rosenberg apartment, see *De Chirico: gli Anni Venti* (Milan: Mazzotta, 1987), 154–73; and Christian Derouet, "Un Problème du baroque italien tardif à Paris," in *Giorgio de Chirico*, eds. William Rubin et al. (Paris: Centre Georges Pompidou, 1983), 111–35. See also Maurizio Fagiolo dell'Arco, "De Chirico in Paris, 1911–1915," in *De Chrico*, ed. William Rubin (New York: Museum of Modern Art, 1982), 11–34.

41. See George, "Appels d'Italie," in *XVII Esposizione Biennale Inter-*

nazionale (Venice: n.p., 1930), 93. See also George, "La XVIIIe [sic] Biennale de Venise," *Formes*, no. 7 (July 1930), esp. 20–21.

42. Closely linked to Mussolini, Margherita Sarfatti supported the development of a modern fascist aesthetic through her publications and her work within various official art institutions. Sarfatti helped to found the Novecento movement in 1925. On the Novecento Italiano, see Rossana Bossaglia, *Il "Novecento Italiano": Storia, Documenti, Iconografia* (Milan: Feltrinelli, 1979). On the Groupe d'Italiens de Paris, see Nicoletta Boschiero, "De Pisis con gli 'Italiens de Paris,'" in *De Pisis, gli anni di Parigi: 1925–1939*, ed. Giuliano Briganti (Verona: Galleria del Scudo, 1987), 231–36. On Tozzi, see Maurizio Fagiolo dell'Arco, *Mario Tozzi 'Italien de Paris'* (Rome: Bulzoni, 1990). Among Waldemar George's many commentaries on Italian artists, see the following: "Hannibal ad portas (Lettera Aperta al sig. Jacques Guenne)," in *Prima Mostra di Pittori Italiani Residenti a Parigi* (Milan, 1930); the critic's review of a 1935 exhibition at the Musée du Jeu de Paume in Paris, "L'Art italien des XIX et XX siècles," reprinted in Comitato Italia-Francia, *La Mostra d'Arte Italiana del '800 e 900 al Jeu de Paume Nella Stampa Francese* (Venice: Officine Graffiche Carlo Ferreri, 1935), 40–53; and *La Peinture italienne et le destin d'un art* (Paris: Les Editions Nationales, 1935), 45–46.

43. George, "Essai sur le portrait, suivi de quelques considérations sur l'art romain tardif et sur l'art de ce temps," *Cahiers de Belgique* 4, no. 3 (March 1931), 100–110; *Profits et pertes de l'art contemporain*, 150; "Le Neo-Humanisme," *L'Amour de l'art* 15, no. 4 (April 1934), 359–62; "Le Nouveau Trocadéro," *L'Art et les artistes*, 33, no. 177 (May 1937), 275; and Charles Vildrac, Claude Roger-Marx, and Waldemar George, "Charles Dufresne," *La Renaissance* 21, no. 5 (November 1938), 2–12.

44. Published simultaneously in French- and English-language editions, *Formes* appeared ten times a year beginning in January 1930. In March 1932, the magazine absorbed *Cahiers de Belgique*, a Brussels-based art periodical. *Formes* continued until 1933, then was itself incorporated into *L'Amour de l'art*. Soon after, George rejoined the managing committee of *L'Amour de l'art*. On the merging of *Formes* with *L'Amour de l'art*, see "Aux lecteurs de *Formes*," *L'Amour de l'art* 15, no. 1 (1934), n.p.

45. Les Deux Aveugles (Maurice Raynal and E. Tériade), "'Provisoire,'" *L'Intransigeant* (18 November 1930), 7.

46. For a synthesis, see Jean Laude, "La Crise de l'humanisme et la fin des utopies. Sur quelques problèmes de la peinture et de la pensée européennes, 1929–1939," in *L'Art face à la crise, 1929–1939* (St. Etienne: Centre Interdisciplinaire d'Etude et de Recherches sur l'Expression Contemporaine, 1980), 295–391.

47. Edmond Humeau, "Transmission des pouvoirs," *Esprit*, no. 18 (1 March 1933), 1026. On *Esprit* and its intellectual context, see Jean-Louis Loubet del Bayle, *Les Non-conformistes des années 30, une tentative de renouvellement de la pensée politique française* (Paris: Editions du Seuil, 1987 [1969]).

48. Walter Benjamin, "Pariser Brief (2). Malerie und Photographie" (unpublished book review for *Das Wort*, 1936), in *Gesammelte Schriften*, vol. 3, ed. Hella Tiedemann-Bartels (Frankfurt am Main: Suhrkamp Verlag, 1972), 498.

49. Amédée Ozenfant, in *Ceux qui ont choisi. Contre le fascisme en Allemagne. Contre l'impérialisme français*, eds. Henri Barbusse et al. (Paris: l' A.E.A.R., 1933), 15–16. Ozenfant was reacting to the following comment in *Formes*: "Whatever may be its value, the National Socialist Party, which is a young party oriented toward the future, sniffs out in the art instruction at Dessau, where Klee and Kandinsky taught in a setting that was worthy of 'Metropolis,' the cult of an abstract, magic language, [and] a spiritual, moral, and esthetic atomization of both man and citizen." See "Un Bilan et un programme. Peinture, achitecture, art décoratif," *Formes* no. 31 (1933), 341. George later made an extended presentation of the situation in Germany: "L'Art et le national-socialisme," parts 1 and 2, *Beauxarts* 75, no. 241 (13 August 1937), 1, 6; no. 242 (20 August 1937), 2.

50. On the second phase of futurism and the movement's relation to the fascist regime, see Enrico Crispolti, "Second Futurism," in *Italian Art in the 20th Century: Painting and Sculpture, 1900–1988*, ed. Emily Braun (London/Munich: Royal Academy of Arts/Prestel-Verlag, 1989), 165–71.

51. "Les Futuristes italiens" (Paris, Galerie Bernheim-Jeune, 6–27 April 1935). The invitation to Marinetti's lecture and other documents pertaining to the exhibition are in the archives of the Galerie Bernheim-Jeune, Paris.

52. F. T. Marinetti, "Quale Sarà l'Arte di Domani?" *Stile futurista* 2, no. 8/9 (May 1935), 3.

53. Ibid. Soon afterward, during a banquet that was jointly sponsored by a group called "Les Amis de 1914" and by the Académie de la Coupole, a Montparnasse artistic and intellectual association, Léger lauded Marinetti for his defense of aesthetic modernism. "Without Marinetti, my friends, we would have been drowning in an unbearable Pre-Raphaelism and Michelangelism." Léger's statement is recorded in a summary of the evening by Fernand Lot, "Le Feu futuriste de Marinetti embrase les 'Amis de 1914. . .'" *Comoedia* (23 April 1935), 3. See Giovanni Lista, "La Poétique du cubo-futurisme chez Fernand Léger," in *Fernand Léger*, ed. Hélène Lassalle with Joëlle Pijaudier (Milan: Mazzotta, 1990), 43–44.

54. See Laude, "La Crise de l'humanisme et la fin des utopies," 295–391; Bernard Ceysson, "Réalismes/figurations," in *L'Art dans les années 30 en France* (Saint Etienne: Musée d'Art et d'Industrie, 1979); and Golan, *Modernity and Nostalgia*, 85–104.

55. See, among Roger-Marx's many essays on this subject: "A propos d'une exposition de portraits," *L'Amour de l'Art* 9 (1928), 105–7; *Le Portrait en France. Propos sur l'art français*, IV (Paris: Besins & Cie./Laboratoires Lebeault, n.d.); and the preface to *Réhabilitation du sujet*, exh. cat. (André J. Seligman, Paris, 17 November–9 December 1934), 13–21.

56. See Tériade, "De la nature morte à la nature vive," parts 1 and 2, *L'In-*

transigeant (11 May 1931), 5; and (18 May 1931), 5. Tériade reiterated these ideas in articles for *Minotaure*, the journal he founded together with Albert Skira in 1933; see especially Tériade, "Emancipation de la peinture," *Minotaure*, nos. 3–4 (1933), 9–20; "La Peau de la peinture," *Minotaure*, no. 7 (1935), n.p.; and "Constance du fauvisme," *Minotaure*, 2d ser., no. 9 (1936), 1–3. When Lhote touched upon this issue in an essay of 1934, he was careful to distance himself from George's Neo-Humanism. See Lhote, "Sur la matière picturale," *Nouvelle revue française* 23, no. 254 (1 November 1934), 786–90; this text is reprinted in Lhote, *Parlons peinture* (Paris: Denoële et Steele, 1936), 281–87.

57. The conference entitled *Entretiens VI: Vers un nouvel humanisme* (Paris: Institut International de Coopération Intellectuelle, 1937) was one installment in a series of debates sponsored by the International Institute of Intellectual Cooperation, an agency that had been established by the League of Nations in 1924 to coordinate international activity in the sciences, letters, and arts. See Société des Nations, *L'Institut International de Cooperation Intellectuelle* (Paris, n.p.: 1930), 5–9.

58. See *Deuxième Congrès International d'Esthétique et de Science de l'Art. Paris 1937*, vol. 2, *Livre VI: L'art contemporain, 1: Humanisme ou formalisme* (Paris: Librairie Félix Alcan, 1937). The interventions at this meeting included: Gleizes, "Cubisme et surréalisme: deux tentatives pour redécouvrir l'Homme" (377–80); Eluard, "Physique de la poésie. Picasso, Ernst, Dalí" (380–83); Lurçat, "Cubisme—arts abstraits" (387–89); Goerg, "De quelques rapports de la technique avec l'expression" (406–9); Blanche, "Le Portrait et l'art vivant" (416–19); George, "La Crise de l'art et la crise de l'homme" (419–23).

59. For a contemporary presentation of this issue, see Jacques-Emile Blanche, *Les Arts plastiques* (Paris: Les Editions de France, 1931), 501–9. Regarding the effects of the slump on the Parisian art market, see Malcolm Gee, *Dealers, Collectors, and Critics of Modern Painting: Aspects of the Parisian Art Market*, vol. 1 (New York: Garland, 1981), 283–85; and Raymonde Moulin, *The French Art Market: A Sociological View*, trans. Arthur Goldhammer (New Brunswick, N.J.: Rutgers University Press, 1987), 19–20.

60. The conference proceedings are recorded as *Entretiens IV: L'Art et la réalite, l'art et l'état* (Paris: Institut International de Coopération Intellectuelle, 1935). For an overview of the Italian state's management of various national cultural institutions, see Philip V. Cannistraro, "Fascism and Culture in Italy, 1919–1945," in *Italian Art in the 20th Century: Painting and Sculpture, 1900–1988*, ed. Emily Braun, 147–54. See also, in the present volume, Marla Stone, "The State as Patron: Making Official Culture in Fascist Italy."

61. George, in *Entretiens IV: L'Art et la réalité, l'art et l'état*, 295. The critic reported on the 1934 conference in "Le Congrès international d'art moderne, à Venise," *L'Art vivant* 10, no. 189 (October 1934), 416.

62. It is worth noting, however, that by this date Waldemar George was cat-

egorical in his condemnation of Léger's post-cubist abstraction. See Matthew Affron, "Fernand Léger and the Spectacle of Objects," *Word and Image* 10, no. 1 (January–March 1994), 19–20. For an analysis of Léger's mural for the Palace of Discovery, *Le Transport des forces*, see Rosi Huhn, "Art et technique: la lumière," in *Paris 1937. Cinquantenaire de l'Exposition Internationale des Arts et des Techniques dans la Vie Moderne* (Paris: Institut Français d'Architecture and Paris-Musées, 1987), 400–401.

63. George, typescript report in Archives Nationales, Paris, F12 12181, "Palais de la Découverte/Commandes/Peinture." For a reproduction of Lhote's mural, see *Paris 1937. Cinquantenaire de l'Exposition Internationale des Arts et des Techniques dans la Vie Moderne*, 370. On the Palace of Discovery, see Pascal Ory, "Une 'Cathédrale pour les temps nouveaux'? Le Palais de la Découverte (1934–1940)," in *Masses et culture de masses dans les années 30*, ed. Régine Robin (Paris: Les Editions Ouvrières, 1991), 180–204.

64. See George, "Le Nouveau Trocadéro," *L'Art et les artistes* 33, no. 177 (May 1937), 265–79.

65. George, "L'Exposition des commandes de l'état à l'Ecole des Beaux-Arts," *La Renaissance* 21, no. 2 (April 1938), 43. Chapelain-Midy conveyed his views on art in an interview of 1935, "Examens de conscience, 1. Chapelain-Midy," *L'Amour de l'art* 16, no. 2 (February 1935), 63–66. For a general study of the painter's work up to 1944, see Bernard Champigneulle, *Chapelain-Midy* (Paris: Editions du Vieux Colombier, 1944). Héliane Bernard traces the appearance, in interwar French painting, of the theme of wine and its harvest: *La Terre toujours réinventée. La France rurale et les peintres, 1920–1955* (Lyon: Presses Universitaires de Lyon, 1990), 202–28.

66. See George's collection of essays entitled *L'Art traqué* (Paris: ARTED, 1968).

67. See George, "Jeunes sculpteurs," in *Jeunes sculpteurs français* (Paris: n.p., 1946), 9–66; and Raymond Cogniat and Waldemar George, *Oeuvre complète de Roger de la Fresnaye* (Paris: Editions Rivarol, 1950).

68. See George's preamble to a volume of shorter critical essays, *Paradoxes sur l'art* (Pully-Lausanne: Pierre Cailler, 1960), n.p.

69. See "Le Chemin de Damas," the preface to George's *L'Humanisme et l'idée de patrie*, 9–16.

70. On the polarities of fascist ideology, see the introduction to this volume and Roger Griffin, *The Nature of Fascism* (London: Pinter Publishers, 1991), 46–48.

The State as Patron:
Making Official Culture in Fascist Italy

Marla Stone

The Italian fascist dictatorship in 1932 commissioned a new facade for the main pavilion at the Venice Biennale of International Art, the biannual exhibition of international art first held in Venice in 1895. The government-commissioned facade offers a physical representation of the eclectic and complex arts patronage style characteristic of Italian fascism. As a visible emblem of official taste in high culture, the regime's choice to adorn the Venice Biennale provides revealing insights into fascist cultural politics. The Venice Biennale was the most prestigious and well-known international event on Italian soil and, as such, the institution was of great importance to the fascist regime, which treated it as the linchpin of its arts patronage network. The extensive attention and funding directed toward the Biennale by the offices and functionaries of both the government and the party between 1928 and 1942 made it a locus for evolving fascist arts patronage styles and strategies.

The preexisting Venice Biennale facade built in 1914 stood in a heavily ornamented neo-Renaissance style that utilized classical orders, decorative marble motifs, and two towers. The 1914 facade was composed of four modified Corinthian pilasters surrounding a door, above which appeared the words *Pro Arte* (For Art), and a large brass relief of the lion of Saint Mark, Venice's patron saint and symbol (fig. 34).

In contrast, the new fascist-commissioned rationalist facade of 1932, designed by Dullio Torres, replaced the detailed portico with simple, clean lines. Ornamentation disappeared, reduced to linear form, as in the cornice and archway (fig. 35). This facade, declared the government-run architecture journal, is "modern and synthesizes a motif of classical flavor."[1] It has four simple columns under a linear, non-ornamental pediment. The inscription *Italia*, in large marble sans serif lettering, replaced *Pro Arte*. The winged Lion of Saint Mark now

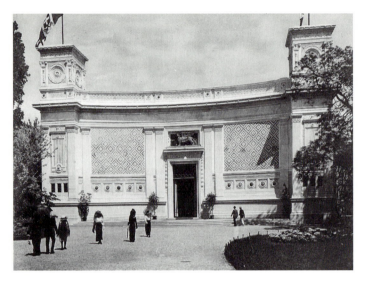

34. Main Pavilion, Venice Biennale of International Art, facade by
Guido Cirilli, 1914

shared the facade with the fascist symbol, the imperial eagle grasping a
fascio littorio. The central theme of the facade has become Italy, not
arte or Venice. Aesthetically and iconographically, the old facade spoke
to pre-fascist elites through historically loaded referents. The signs of
the new facade read the Nation and the Party. A facade in a function-
alist, rationalist style implied an environment of openness to new aes-
thetic forms, as well as to expanded audiences bringing with them
different kinds of cultural literacy.

The fascist-commissioned Venice Biennale facade presented a
mix of concurrent messages: of hybridity and heterodoxy emblematic
of fascist arts patronage. It simultaneously pursued modernity, sim-
plicity, monumentality, and classicism. The blend of classical elements
with functionalist ones, of historical references with contemporary
ones projected a decision to mix and combine, rather than exclude.
Through the facade's iconography can be read an approach to cultural
politics that I call hegemonic pluralism—the acceptance, appropria-
tion, and mobilization of a variety of aesthetic languages in the pur-
suit of consent and legitimation and in the search for a representational
language evocative of the fascist new era. Arts patronage under fas-

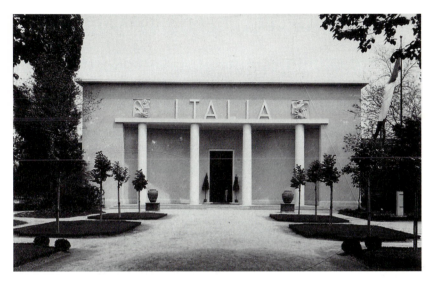

35. Main Pavilion, Venice Biennale of International Art, facade by Dullio Torres, 1932

cism accommodated and appropriated modernism and applied it to the Italian fascist context, taking elements from the international modernist movement and from the historical avant-gardes. The opposing aesthetics of the avant-garde and the traditional, from futurism to neoclassicism to abstraction, all received state patronage under fascism. Flexible patronage produced an official culture that simultaneously commissioned the glass and steel buildings of rationalist/functionalist architecture and neo-Roman equestrian monuments.

The Mussolini dictatorship developed a complex and eclectic system of state arts patronage. The government and the party promoted, through a vast program of exhibitions, competitions, commissions, and purchases, an extensive fine arts culture, attracting, for most of the dictatorship, large numbers of artists and spectators. Fascist cultural politics followed neither the market-fuelled pluralism of the liberal democracies nor the centralized antimodernism of Nazi Germany. For the greater part of the fascist era, the regime sought, above all, the consent of artists, and the association between art and the state was one of mutual recognition and legitimation under official tutelage. The Mussolini dictatorship allowed artists to work and be supported without direct censorship as long as they were not explicitly antifascist.

With a patronage system composed, in varying degrees, of incentive, flexibility and coercion, the fascist dictatorship came to artists and audiences as a patron in search of recognition. The need for mass support produced aesthetic pluralism in the early and mid-1930s and encouraged the promotion of hegemonic pluralism—a Gramscian-informed notion describing a semblance of pluralism that coexists within and gives legitimacy to a repressive regime.[2] Within a hegemonic political structure, the dictatorship balanced its pursuit of rhetorical propaganda with a desire for critically acclaimed art and cultural programs that encouraged widespread participation. A patronage system based on limited pluralism took potentially oppositional discourses and aesthetic languages and integrated them into a ruling structure. A heterodox approach to patronage preempted the creation of an artistic underground and with it the regime appropriated the "intellectual and moral leadership" of the artist class to win the consent of other groups.[3] By accepting a variety of styles and genres, the dictatorship created a cultural politics of widespread adhesion and hegemonic control over the structures of representation. Large numbers of artists and architects lent their work and status to the projects and institutions of official culture.

A significant cross section of working Italian artists and architects, both the celebrities and the unknown, accepted fascism's identity as patron of the arts and promoter of national culture. For artists, hegemonic pluralism translated into extensive funding without aesthetic directives. It also produced the conditions under which artists and architects performed formal explorations within the confines of state structures. For audiences, it meant experimentation with inherited cultural forms—the addition of previously excluded art forms, such as film and the decorative arts, to high culture and expansion of and experimentation with mass culture.

This essay traces the trajectory and meanings of hegemonic pluralism as a form of state patronage. Through 1937, the dictatorship's role as enabler of cultural production was assented to by a majority of artists and cultural functionaries. A dominant discourse of aesthetic diversity held the system in place and validated an eclectic approach to state patronage. As conflicting visions of the state's role in cultural production destroyed the compromise, the hegemonic system collapsed, challenged by counterdiscourses and alternate, more authoritarian interpretations of the appropriate relationship between art and the state.

Specifically, this essay details changes in state patronage strategies, using the shifts in official taste to understand the character and function of fascist cultural politics. While hegemonic pluralism describes the contours of fascist arts patronage, it was not a static system. Over twenty years of rule, the regime's goals and interests as a patron were contested and reformulated, as differing aesthetic styles, forms, and genres received official attention. Fascist cultural functionaries experimented with patronage strategies as social, political, and economic priorities changed. In the period of political stabilization (1925–30), the dictatorship focused on administrative and bureaucratic control of the arts by regimenting artists into fascist-run unions and by placing the institutions of cultural display under official control. The middle years of fascist arts patronage (1930–37) simultaneously stressed the creation of a visible and modernist official culture and the formation of a cultural consensus around fascism. In the years 1937–43, the dictatorship drew on imperial and militarist discourses and on national socialist patronage models, de-emphasizing the eclectic appropriation that had provided the consensus it originally had sought.

Pluralist state patronage arose from a combination of what was possible, a realization that the arts did not require the level of coordination that other realms did, and a dominant discourse that only a multiplicity of expressions produced politically functional and critically and popularly acclaimed art. Aesthetic debate within an Italian and fascist context would lead to cultural regeneration and a replacement of the desiccated bourgeois culture of the nineteenth century. Conceptions of cultural degeneracy and modernism as a corrosive force that drove Nazi cultural politics toward "a program of aesthetic eugenics" found little root in fascist Italy.[4]

While hegemonic pluralism functioned as a legitimizing and consent-building technique, fascist cultural bureaucrats and Mussolini himself explained the policy in cultural and aesthetic terms, hailing it as the path to a fascist-led cultural renaissance. According to the faction most supportive of it, Italian cultural traditions and fascist spiritual, antimaterialist goals precluded aesthetic regulation. Mussolini articulated an inclusive cultural politics when, at the Roman Quadriennale of 1931, he declared it was not "an exhibition of a particular tendency, of a particular group, of a particular coterie." Rather, he added, at this first national exhibition of Italian art, "there

is everyone: from old timers to the very young, and also unknown [artists]."[5] Giuseppe Bottai, Minister of Corporations and National Education during the *ventennium*, declared, "Fascism does not promulgate aesthetics. . . . Fascism does not want an art of the State."[6] Those running the culture ministries in the 1930s celebrated a pluralist climate in which new, national, and fascist forms would be nurtured under official care. Such an approach, they added, created a national patrimony of modern art—a modern art that testified to the healthy, creative air of fascism. This attitude was institutionalized in the rules of the exhibitions of the fascist syndicates. For example, in 1933, the program of the Fourth Exhibition of the Fascist Syndicate of the Fine Arts of Sicily declared that it intended to "welcome with the broadest vision every possible Artistic expression and to accept all inspirations and techniques. . . ."[7]

Historians, literary critics, and art and architectural historians are now deciphering the meanings of Italian fascism's multivalenced cultural politics and its attraction for a significant number of interwar intellectuals and artists.[8] Postwar studies allowed room for only two camps—those who saw the cultural artifacts of the fascist era as the hack work of regime propagandists (and therefore devoid of aesthetic value) or those who recognized artworks as separate from political and social conditions. For both these groups, the regime's interest in culture was purely instrumental and functional, with fascist intervention in cultural affairs aimed at the singular goal of cementing an unwilling populace to the regime. Recent work, however, has abandoned the dichotomy "art" vs. "propaganda" and "fascism" vs. "culture," looking instead for the contestations and accommodations between them.[9] In this body of work, the concept of "fascist culture" is considered imprecise and in flux—the product of a constant negotiation between the dictatorship's interests and the cultural tastes of artists and spectators. The following discussion of state patronage stands within the critical tradition that views the dictatorship as unstable, shifting, and contested at both the ideological and functional levels. This essay situates official arts patronage against the background of conflicting tastes, practices, and constituencies.

Italian fascism commenced its cultural politics with a challenge to the structures of cultural display. In the first phase of state arts patronage, bureaucracies and administrators of culture turned to

institutional reform rather than to the promotion or celebration of particular aesthetics or genres. The beginning years of fascist cultural intervention, 1922–30, focused on government and party involvement in existing institutions of high and mass culture, on the creation of new institutions where a lack was perceived and on the professional organization of cultural producers. The reconstitution of the structures of artistic display and production commenced in earnest after the fascist consolidation of power in 1925–26. In this period, the regime entered into the workings of a range of existing institutions, from the La Scala opera in Milan to the Uffizi museum in Florence, as well as building its own. The dictatorship cited a variety of motivations, from financial inefficiency to unqualified personnel, for the overhaul of earlier institutions and systems, but the legacy of fascism's initial intervention in cultural institutions, as the case of art exhibitions attests, was one of bureaucratic streamlining and the implanting of a centralized, national foundation, at the expense of the existing private, local, or regional one.

Fascist culture originated in a contest for control of the forms of representation. As Ivan Karp and Steven Lavine have written in their work on museums and exhibitions, "the struggle is not only over what is to be represented, but over who will control the means of representing."[10] A simultaneous, two-pronged development characterized fascism's first patronage strategy: the professional regimentation of artists and the creation of centralized systems of display. Between 1925 and 1930, the regime founded the regionally organized fascist artists' syndicates. The *Sindacato Fascista delle Belle Arti* (Fascist Syndicate of the Fine Arts) regimented artists into eighteen provincially run unions. Fascism declared that even the historically "free" profession of the artist must join the corporate reorganization of society.[11] According to fascist corporatism, artistic production would be subsumed within the state and aesthetic realization would be achieved through the state. State patronage, held the corporatist vision, was the answer to the previous antagonistic relationship between state institutions and cultural producers.

The artists' syndicates presented themselves as a program of "professional discipline" and as representatives of artists' corporate interests in the new fascist state. "Elevation of the profession within the framework of national life," declared the Secretary of the Fine Arts Syndicates, Antonio Maraini, was the ultimate aim of the artists'

unions. Because the syndicates "desire neither uniformity of style nor form," the discourse of the regimentation of artists focused on using the "syndical order" to encourage dedication to fascism through access to exhibitions, prizes, and competitions.[12] Professional organization boasted its ability to coordinate artists to the further benefit both of the regime and artists.

Following the creation of the artists' syndicates between 1926 and 1930, the government coordinated previously communal, local, and regional art exhibitions into a pyramid-shaped national hierarchy, with the Venice Biennale of International Art at the top and the shows of the Fascist Syndicate of the Fine Arts at the base. The centralization and bureaucratization of art exhibitions brought government and party officials and funding into a previous private and local system. In 1929, the government transferred control over non-national art exhibitions to the Fascist Syndicate of the Fine Arts.[13] Between 1927 and 1939, the artists' syndicates held more than 300 regional exhibitions.[14] The number of works featured annually at the local, regional, and inter-provincial shows of the syndicates rose from 497 to 7,720 between 1927 and 1938.[15] Sales figures and prize monies increased dramatically as the government and the party enlarged their presence: between 1930 and 1938 prize monies rose from 7,500 lire to 153,350 lire.[16] Union leadership consistently celebrated the amount spent at the syndicate's exhibitions, with sums ranging from 546,975 lire in 1930 to 401,605 lire in 1933 to 832,309 lire in 1938.[17] Organizational control laid the groundwork for the creation of a hegemonic system and for the pursuit of more interventionist patronage strategies.

After 1930, the regime moved from enabler of official culture to attempts at becoming its shaper. The first strategy, that of determining access through the artists' syndicates and control over the institutions of display, was compounded in the mid-1930s by active purchasing and official prizes, competitions, and commissions. Expansion of the state's influence characterized the second phase (1930–37) of fascist arts patronage.

High culture, in the form of the fine arts of easel painting and non-monumental sculpture, with its accumulated prestige, offered the consolidating regime essential cultural capital. As Pierre Bourdieu has detailed in his work on the creation of cultural tastes in European societies, high culture is freighted with symbolic capital that can be

used by those with knowledge of it and access to it.[18] In the years after 1925, with the assumption of power recent and the declaration of dictatorship new, fascism's reputation for thuggery and vulgarity remained; arts patronage gave the bureaucracies and individuals of the government and the party an opportunity to declare their cultural authority within existing networks and discourses. While fascism came to power coded by existing elites as outsider and dangerous, messages of cultural continuity and respect for the classics drew the dictatorship closer to nationalist and bourgeois elites who harbored anxieties about the regime. Partial emulation of the patronage styles and aesthetic tastes of the bourgeois and aristocratic elites of Liberal Italy gave the emergent regime cultural legitimacy and strengthened class alliances.

Yet, fascist fine arts patronage was far more than a replication of the tastes and practices of the aristocratizing bourgeoisie that had set the cultural tone for Liberal Italy. Given the antibourgeois mass politics and antipositivist idealism that had launched fascism as a movement in the heady days of 1919–20, arts patronage could never be a simple copy of a previous cultural system or cultural practices.[19] Fascist arts patronage was founded on the simultaneous appropriation of and reconstitution of cultural authority. The most significant challenges to cultural authority, challenges to the social practices and forms of culture, were found in mass culture. But, even in the realm of high culture, the patronage style that evolved by the mid-1930s represented a negotiation between the regime (which juggled its own unstable internal cultural compromise between bureaucrats and policymakers drawn from a Nationalist past and those from a futurist/modernist present), cultural producers, and consumers. In high culture, the challenge took the shape of fascist modernism—a blended/hybrid aesthetic of modernist roots and substantial Italian, Roman, and Mediterranean branches. As a patron of the fine arts, the dictatorship rejected the domination of traditional aesthetic languages and genres—searching, instead, for something it perceived as evocative of fascism.

The regime desired the cultural capital associated with elite culture, artists demanded financial support and access to the institutions of cultural display, and consumers of high culture wanted continued association with that culture. In this way, the fine arts represented a glue between the dictatorship and elites, functioning similarly as mass

culture did between it and other segments of the population. The dictatorship sought both to inherit the hierarchical categories of cultural capital and to restructure them to allow entrance to the new agencies of the government and the party and the unarticulated discourses and narratives of fascism. Fascist taste tended toward the neo-impressionism of the return-to-order movement and the Italianità-modernism of the *Novecento* movement, with a long-standing commitment to futurism. The pluralities of tastes also translated into patronage of many genres, such as landscapes, still lifes, portraits, and abstract works.

Active arts purchasing was the most visible form of fascist intervention in high culture production after 1930. From 1930 until its collapse in 1943, the fascist dictatorship consistently allocated funds for the purchase of paintings and sculpture from the international, national, and regional exhibitions under its sponsorship. The organs of the party and the government made acquisitions at every Venice Biennale between 1930 and 1942, the Roman Quadriennales of 1931, 1935, and 1939, as well as at the numerous provincial and interprovincial shows of the fascist Syndicate of the Fine Arts.

Beginning in 1930, government and party purchases at the Venice Biennale remained at between 25 percent and 32 percent of total sales and increased in the early 1940s.[20] In 1930, at the first Venice Biennale with major government and party presence, total sales amounted to 1,407,892 lire for 462 works of painting, sculpture, and drawing.[21] Government ministries, local agencies, and party organizations together spent 291,700 lire.[22] As the largest official buyer, the Ministry of National Education spent 130,000 lire on thirty-five paintings and sculpture destined for the new Galleria d'Arte Moderna in Rome.[23] The government was also represented by the Governatorato of Rome, the Ministry of Corporations, and the Undersecretariat for the Fine Arts. The National Fascist Party, and some of its affiliated organizations, such as the Confederation of Artists and Professionals, bought 54,000 lire worth of artworks.[24] In 1932, of a total of 1,154,675 lire spent on art purchases, state and local government and party organizations expended 375,403 lire.[25] Of 516 works of art sold in 1932, the government and the party purchased 159. While the Depression slowed private art consumption in 1934, the government and the party continued their active policy. Out of a total of 915,185 lire spent, government and party acquisitions amounted to 184,800 lire.[26]

In keeping with the system-wide adherence to aesthetic plural-
ism, official purchases were various in aesthetic school and genre.
They favored the *Novecento* school, but included contributions from
futurists, members of the "return-to-order" movement, Tuscan natu-
ralists, Strapaese artists, metaphysical painters, and abstract painters.[27]
The Ministry of National Education bought paintings by Antonio
Donghi, Alberto Salietti, Marino Marini, and Enrico Prampolini,
among others.[28] Between 1930 and 1935, the *Novecento* and the
futurists enjoyed the greatest official appeal, appearing repeatedly on
the lists of both the government and the party, with the names Achille
Funi, Felice Carena, Tato, and Enrico Prampolini receiving the highest
prices. The aesthetic tastes of party organizations deviated little from
those of government ministries: once again, all schools from the futur-
ists through the metaphysicals found party purchasers.[29]

Works of explicit fascist content appear rarely in the middle years
of fascist patronage. In an effort to address the interests of artists and
to offer a vibrant, well-attended official culture, the cultural compro-
mise of the mid-1930s precluded the dominance of rhetorically or nar-
ratively fascist works. On the local level, the catalog for the 1930
Exhibition of the Fascist Syndicate of the Fine Arts of the Venezia Giu-
lia reproduced thirty-one works of art: four landscapes, two still lifes,
thirteen nudes and portraits, three city scenes, four country scenes,
two religious themes, and four sculpted figures.[30] In the 1932 catalog,
of thirty-two reproductions, three have fascist themes, with three land-
scapes, ten portraits, nine city and country scenes, three abstract
works, and four figurative sculptures.[31] By the time of the second
Roman Quadriennale in 1935, fascist themes had increased slightly:
of 130 reproductions, nine depicted fascist scenes.[32]

Official patronage's dependence upon arts purchasing made the
offices of the party and the government visible arts buyers, tied into
the growing art market. By 1934, state patronage constituted a defin-
ing aspect of the shows themselves. The regime, artists, and critics all
noted the centrality of government and party acquisitions. Giuseppe
Pensabene, a critic of pluralist patronage, noted that "each show
always closes with a notable number of acquisitions and . . . the vast
majority of these goes not to private patrons, but to state institu-
tions."[33] Successful artists could participate in the officially sponsored
exhibition culture with the confidence that a branch of the govern-
ment or the party would purchase their work. In 1932, Antonio

Maraini acknowledged the dependence upon official support that fascism had cultivated: "Given the difficult times which artists are experiencing, it would be painful to cut them off from resources which they have come to rely upon by now."[34] Through aesthetic pluralism's dependence on forging consent and its need to bind artists financially to the regime, the dictatorship had created a situation in which artists understood participation in official culture to mean material reward.

Artists, particularly prominent ones, found fascist patronage sufficiently flexible as to venture negotiation. Three of the thirty-one artists whose work was purchased at the 1931 Roman Quadriennale were displeased with the regime's offer: according to a government report, Arturo Martini requested "at least 15,000 lire instead of the 8,000 offered" for his sculpture, Gino Severini "wanted 6,000 lire rather than the 5,000 lire offered," and Ercole Drei "refused [the offer] in an altogether rude manner."[35]

In the middle years of fascist arts patronage, the climax of aesthetic pluralism, the dictatorship turned to multiple strategies for the introduction of fascism to the display and production of the fine arts, but without censorship. Prizes, competitions, and commissions, the regime's other patronage methods, acted as potentially more coercive forms than purchases, as they encouraged the adoption of designated narratives and discourses, if not formal languages. Some culture bureaucrats hailed competitions as forces driving the creation of a fascist aesthetic. At the 1930 Venice Biennale, the National Fascist Party, the Ministry of National Education, and other organs of the government and the party introduced a series of nineteen prizes worth a total of 331,000 lire. The Fascist Party and the Ministry of National Education promoted the most prestigious and lucrative prizes; the latter offered 50,000 lire for a statue "that exalts the physical and spiritual vigor of the race" and the former presented 50,000 lire for "a painting inspired by a person or event from the founding of Fascism."[36]

Despite high expectations, the quality and quantity of the competing works disappointed the jury.[37] "[N]ot all the competitions," the jury noted, "reached an outcome worthy of much faith."[38] Indeed, some artists "contented themselves to follow the themes of the competition by the application of an improvised title to a work previously conceived and begun."[39] For three competitions of 1930, the jury awarded no prize at all; for five categories, the prizes were reduced or divided between several artists. The Ministry of National Education withdrew

its prize, claiming that "it should have and could have found a more fortuitous response."[40] A 25,000 lire prize offered by the fascist General Confederation of Industry for a painting dedicated to the poetry of work drew thirteen contestants, but it was withheld because none of the submitted works addressed the theme. The prize of the fascist Confederation of Merchants, offered for a piece "inspired by the works of Commerce," found only two aspirants.[41] Neither won. A mere twelve artists competed for the 50,000 lire prize of the National Fascist Party in 1930. Arnaldo Carpanetti won 40,000 lire for *Incipit novus ordo*, with the commentary that his painting, despite "all its defects...best approached the assigned theme."[42] Carpanetti, an artist who skillfully used the fascist patronage system to his own advantage, anticipated the jury's desires by attaching an explanation of the canvas to his entry. In it, he narrated his "attempt to interpret the formative phase of fascism":

The Black Shirts, baptized by the war, advance in a disciplined and relentless march commanded by Benito Mussolini, creator of the new Italian order. . . . Into the chaos of postwar Italy . . . [in which] many insulted the flag and men were discouraged by sectarian and demagogic passions, the Black Shirts inevitably enter and return the people to their best sentiments: here, a mother offers the new-born baby, a future *ballila*, to the *Duce*. . . .[43]

Carpanetti employs a baroque- and metaphysical-influenced aesthetic for his allegory of the fascist assumption of power (fig. 36). Led by a solitary Mussolini, the new black-shirted order sweeps away the forces of chaos and disorder. The baroque technique of figures overlapping and breaking the frame and strong diagonals generate tension in the painting. Carpanetti alludes to the Last Judgment, with the Mussolini/savior figure dominating the upper register of the painting. The Duce is painted with a glow and aura, implying otherworldliness. The Mussolini figure drives away the debris of the past—the damned, the grotesques, the tortured who writhe at the bottom of the canvas. Rather than the biblically damned of the Last Judgment, these figures are condemned to the purgatory of history. The converts turn back to face the approaching new order, represented by the marching fascist *squadristi*, who move forward as a bloc. This new, redemptive elite wave the flag of Italy, together with fascist skull and crossbones flags, and their chests bear medals of the First World War. Mussolini is the transfiguring agent between chaos and damnation and order and redemption.

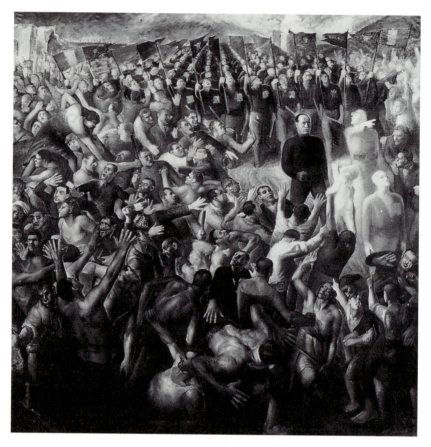

36. Arnaldo Carpanetti, *Incipit novus ordo*, XVII Venice Biennale of International Art, 1930

Two years later the regime attempted competitions once again, although with a substantially smaller investment of 150,000 lire, compared to the 330,000 lire of 1930. In an effort to attract a larger showing, announcements ran in all national, local, and trade journals, well in advance of the entry deadline.[44] Seven prizes were offered: 50,000 lire each from the Ministry of National Education and the Ministry of Corporations and 10,000 lire each from the City of Venice, the Opera Nazionale Balilla, President Volpi, the Consiglio Provinciale dell'Economia Corporativa di Venezia, and the Rotary Club.[45] The prescribed themes, all tied to the Decennale celebrations,

included "The Victory of Fascism," "The Pact of Labor," "A Personality Who in These Ten Years Has Well Served the Fascist Revolution," and "Year X."[46] Again, interest was minimal: 213 artists participated in the seven competitions.[47] The preliminary jury, appointed to choose for display ten works from each competition, was unable to complete its task, claiming "the outcome has shown the artists ill-prepared to elevate themselves to the level required by the civic and historic allegory requested of them."[48] Of those works selected for prizes, the jury reported, "not one is worthy of the entire allotted amount of any of the prizes."[49] Moreover, where the commission conferred even a portion of the prize money, it acknowledged travail, not talent, saying, "it desired to award the effort demonstrated by the artist, more than the level of the art delivered.[50]

Artists resisted the competitions, despite the rewards associated with them. In an economy where a kilogram of flour cost 1.60 lire and the average hourly wage for industrial workers amounted to 1.98 lire,[51] 50,000 lire represented a windfall.[52] But the discourse of aesthetic pluralism led artists to believe that government and party support could be obtained without having to compromise their art.[53] In the light of an official rhetoric on the arts and artists that focused on professional regimentation and aesthetic liberty, rather than an art of the State, the call for specific responses fell largely on deaf ears. Artists active in official culture were unmoved by the competition calls, because they were also sufficiently confident of their power and position over the dictatorship: at this point, the regime was loath to risk the support of prestigious and established artists who could retreat into private galleries and exhibitions if state patronage became troublesome.

Even though the competitions were open to any artist belonging to the fascist artists' syndicates, few entered them. One artist, Antonio Discovolo, refused to participate in the competitions, "I did not," he wrote, "fill out the application form for participation in one of the prize competitions. . . . I hope that my displayed painting can have the fortune of being purchased, given the fact that this is a time of financial crisis for me."[54] While many artists happily accepted the fascist state as arts administrator and buyer, they rejected patronage that regulated pictorial content. As long as consent-building techniques that stressed flexibility were offered simultaneously with more coercive ones, the latter found fewer adherents.

Artists did not resist government and party institutional control or sponsorship. Working for the fascist regime did not deter artists, only policies that required overt changes to work. At the 1930 Biennale, the competitions that called for more specific and partisan thematic responses fared worse than those with broader, more adaptable themes. For example, the two competitions that found no respondents at all asked for "a series of four lithographs that grasp the educative and sporting activity of the *Opera Nazionale Balilla*," and "a bronze plaque that depicts the collaboration of citizens with the structure of the state."[55] The competition asking for a bronze medallion of Mussolini attracted four contestants and that for a work inspired by the "Accomplishments of Commerce" found two aspirants.[56] But in comparison, broadly defined competitions, such as that for a "Composition with Figures," received fifty-four entries. The competition calling for a depiction of Maternity attracted sixty-three responses.[57]

While few artists applied for the patriotic job of giving aesthetic expression to fascist themes in the mid-1930s, artists turned out in large numbers for regime-sponsored cultural events, accepting the regime's control over the means of representation. At the 1930 Biennale, 1,767 works of art were entered into competition for general display, of which 17 percent were chosen.[58] The regional shows of the fascist syndicates were also well attended: at the 1930 show of the Fascist Syndicate of Venezia Giulia 76 artists submitted 204 works of art, 55 artists with 90 works were accepted.[59] At the Syndical Exhibition of Venezia Tridentina in 1933, 211 works were presented, 133 accepted, and 19 invited.[60]

The composite character of the juries reflected the problems inherent in aesthetic pluralism as the official ethos of state culture. Aesthetic pluralism produced frustration when forms evocative of fascism were sought. Composed of dissonant voices, the juries lacked consistent, shared aesthetic and thematic criteria, agreeing only on the state's role as cultural organizer. Consensus on the state's hegemonic function created a situation where the fascist regime worked well as a patron but failed as arbiter of aesthetic choices. In 1932, the Venice Biennale jury comprised representatives from a range of viewpoints on the arts: F. T. Marinetti, the futurist leader; Cornelio Di Marzio, who believed in bringing various aesthetic tendencies under the fascist umbrella; Roberto Paribeni, the Director of the Office of Antiquities and Fine Arts, an archaeologist, and classical scholar, who defended a

more conservative, classicizing aesthetic. The remainder of the jury consisted of five artists from a range of schools: Felice Carena and Arturo Tosi belonged to the *Novecento*; Arturo Dazzi sculpted in the static, classicizing style of the "return-to-order" movement; Italico Brass painted Venetian landscapes and Edoardo Rubino sculpted nudes in a naturalistic style.

If the dominant discourse regarding state patronage focused on "welcoming, without prejudice, every tendency, school and technique of a chosen work of Art,"[61] heterodox cultural politics bred discontent from within fascist circles. As aesthetic pluralism became entrenched as the modus operandi of state patronage, a faction of fascist officials and intellectuals began a campaign against it. In 1934, Giuseppe Pensabene remarked regretfully that the regime had come to replace "the courts, the great families, the church and the confraternities" as primary patron.[62] Pensabene, editor of the militant, pro-Nazi Roman cultural weekly, *Quadrivio*, declared that fascism must demand artists to do more than merely show up at cultural events. For Pensabene and the cultural antipluralists he came to represent, the dictatorship wasted its resources, coddled artists, and failed to create what he considered a truly fascist culture by courting financial dependence without requiring political and aesthetic adherence. For the antipluralists, the authoritarian coordination of state and society necessary to fascism was not being reproduced in the cultural field.

The critics of aesthetic pluralism challenged the cultural system in production. They decried it as weakness, as something that must change in order for the fascist revolution to succeed. For this group, tolerance of multiple aesthetic formulations, from the traditional to the most contemporary, reeked of both liberalism and socialist internationalism. This faction blamed flexible patronage for the modernist and internationalist character of much official culture—they maintained that a coercive and censored system could rid fascist culture of such corrosive influences. This rising counterdiscourse challenged aesthetic pluralism and contested the compromise of mid-1930s fascist culture. In the next phase of fascist patronage—the later 1930s—the antipluralists would couch their critiques in racial and imperialist language and would declare international modernism a Bolshevik hoax.

War and autarchy took official culture in new directions and introduced the third phase of fascist patronage. On 5 October 1935, fas-

cist Italy declared war on Ethiopia and three days later the League of Nations announced economic sanctions against Italy. By the time of the opening of the XX Venice Biennale in June 1936, Addis Ababa had been captured and empire declared. With the Ethiopian War and the fascist regime's movement toward alliance with Nazi Germany, the cultural compromise that shaped state patronage in the early 1930s unraveled. The sacrifices of war, the regime's call for economic autarchy, and the radicalization of the dictatorship as it moved into the national socialist sphere of influence strengthened the power and position of the critics of aesthetic pluralism. Demands for increased regulation and politicization of the arts gained influence. For a growing section of the fascist hierarchy, overt propaganda became more important than consent from artists and audiences. A call for art to work for the goals of the regime challenged the earlier commitment to flexibility and inclusion for those who accepted the regime's institutional control.

As the detractors of aesthetic pluralism grew more powerful and vociferous, tensions implicit in aesthetic pluralism became explicit. The existence of separate factions fragmented cultural life, as various groups rejected official cultural institutions in order to construct ones reflective of their individual visions. For example, the *Premio Bergamo*, promoted by Giuseppe Bottai, displayed the work of artists of a range of modernist tendencies, such as the expressionists Robert Guttuso and Emilio Vedova. Roberto Farinacci, the powerful fascist leader in Cremona and declared enemy of the "foreign-loving malaria" he called modern art, established his own national art exhibition in 1939, the *Premio Cremona*. This show celebrated an Italian version of Nazi "fascist realism," a glorifying naturalized and idealized representational art, and it promoted competitions for works entitled *Listening to a Speech of the Duce's on the Radio* or *Out of Blood, the New Europe*.[63]

The struggle between those committed to aesthetic pluralism and its decriers led to the final stage of official patronage, one defined by a post-1937 "Battle for Culture." Critics of aesthetic pluralism denounced moderates and supporters of aesthetic pluralism as unpatriotic and unfascist. The Culture Wars of the late 1930s testified to the limits of pluralism in the fascist context and the contradictions inherent in the search for the consent of prominent artists. "Journalists, critics, exhibition organizers. . . ," wrote Telesio Interlandi, a vocal critic of aesthetic pluralism, in 1938, "have bowed to the tyranny of the Inter-

national. . .by giving exhibition space and prizes worth tens of thousands of lire to the clumsy bursts of a Chagall or an Ernst."[64] Such critics declared that pluralism had failed to produce a "fascist art"; war, race, and empire, asserted the antipluralists, provided categories by which to determine the commitment of artists and the themes by which to judge art.

Giuseppe Bottai and his followers hailed pluralism augmented by increased professional regimentation and enlarged government intervention in the means of cultural production. Many of the fascist bureaucrats who were reluctant to follow a restricted path of arts patronage had come to fascism from the Nationalist movement and had their political and cultural roots in the Liberal era. This faction believed that modern art and a multiplicity of aesthetic expressions could work for the cause of fascism and that, given the correct incentives, artists would assent to the dictatorship's projects. Smaller factions, or "free zones," also existed. The futurists took up the cause of pluralism, as did increasingly alienated younger artists. While intransigents around Farinacci called for an Italian degenerate art campaign, F. T. Marinetti, his futurists, and a growing artistic *fronde* proclaimed its intention to defend aesthetic freedom and experimentation.

In contrast to the expansion of 1930–37, the years 1937–43 witnessed the weakening and marginalization of official art exhibitions, as artists and spectators found them less responsive to cultural tastes. In all its elements, from patronage to administration, official culture after 1937 reflected a conflicted attitude toward art's role in the fascist state. In addition to attempts at formal regulation, fascist patronage moved away from emulation of traditional elites. Public art forms, less tied to bourgeois patronage, and administrative techniques imported from the Ministry of Popular Culture introduced fascist mass culture to elite culture.

Challenges to aesthetic pluralism arrived at the Venice Biennale in 1936. That year the competitions, weaving together a number of newly emphasized ideological strands, were divided into sections: one for "seven frescoes" and one for "eight statues to decorate a central hall chosen for this purpose."[65] All submitted works had to be "on themes of Fascist life."[66] Restrictions of age and experience were the outstanding innovative elements. Contributing artists had to be less than thirty-five years old, members of the fascist syndicates, and from

among those not otherwise invited to the Biennale.[67] Where past prize competitions accepted all willing Italian artists, youth and outsider status were now prerequisite. Artists with established reputations and those who previously had ascended through the fascist exhibition system, had not met the regime's expectations.

The new requirements for participation in the competitions accommodated the concerns of the cultural antipluralists. The designation of outsider status (non-invited, youth) sprang from a critique that saw prizes and patronage at official exhibitions as an insider's network fraught with nepotism. Writing in *Quadrivio*, the journal run by Pensabene and Interlandi, the proponents of this position maintained that the same unqualified artists repeatedly won and that the prizes had become "simply subsidies."[68] Cultural hardliners viewed successful artists as overly concerned with the marketplace and personal fame. These commercially successful artists had been in the system so long as to become a "parasitic class," interested only in their own promotion.[69] Consecrated artists of the era saw themselves as autonomous from the state: proponents of a rising official counterdiscourse sought to cultivate and reward artists committed to the fascist revolution, whether or not they came with established reputations. They declared that the regime could do without the symbolic capital of "consecrated" artists and that it should begin to reconstitute the artistic field, rather than accept inherited positions.[70]

Indeed by 1937, the turn to the young and uninitiated had become a central element of the regime's propaganda campaign for a perpetual fascist revolution. Concerned with the creation of the next generation of fascist leaders, cultural policy in the late 1930s focused on cultivating the young whom many in the party hierarchy perceived as the source of rejuvenation for a fascism gone soft. From films focusing on youth to special government and party funded programs, such as the *Littoriali*, late fascist culture stressed cultivation and education of the young.[71] After the declaration of war against Ethiopia, this propaganda added the image of fighting youth as the saviors of the nation. Thus, state patronage directed at artists under thirty-five mirrored the concerns of the regime as it moved from the relatively stable early and mid-1930s into war. If older artists, who had come of age in liberal, parliamentary Italy, continued to be too egoistic, perhaps a new generation of artists, raised under fascism, would be selfless enough to redefine their art in accordance with political contingencies.

The response of the younger artists to the competitions marked a striking contrast to earlier disinterest: eighty-three painters presented ninety designs for murals and sixty-five sculptors submitted seventy models.[72] The level and quality of the presented works pleased the jury, which declared the "successful outcome of the competitions."[73] The jury's report concluded that ". . . the appeal found a profound echo in the souls of the young, who were particularly moved."[74] The mural competition proved so successful that the jury chose eight rather than the original estimate of seven winners to execute their designs on the Biennale interior. The designation of additional honors stood in stark contrast to the competitions of 1930 and 1932, in which the majority of prizes was not awarded.

The acclaimed murals at the 1936 Biennale shared topical and aesthetic orientation. They stayed close to the assignment of themes of life in fascist Italy and all bore the mark of the Italian return-to-order movement and a stress on *italianità*. One celebrated piece, by Gottfredo Trovarelli, entitled *Vita Agreste*, depicted, in quattrocento-influenced forms, a village scene of a black-shirted farmer shoveling seed from a bag. Critics hailed it for its "Tuscan equilibrium, which one could call classical, between figures and rural landscape, between linear rhythms and full-bodied hues."[75] Stylistically, Trovarelli's work offered the return-to-order and classicism that many cultural conservatives sought; topically and functionally his mural responded to the antipluralist's prescription. Cafiero Tuti's *Opera Assistenziale* presented a crowded village scene in which party officials donated cakes and grain to villagers. Influenced by the *Novecento* movement and the calls for indigenous inspiration, Tuti worked in classical and historical languages. Other noted entries included *Epic Depiction Inspired by the Night-Time Departure of the Troops for East Africa* and two depictions of *Maternità*.[76]

The introduction of murals and bas-reliefs to official culture emerged from an Italian and international elevation of public culture in the late 1930s and out of challenges to elite art forms. Murals and reliefs fit both formally and discursively into new patronage agendas: momumental frescoes combined an Italian tradition dating from antiquity with fascism's interest in opening the social boundaries of culture. In the mid-1930s, factions within the regime questioned the emphasis on bourgeois patronage styles and the dependence upon easel painting and non-monumental sculpture, claiming that fascist art was art

with a broad social role. The intersection of public art and state patronage took place on an international level, with the crisis of the 1930s producing a reconsideration of the social function of the arts and of artists.[77]

By 1938, public art had moved to the center of fascist patronage. That year, the Biennale promoted competitions for frescoes, bas-reliefs, portraits, landscapes, engravings, and commemorative medals. Each category specified that the works "will have to be inspired by events or aspects of Italian life during the Fascist era."[78] The commemorative medal competition asked that one side depict a figure "most representative of the fascist era" and the other an "allegory drawn from the work of the person depicted."[79] In contrast to the early 1930s when the competitions requiring specific themes failed, this time rigidly defined competitions, such as celebratory portraiture, fared equally well as the loosely constructed ones for landscapes. In all, 2,491 artists competed in the five contests, with 957 participants for the portraiture competition, 372 for the sculpted bust contest, 909 for the landscapes, 191 for cityscape engravings, and 62 for commemorative medals.[80]

Regime-sponsored culture had fragmented by 1940 into opposing camps. Giuseppe Bottai's *Premio Bergamo* continued to celebrate experimentation and debate, but the centerpiece of official culture, the Biennale, moved increasingly toward regulation. For the 1940 Biennale competitions, both form and content were dictated, as the competitions combined fascist topics with public and monumental art forms. Seven competitions were divided among frescoes and bas-reliefs on "themes of fascist life," engravings "illustrating the words of Mussolini," medallions "inspired by sports," garden statues, paintings "interpreting antiquity," and Venetian landscapes.[81] The frescoes and bas-reliefs had to be based on one of the following themes: "The Duce and the People," "The March on Rome," "The New Cities," "The Empire," "*Squadrismo*," or "Legionnaires."[82]

Official instructions to artists employed the language of cultural autarchy and National Socialist cultural ideology. The recruitment of the Nazi view of art as the unchanging and transcendent expression of the race introduced racialist and spiritual discourses. The portrait competition called for works conveying the "eternal humanity in art"—a formulation that mirrored the Nazi precept that art was a static phenomenon, untouched by political and social contexts.[83] The com-

petition for garden statues declared that it recaptured "an antique and characteristic Italian tradition."[84] With the belligerent rejection of international influences and the search for imperial culture, the looking back to classical Rome became the core of *italianità*. The seventh competition called for "an interpretation of the antique in painting, sculpture, engraving, or drawing."[85] "Studying the legacy of the ancients directly," declared Maraini, ". . . would allow artists to remain faithful to the genius of the race."[86]

The revised patronage style elevated the production of art that was measurably fascist over the consent of artists; juries now chose competition winners explicitly committed to the regime's policies. The fresco and bas-relief competitions reserved half the winning places for "young artists enrolled in the Fascist University Groups" and half for artists belonging to the Fascist Syndicate of the Fine Arts.[87] Nine commissions, in various regions of Italy, composed of representatives from the local Fascist University Groups, or GUF, the Academy of the Fine Arts, and the Fascist Syndicate of the Fine Arts made the preliminary selections.[88]

Of the fifty-eight fresco proposals submitted, eight were chosen from the GUF competitors and eight from the syndicates. Six of the sixteen selected works were entitled *The Family*, with the others called *Legion at Rest*, *They Found the Cities*, *Dawn of October 28th*, and *Towards Empire*.[89] In total, 1,470 artists competed in the seven competitions. Of this number, 304, or 20 percent, were chosen.[90] This was the highest percentage selected from the competitions since the Biennale administration had begun their promotion in 1932. Where the usual rate of acceptances had been approximately 8 percent, the commission was "very broad" in its 1940 policy because it wanted to reward the young participants.[91] The winners were primarily newcomers to the exhibition system, as few of the 1930s most prominent artists had competed. Fascism's late patronage style exchanged celebrity for commitment, consensus for allegiance.

Censorship resided in the suggestions the commission offered to the winners. The commission asked the author of the fresco *They Found the Cities* to give the central figure of his composition a closer resemblance to Mussolini.[92] This committee also requested that Ilario Rossi dress the nude female figure in *The Family*, which, they claimed, "had no reason for being that way."[93] Four of the GUF winners revised their murals in order to meet the standards of the jury.[94] An artist's

willingness to follow explicit directions was a new qualification for state patronage.

Reconsideration of the goals and purposes of state patronage also altered the way the government and the party purchased art. Official buyers remained, but they demanded more from artists. Mere participation no longer sufficed, and purchases were used as rewards for commitment rather than as incentives. Official purchases of Italian art in 1936 moved dramatically away from an emphasis upon the *Novecento*. Instead, the Ministry of National Education spent much of its 76,000 lire on the work of younger artists and competition winners, often little known and without recourse through private channels. Artists actively committed to the syndical organizations were also sure to be purchased. In 1938, the government and the party acquired mostly the work of those willing to follow rules. If the category of appropriate fascist art remained vague, at least revised fascist patronage would reward fascist artists—those who committed themselves to the competitions and the rhetorical bases implied in them. Government ministries and party organizations in 1936 spent 350,000 lire (including prize monies) out of total purchases of 1,225,457 lire—a slightly higher percentage of the total than in past years.[95]

For the first time in the history of the fascist regime's patronage of the Biennale, government ministries in 1938 made specific directives regarding purchases. The Ministry of National Education, spending 149,440 lire rather than its customary 130,000, "showed a preference for young artists, the support of whom seemed worthy of encouragement and reward."[96] Further, the Ministry declined to acquire the work of artists who had either shown "a large number of paintings or sculpture" or who had been "regularly patronized by the State."[97] Such requirements led to the overwhelming purchase of the work of competition winners. Of the fifty-three pieces of Italian art bought by the Ministry of National Education, over half were the work of competition winners.[98] For his personal collection, Mussolini purchased a bas-relief by Filippo Sgarlata. Sgarlata's winning entry, *It Is the Plow that Draws the Sickle, but It Is the Sword which Defends It*, shows a classicized Roman soldier and a farmer bound together in their service to the state. The static, monumental figures focus on exaggerated musculature and idealized symbolic representation, as in the soldier's face and armor (fig. 37).

In the early and mid-1930s, the bulk of state patronage had gone to the celebrities of the *Novecento* and return-to-order movements. Few of the once familiar names of Casorati, De Chirico, Morandi, or Sironi were found on the lists of government purchases for 1940. Instead, young artists, members of the GUF or the syndicates, were rewarded by the government and the party. The two most expensive purchases of the Ministry of National Education in 1940 were *The Return of the Legionnaires*, by Giovanni Barbisan for 8,000 lire, and *The Protection of the Mother and the Child*, by Luciano Minguzzi for 9,000 lire.[99] Despite the war, government and party expenditures for acquisitions rose. For the 1940 Biennale, the contributions of the various government ministries and party organizations rose to 40 percent of total sales.[100] In 1940, the government and party spent 390,000 lire, compared to a contribution of 350,000 lire in 1938 and 168,450 lire in 1936.[101] Even losses on the Russian front and the harsh conditions of war did not challenge the regime's commitment to arts expenditures: government and party purchases at the 1942 Biennale reached unprecedented levels, including 289,000 lire on prizes and a record 650,000 lire on foreign works, overwhelmingly of German and Austrian authorship.[102]

This essay opened with the government-commissioned Venice Biennale facade of 1932 as a way into fascist cultural patronage. For the inauguration of the 1938 Biennale, two large frescoes were added to the clean, crisp facade. Where once the unadorned facade expressed a sober harmony capable of attracting vast audiences, two allegorical frescoes now educated the masses. Left of the entry stood *The Queen of the Seas* by Antonio Santagata (fig. 38).[103] Santagata's composition consisted of an upper and lower register: at top a figure representing "the queen of the seas" filled the foreground, with a topography of Venice in the background. The lower foreground of the fresco was divided between Saint Mark pointing to his Evangels and two World War I soldiers, looking toward the World War I trench scene that occupied the remainder of the spaces. The fresco's structure is that of a Renaissance altarpiece following an "assumption of the Virgin" typology, though in this case the "Queen of the Seas" figure is more architectural and powerful than common depictions of the Virgin. The iconography is both national and regional, as the primary symbols of Venice—Saint Mark, the sea, and the city itself share the space with references to national and fascist strength. The "Queen of the Seas"

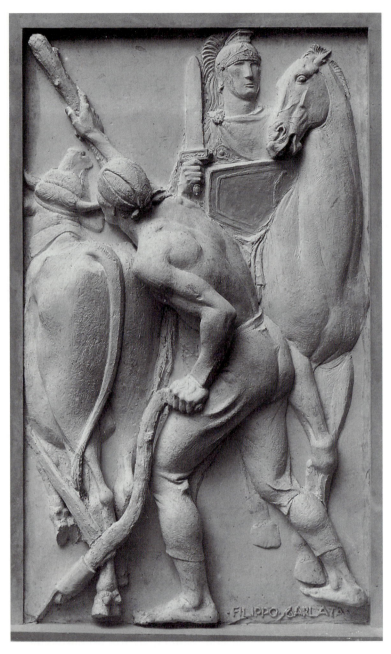

37. Filippo Sgarlata, *It Is the Plow that Draws the Sickle, but It Is the Sword which Defends It*, XXI Venice Biennale of International Art, 1938

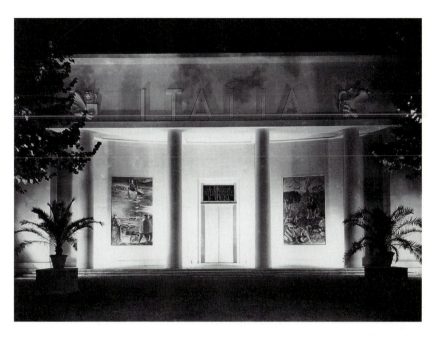

38. Antonio Santagata, *The Queen of the Seas* (left) and Francesco Gentilini, *The Birth of Rome* (right), frescoes installed on the facade of the Main Pavilion at the XXI Venice Biennale of International Art, 1938

holds a *fascio* in one hand and a Venetian galley-ship in the other. The fresco's lessons contain both past and present: Venice, given strength by fascism, will again predominate and fascism as the embodiment of all Italian historical triumphs has the blessing of history—secular and Christian. Francesco Gentilini's *The Birth of Rome*, a naturalist-archaic pastoral scene of peasants surrounding Rome's founders, Romulus and Remus, decorated the facade's right side.[104] These frescoes, emphasizing nationalism and empire, reminded the visitor that official culture now carried specific messages, in both content and style. Both frescoes, executed in styles emulating the Italian Renaissance, connected historical Italian triumphs, the founding of Rome and Venetian naval glory, to national fascist ones.

Between 1925 and 1943, the fascist dictatorship shaped fine arts production through its patronage. It mobilized various strategies to

address changing goals: institutional control led to intervention in the forms of art buying and competitions. Fascist state patronage represented a series of negotiated strategies in which some of the regime's legitimation needs were met in exchange for meeting some of the concerns of producers. Until the late 1930s, the regime maintained a tense truce over culture by juggling a number of opposing aesthetic visions and keeping them in equilibrium through the decision to focus on the organization of the arts.

While a majority of the regime's cultural policy-makers believed hegemonic pluralism the best way to bind together cultural producers, the state and audiences, the system functioned. As factions broke off, elevating conflicting patronage patterns and counterdiscourses regarding the relationship between art and the state, the state's control over the means of representation diminished. With this, the system unraveled, as many artists and spectators abandoned it. Hegemonic pluralism engendered a heterodox modernism—at once experimental and imperial. In the end, it also bred a hybrid patronage system somewhere between coercion and consent.

This essay has explored the tensions implicit in state intervention in the arts and the ways in which an authoritarian, but modernizing and market-oriented polity confronted them. Italian fascism, departing from National Socialism, chose a process of assimilation, searching for widespread allegiance, rather than aesthetic purity. In return, the Italian fascist dictatorship found both a range of artists and aesthetics willing to answer its call and to accept its price.

1. "L'Architettura alla Biennale di Venezia," *Architettura*, vol. I, no. 7 (July 1932), 358.

2. Quintin Hoare and Geoffrey Nowell-Smith, eds., *Antonio Gramsci: Selections from the Prison Notebooks* (New York: International Publishers, 1971), 12.

3. Ibid., 57.

4. Willibald Sauerlander, "The Nazis' Theater of Seduction," *New York Review of Books*, vol. XLI, no. 8 (21 April 1994), 16.

5. Benito Mussolini, "Agli Artisti della Quadriennale," *Scritti e discorsi*, vol. 7 (Milan, 1934), 281.

6. Giuseppe Bottai, "Per l'inaugurazione del Terzo Premio Bergamo," *Le arti*, vol. IV (October–November 1941), 1. Unless otherwise indicated, all translations in this chapter are my own.

7. Regolamento Generale, IV Esposizione Regionale d'Arte, Sindacato Belle Arti di Sicilia, 1933; ACS, MPI, divisione III, dir. gen. AA.BB., 1930–35, busta 129.

8. In addition to the essays found here, see Richard J. Golsan, *Fascism, Aesthetics and Culture* (Hanover: University Press of New England, 1992); Andrew Hewitt, *Fascist Modernism* (Stanford: Stanford University Press, 1993); Alice Kaplan, *Reproductions of Banality: Fascism, Literature, and French Intellectual Life* (Minneapolis: University of Minnesota Press, 1986); Walter Adamson, *Avant-Garde Florence: From Modernism to Fascism* (Cambridge: Harvard University Press, 1993).

9. For the visual arts, Laura Malvano describes the multiplicity of imageries supported or accepted by fascism and fascism's changing use of those imageries: Laura Malvano, *Fascismo e la politica dell'immagine* (Turin: Bollati Boringheri, 1988). The notion of fascist artistic diversity came into general acceptance with the 1982 Milan exhibition and catalogue *AnniTrenta: Arte e cultura in Italia* cat. exh. (Milan: Mazzota, 1983). See also Emily Braun, "Mario Sironi and a Fascist Art," in *Italian Art in the Twentieth Century*, ed. Emily Braun (London, 1989), 173–80.

Re-assessments of the architectural legacy of fascist Italy have been particularly fertile. See, for instance, Giorgio Ciucci, *Gli architetti e il fascismo* (Turin: Einaudi, 1989); Richard Etlin, *Modernism in Italian Architecture* (Cambridge: MIT Press, 1991); Diane Ghirardo, "Italian Architects and Fascist Politics: An Evaluation of the Rationalists Role in Regime Building," *Journal of the Society of Architectural Historians*, vol. 39, no. 2 (May 1980), 109–27; Diane Ghirardo, *Building New Communities* (Princeton: Princeton University Press, 1989); Silvia Danesi and Luciano Panetta, eds., *Il razionalismo e l'architettura in Italia durante il fascismo* (Venice: Edizione "La Biennale di Venezia," 1976); Dennis Doordan, *Building Modern Italy* (New York: Princeton Architectural Press, 1989).

Film studies has produced a number of works detailing the varied forms the cinematic arts took during the fascist era. See Gian Piero Brunetta, *Cinema italiano tra le due guerre* (Milan: Mursia, 1975); James Hay, *Popular Film Culture in Fascist Italy* (Bloomington, Ind.: University of Indiana Press, 1987); Marcia Landy, *Fascism in Film* (Princeton: Princeton University Press, 1986); Riccardo Redi, ed., *Cinema italiano sotto il fascismo* (Venice: Marsilio, 1979); Elaine Mancini, *Struggles of the Italian Film Industry during Fascism, 1930–1935* (Ann Arbor: University of Michigan Research Press, 1985). On theater under fascism, see Mabel Berezin, "The Organization of Political Ideology: Culture, State and Theater in Fascist Italy," *American Sociological Review* 56 (October 1991).

10. Ivan Karp and Steven D. Lavine, eds., *Exhibiting Cultures* (Washington: Smithsonian Institution Press, 1991), 15.

11. Corporatism, as promoted by fascism, held that the economic life of the nation needed to be structured vertically, with all members of a trade or profession, from the factory floor to top management, belonging to the same corporation. Interests would be represented by profession, rather than according to class.

This theory asserted that the vertical structure would lead to greater efficiency, less social discord, and a greater resolution of social and economic problems. For more on Italian corporativism, see: Fernando Cordova, *Le origini dei sindacati fascisti, 1918–1926* (Rome and Bari: Laterza, 1974), and David Roberts, *The Syndicalist Tradition and Italian Fascism* (Chapel Hill: University of North Carolina Press, 1979). On the corporate regimentation of intellectuals, writers, and artists, see Philip V. Cannistraro, *La fabbrica del consenso* (Rome and Bari: Laterza, 1975), 25–65.

12. Antonio Maraini, "L'inquadramento sindacale degli artisti," *Le professioni e le arti*, vol. VI, no. 8 (August 1936), 13.

13. Law, 24 April 1929, n. 1162, "Riconoscimento al Sindacato Nazionale degli Artisti di attribuzioni in materia di disciplina di Esposizioni e Mostre d'Arte," in Antonio Maraini, ed., *L'ordinamento sindacale fascista delle belle arti* (Rome: Sindacato Nazionale Fascista Belle Arti, 1939), 162.

14. Francesco Cosera, *Le professioni e le arti nello stato fascista* (Rome, 1941), 179–81.

15. Maraini, "L'inquadramento sindacale degli artisti," 14; Maraini, ed., *L'ordinamento sindacale fascista delle belle arti*, 201, 211.

16. Maraini, ed., *L'ordinamento sindacale fascista delle belle arti*, 201, 211.

17. Ibid.

18. Pierre Bourdieu, *Distinction: A Social Critique of the Judgement of Taste* (Cambridge: Harvard University Press, 1984).

19. On fascism's antimaterialist, spiritual, and modernist cultural influences, see Adamson, *Avant-Garde Florence*.

20. Archivio Storico dell'Arte Contemporanea (ASAC, Registre Vendite [4] [5], 1930–42).

21. "Diciasettesima Biennale di Venezia, 1930—Elenco delle opere vendute," ACS, MPI, divisione III, 1930–35, busta 141. Also cited in memo, December 23, 1932, Maraini to Capo Gabinetto, PCM, ACS, PCM (1934–36), 14-1-283, sottofascicolo 4.

22. ASAC, Registre Vendite 1930. The total for all *enti pubblici*, which includes banks, corporations, and the Rotary Club, was 575,525 lire.

23. "Elenco delle opere," ACS, MPI, divisione III, 1930–35, busta 141. The Galleria d'Arte Moderna was opened in 1930 as the locus for a soon to be created government patrimony of national modern art.

24. "Elenco delle opere vendute, 18th Biennale," ACS, MPI, divisione III, 1930–35, busta 141.

25. ASAC, Registre Vendite (4), 1928, 1930, and 1932.

26. ASAC, Registre Vendite (4), 1934.

27. "Diciasettesima Biennale di Venezia, 1930—Elenco delle opere vendute," ACS, MPI, divisione III, 1930–35, busta 141.

28. ASAC, Registre Vendite 1930. Antonio Donghi, *Cacciatore* (7,000 lire);

Alberto Salietti, *Ragazza che legge* (6,000 lire); Enrico Prampolini, *Benedetta Marinetti* (5,000 lire); Marino Marini, *Donna Dormiente* (5,000 lire).

29. ASAC, Registre Vendite (4), 1932.

30. *IV Esposizione d'arte del sindicato regionale fascista belle arti della Venezia Giulia* (Trieste, 1930).

31. *IV Esposizione d'arte del sindicato regionale fascista belle arti della Venezia Giulia* (Trieste, 1932).

32. *Prima quadriennale d'arte nazionale* (Rome, 1931).

33. Giuseppe Pensabene, "L'arte e i funzionari," *Quadrivio* (30 December 1934), 1.

34. Letter, November 1, 1932, Maraini to Ministro dell'Educazione Nazionale, ACS, MPI, divisione III, 1930–35, busta 141.

35. Letter, 13 April 1931, Attilio Ferrucci, il direttore della segreteria to Francesco Armentano, ACS, MPI, divisione III, dir. gen. AA.BB., 1930–35, busta 136.

36. "Relazione della Giuria per il conferimento dei premi alla XVII Biennale," ACS, MPI, divisione III, 1930–35, busta 141, p. 1. As a point of comparison, in 1935, 1 lire was equivalent to 5.26 cents.

37. Jury deliberations, 8 September 1930, ASAC, busta 55.

38. "Relazione della Giuria per il conferimento dei premi alla XVII Biennale," ACS, MPI, divisione III, 1930–35, busta 141, p. 2.

39. Ibid.

40. Ibid.

41. Ibid., 3.

42. Ibid., 2.

43. "Incipit Novus Ordo," ASAC, busta 57.

44. See, for example, "La XVIII Biennale di Venezia e il X anniversario della Marcia su Roma," *Corriere della Sera* (3 September 1931); "I concorsi alla Biennale di Venezia per opere glorificanti il Regime Fascista," *Il Popolo d'Italia* (2 January 1932), 3; "I premi per la XVIII Biennale di Venezia," *Gazzetta di Venezia* (3 September 1931); "Il regolamento per i premi della XVII Biennale di Venezia," *Gazetta di Venezia* (2 January 1932); "I premi della Biennale Veneziana nel Decennale," *Le professioni e le arti*, vol. II, no. 3 (March 1932), 21.

When the announced deadline of 30 June 1932 elapsed without significant responses, Maraini extended the deadline for participation to 15 July 1932. "Le iscrizioni ai premi della Biennale," *Gazzetta di Venezia* (23 June 1932).

45. "Regolamento per i premi della XVIII Biennale di Venezia," ACS, MPI, divisione III, 1930–35, busta 141.

46. Ibid.

47. "La XVII Biennale di Venezia," *Il Popolo d'Italia*, August 14, 1932.

48. Memo, 6 September 1932, la Giuria, to Presidente della Biennale, ACS, MPI, divisione III, 1930–35, busta 141.

49. "Relazione della Commissione pel conferimento dei premi della Biennale per celebrare con l'arte il Decennale della Marcia su Roma," 1 November 1932, ACS, MPI, divisione III, 1930–35, busta 141.

50. Ibid.

51. *Annuario Statistico Italiano*, vol. VI, 3d ser. (1932), 238, 263. *Il Popolo d'Italia* (27 October 1932).

52. *Annuario Statistico Italiano* (1932), 250.

53. For an official ennunciation of this position, see the interview with Maraini: "L'inquadramento sindacale degli artisti," *Le professioni e le arti*, vol. VI, no. 8 (August 1936), 13–15.

54. Letter, June 23, 1930, Antonio Discovolo to Maraini, ASAC, busta 55.

55. *XVII Esposizione Biennale Internazionale d'Arte, 1930* (Venice, 1930), 13; "XVII Esposizione Internazionale della Città di Venezia—1930—Riassunto," ASAC, busta 55.

56. "Relazione della giuria," ACS, MPI, divisione III, 1930–35, busta 141.

57. Ibid.

58. *XVII Esposizione Biennale Internazionale d'Arte* (Venice, 1930), 17.

59. *IV Esposizione d'arte del sindicato regionale fascista belle arti della Venezia Giulia* (Trieste, 1930).

60. *III Mostra sindacale d'arte*, Mostra del sindacato interprovinciale fascista belle arti della venezia tridentina, 1933.

61. Regolamento, III Mostra Regionale Sindacato Fascista Belle Art della Romagna-Emilia, Ferrara, 1933; ACS, MPI, divisione III, dir. gen. AA.BB., 1930–35, busta 129.

62. Pensabene, "L'arte e i funzionari," 1.

63. Vittorio Fagone, "Arte, politica e propaganda," *AnniTrenta: Arte e Cultura in Italia* (Milan: Mazzota, 1983), 51.

64. Telesio Interlandi, "Arte e razza," *Quadrivio* (20 November 1938), 1.

65. *Le mostre d'arte in Italia*, vol. II, no. 6 (June 1935), 1.

66. Ibid.

67. Ibid.

68. Giuseppe Pensabene, "Premi per le belle arti," *Quadrivio* (12 April 1936), 1.

69. Ibid.

70. Pierre Bourdieu, "The Field of Cultural Production, or: The Economic World Reversed," in *The Field of Cultural Production*, ed. Randal Johnson (New York: Columbia University Press, 1993), 29–30.

71. On fascism's emphasis on the young in 1930s films, see Marcia Landy, *Fascism in Film* (Princeton: Princeton University Press, 1986), 33–71. For a discussion of fascist youth culture and the stress on the cultivation of a new generation of fascist leaders, see Marina Addis Saba and Ugoberto Alfassio Grimaldi, *Cultura a passo romano* (Milan, 1983), and Tracy H. Koon, *Believe,*

Obey, Fight: Political Socialization of Youth in Fascist Italy, 1922–43 (Chapel Hill: University of North Carolina Press, 1985). Ruth Ben Ghiat discussed the regime's relationship with fascist intellectual youth in "The Politics of Realism: *Corrente di vita giovanile* and the Youth Culture of the 1930's," *Stanford Italian Review*, vol. VIII, nos. 1–2 (1990), 139–64. Ruggero Zangrandi's memoir, *Il lungo viaggio attraverso il fascismo* (Milan: Feltrinelli, 1962), offers a view of both fascism's attempt to train a young elite leadership and the gradual disillusionment of that generation.

72. *Le mostre d'arte in Italia*, vol. II, nos. 11–12 (November–December 1935), 11.

73. Ibid., 12.

74. *XX Esposizione Biennale Internazionale d'Arte, 1936* (Venice, 1936), 16.

75. Alberto Neppi, "La XX Biennale a Venezia e la VI Triennale a Milano," *La Rassegna Italiana*, vol. 19 (July 1936), 492.

76. Ugo Nebbia, "L'arte Italiana alla XX Biennale," *Rassegna dell'Istruzione Artistica*, vol. 19 (July–August 1936), 219.

77. See Barbara Melosh, *Engendering Culture* (Washington and London: Smithsonian Institution Press, 1991), and Walter Kalaidjian, *American Culture Between the Wars* (New York: Columbia University Press, 1993).

78. *XXI Esposizione Biennale Internazionale d'Arte, 1938* (Venice, 1938), 15.

79. *Le mostre d'arte in Italia*, vol. IV, no. 7–10 (July–October 1937), 65.

80. *Le mostre d'arte in Italia*, vol. IV, nos. 11–12 (November–December 1937), 90.

81. *XXII Esposizione Biennale Internazionale d'Arte, 1940* (Venice, 1940), 8; *Gazzetta del Popolo* (24 May 1939); *Vedetta Fascista* (24 May 1939); *Corriere della Sera* (24 May 1940); and "La XXII Biennale—Regolamento," ACS, PCM, 1940–42, 14.1.730, sottofascicolo 6.

82. *L'arte nelle mostre italiane*, vol. VI, nos. 2–3 (February–March 1939), 7.

83. *XXII Esposizione Biennale Internazionale d'Arte, 1940*, 19.

84. Ibid.

85. Ibid.

86. Ibid.

87. Letter, 5 October 1939, Maraini to Presidente della R. Accademia di Belle Arti di Venezia, ACS, MPI, divisione III, 1935–50, busta 279. *L'arte nelle mostre italiane*, vol. VII, nos. 1–4 (January–April), 4.

88. Letter, 4 October 1939, Maraini to Marino Lazzari, ACS, MPI, divisione III, 1935–50, busta 279; and "Concorso per affreschi, bassorilievi e statue da giardino—Verbali delle sedute 21–22 novembre 1939," ASAC, busta 107. The commissions were established in Turin, Milan, Venice, Apuania, Bologna, Florence, Rome, Naples, and Palermo.

89. "Concorso per affreschi, bassorilievi e statue da giardino—Verbali delle sedute 21–22 novembre 1939," ASAC, busta 107.

90. *XXII Esposizione Biennale Internazionale d'Arte, 1940,* 8.

91. Letter, 19 April 1940, Maraini to Bottai, ACS, MPI, divisione III, 1935–50, busta 279.

92. "Concorso per affreschi, bassorilievi e statue da giardino—Verbali delle sedute 21–22 novembre 1939," ASAC, busta 107, 1.

93. Ibid.

94. Ibid., 2.

95. ASAC, Registre Vendite (4), 1938; "Elenco delle opere vendute—Ventunesima Esposizione Internazionale d'Arte," *Le mostre d'arte in Italia,* vol. V, no. 12 (December 1938).

96. Letter, 16 May 1940, Commission to Bottai, ACS, MPI, divisione III, 1935–50, busta 279.

97. Ibid.

98. "Acquisti del Ministero dell'Educazione Nazionale alla XXII Biennale 1940," ACS, MPI, divisione III, 1935–40, busta 279.

99. Ibid.

100. ASAC, Registre Vendite, 1940.

101. Ibid. "Elenco della opere vendute," *L'arte nelle mostre italiane,* vol. VII, nos. 11–12 (November–December 1940), 116–35.

102. *Le arti,* fascicolo 5 (October 1942), v.

103. At the time of his commission to paint the fresco, Santagata sat on the National Directorate of the Fascist Syndicate of Fine Arts. *Confederazioni degli professionisti ed artisti,* documents (ASAC library), 140–41.

104. *XXI Esposizione Biennale Internazionale d'Arte, 1938* (Venice: Carlo Ferrari, 1938), 41. The 1932 facade and the 1938 frescoes still stand on the Biennale grounds, though in a state of disrepair.

Decadence and the Renewal of in the Decorative Arts under Vichy

Michèle C. Cone

To this day the proper appellation of the Vichy regime remains a riddle: Was it fascist? Dirigiste? Corporatist? As a group, French historians are generally loath to call it outright fascist. Rather than seeing Pétain-ist ideology as becoming part of the fascist cloud that blanketed much of Europe just prior to and through World War II, they make a point of singularizing the regime. "Complexity," "distinctiveness," and "ambiguity" are the catchwords.[1] However, answers seem to vary with the criteria used, as a recent colloquium on Vichy attests.

Colloquium participant Stanley Hoffmann, using as his criterion the composition of the political personnel of Vichy, observed "a progressive fascisation" of the Vichy regime.[2] Michèle Cointet-Labrousse, using the argument that the regime rejected the idea of a single party (*parti unique*), refrained from judging Vichy a fascist regime. "It was not fascistically inspired, for what they wanted was an organic regime giving power to elites."[3] Denis Peschanski also refused to call Vichy totalitarian because even in the police-run Vichy of 1944, "the Milice was essentially the instrument of a civil war and not a tool for total control of society."[4]

François Bloch-Lainé, a witness of and brief participant in that period, looking at Vichy from the viewpoint of its economic organization, believes Vichy was more corporatist than dirigiste.[5] Henry Rousso sees the partisans of corporatism and those of dirigisme in opposition during Vichy, the latter triumphant since Vichy had more rather than less state interference than before. For Rousso, both dirigiste technocrats and corporatists wanted the same thing—"[to find] means to combat class warfare, to anticipate crises like those of the 1930s, and to align the industrial sector to that of the dominating country, namely the Third Reich."[6] And he noted, "nothing, except the State, impinged on the theoretical powers of heads of companies, to the loud distress

of 'corporatists,' who demanded a sharing of power within the corporatist framework."[7]

Vichy's proper appellation also seems to vary with the sector being examined. In *Le Projet culturel de Vichy*, Christian Faure focuses our attention on cultural life in the French provinces, with its folkloric spectacles, vernacular architecture, popular literature, popular imagery, and primitive artifacts; on the ethnological *chantiers* initiated by Georges-Henri Rivière, head of the Paris Musée des Arts et Traditions populaires; and on Pétainist discourse to farmers and country craftsmen. He describes the Vichy period as "the golden age of folkorist theories."[8] In Faure's view, the fear of class conflict dominated Vichy ideology. Thus Vichyites sought a unifying myth capable of competing with urban workers' solidarity.

The myth of corporatism—based on natural, organic peasant and artisanal families bound together by folklore, the fulcrum of common soil, common professional interests, traditions, and race—answered that need, while leaving hierarchical separations intact:

The myth of a unity in the farmers' and artisans' world contrasting with the parallel myth of workers' unity . . . feeds, normalizes and justifies the highly hierarchical society that the French state is trying to develop. This unity is necessary to put into place the corporatist organization, [which] substitutes the principle of class collaboration for that of class conflict.[9]

Faure finds in the Vichy cultural project a number of signs of totalitarian political interference. For example, in his concluding chapter, Faure refers to Philippe Pétain's simulacrum of a folklore renewal as a "cultural strategy that achieves a conquest [*opère une conquête*] from the base up, through associations, the village, the region." Finding racist connotations in Pétain's imposition of the peaceful myth of the earth, Faure uses words such as "indoctrination" and "innoculation" with reference to Pétain's covert messages. And he defines Pétain's *Révolution nationale* as a form of totalitarianism.[10]

By disclosing the centralist ambitions that lay behind the corporatist mask and otherwise demystifying the innocence of folk culture, Faure shows himself to be a rare example of a French historian who touches on what Roger Griffin calls the mythic core of fascism. For while *Le Projet culturel de Vichy* demonstrates that Vichy's revival of folk culture was sheer "travesty," it also shows that, as a myth, it had the "inspirational, revolutionary power which an ideology can exert whatever its apparent

rationality or practicality."[11] However, Faure stops short of applying the word fascism to Vichy: "The *Révolution nationale*'s totalitarianism is different from the fascism of Mussolini or from Nazism because the ideologies and the personalities of their leaders differ."[12] Once again, the *Révolution nationale* is seen as a case apart because Pétain was no Hitler or Mussolini, and his ideology was distinct from theirs.

I would like to analyze a sector so far left unmined—the high end of decorative arts under Vichy. Without pretending that lifting the veil on this subject will solve the Vichy riddle, I hope that a new facet of this fascinating question will emerge from focusing on the issue of decadence in the decorative arts raised by Vichy, and on the kinds of remedies proposed to bring about a renewal. I ask whether we can gain new insights on the relationship of Vichy to fascism in this one domain by shifting our investigation from the popular arts to the high end of decorative arts. Faure in his *Projet culturel* shows the myth of renewal being played out for all its worth during Vichy; what still needs exploring is on what grounds renewal was made to appear a necessity—that is, whether Vichy exploited the myth of decadence in the decorative arts in order to justify its demand for a new culture. Fascistic paradigms have been connected to the idea that decadence is reversible and renewal can occur. Griffin, for one, proposes that an ideal type of fascist state invariably relies on "a myth of national decadence, conceived in such a way that it could be reversed by a radical process of national regeneration."[13]

Griffin calls Vichy "para-fascist" because it emerged from a military defeat rather than a populous revolution, and its apologists included a "wide variety of rightist forces" who competed to define the regime's political agenda. He does note, however, that Pétain's *Révolution nationale* found its rationale in "a whosesale condemnation of the decadence of republicanism."[14] Since, according to Griffin, the myth of decadence was fundamental to the para-fascist dimension of Vichy, the impact of this myth on the regime's decorative arts policy is worth exploring, so as to elucidate further the relation of art to ideology under Pétain's leadership.

The Decorative Arts on Trial during Vichy

It is not my intention to argue with the view that folklorist theories flourished during Vichy, nor to deny that the marshal's priority was to

country artisans who—to quote from the 1 May 1941 Commentry speech—"had been the first to understand the great truth [corporatism], and to put it into practice."[15] But the focus on popular culture in the French provinces, which still today show vestiges of folk traditions, and the foregrounding of Georges-Henri Rivière's legendary nostalgia for artisan culture and society have left under the dust the luxury decorative arts and their ardent supporter, Guillaume Janneau, director during Vichy of the state-owned Sèvres, Beauvais, Aubusson, and Gobelins manufactures of decorative arts. What are the issues behind Vichy's interest in luxury craft that do not appear in Vichy's celebration of popular folk culture, and in what sense might they affect the conclusions of *Le Projet culturel de Vichy* and sharpen our understanding of the political nature of the Vichy regime?

Luxury applied arts had indeed a far greater economic potential to France than country craft. In the Thiers speech of 1 May 1942, the marshal made a point of addressing not only artisan-preservers of social peace—that is, country artisans—but artisan-producers of economic wealth, of factory workers: "The artisan is also the auxiliary to the industrialist. He accomplishes certain phases of the fabrication." He went on to say, "a lively and fecund craft is one of the essential elements of tomorrow's economic policies."[16]

The town of Thiers' main resource was fine cutlery, the product of hand and machine work. Manufactures of china, furniture, silver, glass, and crystalware, tapestry firms, cabinetmakers, and modern decorators (*ensembliers*) also relied on a variety of crafts professionals in their businesses. Several of these businesses were state owned. Near Paris was the Sèvres manufacture, with its various *corps de métiers*—potters, decorative artists, glazers, and other craftsmen involved in the production of porcelain. Sèvres, like the state-owned Gobelins, Aubusson, La Savonnerie, and Beauvais were founded during the Monarchy.[17] After the Revolution these manufactures remained the official providers of the offices and households of French dignitaries and embassies, and their wares were marketed worldwide. Such state- or privately-owned enterprises, somewhere between the individual country artisan and the large-scale industrialist, were very much the marshal's concern in the Thiers speech.

In several respects, luxury and folkloric decorative arts overlapped. For one thing, Vichy legislation for the creation of corporatist families involved all so-called artisanal professions. For another, the

review *Métiers de France*, created by Vichy in 1941, published articles about the butcher's craft in one issue and about Sèvres ceramics in another. Its varied advertising caused further confusion, with perfume and interior decoration (June 1942), haute couture (December 1942), and even adding machines (September 1943). Finally, some of the same artists who attached their names to cheap, popular folk imagery also participated in the creation of expensive objects, including tapestries and furniture.

But in one aspect of major consequence, country crafts were looked upon in a different way from luxury crafts: while, as suggested by Faure, regional folk culture before Vichy was pictured by Vichyites as the *forgotten* art of France, "formerly relegated to the status of 'sous produit,'"[18] luxury craft before Vichy was represented by Vichyites as having *declined* in quality.

At the 1942 conference on artists and artisans organized under the auspices of the Institut d'Etudes Corporatives, the issue of quality came up repeatedly: Guillaume Janneau spoke of "errors of taste, stylistic heresies, lack of common sense. . . ."[19] Unlike Georges-Henri Rivière, another speaker at the conference, he did not see "the folkloric cult" as a remedy, claiming that "the most acute problem was regionalism." He said, "[The country artisan] contributes to the persistance of this grave error, namely that craft remains attached to the past, constitutes one of its remnants, and shows itself inapt at entering new directions."[20] This powerful figure in the Vichy government, a decorative arts critic of long-standing, a specialist of French antiques, and the author of scholarly texts on modern decorative arts, warned in his conclusion that for the *beau métier* to recover its former prestige, "it will be necessary to make it worthy of rehabilitation, something which, with few exceptions, contemporary decorative arts are far from deserving."[21]

The president of the newly founded corporatist organization of artist-decorators, Maurice Dufrène, complained about seeing quantities of works "mindboggling in their stupidity!"[22] Jacques Mayet, head of the economic section of the Service de l'artisanat, used the expression "terribly ravaging decadence of taste" for his indictment of some of the productions he had recently seen.[23]

Considering the rousing reception of art deco at the Paris 1925 international exhibition,[24] the innovative spirit of Le Corbusier, Robert Mallet-Stevens, Pierre Chareau, Charlotte Perriand, and other func-

tionalist designers in Paris, the presence in Paris of ceramists (Jean Mayodon, Emile Decoeur), cabinetmakers, and interior decorators of great talent throughout the prewar period (Adnet, Arbus, Drouin, Printz, Groult, Jourdain, Ruhlmann, Leleu),[25] what was that critique about? Without pretending to write in a few pages the history of nearly twenty years of French decorative arts, I will try to assess in what sense and from whose perspective a decline in French decorative arts could be said to have taken place and to evaluate the contribution of Vichy to this issue.

Technical Decadence at the State Manufactures and Vichy's Response

A state-owned manufacture like Beauvais could boast artistic success at the 1925 exhibition of decorative arts, but "practically, from the point of view of clientele, it is null," wrote Luc Benoist in *Beaux Arts*.[26] Although Beauvais obtained financial autonomy from the French state in October 1926, at the same time as Sèvres, the Depression had hit by the time they had reorganized. Financial autonomy, which was supposed to make these manufactures more efficient by cutting down on the red tape with the state, did not produce the desired effect. The manufactures continued to be a burden to the Third Republic.

The manufactures' problems related to politics, waste, and what Janneau would later call "technical decadence."[27] For example, it took nine years (September 1924 to June 1933) for Beauvais manufactures to complete the commission that Raoul Dufy received from the French state to decorate a screen, make tapestry designs for the back of a sofa, four armchairs, and four chairs initially scheduled to be shown at the 1925 decorative arts exhibition.[28] This slow work pace may not be unrelated to government changes during that period. Dufy complained in 1927 about not knowing who would design the furniture for which his decorations were intended.[29] The Beauvais weavers, trained to repair priceless old tapestries, were clearly not equipped to deal with the cartoon by Dufy.[30] Although French taxpayers did not refer to such a waste of their money as decadence, this story remains an example of the spendthrift ways of Third Republic government(s) at which Vichy pointed a finger and which it was happy to use as an excuse for interference and control.

The law of 11 February 1941 (J.O. 4 April) allowed the Vichy government to take away the financial autonomy of the state manu-

factures, to eliminate some positions, and to appoint a single director, Guillaume Janneau, who already ran the Gobelins manufactures of fine furniture, also known as *Garde Meuble*. In addition, a government-owned shop opened on the rue de la Paix to begin selling luxury craft from all the state manufactures to the general public.

In order to accelerate the production of tapestry at Aubusson and Beauvais, Janneau proclaimed a return to traditional methods, giving the weavers greater license to simplify the cartoons provided by artists and urging painters to design cartoons with fewer than twenty colors.[31] At Sèvres, by order of Janneau, production was stopped on many ceramic pieces created there between 1870 and 1940, because they were said to be too impractical to produce. Janneau also ordered the destruction of molds and many plaster casts.[32] To increase further the production at Sèvres, Janneau ordered the manufacture to use a narrower range of porcelain pastes and to reduce the number of firing processes.[33]

Remedies for decadence at the various state manufactures appear in a new light when one realizes that during Vichy these manufactures worked for the "service artistique," the marshal's propaganda machine. Robert Lallemant, who headed the "service artistique du maréchal," was a ceramist, whose objects, many of them porcelain knicknacks, were occasionally inspired by cubism. In the early 1930s, he worked for wealthy individuals as an interior designer and created inventive modernist pieces of furniture. For unknown reasons, he abandoned his artistic vocation in the mid-1930s and became an industrialist, until tapped by the marshal's doctor to join the Vichy hierarchy.[34]

From what remains of the tapestry cartoons commissioned by Lallemant from Aubusson—illustrated in *Beaux Arts de France*—it is clear that they were intended to propagate Pétainist propaganda: the return to the soil; to celebration of work, of craft, of the family; and, of course, to present the marshal as savior. There were sixty-eight tapestry commissions by the French state, according to Georges Hilaire, the successor as General Secretary for the Fine Arts of Louis Hautecoeur.[35]

At the Sèvres porcelain manufactures, "almost all the models created. . .were related to the iconography of Philippe Pétain. . . ."[36] Some were "medallions and busts with the marshal's effigy, vases or ashtrays adorned with the *francisque* and with the marshal's sayings, to be given as official gifts to loyal followers."[37] Some were designed

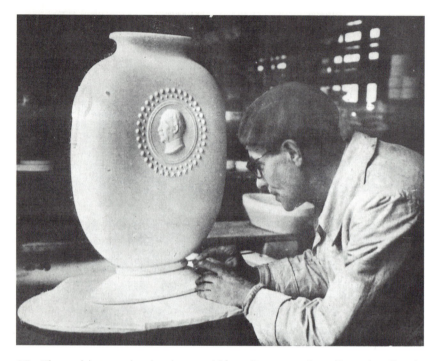

39. "The modelist retouches the plaster mold for a Sèvres vase that will soon be offered by the National Manufactures of Sèvres to Marshal Pétain." Photo D.N.P.

for the use of the marshal and for Madame Pétain (fig. 39). It is not known who paid for the Sèvres pieces on a "cynegetic theme" destined for Goering[38] and for the Sèvres ashtray for Hitler.[39]

The Sèvres museum has on display several white square-shaped ceramic flasks with gold imprints designed by Robert Lallemant in the 1920s, which he reused for propaganda purposes during Vichy: a profile of Pétain can be seen inscribed in a medallion in one of them, with "offert par le maréchal" written in small letters (fig. 40). Illustrations on the theme of plowing and another one showing a potter at work (both decorated by Decaris) are found on two larger flasks of identical shape. The fourth flask has no image, only the marshal's principles inscribed in gold. The back of all of them is full of inscriptions signed "Ph. Pétain."

State manufactures were indeed sitting ducks for manipulation by Vichy. Changes in their operations could be effected by decree; they were obliged to continue their traditional function of serving the

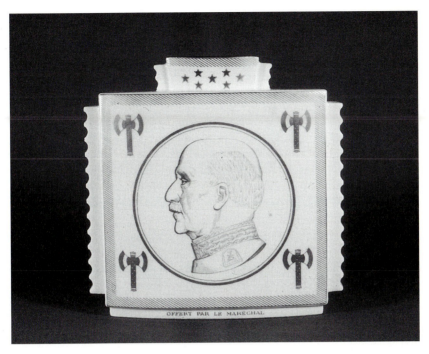

40. Sèvres vase by Robert Lallemant with Marshal Pétain's profile, 1944. Musée des porcelaines de Sèvres, Sèvres, France. Photo Michèle C. Cone

French government; their compliance with Pétainist propaganda illuminates (or caricatures) the functioning of an apolitical administration, when in lieu of serving a Republican institution, it is at the disposal of a demagogue. On another level, the situation of state manufactures during Vichy is a good example of what Stanley Hoffmann calls "state collaborationism" against "ideological collaborationism."

Endangered Luxury Crafts and Vichy's Response

Euphoria may have surrounded the arrival in the 1920s of a new wave of designers who, behind the functionalist architect Le Corbusier, sought to adapt interior design to new lifestyles by doing away with expensive, useless ornamental objects and details, and promoting the idea of models reproducible by industry. But such ideas were hardly welcome by craftsmen whose livelihood came from the production and

ornamentation of luxury craft and by modern French cabinetmakers and decorators.

There is no reason to go over Janneau's skirmishes with Le Corbusier in the 1920s on the question of "rationalism," which Janneau supported, vs. "functionalism," which he rejected, as the controversy has already been analyzed by Nancy Troy.[40] A fiercer enemy of functionalism was the art and architecture historian, Louis Hautecoeur, General Secretary for Fine Arts during Vichy, who wrote in 1928:

[A few decorators] make chairs with metallic tubing, conceive aluminum armchairs or desks made of sheets of iron tole. They do not cover the steel with cellulaque—as does Mr. Ruhlmann in his desks. They show the metal naked. They proclaim with Mr. Le Corbusier that our age is that of steel and that decorative arts are tooling [outillage]. . . .

No more useless knicknacks, no more fabrics on lamp shades but lamps at the end of metallic arms like in a dentist's office.[41]

Indeed, from the point of view of ceramists such as Jean Mayodon, the artistic director of Sèvres during the Occupation, an artist born at Sèvres, trained at the manufacture of Sèvres, and renowned for vases with "infinite colored variations. . .a decorative refinement requiring an extreme complexity of realization (five or six successive bakings),"[42] the anticraftsman, antiornament ethos of the new wave of functionalist designers, spelled disaster. Camille Mauclair, the traditionalist art critic whose perennial vindictiveness against modernism flourished during Vichy, pointed out in 1929 that craftsmen involved in luxury handmade decorative arts—ceramists, cabinetmakers, etc.— would become unemployed, and their métiers would become extinct if the functionalists were to succeed.[43] Without the example of the craftsmen, the French tradition of refined taste and unique craftsmanship would fade away. In the eyes of Vichy officials, that scenario had already taken place, hence the need to boost producers of luxury decorative arts before it was too late.

The state manufactures were not the only beneficiaries of Vichy's attentions. Robert Lallemant's "service artistique" called on a number of manufactures, both state and privately owned, according to the list of works presented at the 1944 Salon de l'Imagerie in Paris under the heading "Oeuvres du Service artistique du Maréchal dirigé par R. Lallemant."[44] Besides Sèvres, Aubusson, the state administration of coins and medals, and the state tobacco manufacture, the list includes the crystal manufacture of Baccarat, under "glassware for the chief of

state, model created in collaboration between G. Chevalier and Robert Lallemant"; Puiforcat under "silverware, box and silver cup, ornamented by Robert Lallemant"; Canale, for a "plaquette by the sculptor Henri Dropsy, offered by the marshal to towns affected by bombings"; Guenin Lecanu, for "a metal box with the marshal's effigy done by the sculptor A. Levrillier"; Degroote for "a plexi brooch and paperweight designed by R. Lallemant"; Draeger Frères, for "a cigarette coffer decorated by Paul Ternat." Other firms whose objects were not yet ready for exhibition were also put to work. It is obviously difficult to find these objects today. One of them, from the Musée d'Histoire Contemporaine, is a Baccarat crystal vase. A symmetrical, V-shaped modern piece, it has the marshal's *francisque* incised in the center and the words "offered by Marshal Pétain" printed below (fig. 41).

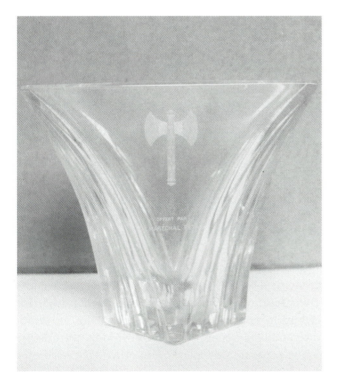

41. Baccarat crystal vase with Marshal Pétain's emblem. Musée d'Histoire Contemporaine, Paris. Photo Michèle C. Cone

It would thus seem that Vichy's assistance to threatened luxury decorative arts was not without ulterior motive. The Vichy government gave business to producers of luxury crafts who were willing to accept the conditions set out by Robert Lallemant and his "service artistique," namely to help Pétain with his image and contribute to his propaganda.

Excessive Individualism Tamed by Corporatist Organizations

Guillaume Janneau placed the blame for the decline of luxury decorative arts on excessive individualism and on the lack of cooperation between fine artists, technicians, and craftsmen. "Today, the head of an atelier, unless he himself invents his models, is nothing but the instrument of a draftsman erected to the status of author," he wrote.

And even in the most artisanal of metiers . . . too often, the decorator intervening as master, deprives his oeuvre of this 'human element' that the collaboration of the artisan might have conferred upon it. . . . Rarely has a vaster and more delicate problem of redressing presented itself to . . . the critical spirit of responsible men."[45]

Under the guise of reclassifying, workers participating in various phases of decorative applied arts were regrouped, simulating the medieval guild system. A first decree organizing "métiers d'art," the generic term for all decorative arts at that time, was signed 20 January 1941, (J.O. 5 February 1941); a second decree completing the first list was signed 3 February 1942 (J.O. 5 February 1942). A third decree of 3 April 1942 (J.O. 26 April 1942) announced the creation of the professional family of "*métiers d'art* and other diverse articles." Yet another decree of 7 July 1941 (J.O. 29 July 1941) instituted the organization of interior decorators and visual artists.

The idea behind reclassifying was to place within the same corporatist entity various categories of workers involved in decorative arts so they would benefit from each other's expertise. Decorators, for example, were placed in the corporatist organization of painters, sculptors, engravers, and medalists because these individuals were being called upon to decorate screens, sideboards, and other accessories for luxurious homes.

Valid as Janneau's argument might be that artisans and artists had suffered from their splendid isolation from one another, a situa-

tion historically associated with the idea of decadence,[46] the system put in place hardly resolved those difficulties. By blurring the hierarchy between free and applied art, between the decorative artist and the artisan, the Vichy state was trying to put every worker including "free" artists under its tutelage. Furthermore, in the new organizations, final say—such as decisions concerning the allotment [repartition] of the scarce materials necessary for the activities of the members of the decorative arts organization—was in the hands of representatives of the Vichy State. The heads of committees for each section of *métiers d'art* were chosen by a Vichy official and supervised by a Vichy appointee who had free access to all the meetings held at the various levels of the new organizations: consultative commissions, bureaux, groups, and work sections (see decree of 20 January 1941, in J.O. 5 February 1941).

The Pure Frenchness Argument in Favor of Ornamentation

In 1937, with foreign decorative arts about to compete with French ones at the World's Fair, the issue of internationalism vs. Frenchness that had lingered throughout the century came vigourously to the fore once again, exacerbated by the high unemployment caused by the great Depression. Starting in 1934 the publication *Art et artisanat* representing the voice of the "groupement syndical des artisans d'art" had taken a firm stand against foreign manpower as plans for the 1937 Paris international expo were taking shape.[47] And in the winter of 1938–39, the review *Beaux Arts* confronted the issue of Frenchness vs. internationalism in its editorials.[48]

Since its beginnings in 1901, the organization that put together yearly exhibitions for ceramists, cabinetmakers, interior decorators, and other luxury artisans, the Société des Artistes Décorateurs (SAD), had had a reputation for its openness to the new.[49] In the beginning functionalists were welcome there, although their professed stand against the ornament, their belief in industrial processes, and their internationalist outlook close to that of the German Bauhaus and the Russian constructivists made them suspect.[50]

Whether functionalists were expelled or seceded on their own from the SAD in 1929 is difficult to determine. What is known is that competition between the SAD and the functionalists—now organized and exhibiting under the name of UAM (Union des Artistes Mod-

ernes)—was intense. Although the latter initially hoped to serve a broader public than the SAD by mass-producing their designs and allying themselves with industry, both groups in fact addressed the same wealthy clientele because the Depression put an end to utopian intentions. Retrospectively, the division between the two groups seems more trivial than it was made to appear. On an aesthetic level, SAD decorators believed that useless ornament was not superfluous if it were part of a design, whereas UAM designers concentrated on making the smallest functional detail of the home into a work of art. One of the founding members of UAM, Jean Puiforcat—the heir to the Puiforcat flatware firm—designed elegant bath and basin faucets and stylish doorknobs in those years.

Even on the political level, the image of the UAM as firebrand progressionist by comparison to the SAD does not stand up. Pétain's artistic adviser, Robert Lallemant, was one of the lesser-known founders of the UAM. The firm of Puiforcat would work for the Vichy propaganda machine. Le Corbusier also offered his services to Vichy.[51]

As for Janneau, he had associated his name if not with functionalism—he was too much on the side of luxury decorative arts[52]—at least with rationalism. In a 1923 text on the ceramist Emile Decoeur, he wrote: "Rationalism is the heritage of French artisans. . . . Decoeur wants his decoration to express the properties of the material."[53] In a 1925 text on modernist lighting fixtures, Janneau concluded: "We are reaching a new stage toward the integral rationalism of the interior decor."[54] In 1942 when he and Louis Hautecoeur coauthored a book on modern furniture, Janneau said: "All that is not spontaneously determined by common sense, by a utilitarian spirit, in the domain of domestic decor is useless."[55] He repeated the same point of view in his 1943 *Meubles nouveaux*.[56]

Even though the ideological lines between the SAD and the UAM were never carefully drawn, the pro-ornament SAD and the anti-ornament UAM were, in 1937, farther apart than ever. The SAD's viewpoint was reinforced by the presence of craftsmen from the French provinces at the World's Fair, who also brandished their ornamental genius and manual expertise as the most prestigious signs of Frenchness, tradition, and quality. Though reason may be on the side of UAM member Robert Mallet-Stevens when he said, "It is neither fashion nor ornament that defines the nationality of a style; it is the personality of the artists and only their personality,"[57] in the conflictual

climate of 1937, strong forces were pushing ornament as a symbol of Frenchness in decorative arts, and its absence as signifying foreign inspiration, hence "decadent."

All UAM members were not tagged as "foreigners"—Judeo-Marxist-decadent in Nazi parlance. During the Occupation an attempt was made to unite the SAD and the UAM under the name of Société des Artistes Décorateurs Modernes.[58] The pro-ornament forces, however, clearly had support in high places. When, during Vichy, two officials, Louis Hautecoeur and Guillaume Janneau, coauthored the text on modern furniture mentioned earlier, the point on which they were in total agreement was the question of ornament. Hautecoeur stated, "Nothing prevents the decoration of a piece of furniture with a medallion, a precious incrustation, a sculpted motif."[59] Janneau likewise concluded, "It is necessary to restore ornamentation, that is decorative sculpture and 'ciselure d'ameublement.' "[60] In addition to Hautecoeur and Janneau, Maurice Dufrène, a steady exhibitor at the SAD from 1904 through 1942, had become head of the decorators' section of the "organisation professionelle des arts graphiques et plastiques," the newly formed artists and decorators corporatist organization mentioned earlier. Among the purchases made by Vichy in 1941, one finds the names of SAD members Jules Leleu, Jean Dunand, and André Devèche;[61] in 1942 one finds Adnet, Leleu, Porteneuve.[62]

A Historicist Style Approved

The word decadent might have defined the sensibility of SAD presentations in the late 1930s. Redolent of idle wealth, pomp, and the languidity of vicarious living—set against the sense of purpose and energy conveyed by the functionalists—SAD displays from 1937 to 1939 abounded in "bedrooms fit for dreamers." Symphonies of pale pastels, with trompe l'oeil effects (actual and simulated fabrics draped on ceilings and walls in Louis Sue's "bedroom," 1939), these rooms exuded a feeling of the uncanny, no doubt because the period styles in which they were furnished reached back to antiquity yet were modern. Typical of this mood is the lounging chair or "méridienne" by André Arbus exhibited at the 1937 SAD pavilion. "It is the era of fake luxury, of theatrical mise-en-scene, of the arabesque which. . .infiltrates objects and furniture."[63]

Surprisingly, far from repudiating this mode of eclectic historicism, which has been called surrealist-influenced, some of the decora-

tors fashionable during Vichy seem to have carried it to extremes. Reviewing the 1942 SAD, Pierre du Colombier observes, "Are we headed for a new baroque, a new rococo? It's possible." To him it feels as if "creators had escaped from the rigorousness of the times by means of an outpour of fantasy."[64]

Wrought iron is a popular material in those years, its renaissance explained by Janneau "as the resurgence of the classical system of the grotesque" on the one hand, and the shop-sign tradition on the other.[65] Wrought iron is used like rope, curling under a marble tabletop by Marc du Plantier (fig. 42). For a wall fixture by Gilbert Poillerat and a small mirror by Raoul Guis, an odd mix of materials and forms are joined—as in a three-dimensional exquisite corpse—in a surfeit of time-consuming detailing and excessive handmade ornamentation. Wood, particularly oak, is subject to elaborate handcarving. Styles continue to be hybrid as when a rectangular sideboard and elaborate figurative sculpture for the door handle coexist in the same piece.

An uncanny datelessness invades classical vases by Mayodon decorated with mythological scenes roughly sketched in, and a set of oak armchairs by Jacques Adnet with high backs ornamented with Aubusson tapestry tondos on the theme of the four seasons by Pierre Olivier.

One sometimes wonders if there was not some irony or perhaps mockery implied in such excessive and gratuitous craftsmanship on the part of cabinetmakers and their artist associates. This being said, such manifestation of the hand at work articulated several goals of the regime: the association of Frenchness, craft, and quality. The foreigner and the Jew are historic scapegoats of decadence. In the mid-1880s, avowal of decadence in decorative arts had already been a leitmotif of xenophobes. Then, "[Louis] de Fourcaud called on the government to support the Central Union's developing program to revitalize the crafts through nationalism. . . . 'Restore our French genius,' he urged, 'help our French art works to triumph.'"[66] Closer to our time, Marcel Duchamp, although a French artist, had first sensitized society to the possibility of art without craftsmanship, and another French artist, Fernand Léger, had predicted the phasing out of the métier of artist and praised the modern machine-made object. Yet "decadence" was repeatedly ascribed to foreign influences by, among others, the man who became General Secretary for Fine Arts under Pétain, Louis Hautecoeur.[67]

Once again, as pointed out by Nancy Troy, "French decorators found that the only way to be modern yet remain French was to invoke

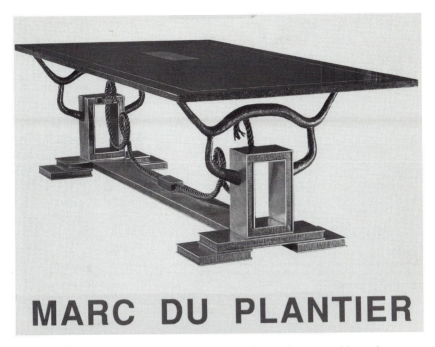

42. Marc du Plantier, Table, ca. 1943. Bronze and wrought iron, marble, and marqueterie. Galerie Neo Senso. Photo Studio FP

the styles and to the extent possible, the modes of production that they believed had made their decorative arts so successful in the past."[68]

Conclusion

The question of origin is imbedded in the disagreement observed at the outset of this paper on the proper appellation of the Vichy regime. Zeev Sternhell sees the origin of Vichy ideology in the theories of fascism that emerged in France (as well as Germany) at the end of the nineteenth century. For him, a French fascist tradition exists, which resembles German *volkism*. For the French historian René Rémond and his followers, Vichy has roots that go farther into the past. It is tied to the French monarchic tradition, and its ideology had to do with reversing the changes achieved by the French revolution.

Given that the decorative arts were among the jewels of the French monarchy, the behavior of Vichy with respect to them is far

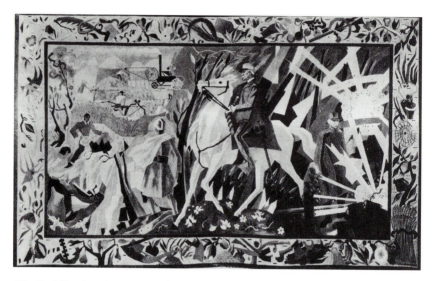

43. Paul Charlemagne, *National Renovation*, 1942. Photo Jacques Faujour. © 1991 ARS N.Y./ADAGP

from irrelevant to the Rémond/Sternhell debate. Let us then compare the tapestry subsidized by Vichy entitled *National Renovation* by Paul Charlemagne (fig. 43) showing Pétain surrounded by workmen with one of Louis XIV surrounded by artisans. In the great tapestry from a design by Charles Lebrun entitled *Louis XIV Visiting the Gobelins* (fig. 44), the Sun King stands discreetly behind and to the far left of the medley of artisans showing off their wares. It is they who "reflect the power and splendor of the sovereign and the state."[69] By contrast, in Charlemagne's work, Pétain in uniform and on horseback occupies center stage and the workmen are diminutive figures at his feet. Whereas Lebrun shows the Sun King as promoter of the decorative arts and friend of its artisans, it is the image of a military man promoting himself that is conveyed by Charlemagne, the marshal's "courtisan."

A similar conclusion could be drawn from comparing the use of ornament during the monarchy and during Vichy. Throughout the classical age, which, according to Jacques Soulillou, all fascist regimes pretend to revive, ornament was never thought of in terms of "supplement," of "*parergon*."[70] But whereas under the monarchy a new

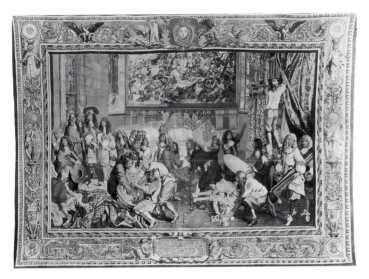

44. Charles Lebrun, *Louis XIV Visiting the Gobelins*, 1673–80. Tapestry from the series "L'histoire du Roi." Mobilier Nationale collection. Photo Mobilier Nationale, Paris

style of ornament would herald a change of leader, a certain dateless-ness characterizes the decorative arts during Vichy; previous orna-mental styles are recycled. The inscription "Philippe Pétain" adorns objects in a variety of styles. More significant than the style of decora-tive arts is the "cult of personality" latent in their content.

The discourse on decadence during Vichy, though consistent with that condemning loss of craftsmanship in modernist painting and sculpture, had less to do with recovering the virtues of quality and taste associated with the French monarchy than with transforming the decorative arts into cult objects. The decorative arts under Vichy, rather than announcing the era of a new monarch with a new decora-tive style, continued to be torn between modernity and tradition. The main beneficiary of an alleged recovery was Pétain himself.

The importance of the myth of cultural decadence for fascist ide-ology is hardly new, and it has been noted by a number of scholars. Eugen Weber has observed that allegations of decline in quality and standards of literary and artistic products can broaden "into the belief that decline in these realms mirror[s] deeper and more significant cor-ruption, an incoherent literature, art or politics being the mere reflec-

tions of incoherent times."[71] The relationship of decadence to ideology is formulated somewhat differently by Zeev Sternhell who considers that "the problem of decadence is one of the major preoccupations of fascism" because at issue is "not only the fate of the nation but also that of civilization."[72] Roger Griffin's contribution to the fascist debate is to shift attention from the rational tenor of fascism—namely its dogma, to its irrational workings—the alarming myths on which it plays in order to justify itself in the eyes of society.[73]

In the period under scrutiny, the Great Depression had certainly threatened all luxury industries, and the luxury craftsman was an endangered species to the extent that his production remained inefficient, costly, and dispensable in times of economic crisis, and that he could not withstand the international competition of more standardized products. Instead of helping artisans adapt to a changing world, Vichy waved the flag of decadence against real or imagined competition—the machine, the foreigner, the Jew, meanwhile taking control of French manufacture, and of professional organizations.

In sum, the call for renewal in the decorative arts on the part of the Vichy regime cannot be separated from a more general attempt to justify the regime's break from democratic forms of government. The efficiency resulting from a corporatist approach to the decorative arts was said to be a cure for the technical incompetence and the excessive individualism that plagued decorative arts production under the Third Republic. In similar fashion, the Vichy regime contrasted its embrace of an ornamental style, grounded in the French tradition, with the functionalism supposedly promoted by foreign artists or those non-French or foreign entrepreneurs whose support of mass production methods had undermined French craft. The fact that technical incompetence, individualism, and functionalism were equally condemned in the name of decadence serves to remind us that mythic ideology permeated all aspects of Vichy arts policy. No solution for the plight of decorative arts was found, other than the invocation of decadence in the name of a para-fascist national revolution.

1. The most influential *porte-parole* of the "complexity" point of view is historian René Rémond, who has taken to task the conclusions and the methodology of Zeev Sternhell, a well-known authority on French fascism. The latest verbal duel occurred when Sternhell criticized French historians (including Rémond) for continuing to present Vichy as "a conservative, paternalist regime under the

enemy's boot, nothing more than a regrettable bout of fever," while Sternhell contends that "the [Vichy] system put in place in July 1940 was no less violent than the Mussolini dictatorship" (Sternhell, "Ce passé qui refuse de passer," *Le Monde* [21 September 1994]). Among Rémond's methodological criticisms was the commonplace argument that hindsight is twenty-twenty vision. For Rémond, the good [objective] historian "interrogates the past starting from the preoccupations of the time, and must not abuse the advantage [he has] of knowing how it came out" (Rémond, "La Complexité de Vichy," *Le Monde* [5 October 1994]). It is only because democracy won out in 1944–45 that de Gaulle's early resistance stance looks right to us and not Pétain's accommodation with . . . fascisms. In June 1940, given the military debacle and the demoralized state of France, the initiatives of Pétain made sense to a vast majority of the French citizenry, not de Gaulle's minority voice. From this point of view, Pétain's role appears in a complex, ambiguous, and uncertain light. So does the young, ambitious Mitterand, measuring his options and choosing first Pétain and then the Resistance.

When a longtime supporter of the "complexity" thesis, Claire Andrieu, wrote that when such a promise was "pushed to extremes . . . [it] might lead to the erasure of the difference between the Resistance and Collaboration" (*Esprit* [December 1994], 208), she was also accused of practicing bad history by the editor of *Esprit*, Joel Roman.

2. J. P. Azéma and François Bédarida, eds., *Vichy et les français* (Paris: Fayard, 1992), 252. This book published the proceedings of an international colloquium. Unless otherwise indicated, all translations in this chapter are my own.

3. Ibid., 254.

4. Ibid., 260.

5. Ibid., 368.

6. Ibid., 359.

7. Ibid.

8. Christian Faure, *Le Projet culturel de Vichy* (Lyon: CNRS, 1989), 270–71. Faure notes that the celebration of folkloric productions was Pétain's own idea: "the fact that they are in effect folkloric, is due to his personality. He calls upon peace, the tradition of ancestors, continuity. The hostility of Pétain against industrialization, the city and consequently intellectuality, comes out of conceptions that identify with a farm society under threat and with corporatism confronted with capitalism. It thus opposes the city to the country."

9. Ibid., 120. For more on the social policies of Vichy see Jean Pierre Le Crom, *Syndicats, nous voilà: Vichy et le corporatisme* (Paris: L'Atelier, 1995).

10. Faure, *Le Projet culturel de Vichy*, 270.

11. Roger Griffin, *The Nature of Fascism* (London: Routledge, 1991), 28.

12. Faure, *Le Projet cultural de Vichy*, 272.

13. Griffin, *The Nature of Fascism*, 201.

14. Ibid.,135–36.

15. Quoted in *Le Nouvelliste* (2 May 1941).

16. Quoted in *Métiers de France* (May 1942), 1.

17. *Tables Royales, Versailles* (Paris: Direction des Musées Nationaux, 1994), n.p.

18. Faure, *Le Projet culturel de Vichy*, 17.

19. *Artistes et Artisans* (Paris: Service de l'artisanat, 1942), 63. This publication was a transcription of six lectures given during the national selection of artisans exhibition in 1942.

20. Ibid., 62–63.

21. Ibid., 71–72.

22. Ibid., 51.

23. Ibid., 78.

24. Yvonne Brunhammer, "Les Années 1920–1930," in *Les Réalismes* (Paris: Centre de Culture Georges Pompidou, 1980–81), 344. See also Nancy Troy, *Modernism and the Decorative Arts in France* (New Haven: Yale University Press, 1991).

25. Brunhammer, "Les Années," 350–51. See also Viviane Jutheau, *Jules et Andre Leleu* (Paris: Vecteurs, 1989).

26. *Beaux Arts* (15 May 1925), 17.

27. Guillaume Janneau, "La réorientation de Sèvres," *Beaux arts de France*, vol. II (December 1942–January 1943), 96.

28. Chantal Gastinel-Coural, *La République dans ses meubles* (Paris: Musée des Arts Décoratifs, 1993), 14.

29. Ibid., 15. His eventual partner was André Groult.

30. In the 1930s, Dufy was among the artists with Matisse, Rouault, Leger, Derain, Miró, and Le Corbusier that Madame Cuttoli called upon when she undertook to revive tapesty-making and to create her own workshops. The San Francisco Museum of Art had a show of these tapestries. See *Beaux arts* (13 January 1939), 1.

31. Guillaume Janneau, "Nouveaux Cartons pour les Manufactures Nationales de Tapisserie," *Beaux arts de France* (October–November 1943), 38.

32. Marcelle Brunet and Tamara Préaud, *Sèvres des origines à nos jours* (Fribourg: Office du Livre, 1978), 311.

33. Janneau, "La réorientation de Sèvres," *Beaux arts de France* (October–November 1943), 96.

34. Jacqueline du Pasquier, "Robert Lallemant, Homme et artiste à multiples facettes," in *Céramique de Robert Lallemant* (Orléans: Musée des Beaux Arts, 1993), 7–15.

35. Interview in *Comoedia* (5 August 1944).

36. Brunet and Préaud, *Sèvres des origines à nos jours*, 320.

37. Ibid., 328.

38. A. Fay-Halle and V. Guillaume, *Porcelaines de Sèvres au XXème siècle* (Paris: Editions de la Réunion des Musées Nationaux, 1987), 23.

39. Brunet and Préaud, *Sèvres des origines à nos jours*, 328. "It was an ashtray with the equestrian statue of Charlemagne holding a scepter, and on the reverse, a legend saying that the Great Reich, split by the sons of the Emperor, had just been reunified by the Fuhrer." I should add that in the opinion of the curators of a 1987 exhibition of Sèvres porcelain at the Louvre, these models were not considered of sufficient quality to be included in the show as "they are not works of art"! Access to them has been denied to the author. Fay-Halle and Guillaume, *Porcelains de Sèvres*, 23.

40. Troy, *Modernism and the Decorative Arts in France*, 208.

41. Louis Hautecoeur, *Considérations sur l'art d'aujourd'hui* (Paris: Librairie de France, 1929), 112.

42. André Vignoles, *Jean Mayodon céramiste* (Paris: Galerie Landrot, n.d.), n.p.

43. Camille Mauclair, "L'architecture va-t-elle mourir?" in Yvonne Brunhammer and Suzanne Tise, *Les Artistes Décorateurs 1900–1942* (Paris: Flammarion, 1990), 84.

44. Bibliothèque Nationale Yd 2 1843 (27) and photos 8 May 1944.

45. Janneau, "L'artisanat des métiers d'art," *Beaux arts de France* (June–July 1943), 284.

46. The old argument of a relationship between decadence and "splendid isolation" goes back to Croce, as explained by Richard Drake in "Decadence Decadentism, Decadent Romanticism. Toward a theory of Decadence," *Journal of Contemporary History* (January, 1982), 85.

47. See in particular *Art et Artisanat*, no. 7, 35, on the necessity to reserve the execution of official sculpture to French practitioners; see ibid., no. 9, on adding the word "Français" to the name of the "Union des artistes dessinateurs."

48. Anonymous editorials, *Beaux arts*, (7 October 1938–January 1939).

49. Brunhammer, "SAD, Société des artistes décorateurs," *Les Années UAM 1929–1958* (Paris: Musée des Arts Decoratifs, 1988), 128–31.

50. Brunhammer, "Pour ou contre l'ornement," *Les années UAM*, 119–21.

51. Mary McLeod, "Urbanism and Utopia: Le Corbusier from Regional Syndicalism to Vichy," Ph.D. diss., Princeton University (Ann Arbor: University Microfilms International, 1985), 421.

52. Troy, *Modernism and the Decorative Arts in France*, 208.

53. Janneau, *Decoeur* (Paris: Moreau, 1923), n.p.

54. Janneau, *Le Luminaire* (Paris: Moreau, 1925), n.p.

55. Louis Hautecoeur, Guillaume Janneau, and Louis Chéronnet, *L'art décoratif: Le mobilier moderne* (Paris: Comoedia-Charpentier, 1942), 16.

56. Janneau, *Meubles nouveaux* (Paris: Moreau, 1943), n.p.

57. Brunhammer, "Pour ou contre l'ornement," 121.

58. See Solange Goguel, *René Herbst* (Paris: Editions du Regard, 1990). "Under the initiative of Robert Mallet-Stevens, René Herbst, Louis Barillet, and

Raymond Templier, proposals were addressed to members of SAD and UAM for a regrouping, under the name of Société des Artistes Décorateurs Modernes, with René Herbst, a UAM member as Vice-President."

59. Hautecoeur, Janneau, and Chéronnet, *L'art décoratif*, 5–6.

60. Ibid., 15.

61. "Les achats et commandes de l'Etat aux artistes en 1941," *Beaux arts de France* (October–November 1942), 25.

62. "Les achats et commandes de l'Etat aux artistes en 1942," *Beaux arts de France* (April–May 1943), 214.

63. Brunhammer, *Les réalismes*, 352.

64. Pierre du Colombier, "Décorateurs et artisans," *Beaux arts* (27 June 1942).

65. Janneau, *Ferronerie d'art d'aujourd'hui* (Paris: Moreau, n.d.), n.p.

66. Deborah Silverman, *Art Nouveau in Fin-de-Siècle France* (Berkeley: University of California Press, 1989), 132.

67. See Michèle C. Cone, *Artists under Vichy* (Princeton: Princeton University Press, 1992), 80–81.

68. Troy, *Modernism and the Decorative Arts in France*, 227.

69. Olga Raggio, Introduction to "The Decorative Arts under Louis XIV," *Metropolitan Museum of Art Bulletin* (Spring 1989), 1.

70. Jacques Soulillou, *Le Décoratif* (Paris: Klincksieck, 1990), 17.

71. Eugen Weber, "Decadence on a Private Income," *Journal of Contemporary History* (January 1982), 1.

72. Zeev Sternhell, *Neither Right nor Left: Fascist Ideology in France*, trans. David Maisel (1986; reprint, Princeton University Press, 1995), 294.

73. According to Griffin, *The Nature of Fascism*, 35, all forms of fascism share the need to make believe that their contemporaries are "living through or about to live through a 'sea change'. . . in the historical process." Change is necessary because "the perceived corruption, anarchy, oppressiveness, iniquities or decadence of the present, rather than being seen as immutable. . . are perceived as having reached their peak and interpreted as the sure sign that one era is nearing its end and a new order is about to emerge." Combine the conjuring up of core myths with populist ultra-nationalism, and you have a fascist minimum or "palingenetic ultra-nationalism."

Selected Bibliography

Fascist Ideology and Politics in France and Italy

Adamson, Walter L. *Avant-Garde Florence: From Modernism to Fascism*. Cambridge: Harvard University Press, 1993.

———. "The Language of Opposition in Early Twentieth-Century Italy: Rhetorical Continuities between Prewar Florentine Avant-Gardism and Mussolini's Fascism." *Journal of Modern History* 64, no. 1 (March 1992): 22–51.

———. "Modernism and Fascism: The Politics of Culture in Italy, 1903–1922." *American Historical Review* 95, no. 2 (April 1990): 359–90.

Andreu, Pierre. "Les Idées politiques de la jeunesse intellectuelle de 1927 à la guerre." In *Révoltes de l'esprit: Les Revues des années 30*, 175–89. Paris: Editions 'Kimé,' 1991.

Assouline, Pierre. *L'Epuration des intellectuels, 1944–1945*. Brussels: Complexe, 1990 [1985].

Benjamin, Walter. "The Work of Art in the Age of Mechanical Reproduction." In *Illuminations*, trans. by Harry Zohn, 217–52. New York: Schocken Books, 1969.

Berman, Russell A. "The Aestheticization of Politics: Walter Benjamin on Fascism and the Avant-Garde." In *Modern Culture and Critical Theory: Art, Politics, and the Legacy of the Frankfurt School*, 27–41. Madison: University of Wisconsin Press, 1989.

Bernstein, Serge. "La France des années trente allergique au fascisme: à propos d'un livre de Zeev Sternhell." *Vingtième siècle*, no. 2 (April 1984): 83–94.

Burrin, Philippe. *La Dérive fasciste: Doriot, Déat, Bergery*. Paris: Seuil, 1986.

Cannistraro, Philip V. "Mussolini's Cultural Revolution." *Journal of Contemporary History* 7, nos. 3–4 (July–October 1972): 115–39.

Carroll, David. *French Literary Fascism: Nationalism, Anti-Semitism, and the Ideology of Culture*. Princeton: Princeton University Press, 1995.

Costa Pinto, António. "Fascist Ideology Revisited: Zeev Sternhell and His Critics." *European History Quarterly* 16, no. 4 (October 1986): 465–83.

De Felice, Renzo. *Intellettuali di fronte al fascismo*. Rome: Bonacci, 1985.

De Felice, Renzo. *Interpretations of Fascism*, trans. B. H. Everett. Cambridge: Harvard University Press, 1977.

———. *Mussolini il revoluzionario, 1883–1920*. Turin: Einaudi, 1995 [1965].

De Felice, Renzo, and George L. Mosse, eds. *Futurismo, cultura e politica*. Turin: Fondazione Giovanni Agnelli, 1988.

De Grand, Alexander J. *Bottai e la cultura fascista*. Bari: Laterza, 1978.

Dioudonnat, Pierre-Marie. *Je suis partout, 1930–1944*. Paris: La Table Ronde, 1973.

Douglas, Allen. *From Fascism to Libertarian Communism: Georges Valois against the Third Republic*. Berkeley: University of California Press, 1992.

Duroselle, Jean-Baptiste. *La Décadence 1932–1939*. Paris: Imprimerie Nationale, 1979.

Folin, Alberto, ed. *Il ritratto dell'Italiano: Cultura, arte e istituzioni in Italia negli anni trenta e quaranta*. Venice: Marsilio, 1983.

Forgacs, David. "Fascism, Violence, and Modernity." In *The Violent Muse: Violence and the Artistic Imagination in Europe, 1910–1939*, eds. Jana Howlett and Rod Mengham, 5–21. Manchester: Manchester University Press, 1994.

Furiozzi, Gian Biagio. *Sorel e l'Italia*, Florence: G. D'Anna, 1975.

Gentile, Emilio. "The Conquest of Modernity: From Modernist Nationalism to Fascism," trans. Lawrence Rainey. *Modernism/Modernity* 1, no. 3 (September 1994): 55–87.

———. *The Sacralization of Politics in Fascist Italy*, trans. Keith Botsford. Cambridge: Harvard University Press, 1996.

———. "Fascism as Political Religion." *Journal of Contemporary History* 25 (May–June 1990): 229–51.

———. "Fascism in Italian Historiography: In Search of an Individual Historical Identity." *Journal of Contemporary History* 21 (April 1986): 179–208.

———. *Le origini dell'ideologia fascista (1918–1925)*. Rome and Bari: Laterza, 1975.

———. *Storia del partito fascista, 1919–1922: Movimento e milizia*. Rome and Bari: Laterza, 1989.

Gregor, A. James. *The Ideology of Fascism: The Rationale of Totalitarianism*. New York: Free Press, 1969.

———. *Young Mussolini and the Intellectual Origins of Fascism*. Berkeley: University of California Press, 1979.

Griffin, Roger. *The Nature of Fascism*. 1991. Reprint, London: Routledge, 1994.

Guchet, Yves. *Georges Valois: L'Action française, le Faisceau, la République syndicale*. Paris: Albatros, 1975.

Hamilton, Alastair. *The Appeal of Fascism: A Study of Intellectuals and Fascism, 1919–1945*. New York: Macmillan, 1971.

Hewitt, Andrew. *Fascist Modernism: Aesthetics, Politics, and the Avant-Garde*. Stanford: Stanford University Press, 1993.

Hinz, Manfred. "The Future of Catastrophe: The Concept of History in Italian Futurism." In *The Promise of History: Essays in Political Philosophy*, ed. Athanasios Moulakis, 172–203. Berlin: W. de Gruyter, 1985.

Hirschfeld, Gerhard, and Patrick Marsh, eds. *Collaboration in France: Politics and Culture during the Nazi Occupation, 1940–1944*. Oxford: Berg, 1989.

Isnengi, Mario. *L'educazione dell'italiano: il fascismo e l'organizzazione della cultura*. Bologna: Cappelli, 1979.

Jay, Martin. " 'The Aesthetic Ideology' as Ideology: What Does it Mean to Aestheticize Politics?" In *Force Fields: Between Intellectual History and Cultural Critique*. New York: Routledge, 1993.

Jennings, Jeremy. "Syndicalism and the French Revolution." *Journal of Contemporary History* 26, no. 1 (January 1991): 71–96.

Joll, James T. "F. T. Marinetti: Futurism and Fascism." In *Three Intellectuals in Politics*, 133–78. New York: Pantheon Books, 1960.

Julliard, Jacques. "Sur un fascisme imaginaire: à propos d'un livre de Zeev Sternhell." In *Autonomie ouvrière: Etudes sur le syndicalisme d'action directe*, 269–85. Paris: Seuil, 1988.

Kaplan, Alice Yaeger. *Reproductions of Banality: Fascism, Literature, and French Intellectual Life*. Minneapolis: University of Minnesota Press, 1986.

Kedward, Harry R., and Roger Austin, eds. *Vichy France and the Resistance: Culture and Ideology*. London: Croom Helm, 1985.

Laqueur, Walter. *Fascism: Past, Present, and Future*. New York: Oxford University Press, 1996.

Laqueur, Walter, ed. *Fascism: A Reader's Guide*. Berkeley: University of California Press, 1976.

Lefranc, Georges. "Le Courant planiste de 1933 à 1936." *Le Mouvement social* no. 54 (January–March 1966): 69–89.

———. "La Diffusion des idées planistes en France." *Revue internationale des sciences sociales et Cahiers Vilfredo Pareto* 12, no. 31 (1974): 151–64.

Levey, Jules. "The Sorelian Syndicalists: Edouard Berth, Georges Valois and Hubert Lagardelle." Ph.D. diss., Columbia University, 1967.

Lipiansky, Edmond. "L'Ordre Nouveau (1930–1938)." In *Ordre et démocratie. Deux sociétés de pensée: de l'Ordre Nouveau au Club Jean-Moulin*, ed. Edmond Lipiansky and Bernard Rutterbach, 1–103. Paris: Presses Universitaires de France, 1967.

Loubet del Bayle, Jean-Louis. *Les Non-conformistes des années 30*. Paris: Seuil, 1969.

Lyttelton, Adrian. "The Language of Political Conflict in Pre-Fascist Italy." *Johns Hopkins University Bologna Center Occasional Papers*, no. 54 (June 1988): 1–20.

Mangoni, Luisa. *L'Interventismo della cultura: Intellettuali e riviste del fascismo*. Rome and Bari: Laterza, 1974.

Mazgaj, Paul. *The Action Française and Revolutionary Syndicalism*. Chapel Hill: University of North Carolina Press, 1979.

Milza, Pierre. *Le Fascisme français: passé et présent*. Paris: Flammarion, 1987.

————. *Le Fascisme italien et la presse française 1920–1940*. Brussels: Complexe, 1987.

Milza, Pierre, and Serge Bernstein. *Le Fascisme italien, 1919–1945*. Paris: Seuil, 1980 [1970].

Mosse, George L. "The Political Culture of Italian Futurism: A General Perspective." *Journal of Contemporary History* 25, nos. 2–3 (May–June 1990): 253–68. Reprinted in *Confronting the Nation: Jewish and Western Nationalism*, 91–105. Hanover, N.H.: University Press of New England, 1993.

Mosse, George L., ed. *International Fascism: New Thoughts and New Approaches*. London: Sage Publications, 1979.

Nolte, Ernst. *Three Faces of Fascism: Action Française, Italian Fascism, National Socialism*. New York: Holt, Rinehart and Winston, 1966 [1965].

Oestereicher, Emil. "Fascism and the Intellectuals: The Case of Italian Futurism." *Social Research* 41, no. 3 (Autumn 1974): 515–33.

Ostenc, Michel. *Intellectuels italiens et fascisme: 1915–1929*. Paris: Payot, 1983.

Paxton, Robert O. "Radicals." *New York Review of Books* (23 June 1994): 51–54.

————. *Vichy France: Old Guard and New Order*. New York: Knopf, 1972.

Payne, Stanley G. *Fascism: Comparison and Definition*. Madison: University of Wisconsin Press, 1980.

Quaza, Guido, ed. *Fascismo e società italiana*. Turin: Einaudi, 1973.

Rees, Philip. *Fascism and Pre-Fascism in Europe 1890–1945: A Bibliography of the Extreme Right*. Totowa, N.J.: Barnes and Noble Books, 1984.

Rémond, René. *Les Droites en France*. Paris: Aubier, 1982.

Rioux, Jean-Pierre, ed. *La Vie culturelle sous Vichy*. Brussels: Complexe, 1990.

Roberts, David. *The Syndicalist Tradition and Italian Fascism*. Chapel Hill: University of North Carolina Press, 1979.

Rogger, Hans, and Eugen Weber, eds. *The European Right: A Historical Profile*. Berkeley: University of Califoria Press, 1974.

Rohrich, Wilfred. "Georges Sorel and the Myth of Violence: From Syndicalism to Fascism." In *Social Protest, Violence, and Terror in Nineteenth and Twentieth Century Europe*, ed. Wolfgang J. Mommsen and Gerhard Hirschfeld, 246–56. New York: St. Martin's Press, 1982.

Roth, Jack. *The Cult of Violence: Sorel and the Sorelians*. Berkeley: University of California Press, 1980.

Sharkey, Stephen, and Robert S. Dombrosky. "Revolution, Myth and Mythical Politics: The Futurist Solution." *Journal of European Studies* 6, no. 23 (1976): 231–47.

Sonn, Richard. "The Early Political Career of Maurice Barrès: Anarchist, Socialist, or Protofascist?" *Clio* 21, no. 1 (Fall 1991): 41–60.

Soucy, Robert. *Fascism in France: The Case of Maurice Barrès.* Berkeley: University of California Press, 1972.

———. *French Fascism: The First Wave, 1924–1933.* New Haven: Yale University Press, 1986.

———. *French Fascism: The Second Wave, 1933–1939.* New Haven: Yale University Press, 1995.

Sternhell, Zeev. "Anatomie d'un mouvement fasciste en France: Le Faisceau de Georges Valois." *Revue française de science politique* 26, no. 1 (February 1976): 5–40.

———. "The 'Anti-Materialist' Revision of Marxism as an Aspect of the Rise of Fascist Ideology." *Journal of Contemporary History* 22, no. 3 (1987): 379–400.

———. *Neither Right nor Left: Fascist Ideology in France.* 1986. Translated by David Maisel. Reprint, Princeton: Princeton University Press, 1995.

———. *La Droite révolutionnaire, 1885–1914. Les Origines françaises du fascisme.* Brussels: Complexe, 1985 [1978].

———. "Emmanuel Mounier et la contestation de la démocratie libérale dans la France des années trente." *Revue française de science politique* 34, no. 6 (December 1984): 1141–80.

———. "The Fascist Temptation." *Jerusalem Journal of International Relations* 13, no. 2 (1991): 69–94.

———. *Maurice Barrès et le nationalisme français.* Brussels: Complexe, 1985 [1972].

———. "Strands of French Fascism." In *Who Were the Fascists: Social Roots of European Fascism,* ed. Stein Ugelvik Larsen et al., 479–500. Oslo: Universitetsforlaget, 1980.

Sternhell, Zeev, with Mario Sznajder and Maia Asheri. *The Birth of Fascist Ideology: From Cultural Rebellion to Political Revolution.* 1989. Translated by David Maisel. Reprint, Princeton: Princeton University Press, 1994.

Sweets, John. *Choices in Vichy France: The French under Nazi Occupation.* New York: Oxford University Press, 1994 [1986].

Tannenbaum, Edward R. *The Fascist Experience: Italian Society and Culture, 1922–1945.* New York: Basic Books, 1972.

Thayer, John A. *Italy and the Great War: Politics and Culture, 1870–1915.* Madison: University of Wisconsin Press, 1964.

Touchard, Jean. "L'Esprit des années 1930: une tentative de renouvellement de la pensée politique française." In *Tendances politiques dans la vie française depuis 1789,* 89–118. Paris: Hachette, 1960.

Vincent, K. Stephen. "Interpreting Georges Sorel: Defender of Virtue or Apostle of Violence?" *History of European Ideas* 12, no. 2 (1990): 239–57.

Visser, Romke. "Fascist Doctrine and the Cult of the Romanità." *Journal of Contemporary History* 27, no. 1 (January 1992): 5–22.

Weber, Eugen. *Action Française: Royalism and Reaction in Twentieth-Century France*. Stanford: Stanford University Press, 1962.

———. "Nationalism, Socialism, and National-Socialism in France." *French Historical Studies* 2, no. 3 (Spring 1962): 273–307.

———. *The Nationalist Revival in France, 1905–1914*. Berkeley: University of California Press, 1968 [1959].

———. *Varieties of Fascism: Doctrines of Revolution in the Twentieth Century*. New York: Van Nostrand, 1964.

Winock, Michel. "Fascisme à la française ou fascisme introuvable." *Le Débat*, no. 25 (May 1983): 35–44.

———. *Histoire politique de la revue "Esprit," 1930–1950*. Paris: Seuil, 1975.

Wohl, Robert. "French Fascism, Both Right and Left: Reflections on the Sternhell Controversy." *Journal of Modern History* 63, no. 1 (March 1991): 91–98.

Woolf, S. J., ed. *The Nature of Fascism*. London: Weidenfeld and Nicholson, 1968.

———. *Fascism in Europe*. London: Methuen, 1981 [1968].

Zunino, Pier Giorgio. *L'Ideologia del Fascismo: Miti, Credenze, e Valori nella Stabilizzazione del Regime*. Bologna: Il Mulino, 1985.

France and Italy: Cultural Relations

Briosi, Sandro, and Henk Hillenaar, eds. *Vitalité et contradictions de l'avant-garde: Italie-France 1909–1924*. Paris: J. Corti, 1988.

Colin, Mariella, ed. *Polémiques et dialogues. Les échanges culturels entre la France et l'Italie de 1880 à 1918*. Caen: Centre de Recherches en Langues, Littératures et Civilisations du Monde Ibérique et de l'Italie, 1988.

Duroselle, Jean-Baptiste, and Enrico Serra, eds. *Italia e Francia dal 1919 al 1939*. Milan: Istituto per gli Studi di Politica Internazionale, 1981.

———. *Il vincolo culturale fra Italia e Francia negli anni trenta e quaranta*. Milan: Franco Angeli, 1986.

Mangioni, Luisa. *Una crisi fine secolo: La cultura Italiana e la Francia fra otto e novecento*. Turin: Einaudi, 1985.

Fascism and Art in France and Italy

Abbate, Marco, and Domenico Pertocoli, eds. *Gli annitrenta: arte e cultura in Italia*. Milan: Mazzotta, 1983 [1982].

Anni Creativi al "Milione," 1932–1939. Milan: Silvana Editoriale, 1980.

Antliff, Mark. *Inventing Bergson: Cultural Politics and the Parisian Avant-Garde*. Princeton: Princeton University Press, 1993.

———. "The Jew as Anti-Artist: Georges Sorel, Antisemitism, and the Aesthetics of Class Consciousness." *Oxford Art Journal* 20, no. 1 (1997): 50–67.

Apollonio, Umbro. *Futurist Manifestos*. New York: Viking Press, 1973.

Armellini, Guido. *Le immagini del fascismo nelle arti figurative*. Milan: Fabbri, 1980.

Baudouï, Rémi. "L'architecture en France des années 40: conflits 'idéologiques' et continuités formelles de la crise à la Libération." In *Art et fascisme: totalitarisme et résistance au totalitarisme dans les arts en Italie, Allemagne et France des années 30 à la défaite del'Axe*, eds. Pierre Milza and Fanette Roche-Pézard, 79–100. Brussels: Complexe, 1989.

Belli, Carlo. *Il mondo di Carlo Belli: Italia anni trenta, la cultura artistica*. Milan: Electa, 1991.

Bertrand Dorléac, Laurence. *L'Art de la défaite, 1940–1944*. Paris: Seuil, 1993.

———. "Les Arts plastiques." In *La Propagande sous Vichy, 1940–1944*, eds. Laurent Gervereau and Denis Peschanski, 212–23. Paris: Musée d'Histoire Contemporaine, 1990.

———. *Histoire de l'art: Paris 1940–1945. Ordre national, traditions et modernités*. Paris: Publications de la Sorbonne, 1986.

———. "L'Ordre des artistes et l'utopie corporatiste, 1940–1944: les tentatives de régir la scène artistique française juin 1940–août 1944." *Revue d'histoire moderne et contemporaine* 37 (January–March 1990): 64–87.

Bossaglia, Rossana. *Il 'Novecento Italiano': storia, documenti, iconografia*. Milan: Feltrinelli, 1979.

Braun, Emily. "The Scuola Romana: Fact or Fiction?" *Art in America* 76, no. 3 (March 1988): 128–37.

———. "Speaking Volumes: Giorgio Morandi's Still Lifes and the Cultural Politics of Strapaese." *Modernism/Modernity* 2, no. 3 (September 1995): 89–116.

Braun, Emily, ed. *Italian Art in the 20th Century*. Munich: Prestel-Verlag, 1989.

Britt, David, ed. *Art and Power: Europe under the Dictators, 1930–1945*. London: Thames and Hudson, 1995.

Canfora, Luciano. *Ideologie del classicismo*. Turin: Einaudi, 1980.

Caramel, Luciano, ed. *L'europa dei razionalisti: Pittura, scultura, architettura negli anni trenta*. Milan: Electa, 1989.

Carpi, Umberto. *Bolscevico immaginista: Communismo e avanguardie artistiche nell'Italia degli anni venti*. Naples: Liguori, 1981.

Ciucci, Giorgio. *Gli Architetti e il fascismo: Architettura e città, 1922–1944*. Turin: Einaudi, 1989.

Cone, Michèle C. "Abstract Art as a Veil: Tricolor Painting in Vichy France." *Art Bulletin* 74, no. 2 (June 1992): 191–204.

———. *Artists under Vichy*. Princeton: Princeton University Press, 1992.

———. "Le Régime de Vichy, l'occupation nazie et la critique d'art: le sort des modernismes face à la censure politique." In *L'Art et les révolutions, 2. Changements et continuité dans la création artistique des révolutions poli-*

tiques, ed. Klaus Herding, 187–210. Strasbourg: Société Alsacienne pour le Développement de l'Histoire de l'Art, 1992.

Cone, Michèle C. "Vampires, Viruses, and Lucien Rebatet: Anti-Semitic Art Criticism During Vichy." In *The Jew in the Text: Modernity and the Construction of Identity*, ed. Linda Nochlin and Tamar Garb, 174–86. London: Thames and Hudson, 1995.

Cork, Richard. *A Bitter Truth: Avant-Garde Art and the Great War*. New Haven: Yale University Press, 1994.

Corradini, Mauro. *Arte e resistenza in Italia*. Reggio Emilia: ANPI, 1986.

Cowling, Elizabeth, and Jennifer Mundy, eds. *On Classic Ground: Picasso, Léger, de Chirico, and the New Classicism, 1910–1930*. London: Tate Gallery, 1990.

Créations en France. Paris-Paris, 1937–1957. Paris: Centre Georges Pompidou, 1981.

Crispolti, Enrico. *Il mito della macchina e altri temi del futurismo*. Trapani: Celebes, 1969.

———. *Storia e critica del futurismo*. Bari: Laterza, 1986.

Crispolti, Enrico, Berthold Hinz, and Zeno Birolli, eds. *Arte e fascismo in Italia e in Germania*. Milan: Feltrinelli, 1974.

Danesi, Silvia, and Luciano Patetta. *Rationalisme et architecture en Italie, 1919–1943*. Paris: Electa France, 1977 [1976].

Daverio, Philippe, Maurizio Fagiolo dell'Arco, and Netta Vespignani, eds. *Roma tra espressionismo barocco e pittura tonale, 1929–1943*. Milan: Arnoldo Mondadori/Philippe Daverio, 1984.

Davies, Judy. "The Futures Market: Marinetti and the Fascists of Milan." In *Visions and Blueprints: Avant-Garde Culture and Radical Politics in Early Twentieth-Century Europe*, eds. Edward Timms and Peter Collier, 82–97. Manchester: Manchester University Press, 1988.

De Micheli, Mario, ed. *Corrente: il movimento di arte e cultura di opposizione 1930–1945*. Milan: Vangelista Editore, 1985.

De Seta, Cesare. *La cultura architettonica in Italia tra le due guerre*. Rome and Bari: Laterza, 1983 [1972].

Doordan, Dennis Paul. *Building Modern Italy: Italian Architecture, 1914–1936*. New York: Princeton Architectural Press, 1988.

———. "The Political Content in Italian Architecture during the Fascist Era." *Art Journal* 43, no. 2 (Summer 1983): 121–31.

Etlin, Richard A. *Modernism in Italian Architecture, 1890–1940*. Cambridge: MIT Press, 1991.

Exposition Résistance, déportation: création dans le bruit des armes. Paris: Chancellerie de l'Ordre de la Libération, 1980.

Fagiolo dell'Arco, Maurizio, ed. *Art astratta Italiana dal futurismo agli anni trenta*. Rome: De Luca, 1986.

———. *Realismo magico: Pittura e scultura in Italia, 1919–1925*. Milan: Mazzotta, 1988.

———. *Scuola romana: Artisti tra le due guerre*. Milan: Mazzotta, 1988.

Faure, Christian. *Le Projet culturel de Vichy: Folklore et révolution nationale 1940–1944*. Lyon: Centre Régional de Publication de Lyon/Presses Universitaires de Lyon, 1989.

Flint, Kate. "Art and the Fascist Régime in Italy." *Oxford Art Journal* 3, no. 2 (1980): 49–54.

Fossati, Paolo. *L'immagine sospesa: Pittura e scultura astratte in Italia, 1934–40*. Turin: Einaudi, 1971.

———. *'Valori Plastici,' 1918–1922*. Turin: Einaudi, 1981.

Ghirardo, Diane Yvonne. *Building New Communities: New Deal America and Fascist Italy*. Princeton: Princeton University Press, 1989.

———. "Italian Architects and Fascist Politics: An Evaluation of the Rationalist's Role in Regime Building." *Journal of the Society of Architectural Historians* 39, no. 2 (May 1980): 109–27.

Gli anni del premio Bergamo: Arte in Italia intorno agli anni trenta. Milan: Electa, 1993.

Gli anni trenta: Arte e cultura in Italia. Milan: Mazzotta, 1983 [1982].

Golan, Romy. "From Fin de Siècle to Vichy: The Cultural Hygienics of Camille (Faust) Mauclair." In *The Jew in the Text: Modernity and the Construction of Identity*, eds. Linda Nochlin and Tamar Garb, 156–73. London: Thames and Hudson, 1995.

———. *Modernity and Nostalgia: Art and Politics in France Between the Wars*. New Haven: Yale University Press, 1995.

Golsan, Richard J., ed. *Fascism, Aesthetics, and Culture*. Hanover, N.H.: University Press of New England, 1992.

Grimm, Reinhold, and Jost Hermand, eds. *Faschismus und Avantgarde*. Königstein: Athenäum, 1980.

Hanson, Anne Coffin, ed. *The Futurist Imagination: Word + Image in Italian Futurist Painting, Drawing, Collage, and Free-Word Poetry*. New Haven: Yale University Art Gallery, 1983.

L'Idea del classico, 1916–1932: Temi classici nell'arte degli anni venti. Milan: Fabbri, 1992.

Italian Art, 1900–1945. New York: Rizzoli, 1989.

Jannini, Pasquale Aniel et al. *La fortuna del futurismo in Francia*. Rome: Bulzoni, 1979.

Kostof, Spiro. "The Emperor and the Duce: The Planning of Piazzale Augusto Imperatore in Rome." In *Art and Architecture in the Service of Politics*, eds. Henry Millon and Linda Nochlin, 270–326. Cambridge: MIT Press, 1978.

Laude, Jean. "La Crise de l'humanisme et la fin des utopies. Sur quelques problèmes de la peinture et de la pensée européennes, 1929–1939." In *L'Art*

face à la crise, 1929–1939, 295–301. Saint-Etienne: Centre Interdisciplinaire d'Etudes et de Recherche sur l'Expression Contemporaine, 1980.

Lista, Giovanni. *Arte e politica: il futurismo di sinistra in Italia*. Milan: Multhipla, 1980.

———. *Les Futuristes*. Paris: Henri Veyrier, 1988.

———. "Marinetti et le futurisme politique." In *Marinetti et le futurisme: Etudes, documents, iconographie*, 11–28. Lausanne: L'Age d'homme, 1977.

———. "Marinetti et les anarcho-syndicalistes." In *Présence de Marinetti*, ed. Jean-Claude Marcadé, 67–85. Lausanne: L'Age d'homme, 1982.

Malvano, Laura. *Fascismo e politica dell'immagine*. Turin: Bollati Boringhieri, 1988.

Marinetti, F. T. *Teoria e invenzione futurista*. ed. Luciano De Maria. Milan: Arnoldo Mondadori, 1990 [1968].

Martin, Marianne. *Futurist Art and Theory, 1909–1915*. Oxford: Clarendon Press, 1968.

McLeod, Mary. "'Architecture or Revolution': Taylorism, Technocracy, and Social Change." *Art Journal* 43, no. 2 (Summer 1983): 132–47.

———. "Bibliography: Plans 1–13 (1931–1932); Plans (bi-monthly), 1–8 (1932); Bulletin des Groupes Plans, 1–4 (1933)." *Oppositions*, nos. 19–20 (Winter/Spring 1980): 185–89.

———. "Le Corbusier and Algiers." *Oppositions*, nos. 19–20 (Winter/Spring 1980): 53–85.

———. "Le Corbusier, from Regional Syndicalism to Vichy." (Ph.D. diss., Princeton University) Ann Arbor: University Microfilms, 1985.

Millon, Henry. "The Role of the History of Architecture in Fascist Italy," *Journal of the Society of Architectural Historians* 24, no. 1 (March 1965): 53–59.

———. "Some New Towns in Italy in the 1930's." In *Art and Architecture in the Service of Politics*, eds. Henry Millon and Linda Nochlin, 53–59. Cambridge: MIT Press, 1978.

Milza, Pierre, and Fanette Roche-Pézard, eds. *Art et fascisme: totalitarisme et résistance au totalitarisme dans les arts en Italie, Allemagne et France des années 30 à la défaite del'Axe*. Brussels: Complexe, 1989.

Morosini, Duilio. *L'arte degli anni difficili, 1928–1944*. Rome: Editori Riuniti, 1985.

Mostra del novecento Italiano (1923–1933). Milan: Mazzotta, 1983.

Poggi, Christine. *In Defiance of Painting: Cubism, Futurism, and the Invention of Collage*. New Haven: Yale University Press, 1992.

Pontiggia, Elena. *Il Milione e l'astrattismo, 1932–1938*. Milan: Electa, 1988.

Les Réalismes, 1919–1939. Paris: Musée National d'Art Moderne, 1980.

Le Retour à l'ordre dans les arts plastiques et l'architecture, 1919–1925. Saint-Etienne: Centre Interdisciplinaire d'Etudes et de Recherche sur l'Expression Contemporain, 1975.

Roche-Pézard, Fanette. "Du Futurisme au Novecento, un engagement politique?" *Cahiers du Musée National d'Art Moderne*, nos. 7–8 (1981): 234–43.

Salaris, Claudia. *Artecrazia: l'avanguardia futurista negli anni del fascismo*. Florence: La Nuova Italia, 1992.

Schapiro, Ellen Ruth. *Building under Mussolini*. Ann Arbor: University Microfilms, 1988 [1985].

Schiavo, Alberto, ed. *Futurismo e fascismo*. Rome: Giovanni Volpe, 1981.

Schnapp, Jeffrey T. "*18 BL*: Fascist Mass Spectacle." *Representations*, no. 43 (Summer 1993): 89–125.

———. "Politics and Poetics in Marinetti's *Zang Tumb Tuum*." *Stanford Italian Review* 5, no. 1 (1985): 75–92.

———. "Propeller Talk." *Modernism/Modernity* 3, no. 1 (September 1994): 153–78.

Schnapp, Jeffrey, and Barbara Spackman, eds. "Fascism and Culture," *Stanford Italian Review* 8, nos. 1–2 (1990).

Silva, Umberto. *Ideologia e arte del fascismo*. Milan: Mazzotta, 1973.

Silver, Kenneth E. *Esprit de Corps: The Art of the Parisian Avant-Garde and the First World War, 1914–1925*. Princeton: Princeton University Press, 1989.

Silver, Kenneth E., and Romy Golan. *The Circle of Montparnasse: Jewish Artists in Paris, 1905–1945*. New York: Jewish Museum/Universe, 1985.

Stone, Marla. "Staging Fascism: The Exhibition of the Fascist Revolution." *Journal of Contemporary History* 28, no. 2 (1993): 215–43.

Tempesti, Fernando. *Arte dell'Italia fascista*. Milan: Feltrinelli, 1976.

Tisdall, Caroline, and Angelo Bozzolla. *Futurism*. London: Thames and Hudson, 1977.

Von Falkenhausen, Susanne. *Der Zweite Futurismus und die Kunstpolitik des Fascismus in Italien von 1922–1943*. Frankfurt am Main: Haag and Herchen, 1979.

Von Hallberg, Robert, and Lawrence Rainey, eds. "Special Issue on Fascism and Culture, Parts I and II." *Modernism/Modernity* 2, no. 3 (September 1995), and 3, no. 1 (January 1996).

Notes on the Contributors

Walter L. Adamson teaches modern European intellectual history and the history of modern Italy at Emory University. His most recent book is *Avant-Garde Florence: From Modernism to Fascism* (Harvard University Press, 1993), winner of the American Historical Association's Marraro Prize for the best book in Italian history, 1995. He has also written numerous articles on fascism and culture, and he is currently at work on a book tentatively entitled *Modernism and Mass Culture in European Cities, 1905–1924*. As part of his own pursuit of mass culture, he joins 49,999 others in the running of Atlanta's Peachtree Roadrace every July 4.

Matthew Affron received his Ph.D. from Yale University in 1994. He is Assistant Professor of Art History at the University of Virginia. Affron is a contributor to the exhibition catalogues, *Exiles and Emigrés: The Flight of European Artists from Hitler* (Los Angeles County Museum of Art, 1997) and *Fernand Léger* (New York: Museum of Modern Art, 1998). He is currently writing a book on the work of Léger.

Mark Antliff, Associate Professor of Art History at Queen's University, is the author of *Inventing Bergson: Cultural Politics and the Parisian Avant-Garde* (Princeton, 1993) as well as articles in such journals as the *Art Bulletin*, *Art Journal*, *Oxford Art Journal*, and *Word & Image*. A Guggenheim Fellow for 1995–96, he is currently completing a book-length study of the aesthetics of Georges Sorel and the impact of his cultural views on the development of fascism in France.

Emily Braun is Associate Professor at Hunter College, City University of New York, where she teaches twentieth-century art and theory. She has written numerous articles on Italian art, with an emphasis on the culture of the fascist period. Braun is author of *Thomas Hart Benton: The America Today Murals* (1985), editor of *Italian Art in the 20th Century* (1989), and coauthor of *Gardens and Ghettos: The Art of Jewish Life in Italy* (1989). Her most recent publication is *The Hillman Collection: A History and Catalogue* (1994). She is currently completing her book *Mario Sironi: Art and Politics in Fascist Italy, 1919–1945*.

Michèle C. Cone, Research Associate at the Institute of French Studies, New York University, is best known for *Artists under Vichy* (Princeton University Press, 1992), "Abstract Art as a Veil: Tricolor Painting in Vichy France" (*Art Bulletin*, June 1992), and "Anti-Semitic Art Criticism During Vichy" (*The Jew in the Text*, Thames and Hudson, 1995). She also writes and lectures on contemporary art and is the author of *Roots and Routes of Art in the Twentieth Century* (1975).

Emilio Gentile, Professor of Political Science at the University of Rome, is the author of numerous works on Italian fascism, including *"La Voce" e l'età giolittiana* (1972), *Le origini dell'ideologia fascista* (1975), *Il mito dello stato nuovo dall'antigiolittismo al fascismo* (1982), and *Il culto del littorio: la sacralizzazione della politica nell'Italia fascista* (1993). The last work has been translated as *The Sacralization of Politics in Fascist Italy* (Harvard University Press, 1996).

Nancy Locke earned her Ph.D. at Harvard University in 1992. Currently she is Assistant Professor of Art History at Wayne State University in Detroit, where she teaches courses on nineteenth- and early twentieth-century art, the history of Paris, and the theory of modernism. Her work focuses on nineteenth-century constructions of sexuality and the ideology of the family, as well as methodological issues pertaining to the incorporation of psychoanalytic theory into the social history of art. She is currently completing a book entitled *Manet and the Family Romance*.

Marla Stone is Assistant Professor of History at Occidental College. She has written extensively on the politics and culture of European fascism. Her book *The State as Patron: The Cultural Politics of Fascist Italy* is forthcoming from Princeton University Press.

Index